Claes Oldenburg

Barbara Rose
Claes Oldenburg

The Museum
of Modern Art,
New York

Distributed by New York Graphic Society Ltd., Greenwich, Connecticut

The Museum of Modern Art
11 West 53 Street, New York, New York 10019
All rights reserved, 1970
Library of Congress Catalog Card Number 69–11450

Designed by Chermayeff & Geismar Associates, New York

Printed and bound in Switzerland by Conzett & Huber, Zurich
Production coordination by Chanticleer Press, Inc., New York

Photograph Credits

Plates for the drawings reproduced in color on pages 71 (left), 74 (left), 115-122, 123 (left), and 124 were made directly from the originals by Conzett & Huber, Zurich.

Photographs for illustrations other than those listed below were supplied by the owners of the respective works of art.

Oliver Baker: 95 (left, above)
Courtesy Paul Bianchini, New York: 160 (right)
Rudolph Burckhardt, New York: 57 (above), 96 (below), 129, 142
Louis Checkman, Jersey City, N.J.: 104 (right)
Geoffrey Clements, New York: 10 (right), 15, 92, 94, 95 (left, below; right, above and below); 96 (above), 97, 98 (left), 99, 100, 106, 107 (left), 108 (left), 109 (left and right), 110, 128 (left), 130 (right), 131, 133 (left and center), 134 (left), 135, 137, 140, 147 (right), 148, 161, 162 (left and right), 163, 164 (left), 168, 172 (right), 173 (left), 203 (above)
Colossal Keepsake Corporation, New Haven, Conn.: 112 (left)
Jonas Dovydenas, Chicago: 204 (right)
Robert Ellison, Dallas: 185 (left)
Arthur Freed, New York: 66 (left)
Hans Hammarskiöld, Stockholm: 61, 93, 203 (below), 204 (left)
Martha Holmes, New York: 50 (left)
Dennis Hopper, Los Angeles: 144
Scott Hyde, New York: 169 (left)
Courtesy Sidney Janis, New York: 130 (left and center), 141, 159 (left)
Burt Kramer, New York: 29 (right)
Julius Lazarus, Hyannisport, Mass.: 77 (right)
Alicia Legg, New York: 205 (center)
Frank Lerner, New York: 71 (right), 73, 75, 76, 77 (left and center), 78 (right), 79, 80, 81, 82, 83 (right), 84, 85, 86, 87 (right, above), 88
Courtesy Los Angeles County Museum of Art: 8 (left)
Robert E. Mates and Paul Katz, New York: 170
James Mathews, New York: 12, 13, 20, 21, 22, 23, 24, 27, 30, 32 (left), 38, 40, 41, 44 (center and right), 45, 46, 47 (left), 49, 56, 57 (left), 58 (right), 59, 60, 63 (left, above and below), 98 (right), 104 (left), 105, 107 (right), 111 (right), 114, 128 (right), 134 (right), 155 (left), 159 (right), 164 (right), 165 (right), 169 (right), 171, 172 (center, above and below), 199
Robert McElroy, New York: 28 (center), 31, 39, 50 (right), 63 (right), 65, 66 (right), 68, 69, 74 (right), 90, 123 (right), 152, 178, 186, 200 (left, above), 201
Peter Moore, New York: 8 (right), 25, 187
Claes Oldenburg, New York: 42, 43 (left), 200 (below)
Rolf Petersen, New York: 98 (center), 165
Eric Pollitzer, New York: 32 (center), 72
Nathan Rabin, New York: 15, 26, 28 (left), 36, 43 (right), 44 (left), 52, 53, 54, 58 (left), 62, 102, 108 (right), 112 (center, right, far right), 126 (left), 147 (left), 155 (right), 156, 157, 158, 160 (left), 172 (left), 173 (center and right), 177
Charles Rappaport, New York: 47 (right), 126 (right)
Walter J. Russell, New York: 67
John D. Schiff, New York: 43 (center)
Allen M. Schumeister, Minneapolis: 155 (center, courtesy Dayton's Gallery)
Shunk-Kender, New York: 113, 146 (right), 202 (right), 205 (left and right)
Gian Sinigaglia, Milan: 78 (left), 83 (left)
Frank J. Thomas, Los Angeles: 87 (right, below), 89, 138, 200 (right)
Jann and John Thomson, Los Angeles: 132, 146 (left, courtesy Sidney Janis Gallery)
Charles Uht, New York: 202 (left)
Mal Varon, New York: 87 (left)
Ron Vickers, Ltd., Toronto: 109 (center), 149 (right)
Julian Wasser, Beverly Hills, Calif.: 185 (right, above and below)
Courtesy Worcester Art Museum: 10 (left)

Acknowledgments

This book was undertaken at the invitation of The Museum of Modern Art in conjunction with its major retrospective exhibition of the work of Claes Oldenburg (September 25–November 23, 1969). I wish especially to thank the director of the exhibition, Alicia Legg, Associate Curator of the Department of Painting and Sculpture, for gathering and correlating much of the data and illustrative material and placing it at my disposal. The Sidney Janis Gallery also answered many inquiries and provided many photographs.

I am grateful to the artist's wife, Pat Oldenburg, for biographical information and discussions concerning the production of many of his works, as well as for many good meals and a great deal of patience during the two years that my study was underway. My students and ex-students at Sarah Lawrence College, Susan Levitt, Donna Kaplan, Victoria Kogan, and Linda Peterson, have aided in research.

William S. Rubin, Chief Curator of Painting and Sculpture, The Museum of Modern Art, and Theodore Reff, Professor of Art History, Columbia University, read early drafts of the manuscript and provided a number of helpful suggestions. I am particularly indebted to Helen M. Franc, Editor-in-Chief of the Museum's Department of Publications, for many imaginative contributions of a substantive as well as an editorial nature, which have immeasurably improved the text. She was assisted in organizing the chronology by Caryl Snapperman, editorial trainee at the Museum, and Victoria Kogan, who also helped compile the bibliography and the index. The design of the book, conceived by Ivan Chermayeff, has been carried out with understanding and painstaking care by Heiner Hegemann of Chermayeff & Geismar Associates.

My greatest debt, of course, is to the subject of these pages, Claes Oldenburg himself. The book would not have been possible without his full cooperation and his generous permission to consult and quote without restriction from his manuscripts, personal files, notebooks, and other documents, on which my study is largely based.

B.R.
September 1969

Acknowledgment is herewith made to the following sources for quotations used as chapter headings:

page 19: Marcel Proust, *Swann's Way,* 1913 (translated by C. K. Scott-Moncrieff. New York: Random House, 1956, Modern Library Edition), p. 61.–Peter Paul Rubens, "Letter to Franciscus Junius," 1637 (translated by Richard Friedenthal. In *Letters of the Great Artists.* London: Thames and Hudson; New York, Random House, 1963) p. 164.–Charles Baudelaire, *The Painter of Modern Life and Other Essays,* 1863 (translated and edited by Jonathan Mayne. London, Phaidon, 1964), p. 8.

page 35: Robert Henri, *The Art Spirit* (compiled by Margery Ryerson. Philadelphia: J. B. Lippincott, 1923; paperback edition, 1960), p. 127.

page 37: Margaret Cavendish, "The Description of a New World, called the Blazing World, written by . . . the Duchess of Newcastle," London, 1666 (in "Utopia," *Daedalus,* Journal of the American Academy of Arts and Sciences, Spring 1965), pp. 319–320.

page 51: Thomas Hooker, "A True Sight of Sin," 1743 (in *The American Puritans: Their Prose and Their Poetry,* edited by Perry Miller. Garden City: Doubleday Anchor Books, 1956), p. 164.

page 55: Herman Melville, *The Confidence-Man,* 1857 (New York: Grove Press, Black Cat Edition, 1961), p. 229.

page 62: Mark Twain, "How To Tell a Story," 1897 (in *Great Short Works of Mark Twain,* introduction by Justin Kaplan. New York: Harper & Row, 1967), p. 182.

page 103: Henry James, *Roderick Hudson* (Revised Edition. Boston: Houghton Mifflin, 1885), pp. 128–129.–Claes Oldenburg, "A Card from Doc" (in *Injun and Other Histories* [1960]. A Great Bear Pamphlet. New York: Something Else Press, 1966), p. 13.

page 127: Donald Judd, "Specific Objects" (in *Arts Yearbook 8: Contemporary Sculpture.* New York: The Art Digest, © 1965), pp. 77–78.

page 139: Petronius, *The Satyricon* (quoted by J. P. Sullivan, "Satire and Realism in Petronius," in *Critical Essays on Roman Literature. II. Satire.* London: Routledge & Kegan Paul; New York: Hillary House, Division of Humanities Press, Inc.; paperback edition, Bloomington: Indiana University Press, 1963), p. 85.–Jonathan Swift, *Gulliver's Travels,* 1726 (edited by Louis Landa. Cleveland: World Publishing Company, 1947), pp. 147–148.

page 145: Claes Oldenburg, "America: War & Sex, Etc." (in *Arts Magazine* [New York], Summer 1967), p. 36.–Howard Hibbard, *Bernini* (Baltimore: Penguin Books, 1966), p. 134.

page 154: Claes Oldenburg, "America: War & Sex, Etc.," pp. 33, 38.

page 168: Claude Lévi-Strauss, *The Savage Mind,* 1962 (translated by George Weidenfeld. Chicago: University of Chicago Press, 1966), p. 245.–Claes Oldenburg, *Store Days* (New York: Something Else Press, 1967), p. 60.

page 175: Norman O. Brown, *Love's Body* (New York: Random House, 1966; Vintage Book Edition, 1968), p. 152.–Mircea Eliade, "Paradise and Utopia: Mythical Geography and Eschatology" (in *Utopias and Utopian Thought,* edited by Frank E. Manuel. Daedalus Library, published by the American Academy of Arts and Sciences and Houghton Mifflin Company, 1967; Boston: Beacon Press Edition, 1967), p. 268.

page 178: Charles Baudelaire, "On the Essence of Laughter, and, in General, on the Comic in the Plastic Arts," 1855 (translated and edited by Jonathan Mayne. In *The Mirror of Art: Critical Studies by Charles Baudelaire.* New York: New York Graphic Arts Society, 1956; paperback edition, Garden City: Doubleday Anchor Books, 1956), p. 153.

page 183: Constance Rourke, *American Humor—A Study of the National Character,* 1931 (New York: Harcourt, Brace & World; paperback edition, Garden City: Doubleday Anchor Books, 1955), pp. 19, 21.–Herman Melville, *The Confidence-Man,* p. 128.–Claes Oldenburg, interview with Robert Pincus-Witten ("The Transfiguration of Daddy Warbucks," *Chicago Scene,* April 1963), p. 34.

For Rachel and Michael

Contents

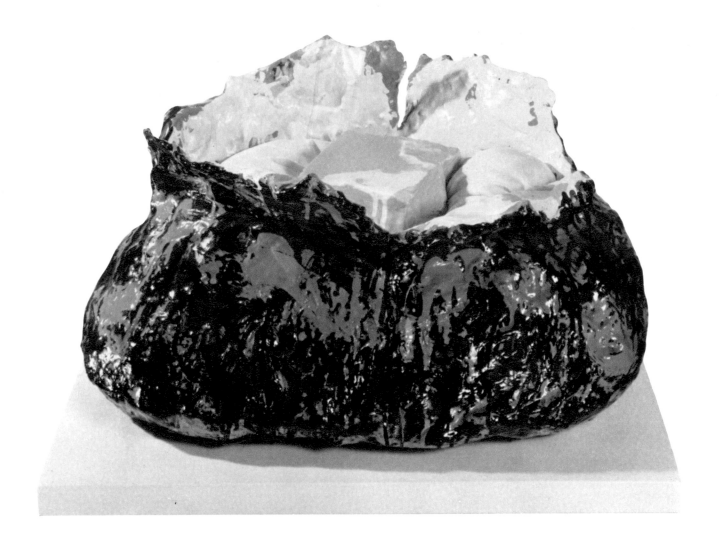

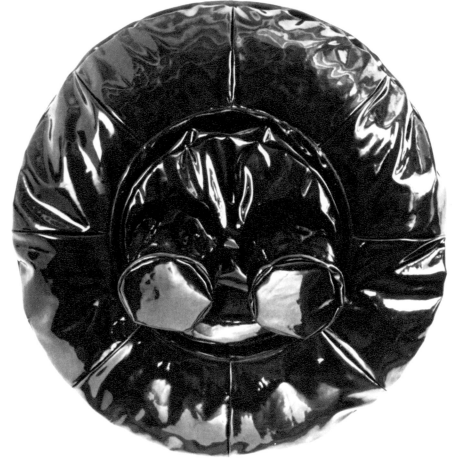

Baked Potato, I. 1963
Burlap soaked in plaster, painted with enamel; jersey stuffed with kapok, 14 inches high x 24 inches wide
Collection Dr. and Mrs. Nathan Alpers, Los Angeles (courtesy Los Angeles County Museum of Art)

8

Giant Soft Swedish Light Switches. 1967
Vinyl filled with kapok, 51⅝ inches high x 47 inches wide x 16½ inches deep
The Albert A. List Family Collection

Introduction

What is both hard and soft? What changes, melts, liquefies, yet is solid? What is both formed and unconformable? structured and loose? present and potential? What unites conception with process? movement with stasis? What is painting? sculpture? architecture? or landscape? portrait? still-life? What personalizes anonymity and objectifies the subjective? What is hermetic, yet overt? What hides beneath layers of disguises, while proclaiming complete self-exposure? What is both self-conscious and automatic, logical and lunatic, real and fantastic?

Perhaps only by a series of questions cast in the naive form of a child's riddles can one begin to confront the shifting images within the hall of mirrors that is Claes Oldenburg's art. Like the ancient philosophers and poets who first observed that life is marked by change and paradox, Oldenburg attempts to delve beneath surface appearances in order to uncover more fundamental realities and find the universal constants of human experience in the flux of modern life.

The artist who takes on such a task must be either a hero or a buffoon. Oldenburg always leaves open the question of which of these roles he is assuming. We are on surer ground, however, as regards the importance of his art, both as formal invention and as aesthetic object. So we should properly begin with the objects themselves, and through them ultimately become acquainted with their multifaceted, chameleonlike creator.

Oldenburg's objects demand close examination. Even when they present single large forms, their surfaces are articulated, sometimes by stitching or the application of paint, sometimes by the use of shining, highly reflective materials. As a result, these objects, shaded, patched, divided into zones, embroidered, painted, crumpled into pleats—in short, varied by every conceivable technique of enrichment—seem constantly alive.

This desire to enrich what pessimistic critics have regarded as the impoverished quality of contemporary art is at the heart of Oldenburg's endeavor. Although, as we shall see, his work shares certain formal characteristics with Minimal Art, it is in every respect the opposite of a reductive statement.[1] In retrospect, it is clear that at the outset of his career, his formal conventions were those of Abstract Expressionism and its derivatives. For example, although his Store reliefs, like much of Pop Art, were based on mechanically drawn commercial ads, they bear hardly the slightest resemblance to them; whereas, with their restless contours rising and falling from fluttering, unstable edges, they have many similarities to "action painting."

An artist at once sensuous and cerebral, Oldenburg seeks to explore the largest possible range of expression and sensation and so achieves maximum contrasts of surface, silhouette, color, texture, and form. Irregularity is cultivated to create such unexpected shapes as the hollow organic shell of the *"Empire" ("Papa") Ray Gun,* prototype of his phallic forms, or the unpredictable contours of the flat Street figures and bulky reliefs of The Store. *p. 58*

"Nothing is irrelevant," Oldenburg observed in one of his notebook entries, "everything can be used."[2] More consciously and consistently than most artists, he sifts and refines everyday experience in order to discover the greatest common denominators among phenomena. Gravity is utilized to create surprising configurations and relate art more closely to the processes of nature. At times, the textures of the city are literally incorporated in an art as varied and vital as city life itself. In the sad-sack Street figures, for example, corrugated cardboard is juxtaposed with rough burlap. Line functions as a sensual, ragged edge, and these torn edges make the figures of The Street and the objects in The Store seem to have been ripped from their environment. This both lends immediacy and introduces a note of violence; for in the work of an artist determined, as is Oldenburg, to serve as witness to his times, violence must indeed have its place.

Oldenburg's dictum that nothing is discarded, that everything is used, reveals his intention to create an art as full to the point of overflowing as life itself. Just as he telescopes subject matter, content, and form, so he

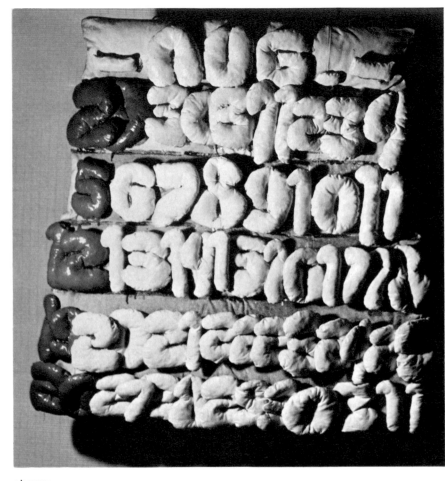

above:
Soft Calendar for the Month of August (August Calendar). 1962
Canvas filled with shredded foam rubber, painted with Liquitex and enamel,
42 inches square x 6 inches deep
Collection Mrs. Albert H. Newman, Chicago

right:
Soft Manhattan, I—Postal Zones. 1966
Canvas filled with kapok, impressed with patterns
in sprayed enamel, wood rod,
79 inches high x 27 inches wide x 4½ inches deep
Albright-Knox Art Gallery, Buffalo (gift of Seymour H. Knox)

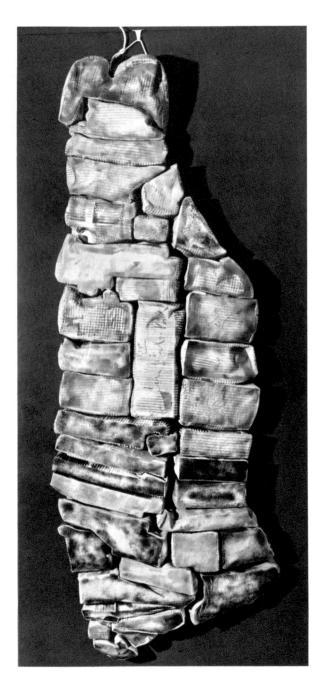

also distils and compresses the various mediums: his work successively incorporates drawing, then painting and sculpture, then architecture, and finally, in his projects for monuments, even some aspects of urban design. Layer is superimposed upon layer, until the multiple traditions of art history are absorbed in a complex synthesis. His thought processes conform closely to the dialectical principle that every development contains within itself an inherent contradiction, which must be identified and isolated, consciously comprehended, and finally amalgamated in a synthesis. His ambition for comprehensiveness, to be all things to all men, leads Oldenburg to aspire to subsume within his work the entire dialectical process: to provide his own thesis, antithesis, and synthesis, and himself create the response to his self-generated challenges.

Oldenburg complains that Americans are too rational; they do not go to extremes. To encompass such extremes, he creates an art based on polarities. "All my thought circulates about opposites; satirical-mystical (worldly unworldly)," he notes. "People I disapprove of are those who, whoever they are, are not innocent, intense, in it. Who have had their intensity or innocence educated out of them, and so reduced all to some hand-label *in their minds*." Given to unremitting speculation and self-analysis, Oldenburg nevertheless strenuously objects to over-intellectualization and asks instead for a more intense, direct appreciation of experience.

Everything in Oldenburg's work is carried to an extreme. According to him, even the banal must be intense: "The ordinary must not be *dull*," he declares. "It can be excruciating, *excruciatingly banal*." Deliberately choosing the most commonplace subjects, he exaggerates their banalities and so pushes them in a direction opposite to the familiar. For the hottest subject, he usually reserves the coldest, most detached treatment, and vice versa. Thus, although eroticism is the dominant theme throughout his work, his *Bedroom Ensemble,* a setting in which sex should most naturally be found, is visualized in terms of hard geometric

pp. 94–95

curves and angles. A drawing to decorate a memorial *p.12* portfolio for Oldenburg's friend, the late Frank O'Hara, is executed with the most impersonal and mechanical draftsmanship. "It is the false and cynical treatment of real emotion, as in today's publications, that fascinates me and yields more truth," Oldenburg wrote in 1963, observing that "language and idea is used in a way that accepts its shallowness because the picture next to it does the actual job ... The world is seeking its way back to feel and touch things. But American commercial art with its distance . . . while presenting eminently 'hot' matter ... 'object pornography' is in a way a model of the 'objective expressionism' I practice."[3]

The polarities in Oldenburg's work constantly evoke and equate with each other: hard and soft, erect and relaxed, formal and informal receive equal treatment. Even form itself is reduced to two basic antithetical classes—the organic and the geometric—which alternate throughout his art. Similarly, he does not see style as a progressive development, but rather as an oscillation between the traditional poles of the classic and the romantic, the painterly and the linear. Just as he has deduced the basic form classes from the multiple examples of art history, so he has attacked content in a similarly analytical fashion, arriving finally at a statement so generalized that it can engage any spectator on a preverbal level, plunging him back deep into his own instinctual life, from which no man, no matter how rational, can escape.

Oldenburg's content is as timeless as his subject matter is contemporary and American. In his telescoping view, the human body is visualized as a landscape; its corrugations, wrinkles, folds, and furrows are like the striations, caverns, mountains, and valleys of a topographical map. The body's irregular silhouette resembles the fine indentations of a coastline, and its features are like natural formations—hills, rivers, *pp.13,* streams, and caves. The landscape, in turn, can be per- *124* sonified. Consequently, Oldenburg's work is predicated on dual and seemingly contradictory metaphors for both the human body and the natural landscape.

Perhaps the simplest way to view Oldenburg's development (though we shall explore many others as well) is in terms of the environments from which he has chosen his themes: The Street, The Store, and The Home. Each of these represents for the artist a microcosm with its own laws; each allows him to examine and isolate a specific formal element as a distinguishable problem. Although painting was his point of departure, The Street is involved primarily with drawing, The Store with plane and color, and The Home and its various soft objects—furnishings for the bedroom, bathroom fixtures, electrical appliances—with volume. Each plastic element is investigated with tenacity and thoroughness, yet "Nothing replaces anything. Everything accumulates, binoculars and telescopes."[4]

Movement, change, and metamorphosis are the constants of Oldenburg's work; in this respect, his imagination may be regarded as linking him with the Surrealists, not in the sense of having been influenced by them but rather of belonging to the same family of mind. It is typical that the mind that delights in paradox should make a constant of flux. Things are apprehended and visualized in one moment in their continual process of change; "hard," "ghost," and "soft" versions of the toilet, the telephone, the typewriter, the light switch *p.15* denote different states of the same object. In a related series, Oldenburg may alter the size, shape, form, substance, or stage in time of each successive model. This alteration emphasizes the process of change: the state of each object within the series is always represented as unstable and transitional, visualized in the existential process of "becoming," rather than fixed in a resolved, closed state.

A recollection from Oldenburg's childhood is significant in this connection. His insatiable curiosity manifested itself at an early age, and as a child he was fascinated by an exhibit that showed sand turned into glass when struck by a bolt of lightning. The immaterial lightning bolt, an ephemeral natural phenomenon materialized and transformed into durable, solid matter, may serve as a metaphor for Oldenburg's concept

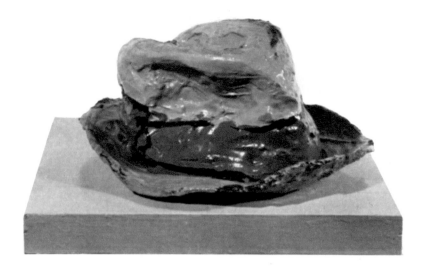

Blue Men's Hat. 1962
Felt hat soaked in plaster, painted with enamel,
5³/₈ inches high x 12 inches wide x 10 inches deep
Collection Mr. and Mrs. S. Brooks Barron, Detroit

11

TEAPOT

Image of the Buddha Preaching

I am very happy to be here at the Villa Hügel
and Prime Minister Nehru has asked me to greet the people of Essen
and to tell you how powerfully affected we in India
have been by Germany's philosophy, traditions and mythology
though our lucidity and our concentration on archetypes
puts us in a class by ourself
 "for in this world of storm and stress"
—5,000 years of Indian art! just think of it, oh Essen!
is this a calmer region of thought, "a reflection of the mind
through the ages"?
 Max Müller, "primus inter pares" among Indologists
remember our byword, Mokshamula, I rejoice in the fact of 900 exhibits

I deeply appreciate filling the gaps, oh Herr Doktor Heinrich Goetz!
and the research purring onward in Pakistan and Ceylon and Afghanistan
soapstone, terracotta-Indus, terracotta-Maurya, terracotta Sunga,
 terracotta-Andhra, terracotta fragments famous Bharhut Stupa
Kushana, Ghandara, Gupta, Hindu and Jain, Secco, Ajanta, Villa Hügel!
Anglo-German trade will prosper by Swansea-Mannheim friendship
waning how the West Wall by virtue of two rolls per capita
and the flagship BERLIN is joining its "white fleet" on the Rhine
though better schools and model cars are wanting, still still oh Essen
 Nataraja dances on the dwarf
 and unlike their fathers
 Germany's highschool pupils love the mathematics

 which is hopeful of a new delay in terror
 I don't think

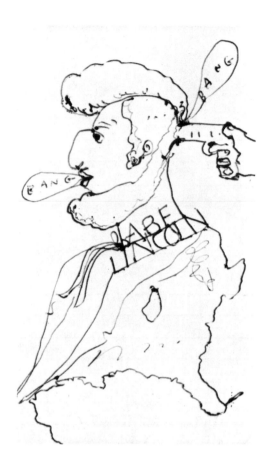

above:
Abe Lincoln (notebook page). 1963
Ball-point pen and ink,
4⅞ inches high x 2¾ inches wide
Owned by the artist

opposite:
Decoration for Frank O'Hara's poem
"Image of the Buddha Preaching." 1967
Pencil, colored pencil, and ink on two printed sheets,
12 inches high x 17⅞ inches wide
The Museum of Modern Art, New York

of the creative act. It is his own immaterial fantasy, his own shifting vision and view of space, that he seeks to freeze and capture in his art.

This freezing of motion, the momentary apprehension of cloth flapping in the wind (one way in which Oldenburg's reliefs can be seen), is like that dramatic moment of impact when the lightning bolt changes from one physical state to another. What interests Oldenburg is not the alteration of psychological states (the traditional content of expressionist art), but the alteration, real or imagined, of physical properties.

This emphasis on the physical as opposed to the metaphysical is one of the factors that marks Oldenburg's work unmistakably as American art of the 'sixties. The question he poses is not whether "significant form" exists, but whether it is the exclusive property of abstract art—a postulate toward which "modernism" has been tending since early in our century. What Oldenburg proposes is a low, vulgar, representational art of formal significance. The initial shock of recognition, the secondary appreciation of witty analogies between one configuration and another, does not obviate nor transcend the appeal of surface, silhouette, form, and color, though these qualities will elude the viewer involved solely in identifying the subject. Unquestionably, part of Oldenburg's intention is to foil the literal minded. He is no naive simpleton, but a complex artist who seeks to exploit as fully as possible the various levels of meaning—subject, content, and form—available to any work of art. The constant pressure applied to each of these kinds of visual "meaning," and the interrelationships among them, provide the special tension and excitement of his work.

The pleasure-giving qualities of Oldenburg's objects are sufficiently outstanding to command our attention. Beyond that, his work raises virtually every significant critical question involved in a discussion of contemporary art: the interaction of form and content, the relation of representational to abstract art, the nature and importance of formal radicalism in new art. With a thorough knowledge of the art of the past and an extreme consciousness of contemporary relevance, Oldenburg calls into question the very concept of style itself, by proposing a rampantly eclectic style that in essence presupposes all the historical movements preceding it. An understanding of Oldenburg's art, therefore, is absolutely crucial for an understanding of what is at stake in the art of the 'sixties.

1. Oldenburg's art is the opposite of Minimal Art, because it is based on accretion rather than reduction; yet it is related to Minimal Art in its search for essences and its attempt to isolate and define the fundamental processes of the making and perceiving of art.

2. Unless otherwise indicated, all quotations are from Oldenburg's notebooks of 1959–1961.

3. In certain respects, Oldenburg's analysis of the disjunction between language and meaning in contemporary forms of communication, such as propaganda, advertising, and TV commercials, has analogies with investigations by such "new wave" film-makers as Jean-Luc Godard, and with the analyses of such European critics of literature and culture as Roland Barthes and Jacques Ellul.

4. Claes Oldenburg, "America: War & Sex, Etc.," *Arts Magazine* (New York), Summer 1967, p. 38.

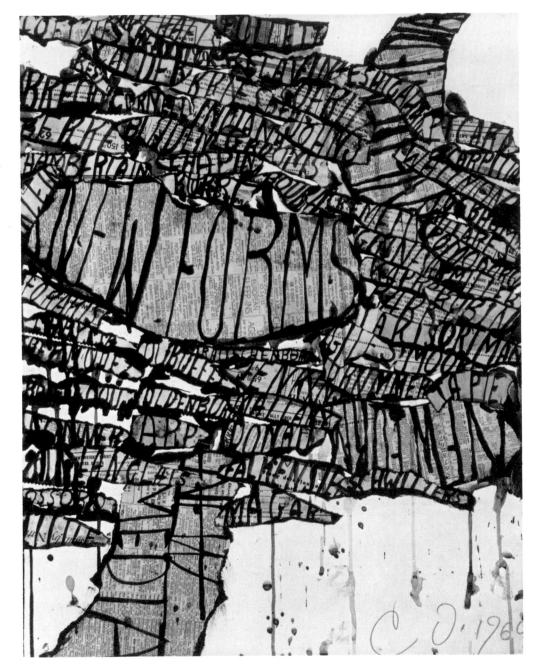

Poster study for the exhibition
"New Forms—New Media, I,"
Martha Jackson Gallery. 1960
Collage, ink and watercolor,
24 x 18½ inches
Collection Mr. and Mrs. Robert C. Scull,
New York

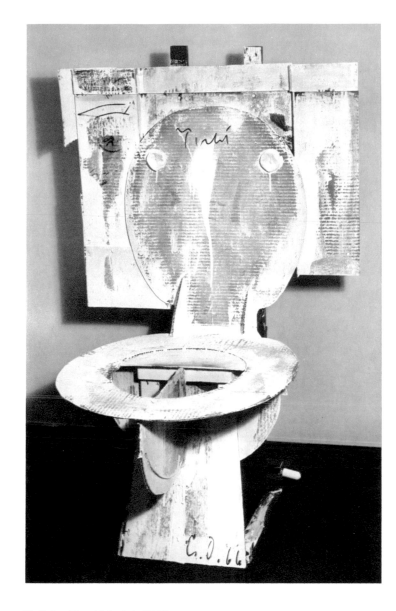

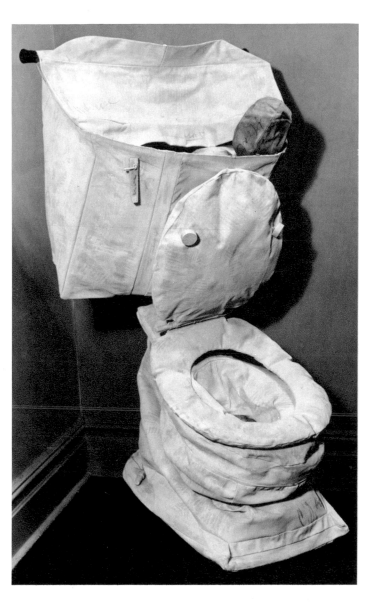

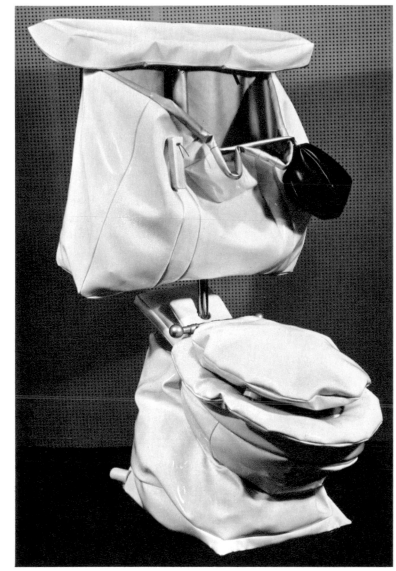

Toilet—Hard Model. 1966
Cardboard, wood, other materials,
44 inches high x 28 inches wide x 33 inches deep
Karl Ströher Collection, 1968, Darmstadt

Soft Toilet—"Ghost" Version (Model "Ghost" Toilet). 1966
Canvas filled with kapok, wood, painted with Liquitex,
51 inches high x 33 inches wide x 28 inches deep
The Albert A. List Family Collection

Soft Toilet. 1966
Vinyl filled with kapok, painted with Liquitex, wood,
$50^{1}/_{2}$ inches high x $32^{5}/_{8}$ inches wide x $30^{7}/_{8}$ inches deep
Collection Mr. and Mrs. Victor W. Ganz, New York

Part I:
Life and Art

Portrait of the Artist

The past is hidden somewhere outside the realm, beyond the reach of intellect, in some material object (in the sensation which that material object will give us) which we do not suspect.

Marcel Proust, *Swann's Way*

Things that can be grasped by our senses make a deeper imprint and more lasting impression; they call also for more careful study, and offer richer material for understanding to the student than mere phantoms of our imagination. And those things which we can only apprehend by words may easily disappear, even if we triple our effort, like the image of his beloved Eurydice to Orpheus, and all our hopes have then been in vain. I speak from experience.

Peter Paul Rubens to Franciscus Junius,
Antwerp, 1637

But genius is nothing more nor less than childhood recovered at will—a childhood now equipped for self expression, with manhood's capacities and a power of analysis which enables it to order the mass of raw material which it has involuntarily accumulated.

Charles Baudelaire, *The Painter of Modern Life*

Perhaps no approach is less fashionable among art critics today than that of biographical criticism. Because Oldenburg, however, has consciously chosen to generate his art from his own psychology and life experience, his biography assumes paramount importance. It therefore seems appropriate to emulate the artist in his working process: use the facts of his life as the key to the meaning of his art.

Claes Thure Oldenburg was born in Stockholm on January 28, 1929, the elder of two sons of a Swedish diplomat, Gösta Oldenburg, then stationed as an attaché in New York, and his wife, the former Sigrid Elisabeth Lindforss. Oldenburg was brought to the United States as an infant and spent his first three years in New York City and Rye, New York. His younger brother, Richard Erik, was born in 1933. In the same year, Oldenburg's father became first secretary at the Swedish Embassy in Oslo, where the family lived until 1936. By the time they finally settled in Chicago, where Oldenburg's father had been appointed consul, the seven-year-old boy had already been exposed to a number of diverse environments, which may help to explain his later hypersensitivity to his surroundings and to cultural change.

When Claes arrived in Chicago, he spoke no English, and communication with other children was extremely difficult. Not surprisingly, he led an even richer fantasy life than most children. Many of his fantasies centered around the history, geography, sociology, economics and science of the imaginary country of "Neubern"—an island between Africa and South America whose language was half Swedish, half English.[1] This fantasy took shape when he was allowed to use the typewriters in his father's office during off hours at the Consulate. His playground was an abandoned office, where he and his brother made buildings out of file cabinets, which they circled with their tricycles. A score of scrapbooks still exists, filled with maps, documents, lists of streets, and indexes of the exports and imports of Neubern, and illustrated with hundreds of colored scale drawings. Originally, the Neubern note-

books resembled a newspaper, and the illustrations were intended to imitate news photographs; in fact, one of the earliest references to Neubern is in the form of a newspaper dated January 10, 1937. (In Sweden, the Oldenburg family were printers, which may explain why young Claes was attracted to the idea of a newspaper.) The later illustrations, however, imitate magazine ads and posters, such as movie posters, and images of flags and emblems are frequent. There are also many maps, both of the city with its rectangular grid of streets bearing strange Swedish-English names of Oldenburg's invention, and of the country—its geological cross-sections, climatic zones, and so forth. It is noteworthy that there was no literature in Neubern; writing about the country was confined to facts and statistics, accompanied by maps, charts, diagrams, plans, and images of such objects as airplanes, flags, and guns, many of which recur later in Oldenburg's art.

The extraordinary thing about Neubern is not that its complex universe of planned towns, model industries, entertainments, and systems of commerce and warfare was the creation of a young child. What is significant is how coherent Oldenburg's childhood fantasy was, how inclusive of every aspect of living, working, and relaxing, and how complete its staggering inventory of concrete, factual detail.

Surely one of the most seemingly outrageous claims ever made by an artist is Oldenburg's facetious assertion in 1966: "Everything I do is completely original I made it up when I was a little kid." The Neubern scrapbooks, however, prove that even as a child Oldenburg fantasied a world formulated in his own image. At first glance, this grand comprehensive design appears to be a duplicate reality; but closer inspection reveals that even the smallest details, from the shapes of the fictive airplanes to the names of minor technicians on movie posters, were all invented. Like the work that Oldenburg was to produce as a mature artist, Neubern was a parody of reality, providing a counterpart cosmos that paralleled the real world instead of imitating it. He was apparently aware at an early age

Page from scrapbook made by Oldenburg's aunt, Karin Lindforss, ca. 1934–1935
Collage of pasted papers, 10⁷/₈ x 15 inches
Owned by the artist

of his role as a creator and his identity as some kind of "inventor." It is natural, therefore, that when he subsequently decided to follow Klee's precedent and look to children's art as an antidote to the staleness of "civilized" art, Oldenburg did not choose to approximate the formal conventions of a generalized notion of child art. Instead, he returned to the conceptions—although not necessarily to the immature execution—of the art of his all-inclusive childhood fantasy.

When he was not working on the history of Neubern (a project encouraged by his parents and private tutor to help him learn English), young Oldenburg made model airplanes, which he decorated with the insignia of the Neubern Air Force. They were never meant to fly; he was interested only in their complex structure and the careful manual work of assembling them. He always combined parts of various models to make a composite that was clearly identifiable as a plane but conformed to no existing aircraft. In his 1968 notebooks, Oldenburg recalls that: "Following the Neubern publications I became interested in constructing model airplanes of the solid variety, and in making films. I built miniature sets and staged fires and crashes of cars and airplanes on a miniature scale." He also remembers that one of his favorite toys at this period was the model of a Chrysler Airflow sedan with battery-powered headlights, and that he had an extensive collection of scale-model ships. All these, too, were to reappear as images in his art.

Other sources from his childhood to which he was to turn for inspiration included scrapbooks sent to him from time to time by his mother's twin sister in Sweden. They contained collages made up of illustrations taken from advertisements in popular magazines —mainly of household appliances, food, clothing, and other consumer goods. Their bizarre juxtapositions of objects in varying scales provided another point of departure for Oldenburg when he later determined to emulate Proust and attempt to recapture the past in art.

Oldenburg attended the Chicago Latin School, an all-male institution—an experience that may have

contributed to his forming the idea of the exotic otherness of women that permeates his work. For recreation, the teen-aged Oldenburg explored the burlesque houses on Rush Street, talking to the dancers and looking for sex and color. He remembers that he was somewhat perplexing to his teachers, who expected him to achieve great things, but in some area they could not define. In the 1946 class yearbook, which he edited and illustrated, "Ceto" or "the Swede" was voted "most sophisticated," "funniest," and "most intellectual." His hobbies were art and music; his profession was undecided.

Despite his obvious talent for drawing, Oldenburg was not encouraged to become an artist. His decision to pursue a career in art came only after he had considered many other possibilities. He left Chicago in 1946 to attend Yale. There, he was selected to participate in the experimental Directed Studies program, which sought to overcome the rigidity of specialization by introducing the student to a wide range of subjects in both science and the humanities. The program demanded that the student write constantly—something Oldenburg was already accustomed to doing and has continued to do ever since. As a result of his habit of observing, recording, and analyzing his own experience, he has filled innumerable journals and notebooks with random, impressionistic jottings and theoretical essays. Their content varies from the rawest honesty to the murkiest self-delusion, and their style is a crazy quilt ranging from mock heroic to folksy plebeian. Oldenburg's notebooks, like his art, are full of contradictions, but they allow him the freedom to express whatever he may feel at the moment, reserving judgment until later critical appraisal.

During his last year at Yale, Oldenburg began his first formal study of art, with courses in art history and studio work in figure drawing and composition. He came into contact with the teaching of the great French scholar Henri Focillon through his book *The Life of Forms in Art*. The distinctive feature of Focillon's approach was that he viewed art history as a series of linked formal innovations; he associated

Variation on the root of a tree. 1955
Pencil, 9 x 7 inches
Owned by the artist

Pen variations with peacock. July 9, 1955
Pen and ink, 10 x 7 7/8 inches
Owned by the artist

Two drawings in "metamorphic" style, applied to the rendering of plants and machines. 1954
Pencil, left: 8¹⁄₈ x 6³⁄₄ inches; right: 10 x 7⁵⁄₈ inches
Owned by the artist

artists not only by their period but also across the ages by their "family of mind," or sensibility. Oldenburg also had a class with the distinguished literary critic Cleanth Brooks, whose textbook *Understanding Poetry* brought the New Criticism to a generation of college students. Some welcomed its message more than others; it is doubtful, for example, that Brooks realized that his teaching inspired one daydreaming undergraduate from Chicago to begin plotting revenge against the bloodless, restrictive canons of formalism. "I shall always have an undying grudge against Cleanth Brooks," Oldenburg recalls, as he speculates "how poetry *might* be taught if the aim were not didactic. I myself accepted poetry as I might the morning newspaper, with my eyes wide open—but that was soon knocked out of me."

After four years at Yale, where he concentrated on literature and art and took a course in drama, Oldenburg returned to Chicago in 1950. There he began working as a novice reporter with the City News Bureau, covering mainly the police beat. His six months on the street were his first prolonged exposure to the life of the city slums. But soon he grew restless: "I could not see myself spending a lifetime writing meaningless reports about meaningless events." Rejected by the Army in January 1952, and no longer under the threat of the draft, Oldenburg was free to find a specific focus for his talents. He then decided to concentrate his energies on art, which he believed could also absorb his interest in literature and theater.

From 1952 to 1954, Oldenburg read, drew, and supported himself with a variety of jobs—working as an apprentice in an advertising agency, selling candy in Dearborn Station, and doing illustrations for the magazine *Chicago*. Meanwhile, he sporadically attended art classes at The Art Institute of Chicago. During this period, he became acquainted with a number of Chicago artists. Among his friends and acquaintances at this time were the figure painters George Cohen, June Leaf, Robert Barnes, Leon Golub (known for his paintings of gargantuan, expressionist nudes), and

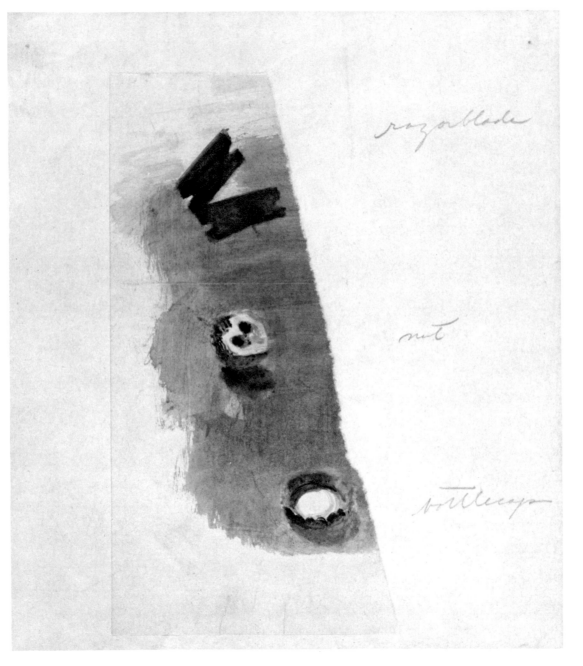

razorblade

nut

bottlecap

New York, although painterly and expressionist, was abstract, while he, like many of his friends in Chicago, continued to paint the figure. "I was entirely on my own," he wrote. "I was only looking for the experience of the city; I spent a lot of time walking and drawing on the streets." He drew constantly: street scenes and sensitive still-lifes of small objects like shells, bottle caps, pencils, and plants. In fact, among the few possessions he brought with him from Chicago were his drawing tools and a few favorite small still-life objects.

Shortly after his arrival in New York, Oldenburg was fortunate in finding a part-time job (which he held until the fall of 1961) shelving books in the libraries of the Cooper Union Museum and Art School. His work at Cooper Union gave him the opportunity to examine the many original drawings in the museum's collection. As he shelved books, he gave himself what amounted to a cram course in art history, browsed through volumes on old New York, and studied early encyclopedias and illustrated texts on art. From the school windows, he could look out at the teeming activity of the Bowery and other Lower East Side streets; on his way to work, he often made quick sketches of the daily life of the slums he passed. Like the painters of the Ash Can School early in the century, Oldenburg found this area full of vitality and raw excitement.

Oldenburg had few social or professional contacts during the first few years after his arrival in New York. Most of his time was spent in reading, observing, and drawing. For a few months in 1957, in the course of attempts to elicit erotic fantasies, he also made collages; the irregular contours of unrecognizable single images were silhouetted sharply against the white background of the paper. Later, the eccentric silhouette of these obsessive shapes was to find expression in the twisting outline of the *"Empire" ("Papa") Ray Gun.* *p.58* Throughout this period of generating images, he continued his exercises in style, working in various modes as experiments in expression.

The period of detached solitude ended at the close of 1957, when Oldenburg rented an apartment at

330 East Fourth Street which was large enough to paint in. It served him as a studio until June 1961. The East Fourth Street apartment was found for him by a friend from Chicago, the eccentric printmaker Dick Tyler, whom Oldenburg had persuaded to join him in New York. Tyler acted as superintendent of the building, occupying a basement apartment with his wife, Dorothea Baer, who was also a printmaker. During 1957–1958, the Tylers were Oldenburg's closest friends in New York. He joined them in their many disorganized bohemian activities, which included involving local slum children in amateur theatricals and making papier-mâché animal masks for the children to wear in the streets. Oldenburg admired Tyler's vitality and free behavior, which often culminated in violent outbursts. Tyler also sold occult tracts and alchemical prints and literature from an open wheelbarrow in front of the Judson Memorial Church on Washington Square. Oldenburg discussed various theatrical projects with Tyler and was particularly impressed by his plans for an event—which fortunately never took place—to be held in front of the church's altar and end with the bombing of the audience.

Oldenburg's interest in the theater provided one of the few threads of continuity between his years at Yale, his Chicago period, and his new life in New York. Beginning in 1958, this interest brought him into contact with a whole group of environmental artists who were abandoning the flatness of painting in favor of a three-dimensional art. From its inception, therefore, Oldenburg's art had theatrical connections. Oldenburg and Tyler read and discussed together a report in *The New York Times* on the free-form theatrical activities of the Japanese Gutai Art Group.[4] They also heard of a talk given by Allan Kaprow at the Artists' Club.[5] Oldenburg was further impressed by Kaprow's "tarbaby" sculptures and daringly explicit man with an erection.[6] He was especially struck by Kaprow's article, "The Legacy of Jackson Pollock,"[7] which now reads like a manifesto for environments and happenings, and was determined to meet its author.

Kaprow, one year Oldenburg's senior, had studied painting with Hans Hofmann, art history at Columbia University with Meyer Schapiro, and composition with John Cage at the New School for Social Research. Far from considering Pollock as a new beginning for painting, Kaprow interpreted Pollock's drip paintings as the end of a tradition. Inspired by Harold Rosenberg's exposition of the existentialist necessity for "action," Kaprow saw the large scale and directness of Pollock's painting as calling for an art of literal environment and actual gesture, an art that "must become preoccupied with and even dazzled by the space and objects of our everyday life, either our bodies, clothes, rooms, or, if need be, the vastness of Forty-second Street." His vision of Pollock colored by Rosenberg's formula, Kaprow assumed Pollock's image to be a fragment of a larger whole, an image that "tends to fill our world with itself." He predicted that "not satisfied with the *suggestion* through paint of our other senses, we shall utilize the specific substances of sight, sound, movements, people, odors, touch."[8] Kaprow progressed from collage to "environments," which he defined as "an art that fills an entire room (or outdoor space) surrounding the visitor and consisting of any materials whatsoever, including lights, sounds and color," and thence to "happenings," which refer to "an art form related to theater, in that it is performed in a given time and space. Its structure and content are a logical extension of 'environments.'"[9] Kaprow's first happening was given a private performance in the winter of 1957–1958, and his first public happening, *Communication,* was presented the following April. His subject matter, like that of Pop Art, was deeply involved with the urban environment, another fact that was naturally attractive to Oldenburg.

In his cramped fifth-floor apartment, Oldenburg continued to paint brooding self-portraits and loosely brushed figure studies. The subject of many of these studies was a puckish, fine-boned young artist's model, Pat Muschinski, whom Oldenburg had met briefly in

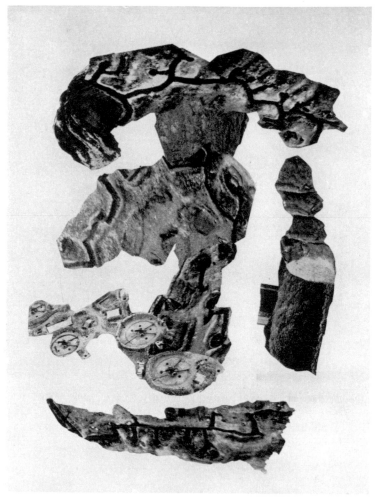

Obsessive shapes: man's profile, gun emplacements, or imagery out of feces. 1957
Collage of fragments cut from magazines, 14¼ x 11 inches. Owned by the artist

opposite:
Razorblade, Nutshell, Bottle Cap
(study of small objects in light). 1956
Brush and ink, pencil, 11 x 8½ inches
Owned by the artist

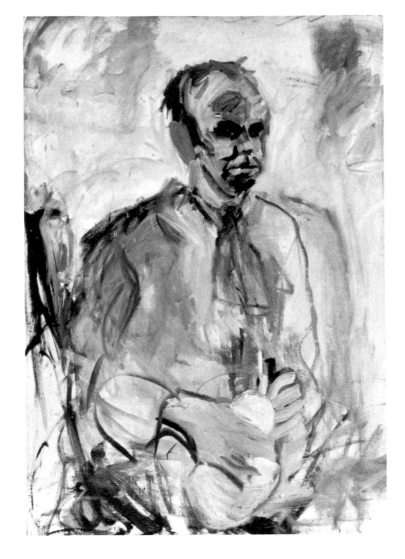

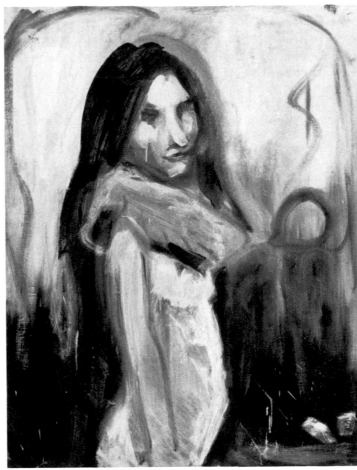

Saugatuck in 1954. They reestablished contact in New York in 1958, and eventually they were married in April 1960. During this period, Oldenburg wrote poems, influenced mainly by Rimbaud, which combined Surrealist jumps in logic with concrete everyday details.

Late in 1958, while looking for a gallery, Oldenburg met Red (Charles) Grooms, who was then running in his studio an informal gallery where figurative and deliberately crude *art brut* was shown.[10] Oldenburg's first exhibition in New York was at this City Gallery, when a number of his drawings were included in a group show there (December 19, 1958–January 6, 1959). Grooms, who despite his immersion in city life preserved the innocence of a *naïf,* became for Oldenburg the epitome of the fresh eye that found constant wonder in banality. Through Grooms and Kaprow, Oldenburg soon came into contact with a lively group of artists, who were inspired as he was by the marginal life of the slums. They included Robert Whitman, Lucas Samaras, and George Segal, who had been students of Kaprow's at Rutgers University. Segal's chicken farm in New Jersey occasionally served as the site for informal picnic-happenings, in which the participants engaged in uninhibited, self-expressive behavior. At about the same period, Oldenburg met Jim Dine, who was also interested in Kaprow's ideas about happenings and environments as a logical way of extending painting into actual space and time. Contact with the sympathetic ideas of this group stimulated Oldenburg to a clearer formulation of his own views.

Little remains of Oldenburg's work of 1957–1958. Those years, during which he absorbed and generated many new ideas concerning theater and art, coincided with the dissolution of late Abstract Expressionism under the critical attacks of younger artists like these. It was a crucial and difficult period, both in Oldenburg's life and in the history of American art. The strongest artists of his generation were rejecting the heroic pose and rhetoric of Abstract Expressionism. Oldenburg's own efforts were an important part of the painful analysis that took place in the late 'fifties,

Self-Portrait. 1959
Oil, 68 x 47½ inches
26 Owned by the artist

Girl with Furpiece (Portrait of Pat). 1959–1960
Oil, 41 x 31 inches
Owned by the artist

Street Event: Woman Beating Child. 1958
Pen and watercolor, 7½ x 5 inches
Owned by the artist

leading in the 'sixties to the sorting out of the many contradictory impulses within Abstract Expressionism. That movement had absorbed the frequently opposing currents of Cubism, Surrealism, and indigenous American art into contexts in which they were no longer contradictory. During those years in which Abstract Expressionism peaked and became the establishment art in the uptown galleries, artists like Oldenburg were meanwhile attempting fresh formulations. Below Fourteenth Street, rebellion was brewing.

This period was likewise one of great turbulence and inward development for Oldenburg. Early in 1958, he began painting large-scale oils of nudes, faces, and everyday situations; most of them have been destroyed. Many of his drawings were studies for these works, and like the paintings they emphasized light and tone. Besides drawings made in the studio, Oldenburg made many in his sketchbook, on location in the city, riding on the Staten Island Ferry, and attending frequent parties in smoky, crowded lofts. He also drew from memory incidents observed in the city, as well as imaginary figure subjects. At this time, Oldenburg began separating his drawings into general thematic categories, such as "The City" (the street) and "The Country" (the beach).

In March 1959, a few months after the group show of sculpture and drawings at Grooms's City Gallery, Oldenburg had a one-man show at the Cooper Union Art School Library. It consisted entirely of figure drawings of Pat. This show had an important outcome; it resulted in his being asked by two Cooper Union art students, Marc Ratliff and Tom Wesselmann, to join a gallery in the basement of the Judson Memorial Church—a space that Ratliff had occupied as his studio. Under the leadership of Howard Moody and Bud (Bernard) Scott, the Church had initiated one of the first programs attempting to bring live art into the neighborhood and draw on the creative energy within the community for a series of dance, theater, and poetry events, as well as open exhibitions. The program's vitality resulted from the fact that the

Judson community happened also to be that of a number of highly gifted artists. As its program expanded, the church sponsored exhibitions in its basement rooms, which became known as the Judson Gallery. Both Dine and Wesselmann exhibited there, and it was there that Oldenburg had his first public one-man show in New York, from May to June 1959.

Originally, it was to have been a painting show, but at the last minute Oldenburg decided to present a show of figurative and metamorphic drawings, wood or newspaper sculpture and objects painted white (among them the mounted seed-pod prototype of the *p. 28* ray gun), and enlarged poems. Like every subsequent show of Oldenburg's, this "white" show, as he referred to it, was conceived as an environment in which all the elements were related thematically, stylistically, and technically. Because of their perishable nature, most of the works from this Judson Gallery show no longer exist. Many of the crudely executed sculptures were of the same material, a kind of rough papier-mâché made by dropping newspaper into wheat paste and molding it on a rigid chicken-wire armature. Most of the pieces were covered with a rapidly applied, semitransparent coat of white tempera that served to unify them as an ensemble. Some of these first sculptures by Oldenburg, for example the *"Lady,"* a modified coat rack, incorpo- *p. 28* rated found objects and used techniques with which he had experimented while helping Dick Tyler with his theatrical projects. The outstanding piece in the show was the large *Elephant Mask*, reminiscent of masks worn *pp. 28 29* in primitive festivities; this Oldenburg or Pat sometimes took off its stand to wear outdoors in the streets of the Village. One of the works in the show was a photograph of the *"Lady"* and the *Elephant Mask p. 29* combined in a dramatic situation.

Throughout this period, Oldenburg became increasingly interested in the theater, stimulated by Bud Scott, Dick Tyler, and the activities at the Judson. He read Artaud, one of whose works had recently been published in English translation,[11] and he discussed with Tyler plans for a "psychastenic spectacle." Mean-

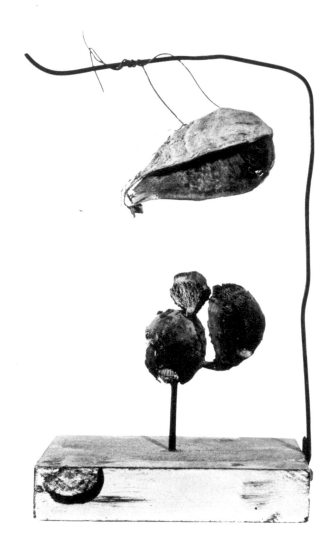

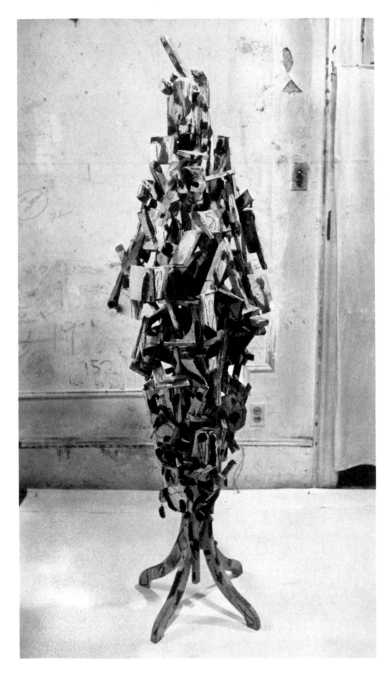

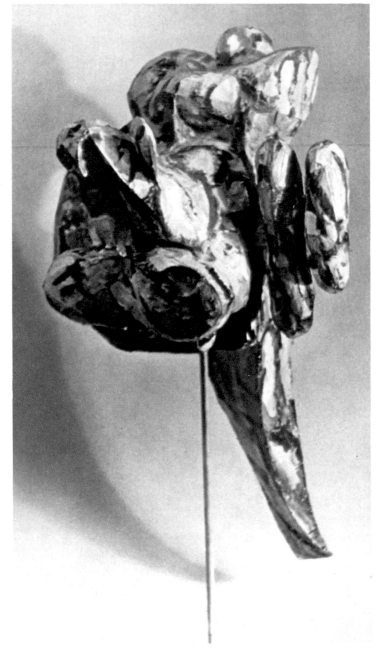

Milkweed Pods. Collected 1954; mounted 1959
Milkweed pods, nail, wire, on wood base,
painted with latex and casein, 8½ x 4¼ inches

Owned by the artist

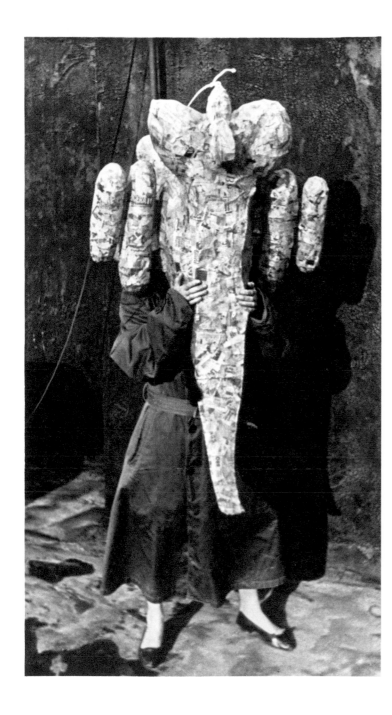

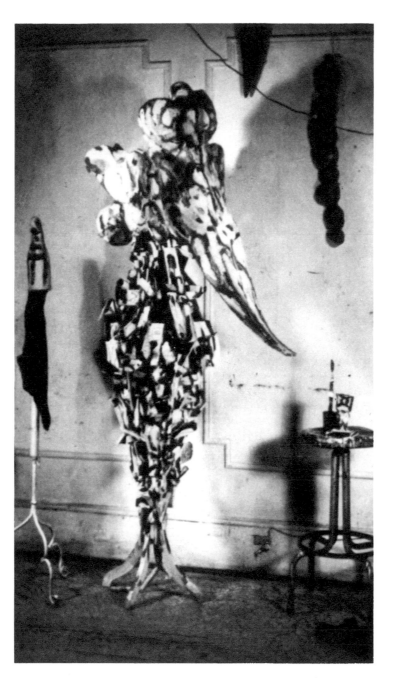

opposite, left:
"Lady" (study of small planes and line in space)
Scrap wood nailed around axis of a coatrack,
painted with casein, ca. 72 inches high
(destroyed 1959)

opposite, right:
Elephant Mask
Newspaper soaked in wheat paste over wire frame,
painted with latex,
39 inches high x 27 inches wide x 24 inches deep
Owned by the artist

far left:
Elephant Mask
(before painting; worn by Pat Oldenburg in army raincoat)

left:
Elephant Mask and "Lady"
Photograph included in one-man show
at Judson Gallery, May 1959

while, he was developing his own ideas about the theory and form of the theater, especially the elements of simultaneity and repetition. When Oldenburg saw Kaprow's first theater piece, *18 Happenings in 6 Parts,* in October 1959, he was disappointed by the boredom of repetition, which he attributed to the Zen influence of John Cage.[12] Much more to his natural taste for spectacle and drama was Red Grooms's presentation of *The Burning Building,* which was performed in Grooms's loft, the Delancey Street Museum, in December 1959. Oldenburg saw it several times; its vivid imagery triggered his own imagination, which a few months later found expression in the "Ray Gun Spex" (see pp. 46, 48).

Shortly after his exhibition at the Judson Gallery was over, Oldenburg left New York for Lenox, Massachusetts, where Pat had a job modeling in a summer school. He himself worked as director of the newly founded Lenox Art Gallery, sponsored by a local resort and art school, Festival House. Most of the artists shown were drawn from the A.C.A. Gallery in New York, but Oldenburg also included the work of friends, as well as some of his own landscapes and figure paintings done in Lenox (and later destroyed). Away from the city, he was able to gain perspective on his work and sort out some of the many impressions and stimuli he had received through his recent contacts with other artists in New York.

Beginning with his return from Lenox in the fall of 1959 and continuing through the opening of the second version of The Store in December 1961, Oldenburg subjected himself to a most strenuous, agonizing, and meticulous analysis of his own psychology, talents, and limitations, which he recorded in notebooks. Simultaneously, he conducted analyses of the main lines of American thought and of the history of modern art. His investigations involved the attempt to isolate the essence of various plastic elements—line, space, volume, color. His notebook entries include scribbled jottings, sketches (mostly in ball-point pen), essays on aesthetics, clippings from newspapers and magazines,

and notes for future projects. In these germinal notebooks, Oldenburg developed virtually every idea that he has since realized in sculpture, drawing, theater, graphics, and film. He also provided himself with a method of working that has enabled him to continue to generate new ideas from his interaction with his environment and his response to other works of art.

Before attempting this self-analysis, Oldenburg had done extensive reading of Freud's writings. Employing the psychoanalytical technique of free association, he began to probe the contents of his own fantasy life, to find themes and forms that he could elaborate in art. His wife and friends took on roles as principal actors in the drama of his life; he criticized their activities, fictionalizing them so that they might serve as foils for his own preoccupations.

In the course of this exhaustive self-analysis, Oldenburg pressed himself to reveal as fully and honestly as possible the basis of his intentions and goals as an artist. In his nature, he found extremely traditional elements mixed with radical aspirations for a revolutionary art. The future of his art was bound up with the reconciliation of these contradictions. The traditional elements in his makeup linked him to such painters as Rembrandt, Goya, and Picasso, who had made broad universal statements about the nature of the human condition. The radical elements, on the other hand, made him dissatisfied with the formal conventions of art as it was being practiced around 1960. Oldenburg realized that he wished to communicate with a wide public. Although the Abstract Expressionists believed that they were indeed making a "universal" statement, Oldenburg saw their work as essentially private and hermetic, and he also considered their heroic stance to be mere rhetoric.

"My procedure," Oldenburg said later of this period, "was simply to find everything that meant something to me, but the logic of my self-development was to gradually find myself in my surroundings." Feeling himself drawn by conflicting urges, he decided not to avoid the issue of the contradictions within his

personality, but to make an art based on oppositions—an art of inherent paradox, in which a given statement would immediately call forth its own reversal. Rather than ignoring his personal conflicts, he determined to "revel in contradiction, in bringing out of myself numerous identities." "Drawn to demonstrate what is not allowed," he would make art of "the impossible, the discredited, the difficult." Repeatedly, he described himself as "an outsider" who could have "no group involvement." With a high degree of objectivity for an artist, he saw himself as impulsive, greedy for experience, restless, drawn to movement and change, eager to consume life and ideas. He realized that he was so responsive to the environment that the changing seasons seriously affected his capacity to work. "The year carries me from manic to depressive," he noticed, yet found comfort in having recognized a natural cycle "that corresponds to the rhythm of the earth."

Oldenburg's protracted self-analysis resulted in an acceptance of himself and his peculiar gifts and limitations. His working method in the future would be the same as that used in his self-analysis: examining his experience and responses through free association, he would distil from them a single synthetic form into which they could be funneled. Often he would resort to self-irritation, a kind of mental scab picking, in order to achieve results; but he had resigned himself to such self-exploitation and to "life with myself as a neurotic." Constantly prodding and goading himself, he remarked a tendency to rigidity and admonished himself to take risks, "to slop over; don't be dried up and afraid of being bad."

In a sense, this method of working represents a metaphor for cathartic evacuation. The first stage is the ingesting or "devouring" of experience—the priming that results from contact with the environment, reading, looking, responding, random sketching, and note-taking. The second stage is the analysis of experience; and the final stage is the synthesis of these impressions and memories into a single form. Oldenburg has described the three phases of his working

right:
MUG (hanging figure of derelict bum
in the shape of a mug). 1960
Corrugated cardboard on wood, painted with casein,
76 inches high (including "tail") x 50 inches wide
Owned by the artist

opposite:
Two studies for MUG (notebook pages). 1960
above: crayon, 6⁵/₈ x 5 inches;
below: pencil, 8³/₈ x 4¹/₂ inches (composition)
Owned by the artist

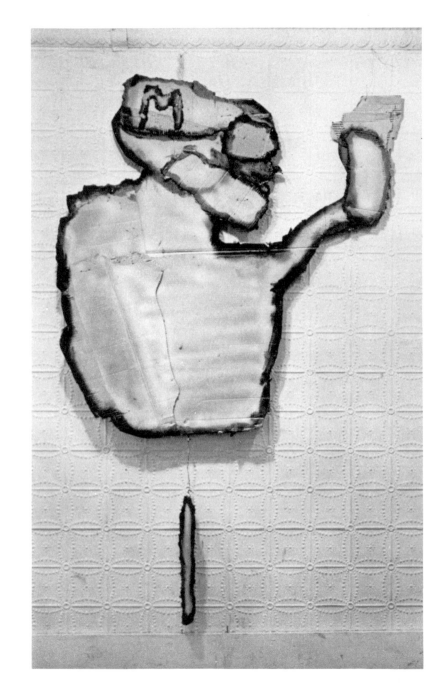

31

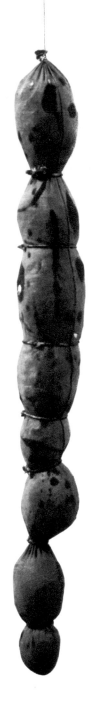

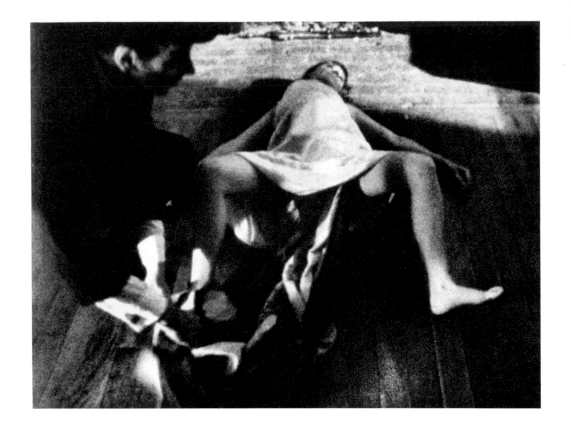

above:
Frame from the film Birth of the Flag. 1965–1966

left:
Study for a street figure to be made by tying burlap around a coatrack
(notebook page; figure not executed). 1960
Crayon, 8⅝ x 6 inches
Owned by the artist

center:
"Sausage." 1957
Ladies' stocking, stuffed and tied with string, 35 inches high
Collection Richard Bellamy, New York

process as follows: 1. inaction, grayness, nothingness (hate). – 2. action, outwardness (love). – 3. reflection, creation, outwardness (indifference). From this description, it is obvious that he uses art as catharsis for excess emotion.

One may remark in this context the frequency of scatological references in Oldenburg's work. Feces hang from the cardboard head known as the *MUG*. A sausagelike object in the collection of Richard Bellamy (originally made as a switch for the head of a now-destroyed doll fetish of metal) has obvious analogies. Of The Store, Oldenburg wrote: "Store is cloaca; defecation is passage," indicating that an art that spills out into society is an end to the "constipation" of the 'fifties.

The artist in his studio is therefore like a sausage-maker who feeds diverse and variable materials into his grinder to produce a single cumulative form. Interestingly, the image of the sausage-maker appears in Oldenburg's happenings, in which other images obviously highly charged with personal associations also occur. Later, Oldenburg said of himself, "I am a sausage-maker," and he described the studio as his "lyrical sausage factory."

At another point, Oldenburg claimed that the goal of his activity was "to deliver like an oyster... a summarizing immortal form." Such an analogy seems to illustrate Freud's contention that the artist identifies creation with birth, and art-making with giving birth. The image of an actual birth is recorded in *Birth of the Flag*, the second, filmed version of Oldenburg's 1965 happening *Washes*. Here a woman (Oldenburg's wife) gives birth to the American flag. One need not stretch the imagination too far to realize that Oldenburg is equating the birth of his own art, in which the American flag figures prominently in early works, with the birth of a child. That his "soft" sculptures were actually sewn by his wife, who in this way "gave birth" to them, further corroborates such an interpretation.

NOTES

1. Oldenburg recalls that on the island outside Stockholm where his family had a country home, his father and uncle had built a miniature village, complete with a working communications system—a project that attracted considerable attention in the Swedish newspapers. His father later invented a country, "Nobbeberg," to amuse his sons, each of whom also had his own competing country. Although "Neubern," the name of Claes's childhood utopia of peace and plenty, is imaginary, it is obviously related to the English "new born." The reference may be either to Oldenburg's "rebirth" in a new land, or, as he has pointed out, it may possibly contain an allusion to competition with his younger brother, the actual "new born" of the family. He also recalls that the street he took to school was named "Neuberg."

2. In "Jackson Pollock: An Artists' Symposium, Part II," *Art News* (New York), May 1967, p. 27.

3. "The American Action Painters," *Art News* (New York), December 1952, pp. 22–23, 48–50. The complicated relationship of Rosenberg's definition of "action painting" to Dada was first brought to my attention by Robert Motherwell, who edited *The Dada Painters and Poets: An Anthology* (New York: Wittenborn, Schultz, 1951), which so profoundly impressed artists of Allan Kaprow's generation. In "En avant Dada: A History of Dadaism (1920)," included in that anthology, Richard Huelsenbeck stated: "Instead of continuing to produce art, Dada, in direct contrast to abstract art, went out and found an adversary. Emphasis was laid on the movement, on struggle" (p. 41). The similarity of certain of the attitudes revealed in this text to those expressed by Rosenberg has also been noted by William Rubin ("Jackson Pollock and the Modern Tradition: I. The Myths and the Paintings," *Artforum* [New York], February 1967, p. 16 and n. 24). Rubin describes the manner in which Rosenberg's influential article colored the vision of Pollock's art held by many younger artists.

The route from Huelsenbeck's article to Rosenberg's essay to Kaprow's original happenings-environment manifesto, "The Legacy of Jackson Pollock" (*Art News* [New York], October 1958, pp. 24–26, 55–57) is not direct, but a sequence of connections surely exists. In other words, the notion popularized by Rosenberg that art was a kind of action, drama, or event was originally a Dada concept. Like many other of the multiple elements which had gone into making up the Abstract-Expressionist synthesis, Dada re-emerged in a purer form once the synthesis began to decompose in the late 'fifties.

Also included in *The Dada Painters and Poets* was an article by Kurt Schwitters on *Merz* (pp. 57–65; translated into English by Ralph Manheim from its original German publication in *Der Ararat*, Munich, 1921). It was accompanied by several reproductions of Schwitters' collages and constructions and described *Merz* compositions utilizing a variety of found materials, as well as *Merz* environments and the *Merz* theater. Without attempting to make any kind of one-to-one correlation, it must be realized that this text, which describes a junk-and-chance art and theater that make use of everyday objects, was widely circulated during the very period in which the New York environment-and-happening artists were generating their art. On the other hand, it should constantly be kept in mind that the context in which these artists' work was actually made was the Tenth Street phase of "action painting," and not that of Dada itself. For, in its assimilation and complex synthesis of earlier movements, Abstract Expressionism had entirely transformed its original Dada, Surrealist, Cubist, and American-Scene components. Robert Rauschenberg's use of common objects, and his paintings that spilled forward to occupy the spectator's space rather than creating an illusionistic, pictorial space, must also be taken into consideration in any attempt to reconstruct the artistic milieu of New York in the late 'fifties. A

p. 31

succès de scandale from the moment he began exhibiting in New York early in the decade, Rauschenberg further attracted widespread attention among younger artists through his first show at the Castelli Gallery in 1958 and his subsequent inclusion in The Museum of Modern Art's "Sixteen Americans" exhibition in 1959.

4. Ray Falk, "Japanese Innovators," Second Section, Sunday, December 8, 1957, p. 24.

5. The "Club" was the outgrowth of Friday evening discussions held at 35 East Eighth Street among artists, students, and invited guests of the cooperative art school, "The Subjects of the Artist," and of other friendships among artists who frequented the nearby Waldorf Cafeteria. The school had been founded in 1948 at Clyfford Still's suggestion by William Baziotes, David Hare, Robert Motherwell, and Mark Rothko (later joined by Barnett Newman), and although it closed at the end of the 1949 spring term, the Club continued to serve as a weekly forum for avant-garde artists and writers. Many of the most fertile ideas regarding environments and happenings were first voiced there by speakers such as Frederick Kiesler, John Cage, and Allan Kaprow. It was still active in the late 1950s, serving as a magnet for young artists arriving in New York and eager to "make the scene" there, although many of the first-generation Abstract Expressionists, by then successful establishment figures, had quit.

6. The sexual revolution that swept America in the 'sixties was anticipated in the late 'fifties by the exploration of explicitly sexual themes by such artists as Rivers, Kaprow, Oldenburg, and Samaras. Larry Rivers' nude portrait of the poet and critic Frank O'Hara with a three-dimensional plaster penis, though never exhibited publicly, was celebrated throughout the underground. Both Robert Morris and Jasper Johns also made works that emulated Duchamp's casts of genitals.

7. See note 3, above.

8. "The Legacy of Jackson Pollock," p. 56.

9. *Allan Kaprow's Words* (New York: Smolin Gallery, 1962; unpaged). In a slightly earlier definition, Kaprow put more emphasis on the spectator as participant; he spoke of agglomerates that "may grow, as if they were some self-energized being, into rooms-full and become in every sense of the word *environments* where the spectator is a real part, i.e., a participant rather than a passive observer. And in their most extended form, the environments have gone the next step to 'happenings,' events in a given time in which, put simply, 'things happen' according to flexible scores and where theoretically the participant becomes even more actively engaged" ("Some Observations on Contemporary Art," *New Forms, New Media I,* New York, Martha Jackson Gallery, 1960).

10. Grooms's gallery was an offshoot of the Hansa Gallery, a cooperative venture overseen by Ivan Karp, an early promoter of Pop, and Richard Bellamy, at the time an itinerant peddler of art and later the director of the Green Gallery, where Oldenburg was to have his first uptown one-man show in the fall of 1962.

11. *The Theater and Its Double* (New York: Grove Press, 1958).

12. Composer, lecturer, author, and teacher, John Cage has been one of the two most important influences on artists of the New York School after Abstract Expressionism (the other being the critic Clement Greenberg). As a teacher at Black Mountain College in North Carolina in 1952, and later at the New School for Social Research in New York, Cage influenced a generation of young Americans. He stressed randomness in composition, an open attitude toward the environment, the reintegration of art and life, and—based on his appreciation of Zen Buddhism —certain Oriental values with regard to nature and process. Oldenburg's contact with Cage was peripheral, being more a matter of absorbing some of his ideas through the work of Rauschenberg, Johns, and Kaprow, all of whom had been directly and decisively influenced by Cage.

In the American Grain

According to George Kubler, "the great differences between artists are not so much those of talent as of entrance and position in sequence," by which, of course, he means the sequence of formal innovations. He argues that "every birth can be imagined as set into play on two wheels of fortune, one governing the allotment of its temperament, the other ruling its entrance into a sequence."[1] The self-analysis Oldenburg conducted allowed him to make what Kubler has described as an "accommodation between temperament and formal opportunity,"[2] to integrate his own natural inclinations with the opportunities open for innovation, and so to achieve what Kubler terms a "good entrance" —that is, to become one of the significant innovators in the history of recent art.

In the course of his self-analysis, Oldenburg was often mercilessly critical. For example, he rejected the rigid structures of the cardboard and papier-mâché sculpture in his Judson Gallery show of May–June 1959 as "too generalized and in a sense abstract." Having analyzed his deepest responses, he found they related to his own environment and experience. This meant that, if he were to be honest, he could not be an abstract artist, even though the moment was dominated by abstraction. Opting against abstraction in full consciousness, he did so with the intention of challenging its most fundamental premises. "Figurative vs. nonfigurative is a moronic distinction," he concluded. "The challenge to abstract art must go deeper than that."

Oldenburg shared with the Abstract Expressionists an antipathy for an art rooted in pallid aestheticism. Like them, he wished to infuse art with an emotional content, but he did not believe, as they did, that this could be achieved through abstraction. He saw their art as divorced from life; for him, abstract art seemed empty decoration. To Oldenburg's way of thinking, form had meaning only insofar as it fed back into life. In his view, form cannot be merely an end in itself; it must be the means or the vehicle of expressing content. "Significant form" may be created from the humblest subject, even if at times the powerful associations evoked by the subject may stand as a barrier to visualizing the work purely as form. This does not mean, however, that form and content are separable; on the contrary, they are inextricably bound together. Oldenburg differs from abstract artists only in his conviction that the content expressed through form must change and direct the nature of experience, rather than existing outside and apart from life in the disembodied purity of abstract thought.

For Oldenburg, the distillation of form through content, rather than the reverse, is a process that must take place naturally and without artifice. In an entry in his notebook, he expresses disapproval of a friend who "tries to impose something rather than seeing what is there and letting it grow."

Such a pragmatic attitude is a main current of American thought. We find it in the writings of American philosophers such as William James and John Dewey, whose aesthetic of "art as experience" Oldenburg appears in many ways to embrace. Like many others of his generation (especially the Minimalists), Oldenburg rejects the idealist aesthetics of European art, which sees in art a reflection of the Absolute, in favor of the empirical values of American pragmatism. This shift in philosophical outlook, in turn, accounts for many changes apparent in the art of the 'sixties, including those made by Oldenburg himself.

Abstract Expressionism had brought about a synthesis between native and European traditions. As the movement decomposed into the elements that it had originally absorbed, there was a polarization between two tendencies. Late Cubism reemerged as color abstraction, essentially an idealist style. Simultaneously, elements of Dada-Surrealism and the American Scene produced bizarre combinations in Pop and Minimal Art—movements which, although superficially different in appearance, have in common the fact that both are anti-idealist styles. Here, the influence of John Cage was crucial. His focus on the function of art, the role of the artist in society, and the concept that art is a kind of activity, rather than a medium to be judged

by established norms, was a reassertion of the only uniquely American contribution to philosophy: pragmatism. Cage's composition course at the New School for Social Research in the late 'fifties led to a determination on the part of his students to make art out of what was at hand and resulted in the junk-and-debris environments created from 1958 to 1960 by Kaprow, Dine, Whitman, Oldenburg himself, and others.[3]

Oldenburg, then, concluded that he wished to make an art that was not contrived, but that was organically responsive to the environment, and to the confusion and disorder, the contradictions, ambiguities, and irrationality of life itself. Such an art does not attempt to flatten or simplify experience, nor to impose upon it any artificial order; rather, it accepts *complexity* and *change* as the defining features, both of the processes of nature and of the human condition.

NOTES

1. *The Shape of Time: Remarks on the History of Things* (New Haven: Yale University Press, 1963), p. 7.

2. *Ibid.,* p. 86.

3. See above, p. 34, n. 12. I have discussed the breakup of Abstract Expressionism into its idealist and non-idealist components in greater detail in an article, "Problems of Criticism, V. The Politics of Art, Part II" (*Artforum* [New York], January 1969, pp. 44–48). The willingness of certain of the artists to reject the orderly relationships of established traditions in art in favor of random accumulations or accretions of non-art materials as a principle of organization is as easily ascribed to native pragmatic attitudes of using whatever is at hand as it is to the influence of Dada. Similarly, the pragmatist's demand for absolute correspondence between fact and reality, and his insistence on equating "truth" with concrete physical facts, leads him to reject not only illusionism and abstraction but also the metaphoric, metaphysical, and symbolic.

"Dubuffet – Céline – Frenchmen." 1959
Ink, 16¼ x 11¾ inches
Mr. and Mrs. Robert C. Scull, New York

The Street: A Metamorphic Mural

Yes, answered the Spirits; for every humane Creature can create an immaterial World fully inhabited by immaterial creatures, and populous of immaterial subjects, such as we are, and all this within the compass of the head or scull; nay, not onely so, but he may create a World of what fashion and Government he will, and give the Creatures thereof such motions, figures, forms, colours, perceptions &c as he pleases, and make Whirl-pools, Lights, Pressures and Reactions, &c as he thinks best; nay, he may make a World full of Veins, Muscles, and Nerves, and all these to move by one jolt or stroke: also he may alter that world as often as he pleases, or change it from a natural world to an artificial; he may make a world of Ideas, a world of Atomes, and world of Lights, or whatever his fancy leads him to You have converted me, said the Duchess to the Spirits, I'le take your advice, reject and despise all the world without me, and create a world of my own.

Margaret Cavendish,
"The Description of a New World,
called the Blazing World," London, 1666

In Chicago, Oldenburg had illustrated a story by Nelson Algren, who chronicled Chicago slum life.[1] Returning from Lenox to New York in the fall of 1959, Oldenburg turned once again to the theme of life in the slums. He had recently read Céline's *Death on the Installment Plan*, and this gritty version of the city now became identified in Oldenburg's mind with the wasted lives he saw around him. "The street is death," he wrote, and he began thinking in terms of an environment that would be "a set on American death." Reviewing his efforts at the Judson Gallery the preceding spring, he cautioned himself once more "to watch for these: too elegant forms, too dull, too general, too white, too neat." He wished instead to make a statement about city life as brutal, crude, and direct as Céline's ironic, macabre humor. Not surprisingly, the artist to whom he felt closest at this time was Céline's nearest counterpart in visual art, Jean Dubuffet, the inventor both of savage, urban themes and of the deliberately "primitive" *art brut*. Céline and Dubuffet were, in fact, so closely connected in Oldenburg's mind that he originally planned a Dubuffet pendant for C-E-L-I-N-E, *Backwards* (in itself, an ambivalent tribute).

Having definitely rejected abstraction as alien to his nature, Oldenburg now began in earnest to formulate a figurative alternative to abstraction that would fully accept the conventions of modernism. Klee had been able to make modernist art without abandoning representation by turning to art outside the context of Western civilization—primitive art, child art, and the art of the insane. Following Klee's example, Dubuffet had added to these sources the brutal content of urban life. With these two precedents in mind, Oldenburg began to see the potential for a new art in the culture of New York's Lower East Side.

Sketching along the Bowery, Oldenburg reduced figures and objects to line; then he began to translate the calligraphy of his drawings into the material form of two-dimensional figures. In his drawings, violence creates the disorganized pattern of city life. Random and unrelated actions and fragments of objects receive *p.41*

equal treatment. The scores of drawings that Oldenburg executed during the highly productive winter of 1959–1960 suggest several parallels with Dubuffet's ragged contours and his squat, deformed people and objects. But whereas Dubuffet frequently concentrated on the single figure, Oldenburg took in the whole of his environment, refusing to distinguish among persons, places, and things, the animate and the inanimate, the tangible and the disembodied, the solid and the evanescent. For him, all were equally palpable.

"If you're a sensitive person, and you live in the city, and you want to face the city and not escape from it," Oldenburg wrote, "you just have to come to grips . . . with the landscape of the city, with the dirt of the city, and the accidental possibilities of the city."[2] The decision to meet matters head on rather than attempt to evade them—to make art out of the environment at hand, no matter how unpromising it might be—was an extension of John Cage's aesthetic of affirmation, which exerted such an important influence on many of the strongest artists of Oldenburg's generation.

Slowly the concept of the environment that was to be called The Street took shape from Oldenburg's series of graffitilike sketches of the activity of men, *p.40* women, children, and animals. Reminiscent of the deliberate coarseness of Dubuffet's figures, these drawings include, together with people, fragments of the environment, formless substances like clouds, smoke, and wind, as well as "balloons" of speech that resemble those found in cartoons, while also existing as independent solid shapes.

Originally, The Street was conceived as a "meta- *p.41* morphic mural" in three dimensions. It represented Oldenburg's first attempt to telescope painting, sculpture, and architecture within a single framework, mixing these mediums as freely as baroque art had done. Picasso's *Guernica*, which Oldenburg singled out as the "only metamorphic mural," was in a sense the prototype for The Street. Like *Guernica*, The Street had as its subject human suffering; it was not meant to commemorate any single event, however, but rather the

"Céline in foil" (notebook page:
study for a hanging sculpture in paper relief). 1959
Pencil, 10 x 7 inches
Owned by the artist

Homage to Céline and Dubuffet (notebook page:
study for hanging plaques). 1959
Crayon and ink, 11 x 8³/₄ inches (sheet);
6³/₄ x 5 inches (composition)
Owned by the artist

opposite:
C-E-L-I-N-E, Backwards. 1959
Newspaper soaked in wheat paste over wire frame,
painted with casein, 30³/₄ inches high x 39⁵/₈ inches wide
Owned by the artist

"everyday agony," the mundane catastrophe of death in life.

The figures, signs, and objects in The Street were mainly flat, like huge drawings. Some were made of corrugated cardboard cut into jagged silhouettes. Outlines were varied in thickness but were usually heavy and blackish, as if charred, causing the edges to look as if they had been burned or eaten away. The various pieces were made from secondhand materials: string, rope, corrugated and plain cardboard, and scraps of burlap, picked up on the Lower East Side. Since they had been used before, these materials already had a "history." Their textures and monochrome brown-black recalled the actual textures and tones of the decaying slums, and the torn, frayed, bent, and disheveled contents, both human and inanimate, of the street. One might, perhaps, identify the fragile materials as a metaphor for the ephemeralness of human life in the slums; or one could go further, and regard them as a metaphor for the decomposition of a society—since obviously Oldenburg's wish to make a popular art based on slum life did not lack social implications.

The small applied elements within the figures—features, hands and limbs, details of clothing—give scale to the general exterior shapes but do not themselves define those shapes. Rather, they serve to articulate the surface. The Street figures, as already noted, are obviously expanded from a graphic conception: "The empty part of the paper is torn off and thrown away," Oldenburg explains. Making an analogy between the silhouette of these figures and the signs, coastlines, or "drawings of an imaginary country," Oldenburg describes how "the drawn part (the land) is hung in space."

This elimination of background, first accomplished in the Street figures, which are literally ripped out of their graphic context or mural background, places Oldenburg in the forefront of the formal development of the art of the 'sixties. He explains this ripping of images out of context, which results in detaching the shapes from their background, as follows:

"I represent the object in *mind* which is an unpredictable illogical and inconsistent cluster. Because I am representing by concrete means, space (light) is naively realized as solid. The pieces are as if ripped out of a solid space which includes both the object and the 'air' surrounding it. I have made a deep mural in the air, a suspension of solids. The actual space between the solids can be thought of as potentially solid. There is present an amount of invisible material. The concretions are selective, the ellipses highly condensed, spatially and temporally. The edges (which are the edges of perception) do not necessarily correspond to the object. Scale is freely mixed.''

Besides this elimination of the background, the figures of The Street are in other respects prophetic of Oldenburg's subsequent development. The flaccid, sagging forms of the *Street Head, II* and the use of fabric in the melancholy *Street Chick* are forerunners of his soft sculpture. But their frayed, raw edges and austere subject matter were to be discarded in the more elegant, voluptuous later work, for The Street is above all a characterization of deprivation.

Like the later Store reliefs, *Street Head, II* and *III* *p.43* were created by distending the rectangle of a painting (which in the reliefs of The Store would be "made blobby," as Oldenburg puts it). The *Street Chick* is a *p.44* mysterious personage, neither precisely male nor female, who has a death's head. Oldenburg associates this character with Céline's anti-hero Ferdinand, whom he in turn identifies in his notes as a personification of Death. The death's head is fully in keeping with the morbidity of the whole tableau, while the tatters and string-tied shoes add the picturesque note always associated with lower-class genre.

The Street was shown in two versions. It was first presented at the Judson Gallery from January 30 to *pp.42–43* March 17, 1960, as part of a two-man collaboration with Jim Dine, in which Dine's environment was "the house" as opposed to Oldenburg's "street" scene. The second version was a one-man show at the Reuben *pp.46–47* Gallery the following May (in the next month, one of

Oldenburg's cardboard Street figures, *MUG*, was included in the exhibition "New Forms—New Media" at the Martha Jackson Gallery). For this second version, fragmented silhouettes left over from the original showing were pasted up on the floor and then fastened to wooden frames to make them rigid. In their disjointed stiffness, they are reminiscent of marionettes or the Halloween cardboard skeletons still to be found lying around in Oldenburg's studio. Although in the Judson Gallery the figures had been tacked to boards against the walls, in the Reuben Gallery they hung freely in space, suspended from the ceiling. In his review of this show, Irving Sandler wrote: "Oldenburg's characters . . . are humorous and tender, but grim. They are as abstract and as real as the human wrecks that inhabit downtown New York. Cut-out words, 'Orpheum,' 'Empire' and 'Tarzan' cover some of the figures to indicate the American dream of glory, unfulfilled in the anonymity of city life. Above all, it is the drawing that distinguishes these pieces. Line is direct and rough, in keeping with the content, but it is also precise and animate—like children's scribblings on tenement walls."[3]

It is true that Oldenburg, like Klee and Dubuffet before him, used children's drawings as a source; but his line was extremely sophisticated, for he had by this date engaged in years of technical exercises to train his hand. His refinement, however, was difficult to discern because his perishable materials looked so rough and tacky. Like the widespread use of cheap Sapolin by painters of the New York School, Oldenburg's use of materials that could be picked up off the street for nothing stemmed in part from economic necessity rather than from aesthetic preference. But he also assumed that there was something in his "character or experience which *needs* to work in perishable material, a sort of martyric stance." He concluded that such work was "not more perishable than the cotton canvas that very many good artists I know paint on. Or Whistler's suspect colors. The good artist—it is a modern fault—is not a good craftsman." He also felt

Man and Woman Talking. 1960
Pen and ink, 11⅞ x 9⅛ inches
Collection Mrs. Claes Oldenburg, New York

"Brobdignagian" (notebook page: studies for two hanging Street figures, woman's face in upper right). 1960
Pencil and ink, 11 x 8½ inches
Owned by the artist

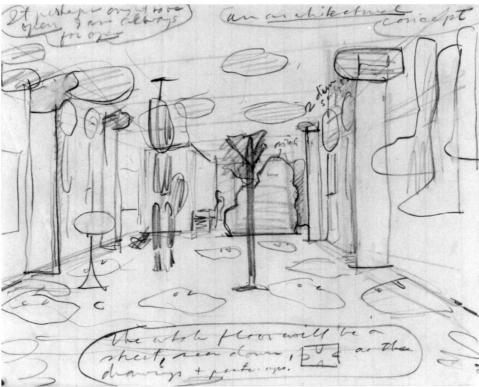

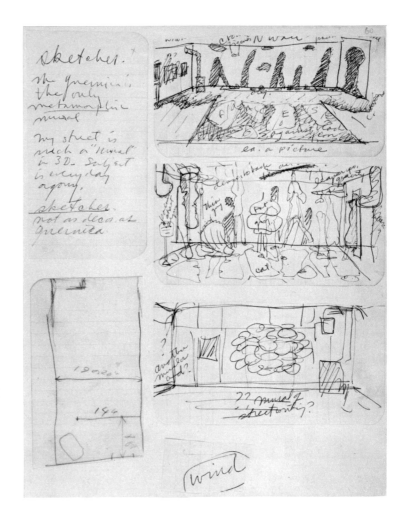

"Bowery spaces" (notebook page:
view down the Bowery from
Cooper Union). 1959
Ball-point pen, 4⅞ x 3⅛ inches
Owned by the artist

Study for installation of The Street, Reuben Gallery
(notebook page). 1960
Pencil, 8½ x 11 inches
Owned by the artist

Studies for installation of The Street
(notebook page). 1960
Ball-point pen, pencil, 11 x 8½ inches
Owned by the artist

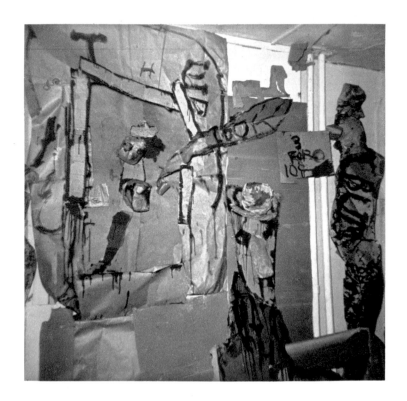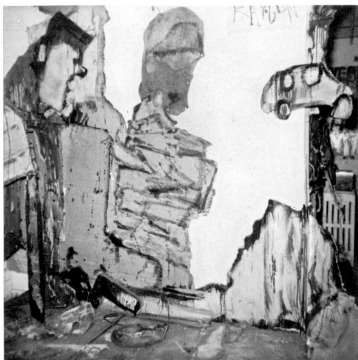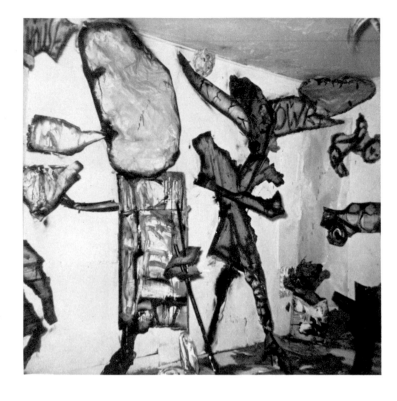

above:
The Street under construction for Judson Gallery showing,
late 1959 – early 1960

above, above right, and opposite, left:
Three views of The Street
as installed at the Judson Gallery, Spring 1960

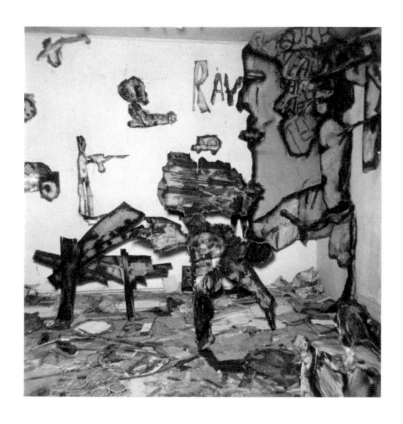

right:
Street Head, II ("Pear"). 1960
Burlap, paper bags, metal band, wire,
55 inches high x 34 inches wide
Collection Richard Bellamy, New York

far right:
Street Head, III (Profile with Hat). 1960
Burlap garbage bag filled with newspaper,
painted with casein, 76 inches high x 46 inches wide
Owned by the artist

43

left:
Street Chick. 1960
Burlap, muslin, cardboard, wood, string, painted with casein,
120 x 38 inches
Collection Samuel J. Wagstaff, Jr., Detroit

above:
U.S.A. of America. 1960
Lithograph after drawing in bamboo pen and ink,
9 x 11⁵/₈ inches
Owned by the artist

above:
Ray Gun Poster:
"U.S. Death Heart." 1960
Monoprint, 17³/₄ x 11⁷/₈ inches
Owned by the artist

drawn to paper and wood because of his "desire for *organicity,* for living materials," as well as because of the metaphoric implications, already mentioned, of the use of fragile stuff.

It is typical of Oldenburg to leave open an option in interpretation; one explanation will do as well as another, since all are equally determined by the viewer's preference and associations, rather than those of the artist. The problem that Oldenburg's art creates is that the superimposed layers of meaning are so compressed that the work lends itself to virtually *any* interpretation. Take, for example, his own exegesis on the meaning of an early object, the *Street Head, I ("Big Head"; "Gong"),* included in his two-man show with Jim Dine at the Judson Gallery late in 1959:

"The Big Head, which was called the Daily Head, the big planetary paper construction over which was poured paint, long drip-lines down its planetary sides, refers to a third correspondence: The Street equals The Newspaper equals the Head. Someone said that the head suggested the bloody head of a newborn child, and then another person in the room pointed out that it is common in poorer homes when the baby is delivered there to cover the inside of the room with newspaper. It is Crane's 'Maggie' where I read of the use of newspaper under girls' skirts to rustle like petticoats."

One could elaborate on Oldenburg's associations with the *Big Head* by recalling that he was originally an apprentice reporter. Then the Daily Head might be seen as a reference to global mass communications, the paint dripping like blood as a reference to the nature of the times, and the sexual associations as related to Oldenburg's personal obsession—the voyeuristic, peek-aboo element running through his work, which also causes him to make fetishes of girls' torsos and legs. Perhaps this is going too far; perhaps it is not going far enough. In any case, such interpretations are hypothetical and relative, not verifiable nor absolute.

The two exhibitions of The Street marked the virtual debut of Oldenburg's metaphorical *Doppelgänger,* Ray Gun, of whom we shall hear more later.[4]

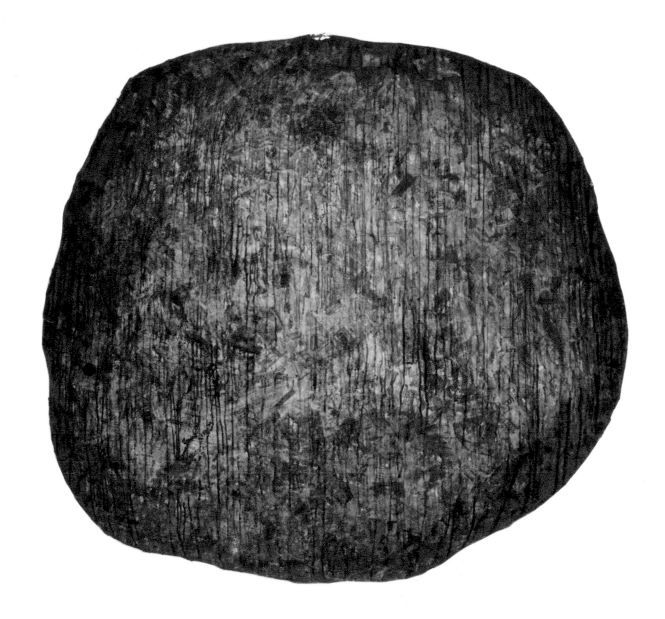

Street Head, I ("Big Head"; "Gong"). 1959
Newspaper soaked in wheat paste over wire frame, painted with casein, 61⅛ inches high x 64 inches wide
Collection Mr. and Mrs. Burton Tremaine, Meriden, Connecticut

The original Ray Gun notes were random thoughts that Oldenburg typed up and pinned to a bulletin board in the Judson Gallery while The Street was exhibited there. He praised "the beauty and meaning of discarded objects, chance effects. . . . The city is a landscape well worth enjoying—damn necessary if you live in the city. Dirt has depth and beauty. I love soot and scorching. From all this can come a positive as well as a negative meaning." He admonished himself to "seek out banality, seek out what opposes it or what is excluded from its domain and triumph over it —the city filth, the evils of advertising, the disease of success, popular culture.... Look for beauty where it is not supposed to be found."

Speaking through Ray Gun, Oldenburg declared his impatience with the limitations of painting: "We are just a little tired of four sides and a flat surface." Painting calms man down and soothes him, whereas Ray Gun saw man as "only alive when he is constantly arranging to upset his existence, when he is solving situations"—a definition of art that conforms to Morse Peckham's conception of the goal of the contemporary aesthetic experience.[5] "Every simple thing is the incarnation of human obsession," Ray Gun concluded, and he stated his aim: "To make hostile objects human."

From his first appearance, Ray Gun was omnipresent—in the notes just quoted, in the monoprints *p. 44* posted on the façade of the Judson Gallery and throughout the neighborhood, during the period of the exhibition; in the drawings on stencils for "Ray Gun Poems," "More Ray Gun Poems," and "Spicy Ray Gun," which were mimeographed and distributed from January to June; and in the announcement for *p. 49* "Ray Gun Spex," a series of six group performances given February 29, March 1, and March 2, 1960 in the Judson Gallery, an adjoining room, and a gymnasium. Participants in organizing these events were Oldenburg himself, Jim Dine, Al Hansen, Dick Higgins, Allan Kaprow, and Robert Whitman. Thus, from its inception, Ray Gun art had theatrical connections.

46

Two studies for installation of The Street, Reuben Gallery (notebook pages). 1960
left: ball-point pen, 10 x 7 inches; right: pencil, 8½ x 5⅞ inches
Owned by the artist

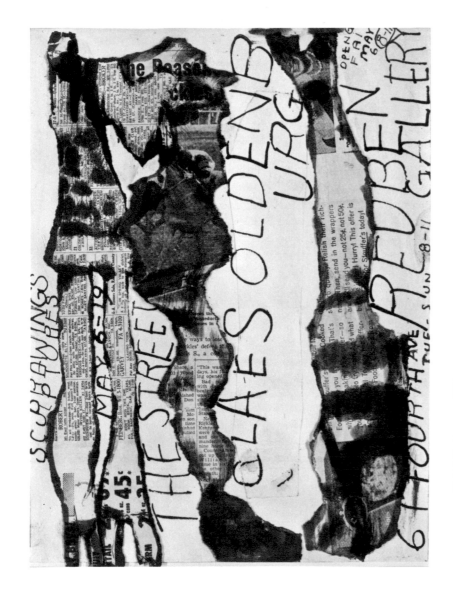

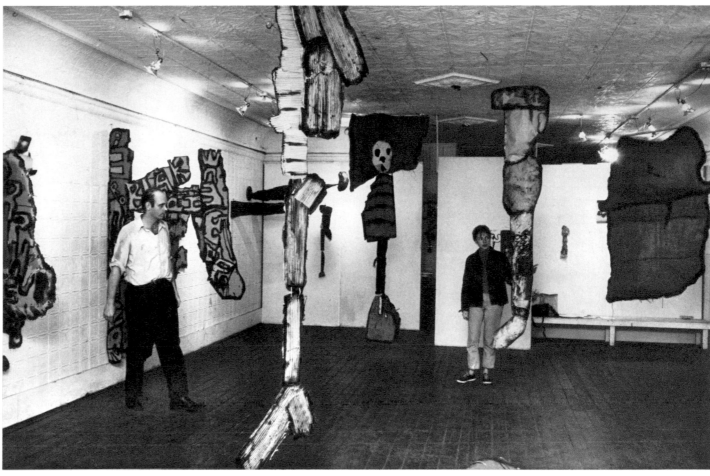

Drawing for announcement of The Street, Reuben Gallery. 1960
Collage: pen and ink on torn newspaper, 13⅞ x 10 inches
Owned by the artist

The Street being installed at the Reuben Gallery
under supervision of Claes Oldenburg and Anita Reuben, 1960

Oldenburg's own contribution was his first happening, *Snapshots from the City*. Presented within the *p. 50* setting of The Street, it consisted of events "such as one might encounter on the streets," in the form of a series of tableaux or compartmented scenes, briefly illuminated and set off from one another by interludes of darkness. As recorded on film, its static quality and dramatic, expressionist images reveal a closer resemblance to Red Grooms's *The Burning Building* than to any of Kaprow's happenings. In fact, Grooms was the original prototype for Ray Gun and has the same initials; but after he left the country later in 1960, to remain abroad for two years, he became a "fading memory" for Oldenburg.

Attracted by the novelty of the happenings, the mass media quickly made them public property, thus destroying their coterie status. An interviewer for one magazine described having found Oldenburg "dressed in tattered clothing, his head wound about with dirty grey rags, his feet tied up in orange rags, sprawled to one side of the street scene he had created for his 'living picture.'... On the floor was greyish dust, more rags, objects carted to the gallery from a nearby empty, garbage-filled lot such as bed springs, old bottles.... Rough figures, leaning against the wall, were made of brown paper bags, stuffed, and were supposed to represent an All-American Shoe Shine Boy, an All-American Sandwich Man and an All-American Bum."[6]

Given Oldenburg's repudiation of the symbolic function of Abstract Expressionism and his expressed wish to communicate with a wide public, there is a certain paradox in his continuing use of metaphor. These metaphors are often complex and full of personal references; they include material generated by his private life, often unintelligible except to himself and initiates. Yet many precedents could be cited in both historical and contemporary Western art, even that intended for public display, for the incorporation of purely private references, whose significance it has been possible to decipher only through the painstaking efforts of iconographers.

Because of its lamination of hermetic meanings, Oldenburg's work lends itself more than does most contemporary art to analysis by the standard art-historical canons of subject, form, and content. The complete integration of these three aspects of visual meaning give to his work both its unity and its complexity. Not surprisingly, disentangling the various levels of meaning can best be accomplished by applying the traditional methods of art-historical investigation; and Oldenburg's iconography—the submerged level of metaphor not immediately graspable from the mere identification of subject—can best be approached biographically and historically. The exhaustive notebooks that chronicle the development of his thought and work in minute detail also serve a practical end; they help us decipher the content of his work.

In a notebook entry of 1961, Oldenburg stated:

"The most important key to my work is probably that it originates in actual experience however far my metamorphic capacities may carry it. A dramatic piece such as The Street at the Judson in 1960 or its environmental counterpart (at the Reuben later) had their origin in very specific aspects of New York and Chicago streets.

"I begin with a realistic period and end at the limits of metamorphosis, when fatigue sets in and the preoccupation is broken up. A rest follows during which I may make lyrical pieces."

"My work is—in its origins is—not arbitrary and this necessity forces me to a lot of difficulties. I want to lead my audience deeper into things and I like a point of departure for them."

The origin of the work, in other words, is deliberately located within Oldenburg's experience at the moment. Using the technique of free association, he oscillates madly between the verbal and the visual in a sequence of word-and-image puns reminiscent of Joyce's uninhibited wit. Because of the close packing of the associations thus generated through his stream of consciousness, the final summation is an image that "means" moret han the word that identifies it. The

problem of subject identification is further complicated by Oldenburg's consistent use of the secondhand—the abused, tarnished, tired, or worn-out subject, image, or material. For in his work, only the form is original; all else is derived from another context.

Oldenburg's use of secondhand images, originally presented in the stylized, once-removed form of ads, posters, or window displays, also calls into question both the nature of the process of representation and the relation of the work of art to reality. The subliminal effect of the erotic metaphor, always implicit behind the stated image, appeals directly to an instinctual response; on the other hand, the stylization of the image and its explicit derivation from an identifiable secondhand source serve as further distancing factors. The result is a curious tension between the immediacy of the viewer's response to the implied eroticism and the sensual qualities of surface and material, and the deliberate "distance" imposed by the artist between the viewer and the apparently familiar.[7]

Within the general context of the times and of Oldenburg's own biography, The Street is comprehensible as a metaphor for scarcity, whereas The Store, which succeeded it in 1961, is a metaphor for affluence. This progression parallels the actual development of the American economy shortly before, which in the 'fifties had shifted decisively from an economy of relative scarcity (that of the Depression and war years) to an economy of abundance. The deprived and run-down character of The Street also corresponds to a particularly depressing and impoverished period in Oldenburg's life, preceding his success and recognition. Like the emaciated, working-class figures of Picasso's Blue Period, Oldenburg's Street figures, clad in hand-me-down robes and scraps of cardboard, reflect the meager life style of an artist living on the fringes of society and participating in the marginal existence of the depressed classes, petty criminals, classless bohemians, and other outcasts.

Nevertheless, although the year during which The Street was created was a bleakly impoverished one for

Suggested Ray Gun posters:
"I drink Ray Gun because," "U.S. popsy," etc.
(notebook pages). 1960
Ball-point pen; 4 sketches:
9 x 6 inches (over-all composition)
Owned by the artist

Suggested design for a brochure announcing Ray Gun show
at the Judson Gallery. 1960
Crayon, pastel, typing, 8¹/₂ x 10⁷/₈ inches
Owned by the artist

Oldenburg and Pat, it was rich in terms of contact with the disorganized, heterogeneous downtown milieu. The group of artists including Grooms, Dine, Kaprow, Whitman, and others continued to serve as principal foils for Oldenburg's own imagination. What knit the group together, according to Oldenburg, was the consciousness of "the difficulty of living an imperfect experience," somewhat of an understatement to describe the confusion, or more precisely the chaos, that reigned in the anarchistic bohemia of the Lower East Side. An aura of mystery and a fascination with the occult, an undercurrent of violence, and a willingness to take extreme positions in order to explore "forbidden" areas of experience surrounded the activities of this group. Oldenburg felt that its members shared an element of self-destructiveness, which could ultimately be tapped for its creative potential. A romantic cult of self-expression and a dedication to experiment at any cost marked the raw, unfinished, impolite art they produced out of the junk and garbage of the slum streets. The spirit that prevailed, however, was not so much that of Dada as it was of native American pragmatism. The point was not to turn junk into art, but rather to make art out of what was at hand. The art produced was consequently less akin to collage than it was to bricolage—the use by primitive or naive artists of whatever heterogeneous materials are immediately available.[8]

Despite the excitement with which the year 1960 began, and his intense involvement with new projects, Oldenburg was glad to escape the turbulent slums for the relative peace and privacy of Provincetown. During his summer there, he was to change his orientation completely. No longer would he focus on the sadness and evil of the slums, but on their life and vitality. In Provincetown, pessimism would give way to optimism, and a new, affirmative art be formulated, which would do battle with puritan repression and inhibition in the name of the pleasure principle.

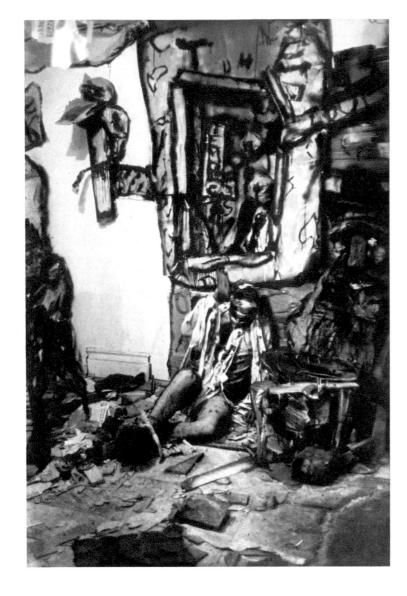

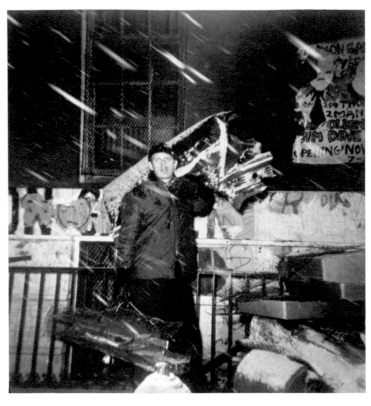

NOTES

1. For these drawings, which illustrated Algren's story "Too Much Salt on the Pretzels," see p. 23.

2. Quoted by Robert Pincus-Witten, "The Transfiguration of Daddy Warbucks: An Interview with Claes Oldenburg," *Chicago Scene,* April 1963, p. 38.

3. "Reviews and Previews," *Art News* (New York), Summer 1960, p. 16 (signed "I. H. S.").

4. See pp. 55–56, 60. Some early Ray Gun drawings had been included by Oldenburg in his two-man show with Jim Dine at the Judson Gallery in November 1959, and *"Empire" ("Papa") Ray Gun,* made of newspaper and wire painted with casein, was shown in the "Below Zero" group exhibition at the Reuben Gallery in December of that year.

5. *Man's Rage for Chaos* (Philadelphia: Chilton Books, 1965).

6. Notes taken at the Judson Gallery by a researcher for *Time,* Anne Hollister.

7. Such a setting off of the image in quotation marks, as it were, by dissociating it from its context bears a certain similarity to the process described as "bracketing" by the philosopher Edmund Husserl, father of phenomenology. Oldenburg, who studied phenomenology at Yale, had been impressed by the aim of phenomenological reduction: to make experience direct by reducing phenomena to their pure state, in which they could be felt or intuited without reference to intellectual context or definitions.

8. For bricolage, see Claude Lévi-Strauss, *The Savage Mind* (Chicago: University of Chicago Press, 1966; translated from *La Pensée sauvage,* Paris: Librairie Plon, 1962), pp. 16–33.

Snapshots from the City. February 29, 1960
Photograph taken during performance

Oldenburg outside the Judson Gallery during the showing of The Street, bringing materials for an environment

Land of Our Pilgrims' Pride

Yea, sin is so evil (that though it be in nature, which is the good creation of God) that there is no good in it, nothing that God will own; but in the evil of punishment it is otherwise, for... all the plagues inflicted upon the wicked upon earth, issue from the righteous and revenging justice of the Lord, and He doth own such execution as His proper work...

Thomas Hooker, *"A True Sight of Sin,"* 1743

In Provincetown, Oldenburg rented as his studio a cabin near the house of a blind Negro named Roach, who appeared to him in his daydreams as a sorcerer or alchemist. In these daydreams, which Oldenburg cultivated with a certain degree of self-consciousness, demonic presences and violent fantasies possessed the artist, who spewed them out on paper as if in an act of exorcism, to rid himself of their capacity to frighten.

Opposed to the fantasies, however, was the banal routine of his life in Provincetown. Oldenburg has described it: "Up 9 or 10 breakfast. Cleaning (part of thinking process until 12). 12 or 1 out to work somewhere. Back by 4:30. Beer. Dinner. Work 6–11 or 12. Bed or out." The night work referred to was dishwashing, a job that Oldenburg had taken to support himself while in Provincetown, and which first suggested to him the idea of making food out of plaster.

During the day, he explored the beaches and dunes. On the beach, he picked up pieces of driftwood and debris, which he fashioned into sensitive, weather-beaten reliefs reminiscent of Arthur Dove's wood col- *pp.52–53* lages. Because each contained an allusion to stars and stripes, Oldenburg called them "Provincetown flags"; they were also meant to recall souvenir postcards of historical landmarks. Many are landscapes in which a crescent moon—the "C" standing also for "Claes"—and a phallic lighthouse reappear in various combinations. During the summer, he exhibited some of them, and related drawings in india ink or wash on *p.54* paper with torn edges, in a two-man show with Irene Baker at the Sun Gallery and a group show at the HCE Gallery in Provincetown.

In his periods of introspection, Oldenburg asked himself: "Should I see myself then as ... a Munch, a Strindberg of Nordic melancholy and neurotica?" As he visited the Provincetown cemeteries, he continued to indulge in reveries on "the healthy body and a head full of death," like the morbid fantasies that had preoccupied him when he was creating The Street.

As he observed himself observing himself, he proposed founding the Oldenburg School of Psychoana-lytical Nature Study, to be presided over by Claes Oldenburg, P.N.A. (Psychonatural Analyst).[1] In the dual role of patient and analyst, he began to identify the investigation of his own consciousness, and the ensuing prescription of a self-administered catharsis that would exorcise his private devils, with a psychotherapy of American society. Noting that the "self is generally denied in U.S. culture," he deliberately set out to create an art of the forbidden, the taboo, and the repressed, presumably for the purpose of "curing" civilization of its discontents by forcing a conscious acknowledgment of repressed instincts. His main inspirations were still Proust and Freud: the past (both that of American history and that of his own life) was to be recaptured, and the repressed (the erotic and instinctual) was to be reinstated through art. The resulting catharsis would serve as therapy not for the artist alone but for all of society.

Seen in this light, the role of the artist becomes identical with that of the priest or shaman in other cultures. He is not only the arbiter of taste, but the moral leader who provides the ethical examples. A case might indeed be made for the thesis that in the moral vacuum of the period in American history under discussion, only the artist *could* act. In any event, art such as Oldenburg was contemplating and was soon to begin to make would shortly become one of the most vital forces in American life.

The extensive notebook entries make it possible to pinpoint the precise critical moment in Oldenburg's thinking when he realized that he did not want to escape the present, either in his own life or in American culture, but to live with it and make art out of it. In the summer of 1960, he wrote: "Ironically I returned to a sense of myself on reading this bad Kerouac book [The Subterraneans]. My position and that of others like me is one of the super-sensitive and super-intellectual in an insensitive and unintellectual society WHO DO NOT WISH TO ESCAPE or who realize escape is impossible. We thus become clowns or wits or wise men. The danger is to forget art and merely construct

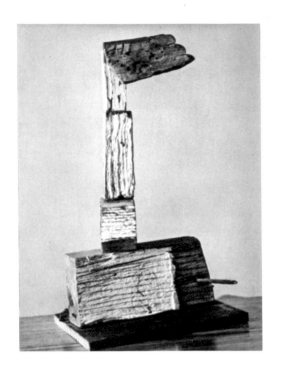

parables, to become a wise man rather than an artist.... No one can say that Cage with his mushroom picking... is not a super-wise man, but there is some argument about his being an artist."

Oldenburg's rejection of Kerouac and other Beat writers as escapists from society was accompanied by a conscious rejection of the sentimentality of his former Chicago ambience. His rejection of Cage's identification of art and life, on the other hand, meant separating himself from the very group in New York to which he now felt closest, by drawing a firm distinction between the simple affirmation of life as in itself constituting art (essentially Cage's attitude) and the making of work with measurable aesthetic quality. Found art, or art that was "art" only by virtue of its context, never held any interest for Oldenburg, who from childhood had always conceived of himself as a creator with a vision.

Such distinctions also mark Oldenburg as a true innovator within the tradition of modernism, rather than as a neo-Dada experimenter with novelty. What Oldenburg wanted to do was to extend the limits of art, not efface them. Although his life has always been the point of departure for his art, he has never confused art with life. Yet, while acknowledging that art and life are separate, at the same time he has sought the more acutely to integrate (or reintegrate) art into society, from which, to borrow Michael Fried's phrase, it had been "prized loose."

Under no circumstances, however, did Oldenburg believe that art was to be confused with the unordered, unstructured, and unformed mass of ordinary activities that make up daily living. In recapturing its role in society, art would not change to conform to the values of that society; on the contrary, in order to assimilate the new art, society would be forced to reformulate its own values. Analyzing the condition of both art and society, Oldenburg found them identical: "It is a time to move and painting in its present form has lost the power to move. It is the empire stage, money, fatness, ease, communication."

Cemetery Flag (Provincetown). 1960
Scrap wood,
14½ inches high x 8 inches wide
Collection Raymond Saroff, New York

Landscape with Lighthouse (Provincetown). 1960
Scrap wood, 13¼ inches high x 18 inches wide
Owned by the artist

"Kornville" Flag (Provincetown). 1960
Scrap wood, 19¼ inches high x 17 inches wide
Collection Raymond Saroff, New York

Clues to Oldenburg's intention appear throughout the notebooks. He began tearing out newspaper ads for cheap commercial goods, proposing to cultivate "every trite and quickly rejected idea," to develop "every vulgarity that technique is capable of." In order to preserve the freshness of his art, he would use concealment and reversal to disguise it as low art, mass art. In the midst of self-consciousness, he would labor to maintain a lack of self-consciousness. He anticipated how his art would be received: on its most superficial level, as a negative comment on American culture. He anticipated, too, that this would bring success for the wrong reasons, and this in turn would require further reversals and masquerades.

Although he realized that his art would be exploited in a way contrary to his intention, Oldenburg clearly recognized that he was "interested in an art object, finally, not in a witticism or in a statement of philosophy." From the moment that he began thinking about this new art, it was nevertheless obvious that Oldenburg wished his objects to have the power not only to move the viewer aesthetically but also in some way to transform his consciousness as well. As he began to define his purpose, he saw his art as bringing man back into contact with his own instincts, and with nature and natural processes—birth, death, growth, and change. Clearly, Oldenburg's universe is the antithesis of the anthropocentric universe of the Renaissance. Man is not the center of his cosmos, but merely a part of nature, sharing the world equally with other forms, natural and man-made, animate and inanimate, organic and inorganic.[2] The desire to create an art that would encompass every aspect of the world testifies to Oldenburg's gluttony—for it surely goes beyond mere appetite—for experience, richness, fullness, and complexity.

Inspired with a new vitality, Oldenburg suddenly began to feel "a tremendous reaction which takes the form of wanting both to make a real object and to relax the personal involvement to some degree, to forget about yourself a little bit." If the ego projection of the self was no longer the content of art, as it had been for the Abstract Expressionists, a new content had to be substituted.

Oldenburg began thinking of "the childishness of america with a small 'a,'" which he simultaneously enjoyed and deplored. Analyzing the role of art in American culture, he concluded, "There's this about America—the popular arts succeed very well here even among those who might be thought to be above them. They are taken very seriously." He soon focused on the notion of a "popular" art based on "the feeling that true poetry comes out of unpoetic elements (like all America) and is better sustained there than among poets." But his approach to popular art was not to create it but to use it "for something more serious."

"It is the easiest thing in the world, now, to do the right thing, the slick thing, the thing everybody will agree is 'good.' Finish and commerce, that's what culture fights in America," he complained. "It is quite right to emphasize the vulgar if it has been neglected, if art has become too lyrical . . . by vulgar I mean proletarian, ordinary, tasteless, but also instinctive (life affirming)." He found himself despising what he termed artificial, decorative art—"that kind which begins with buying a tube of some colored stuff in a store and going home and making a four-sided figure, very straight (no matter how large) to smear it on." He found, in short, that painting was dead for him; it was too overburdened with convention, too anemic, too academic.[3] He wanted a more immediate and direct art, an art more connected with human experience than he felt that painting could be at the time. "Art should be literally made of the ordinary world; its space should be our space; its time our time; its objects our ordinary objects; the reality of art will replace reality," he predicted—not understanding, perhaps, how quickly his prophecy might materialize.

NOTES

1. "I am quite willing to exploit myself and live with myself as a neurotic," Oldenburg wrote in 1960. In his self-analysis, he found that "I get bored and restless very soon, and really consume so much material at one time that there is not enough left. I let a little touch stand for a lot and can't bear taking a lot after just a little bit. I say I've tasted it."

2. Although there is no evidence that Oldenburg was ever directly influenced by Oriental philosophy, which, in contrast to the traditional Western attitude that favors man's domination of nature, stresses man's integration into nature and natural processes, he must have been affected by the general interest in Zen thought current in New York art circles in the 1950s. The works of D.T. Suzuki and Alan Watts, interpreting Zen philosophy to a Western audience, were being widely circulated in New York; their ideas were further spread through the lectures and essays of John Cage, who likewise preached an affirmative attitude toward nature and reality.

3. In 1960, Oldenburg wrote, "I wish to destroy the rectangle and substitute the 'medium' of indefinite form." He speculated as well on "how to make painting be a thing in itself through image"—something that Jasper Johns had already accomplished with his flags and that Oldenburg was shortly to achieve in his Store reliefs. Seeking to free painting from its rectangularity, two-dimensionality, and rigidity, Oldenburg aggressively sought to deprive the medium of its alleged "purity." Reading his statement (see p. 191), one realizes that Oldenburg wished to give painting a sexual experience, to assault its "frigidity." He writes of painting as a Sleeping Beauty to whom he must play Prince Charming—although there is also allusion to the raising of the dead by the Savior.

U.S. Flag. 1960. Collage and wash drawing, 16 x 20 inches
Collection Rolf F. Nelson, Los Angeles

Hero of a Thousand Faces

"An operator, ah? he operates, does he? My friend, then, is something like what the Indians call a Great Medicine, is he? He operates, he purges, he drains off the repetitions."

"I perceive, sir," said the stranger, constitutionally obtuse to the pleasant drollery, "that your notion, of what is called a Great Medicine, needs correction. The Great Medicine among the Indians is less a bolus than a man in grave esteem for his politic sagacity."

"And is not my friend politic? Is not my friend sagacious? By your own definition, is not my friend a Great Medicine?"

"No, he is an operator, a Mississippi operator; an equivocal character."

Herman Melville, *The Confidence-Man*

When, in the fall of the previous year, Oldenburg had returned from Lenox to New York, the impact of renewed contact with the Lower East Side and the disparity between the idyllic countryside of Lenox and the "city nature" of the slums, as he later termed it, produced an outpouring of observations. "The switch from the country (which I had associated with a Romantic idea of purity), to the city (where there is no purity) is a maturing development," he wrote. During the summer at Lenox, his basic task had been to find a means of surviving, as a human being and as an artist. In the tradition of socially oriented artists like Goya and Picasso, whose names appear repeatedly in his notes, Oldenburg wished his own salvation to become the instrument of salvation for all.[1]

Obviously, this attempt to reconstruct Oldenburg's thinking in a logical way is a simplification of his actual thought processes. In point of fact, it was not until after he had analyzed his activities in retrospect that he became fully aware of what he had been engaged in. Looking back, he realized that finding his identity as an artist was the means to finding his identity as a man, and arriving at an art style uniquely his own signified the integration of his personality.

As it turned out, in order to bring about this resolution Oldenburg had to invent a double—someone who could act for him if he did not yet feel capable of acting for himself. This double would permit him to act as a social artist, even while society at large was still mired in the stultifying years of the Eisenhower administration. The "secret sharer," to borrow Conrad's term, that Oldenburg invented began to take on specific characteristics of thought, form, and values during the summer while Oldenburg was exploring the lakes and woods around Lenox. Just as solitary children invent imaginary playmates, so Oldenburg allowed his fantasy to shape the personage who would serve as his double. But by the time that this double had taken on sufficient characteristics to be identifiable, it was clear that Oldenburg had conceived not another person, but an object with human attributes.

Although by this time Oldenburg had virtually stopped painting,[2] he was still thinking in terms of a figurative art. Ray Gun was born—and it is hard to think of any other term to describe the sudden appearance of Oldenburg's alter ego, who was both a person, with a name that could have been borrowed from any of the TV Westerns popular at the time, and an object. His birth allowed an actual transition to take place from Oldenburg's previous pictorial, figurative art to the making of three-dimensional objects, which for all their "objectness" nevertheless continue to serve as surrogates for the human body.

Ray Gun is no ordinary hero. He is cast in the image of Beckett's pathetic antiheroes and is thus far removed from the dignified, tragic, and humanistic heroes of Hemingway, Camus, and Sartre, who struggle against extreme obstacles—a "heroic" vision which coincides closely with that of the Abstract Expressionists. While Oldenburg's conception is clearly existentialist, in its cold and passionless detachment it has far more in common with the pessimistic acceptance of the human condition put forth in the "objective" new novel of such contemporary French authors as Alain Robbe-Grillet, who like Artaud describe a world that lies *beyond* tragedy. Oldenburg's is in no way a tragic vision; he accepts the gritty, earthy, macabre, and devastating elements of life as primary. He belongs, then, to that group of writers and artists, which includes Artaud, Beckett, Céline, and Dubuffet, who have rejected Unamuno's "tragic sense of life" and have in a sense gone beyond tragedy and the tragic hero in the direction of the absurd, the ridiculous, the banal, and the cruel. Emptied of passion, beyond tragedy and heroics, such a "cold" existentialism can view matters of life and death with equal calm and objective detachment; and the artist is like an anatomist who dissects the emotions, not an egotist who projects his emotions onto his surroundings or leisure.

If, then, contemporary humanism can express itself only in terms of the comic and the absurd, the artist can no longer assume the lofty Mosaic stance

Variations on a Milkweed Pod. 1954
Pencil, 10 x 7³/₄ inches
Owned by the artist

Variation on a Milkweed Pod. 1956
Pen and ink, 11 x 8¹/₂ inches (sheet);
2¹/₂ x 2¹/₂ inches (composition)
Owned by the artist

of the Abstract Expressionists; he must descend to the people and, transforming the "hero into the loonie," mask his sensitivity in the guise of vulgarity or folly.[3] In Oldenburg's art, nature was to play a large role, just as the original ray gun took its irregular form from the first "object" he had ever made—a small seed pod that he had collected in 1954, drawn frequently, and *p.28* mounted on a stand for his first show in 1959.

Soon the notebooks are filled with references to Ray Gun, the hero of a thousand faces and wearer of a thousand disguises—metamorphic transvestite, aphorist, visionary, destroyer of old cultural values, and defender of the new faith; in short, the artist's projected fantasy of himself as an all-powerful and all-embracing creator and savior.[4]

Beginning in late 1959, drawings of the metamorphic Ray Gun begin to appear, culminating in a *pp.58–59* free form hanging in space. In the exhibition of The Street at the Judson Gallery, there was a series of small mounted "ray guns," battered re-creations of a child's *pp.71,172* toy gun. During the following summer in Provincetown, Oldenburg was obsessively preoccupied with the theme. In his notebooks, pages of free association read like an existentialist novel with a Freudian plot line, as the artist struggles to "define" himself through the medium of his double. The appearance of Ray Gun is accompanied by a burst of creative activity and, for want of a more specific explanation, of inspiration. Ray Gun is now visualized as a house front with a head and described as an "instrument for survival." Survival is to be found, evidently, in the home—in Oldenburg's close, sustaining relationship with his wife; and in the head—that is, in an art that is strictly conceptual and therefore diametrically opposed to the improvisations of the Abstract Expressionists.

Rejecting the forms and attitudes of Abstract Expressionism, Oldenburg began to shift his focus to the content of American culture, which in recent art, at least, had remained unexplored. The lingering pall of American puritanism, with its repudiation of sex and leisure, its guilt, and its denial of pleasure, became

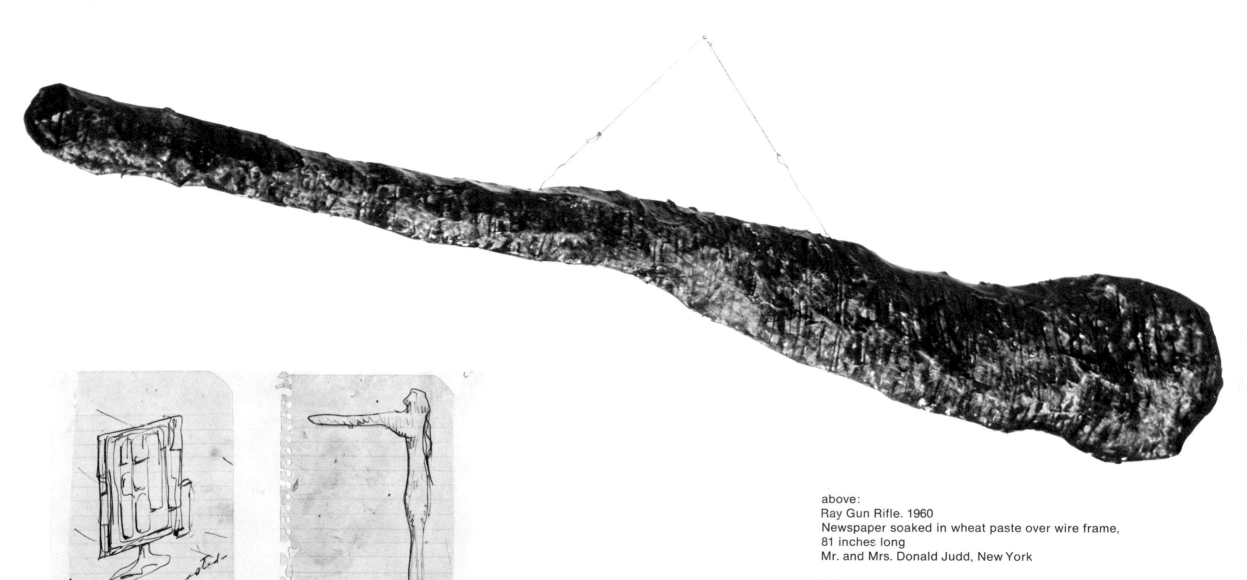

above:
Ray Gun Rifle. 1960
Newspaper soaked in wheat paste over wire frame,
81 inches long
Mr. and Mrs. Donald Judd, New York

left:
Studies for sculpture: "Giant Head";
"Rifleman" (derived from photograph of man
demonstrating Marey's photographic gun;
notebook page). 1960
Pen and ink; 2 sheets: 5¹/₈ x 3 inches each
Owned by the artist

57

above:
"Empire" ("Papa") Ray Gun. 1959
Newspaper soaked in wheat paste over wire frame,
painted with casein, 40³/₈ inches high x 39¹/₄ inches wide
The Museum of Modern Art, New York (gift of the artist)

right:
Woman's Leg. 1959
Newspaper soaked in wheat paste over wire frame, painted with casein,
38¹/₂ inches high x 16¹/₂ inches wide
Collection Raymond Saroff, New York

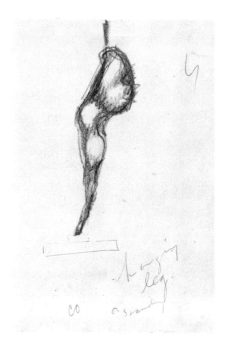

above, left to right:
Study for a relief for The Store
(from an advertisement for ladies' stockings;
notebook page). 1961
Crayon, 8¹/₂ x 6 inches
Owned by the artist

Study for a relief for The Store: Red Tights. 1961
Crayon and watercolor, 11 x 8¹/₂ inches
Owned by the artist

left, above:
Study for Woman's Leg (notebook page). 1959
Colored crayon, pen and ink, 8¹/₄ x 5¹/₈ inches
Owned by the artist

left:
Study for "Empire" ("Papa") Ray Gun (notebook page). 1959
Crayon and pencil, 6³/₄ x 5 inches
Owned by the artist

"Little legs" (sketch of a small mannikin to display ladies' tights;
notebook page). 1962
Crayon, 8¹/₂ x 5¹/₂ inches
Owned by the artist

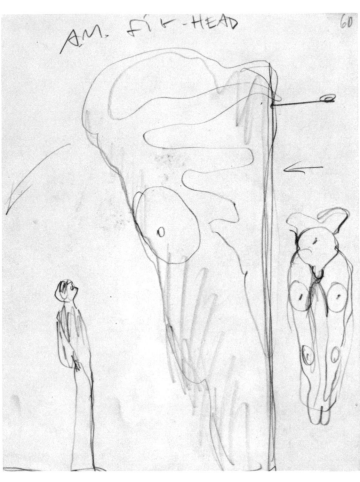

identified in his mind with the "ghost" that he wished above all to exorcise. Cutting out photographs of monuments to American history around Provincetown, such as the Pilgrim Memorial, he pasted them into his notebooks alongside reproductions of various local and national flags. His ambition was eventually to replace these monuments to the old culture with contemporary monuments, conceived in his own image and presumably appropriate for the new culture in the making. For the time being, however, he was involved in finding a series of protean forms that would take on a variety of "disguises": "an archetype that the mass magazines want to find or will find."

The appearance of Ray Gun solved many problems for Oldenburg. Previously, he had attempted to make the leap from the figure to the object by using early American figureheads, which, like Ray Gun, were both figure and object; but he rejected this solution because the figureheads were "too close to the *real* thing." In other words, he wished his objects to stand at a certain remove from reality; they should be close enough to be identifiable, but not so close as to be confused with the thing itself. As he strained to find a "simple and obvious form" that would *not* be simple and obvious, he asked himself in despair, "Why do I make it so difficult for myself; why not use figures?"

The grafting of figure onto object that Oldenburg accomplished with the invention of Ray Gun made further innovation possible. As the great liberator, Ray Gun was defined as "an assertion of a new and rude potency," and later as "the necessity of composing true and vulgar art" (by now taken to be identical). As Ray Gun became more firmly identified as Oldenburg's *Doppelgänger,* he became more articulate. He began to issue prophecies and serve as a medium for visionary experiences. At this point, Oldenburg fused the technique of free association with the notion of the artist as medium—a seismographic recorder of cultural vibrations, or a kind of ouija board receiving from the forces of history their collective message to be read by future ages.[5]

Sketches of figureheads from a storefront
Provincetown, 1960
Pencil, 8³/₄ x 6 inches
Owned by the artist

"American Figurehead" (study for a jutting plaque of forms suggested by the account of an Indian massacre,
Fort Dilts Memorial; notebook page). New York, 1960
Pencil, 11 x 8¹/₂ inches
Owned by the artist

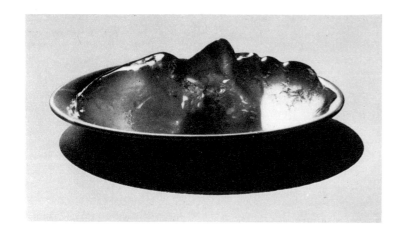

Jelly mold in form of the artist's face. 1966
Glazed ceramic by Signe Persson-Melin
(from life-cast by Michael Kirby)
Owned by the artist

NOTES

1. The Christian theme of martyrdom and salvation can be traced both in Oldenburg's notebooks and in his work. The mold made in Sweden in 1966 in the form of Oldenburg's face, to shape jelly that was meant to be consumed, is an obvious reference to the communion rite; instead of the religious community's consuming the Savior's blood and flesh, however, the public consumes the artist. There are numerous examples in the history of art of an artist's identification of himself with a religious figure: for example, Dürer's self-portrait as Christ, Rembrandt's self-portrait as the Apostle Paul, and in more recent times Ensor's representation of himself as the crucified Christ, and Gauguin's self-portrait with a halo. Such an identification is entirely in keeping with Oldenburg's view that the artist functions in society as a priest or shaman, who exorcises evil spirits and thereby effects a psychological catharsis; in a moral vacuum, it is the artist who provides the moral example.

Oldenburg was raised as a Christian Scientist, and his Christian metaphors often recall the beliefs of some popular American Protestant sects. His childhood memories of texts by Mary Baker Eddy, for example, are apparently responsible for his liberal capitalization of nouns, and perhaps also for his determination to resolve any dualism between mind and body. In serving as a kind of faith healer for social ills, the artist "works" like the Christian Science practitioner.

2. His last painting was *Girl with Furpiece,* the portrait of Pat completed early in 1960. *p. 26*

3. The phrase "hero into loonie" first appears in the original Ray Gun notes, which were tacked to the walls of the Judson Gallery during the presentation there of The Street. The notes were lost or destroyed (a fact that Oldenburg later interpreted as a kind of suicide from which he was "resurrected") and survive only in the fragments recorded by *Time* magazine's interviewer Anne Hollister. Oldenburg sees the turning of the "hero into loonie" as a necessary way of practicing disguises, in order to enable the artist to avoid assimilation into the very society of which he is critical (corresponding to Herbert Marcuse's definition of the fate of criticism in a "one-dimensional" society). "The artist must practice disguises," Oldenburg advises. "When his intentions are best, he must appear the worst (which is often so, even when he doesn't try). I admire good people who are not afraid to appear evil. Céline, 'to be a pain in the ass.' That is the meaning of the Céline plaque."

The "ray gun" itself of course also had its source in popular culture. It was a variation on the all-powerful weapons in the "Buck Rogers" comic strip. Although Oldenburg did not actually paint comic strips, as Dine, Johns, Lichtenstein, and Warhol did, some of his early drawings connected with The Street took that form, and as part of the activity connected with The Street a pseudo-comic called "Ray Gun Spex," illustrated by Dine and Oldenburg, was published.

4. One of the original associations that Ray Gun had for Oldenburg was with Hart Crane's "religious gunman," who is identical with Christ; hence, Ray Gun is not only the artist's alter ego but the "religious gunman," or Christ, as well.

5. This notion may have been suggested to Oldenburg by his mother's interest in spiritualism. Seeing the artist as medium, Oldenburg accepts the role of the wall on which the moving finger writes.

The Ray Gun Manufacturing Company

The humorous story is American, the comic story is English, the witty story is French. The humorous story depends for its effect upon the manner *of the telling; the comic story and the witty story upon the* matter.... *The humorous story is strictly a work of art—high and delicate art—and only an artist can tell it....The humorous story is told gravely; the teller does his best to conceal the fact that he even dimly suspects that there is anything funny about it...*

Mark Twain, *"How To Tell a Story"*

Ray Gun is both a form of deception (to everyone, including myself) and a form of play ... i.e., only the comic is serious, only the offhand is effective. Therefore, Ray Gun is a series of contradictions, paradoxes. Ray Gun is ultimately the unknowable, pursued futilely through all its disguises.

Claes Oldenburg, notebooks, 1960

It is part of the democratic attitude for its intellectuals to go about in disguise and not *to attack (which is easy enough for anyone with a little wit) but to make something of a society which they must admit has its general advantages...*

Claes Oldenburg, notebooks, 1961

On his return to New York from Provincetown in the fall of 1960, Oldenburg began considering making "objects, plaques, flags, monuments, space forms, house-rooms." Eventually he was to make them all, but at the moment he complained that "the limitation of space forces me to consider making only smaller pieces at home." To execute larger pieces, he would obviously need more room. The following spring, passing an empty store while on his way to work at Cooper Union, he realized that the answer was to allow Ray Gun to become the Horatio Alger of the Lower East Side and, like generations of Americans before him, realize his entrepreneurial ambitions.

By this time, the rough outlines of ray-gun art had been sketched. With his usual obsessive, circular reasoning, Oldenburg concluded that since Ray Gun backwards was Nug Yar (New York), the ray gun was an ideal metaphor for Manhattan Island, whose shape it could also be made to resemble. Ray-gun art was also "a social art: that is true art: form as idea." While Oldenburg was searching for the "American archetypes," toward which he was determined to take "a double view, both for and against," Ray Gun was making his own rules, seeking to create "the extraordinary out of the ordinary."

During this period of trial and search, Ray Gun took on many identities: a sacred phallus, repository of strength and power (the taboo of puritan America turned into its totem), a weapon of self-defense as well as an instrument of aggression. The paradox that the ray gun is both a means of survival as well as of destruction had many implications; by defining it as such, Oldenburg was recognizing his own ambivalent feelings—toward the self as well as toward the outside world. Ray Gun, the phallic object, allowed the artist, perhaps for the first time in his life, to look outward, to direct his energy, even his aggression, toward the world around him. Through the force of Ray Gun —that is, his own potency—Oldenburg would subvert values that he regarded as antagonistic to his own; he would "attack materialistic practices and art." Ray

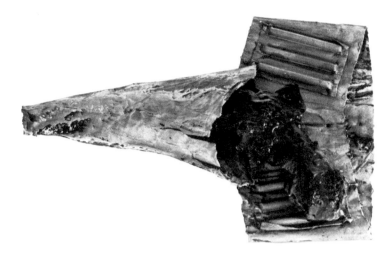

above:
Western Ray Gun in Holster. 1965
Muslin and burlap soaked in plaster, canvas "holster,"
wood "bullets," painted with enamel,
16 inches high x 24 inches wide
Owned by the artist

opposite, above:
Study for Ray Gun Rifle (notebook page). 1960
Ball-point pen, 11 x 8½ inches
Owned by the artist

opposite, below:
"Battleship—Phallic" (notebook page).
Provincetown, 1960
Colored crayon, 10⅞ x 8⅜ inches
Owned by the artist

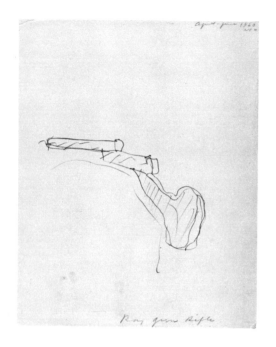

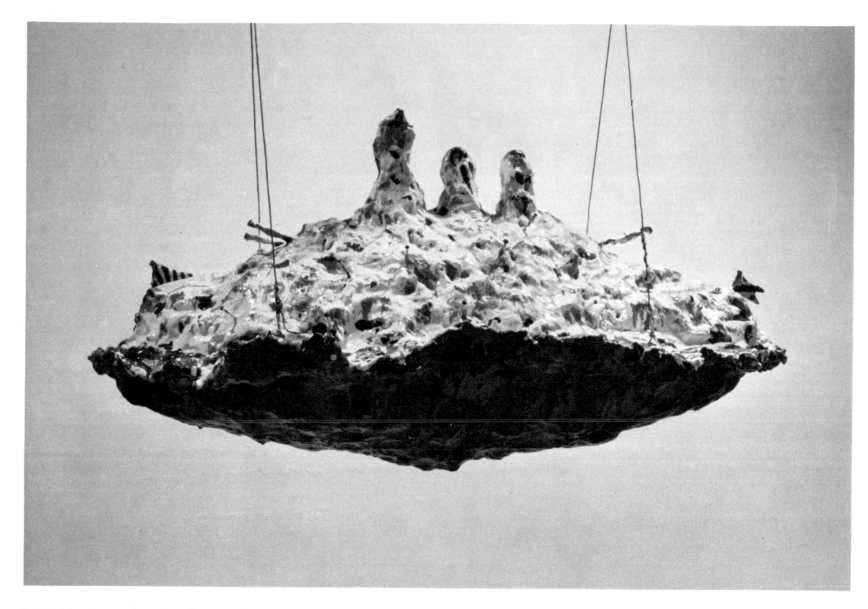

Battleship: Centerpiece for a Party. 1962
Burlap soaked in plaster over wire frame, painted with enamel,
17 inches high x 35³/₈ inches wide x 18¹/₄ inches deep
Collection Mr. and Mrs. S. Brooks Barron, Detroit

Gun thus became the metaphor for a new kind of art, one dedicated to "spiritualizing American sensation." But Oldenburg realized that his attitude toward American culture was complex: "I detest it—to begin with—those who pretend to 'love' it are fake or shallow. But I neither avoid it nor love it. I try to discover the human in it."

This recapturing of the human element in contemporary American urban experience was the ultimate goal of ray-gun art; the way to survive in the slums was to create art from the environment. Oldenburg described the change in his outlook as "the change from the denial of evil to the recognition of evil." His shift in focus from an emphasis on the death instinct to an affirmative attitude based on the healing powers of the erotic has many analogies with the post-Freudian concepts of Norman O. Brown, and particularly with his *Life against Death*.[1] The central thesis of this book—the eradication of the dualism between mind and body—was especially congenial to Oldenburg, who had been raised as a Christian Scientist; for Christian Science, like neo-Freudianism, recognizes no such dualism. Brown also counseled the renunciation of repression and sublimation in favor of a return to the polymorphous perverse condition of infancy. His advice to give up formal logic and the laws of contradiction, because they are "rules whereby the mind submits to operate under general conditions of repression," was welcomed by Oldenburg, who had already accorded himself this permission.

Oldenburg did not read Brown's book until after The Store had opened; but there are many similarities between his thinking and Brown's analysis of the ailments of contemporary society and their possible cure. With such a cure in mind, he began to look for ways to spiritualize (that is, transform into art) the commodities of a materialistic culture. The result was The Store, an environment of plaster reliefs and three-dimensional objects of clothing and food.

Since a large part of this country's manufacturing was devoted to armaments, it was entirely appropriate

that The Store, which would "sell" art as an actual commodity and so reveal the true function of art in a materialistic society, should be "incorporated" as The Ray Gun Manufacturing Company. Its purpose, according to Oldenburg, was "the protection of art through reversals and disguises. From the bourgeois, from commercialism, from rivalry, from all the forces that might destroy art."

The first statement of The Store was in a group show, "Environments, Situations, Spaces," held from May 25 to June 23, 1961 at the Martha Jackson Gallery, where Oldenburg had participated the previous year in "New Forms—New Media." The five other artists included were George Brecht, Jim Dine, Walter Gaudnek, Allan Kaprow, and Robert Whitman. Oldenburg's contribution, originally intended as an enclosed environment, instead took the form of a three-part mural in the stairwell and front of the gallery, with fragments of common objects, the early Store reliefs, hanging freely in space.

It was not until the following winter that The Store itself was fully realized at 107 East Second Street (which Oldenburg had taken over for a studio in June), in a non-gallery, realistic locale. It represented the dissolution of the museum-gallery situation and seems in many respects a forerunner of the kind of integration of art into the community that artists are demanding today. To take art out of the museums, Oldenburg decided to invent his own museum of the slums—for essentially The Store was conceived as a museum of popular art. It was also the "temple" of money, the appropriate shrine of a materialistic culture. In The Store, Oldenburg re-created the articles he *pp. 74–86* passed every day in his slum neighborhood: the cheap underwear and sleazy dresses from Orchard Street, the food displayed in bodegas and delicatessens along Second Avenue. The Store's inventory consisted of the reliefs from the Martha Jackson show plus about sixty new pieces, mostly freestanding.

Like Neubern, The Store was a totally coherent fantasy, thought out to the last minute detail. Once

one accepted its premises, it was entirely logical and consistent; yet as usual the fantasy was rife with paradox. The company "manufactured" only lumpy, misshappen, obviously handmade objects. C. Oldenburg, President (as he was identified on the company's stationery), was also its only employee, at once the capitalist entrepreneur and the proletarian worker.

When The Store came into being, the transformation of Ray Gun was complete. Art, no longer associated with death and violence, had become the instrument of survival, catharsis, and salvation through creativity. The world was remade in Ray Gun's image. Whereas The Street had been dangerous, violent, full of threats and obstacles, its charred relics an apocalyptic warning, The Store was friendly, colorful, open, full of the gratification of good things to eat and wear —a vision of the millennium. The Street and The Store thus present the two faces of Ray Gun: The Street was involved with crudeness and brutality, The Store flaunted sensuality and vulgarity. "I am involved with vulgar art, partly with its discovery and partly with its transformation."

Oldenburg's interest in American popular culture may be compared to Vladimir Nabokov's fascination with adolescence and motel culture in *Lolita;* in fact, the publication of *Lolita* in 1959 may have been the first indication that American popular culture could be viewed with sufficient detachment to make it the subject for high art. Like Nabokov, Oldenburg is the sightseer, the tourist, who views American popular culture from the vantage point of the European aristocrat; unlike Nabokov, however, he is not condescending toward what he sees. Oldenburg, the Ivy-League intellectual, wished to end the alienation of the intellectual from the masses. "The thing I absolutely do not want is to be with it, to be hip, to be inside... to belong, to be sophisticated.... I want to do exactly what everybody does ... I want to laugh at the prepared jokes, I want to obey the fads, I want to speak as everybody else speaks... knowing all that is grotesque, but knowing too that out of such grotesquerie arises

art, which never arises out of escape or rejection. Bad taste is the most creative thing there is...''

Oldenburg's choice of vulgar subjects must also be seen as an attempt to subvert bourgeois values, which are capable of subsuming every type of human endeavor, even art, within a commodity context. Oldenburg therefore confronted the issue directly by making actual commodities, which would be art in spite of themselves. The museum is a bourgeois institution, he reasoned, but the store, the popular museum, is beneath—and therefore safe from—bourgeois values.

In The Store, Oldenburg created a total work of art that combined painting, sculpture, architecture, theatrical display, setting, and light. It may be regarded as a low-life or genre equivalent of Bernini's Cornaro Chapel in Santa Maria della Vittoria. But if Bernini's shrine of Saint Teresa is the apotheosis of spiritual ecstasy, Oldenburg's Store is the apotheosis of materialistic vulgarity—both, finally, being equally sensual in content.

At first, The Store reliefs were like giant watercolors. The first of them, a series of plaster flags p.73 painted with tempera, were executed late in 1960 and early in the following year. As Oldenburg's concept for The Store developed, however, the pale tempera was not strong enough for what he had in mind. "I want these pieces to have an unbridled intense satanic vulgarity unsurpassable, and yet be art," he wrote. Ultimately, the reliefs were constructed of plaster on chicken wire and muslin, painted with cheap, commercial house-paint enamel, splashed on straight out of the can. They were blotched, spattered, and overpainted like a city wall. "Lately I have begun to understand action painting... in a new and peculiar sense," Oldenburg wrote during the period he was making the objects for The Store. Abstract Expressionism suddenly looked to him "as corny as the scratches on a NY wall"; yet by accepting certain of its elements, if not its expressionist aesthetic, he felt that "by parodying its corn I have (miracle!) come back to its authenticity!" Surer now of his own position, he no longer had to

reject his former heroes but could give their art a new lease on life, by crossbreeding it with vulgar, lower-class culture: "I feel as if Pollock is sitting on my shoulder, or rather crouching in my pants!"

As he worked on The Store, Oldenburg set himself the problem of "how to individualize the simple objects, how to surprise them—fragmentation, gigantism, obsession." Each piece suggested analogies with others. "The reference through similarities in structure of one object to another is not symbolism," Oldenburg explained, "but a statement about the unity of nature." He maintained that he was equally against symbolism and abstraction, because both "take one from the concrete, which is the proper subject of art." In other words, Oldenburg completely accepted and extended the basic premise of Abstract Expressionism—which was itself a further extension of Mondrian's literal view of the art object as a thing in itself, rather than an imitation of an object or idea at one remove from reality. On the other hand, his decision to remain a representational artist was made on the assumption that the eye interprets everything it sees. If, therefore, the viewer were in any case going to regard abstract paintings as Rorschach images in which he would see textiles, mattress ticking, or other phenomena, the artist might as well make clothes, beds, or phallic objects to begin with.[2]

The use of identifiable images thus serves to point a moral: one gets from Oldenburg's images what one brings to them. The insensitive, the inexperienced, the blind viewer who has no genuine response to visual stimuli will have only the extremely limited and superficial experience of cognition. Satisfied with identifying the image, he will recognize the objects without being aware of their properties of surface, color, or form—everything, in short, that distinguishes them as art. They will seem to him bad, or at most funny, imitations of real objects; their formal qualities will remain as inaccessible to him as those of abstract art to the uninitiate.

Of the many disguises of Ray Gun, then, the disguise of representational art is perhaps the ultimate

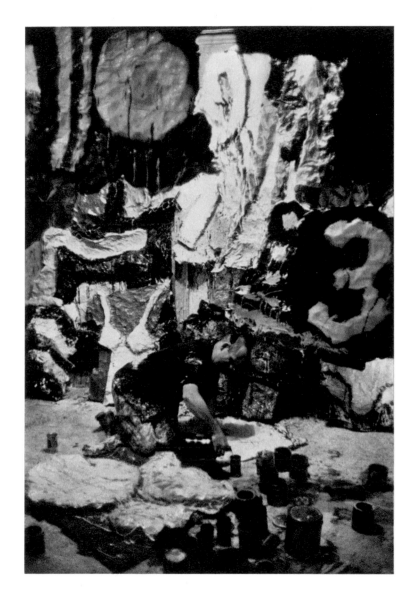

Oldenburg in his residence and studio, 330 East Fourth Street, working on pieces for "Environments, Situations, Spaces" at Martha Jackson Gallery, 1961

masquerade. In this context, it is significant that Oldenburg creates no unfamiliar images and indulges in no Surrealist juxtapositions, whose literary content is of no interest to him. He uses the image, not as an elaborate literary conceit, but merely as an obstacle to approaching the true content of his work, which, as in abstract art, is its form.

One of the fundamental premises of Oldenburg's art, and a part of his democratic intention, was to give the public some foothold in his art—to reach an audience previously untouched by visual art. But he did not care to make "poor art for poor people," as Arshile Gorky once described the art produced under the W. P. A. Oldenburg did not propose social realism but an art that, while adhering to the conventions of modernism, nevertheless would remain accessible to every man on his own terms. Because his images resembled familiar objects (though at times only remotely), his public even from the outset was far larger than that for abstract art. The full message of Oldenburg's art might be understood only by the cognoscenti, but some aspect of it was available to all.

For all their insistence on the self-sufficiency of the work of art as an independent entity, the Abstract Expressionists made much of the fact that they were producing an art of content. It is nevertheless impossible to determine whether the psychological states that they were "communicating" are indeed communicable. With seeming coolness and objectivity, Oldenburg and his generation questioned whether subjective experience *can* be communicated through art. For them, the empathic emotional involvement that is the basis of any expressionist theory of art has no relevance. Oldenburg's art, as we shall see, has certain characteristics of an expressionist style; yet he cannot be classified as an expressionist, for he does not demand that the audience share his personal emotions or attitude toward his subject. He asks instead that the viewer use the work as a point of departure for an experience woven out of whatever individual fantasies and personal associations the object in question may generate

66

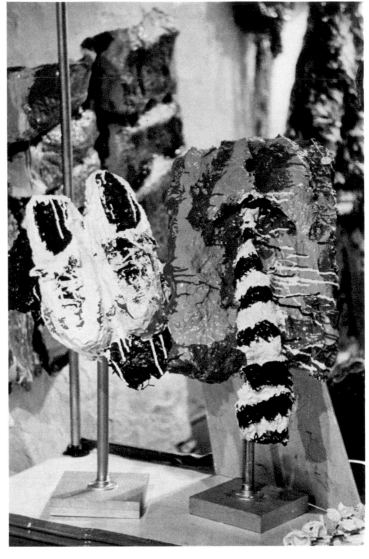

Two views of The Store, 1961. Right: White Gym Shoes (now collection Dr. Panza di Biumo, Milan) and Blue Shirt, Striped Tie (now collection Henry Geldzahler, New York)

for *him,* just as Oldenburg had distilled the object from his own fantasy life. Rather than demanding the same response from each individual, or requiring him to participate in the artist's inner life, Oldenburg, like other artists of his generation, constantly refers the spectator back to his own experience and perceptions. For the artist who, so to speak, came of age in the 'sixties, art is not the expression of any subjective emotion, but a heuristic experience—a means to self-knowledge. The physical sensations, visual perceptions, and poetic associations that the object arouses in the viewer are assumed to be relative entirely to his own experience.

In Oldenburg's work, therefore, meaning is left open. The content is psychological, based on instincts common to everyman, rather than symbolic. The only thing that can be said for certain about this content is that its basis is erotic.[3] All the objects, beginning with the ray gun, are metaphors for the body or parts of the body—most frequently breasts, genitals, or orifices of one sort or another.

For an art of such ambiguity, many interpretations are possible, each functioning as an added layer of meaning accruing to the object.[4] In this context, it should be noted that among Oldenburg's earliest works were signs. The sign, as opposed to the symbol, *is* something, rather than substituting for, or alluding to, a thing or concept. It signifies or has meaning in itself—or, in Oldenburg's case, it has associations. The Store reliefs are "signs," both literally as well as figuratively; they do not represent articles but are "fragments for advertisements." "I reject the presentation of the object without any interference as inconsistent with my need to create. I reject symbolism as an artificial imposition which violates the truth of perception, and for the same reason, I reject 'art,' decorative effects of any sort."

Although imitative of manufactured objects, the shop signs of The Store, with their wrinkled, torn, and creased surfaces, their undulations and incrustations, are the exact opposite of factory duplicates. Their

most salient characteristic, in fact, is probably their unreproducibility. Paint is not only splashed, splattered, and dripped, but also speckled, spotted, flecked, and dotted to produce the richest possible surface. The reliefs differ in their degree of projection. Some, like the *Slice of Yellow Pie,* are nearly three-dimensional; others, like the *Fur Jacket,* are practically flat. *p.82* *p.77* Edges ripple, bend, and curve unpredictably; are we looking at laundry flapping on the line, or the great furled cape of a Baroque pope? This question is never resolved. In the *Auto Tire and Price,* natty black and *p.76* gaudy silver are combined with brilliant yellow, blue, and white enamel to create an effect as glamorous, yet tawdry, as contemporary American life. In the *Bride Mannikin,* the largest freestanding piece and the masterpiece of The Store, plaster is applied like icing, in rich sensual slabs and furrows. Based on the bridal displays in Lower East Side shops (like Léger's sequence in Hans Richter's film *Dreams That Money Can Buy*), the *Bride* is the last direct representation of the human figure in Oldenburg's sculpture. Even so, it is somewhat removed from figural connotations, because it does not represent an actual person but a mannikin—a store dummy.

Oldenburg has described his style as a "realism which copies the posters and the ads instead of the thing itself." Such detachment, estrangement, or alienation is constant throughout his work.[5] Disengagement, like catharsis, is a way of dealing with excessive emotion. For Oldenburg, the question is always: how does a hypersensitive person deal with his own self-generated difficulties, as well as those imposed by a hostile and violent environment? One answer is by disengaging himself, becoming a spectator, viewing the world and its catastrophic events as theater (a theme investigated in a number of recent plays and films).[6] This rejection of emotional empathy may be seen as the final destiny of expressionism, during a period in which events have outstripped the capacity of the human imagination to reexperience them in art, and when there is no longer any tranquility in which the artist can recollect emotion and so effect its poetic

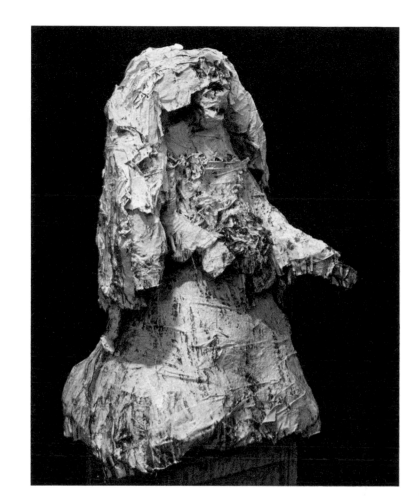

Bride Mannikin. 1961
Muslin soaked in wheat paste over wire frame, painted with enamel, 72 inches high
Collection Dr. Panza di Biumo, Milan

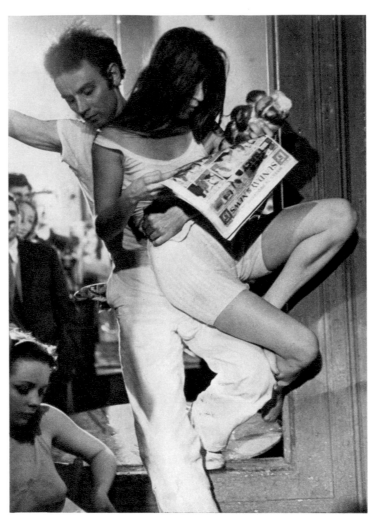

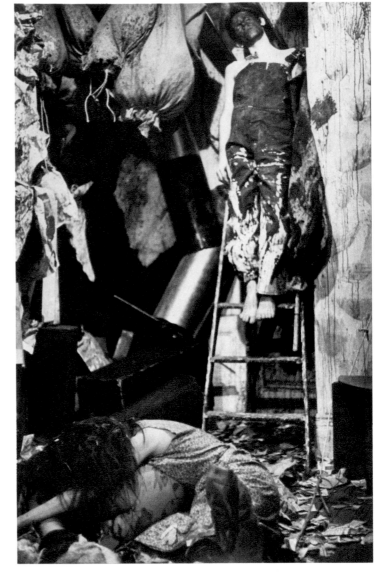

Ray Gun Theater. 1962
left, above: Store Days, I (Terry Brooke and Lucas Samaras)
left, below: Nekropolis, II
center: Voyages, I (Lucas Samaras and Pat Oldenburg)
above: Injun, I (Pat Oldenburg and Lucas Samaras)

transformation. With Oldenburg, expressionism approaches a terminal point. Instead of being asked to participate in or enter into a painful experience, we are instead to experience it only by viewing it at arm's length, so to speak, to preserve sanity and objectivity.

Another factor in this process of alienation is that Oldenburg consistently sees the object as ripped from its environment (see p. 39). The torn edges of the Store reliefs suggest that they have been removed from a larger area; like the figures in The Street, they can be regarded as remnants of a mural whose background has been discarded. In the *Auto Tire and Price*, for example, the image represents fragments of two objects—a tire and a price tag—that have been ripped out of their context. For Oldenburg, vision focuses on fragments. "An advertisement or part of one, ripped from a newspaper, was taken to correspond to a glance at the plane of vision." Like the compositions of Baroque paintings that spill out beyond their framing boundaries, Oldenburg's images are partial and fragmentary. In keeping with the relativity of his realism, he does not represent what he sees, but rather acknowledges the principle by which the act of vision operates, allowing us to see only fragments of our total environment.

"The fragmentation is the concrete realization of vision, passing from one item to another in a multitude," Oldenburg wrote. "The fragments are the naive realization of the piece 'torn' from reality. Literal application of this metaphor. I am convinced originality is achieved through naiveté and literalness. Torn-birth flesh-fragments. I think of space as being material like I think of the stage as being a solid cube or hollow box to be broken, so a hallucination basic to my work is of the continuity of matter, that air and the things in it are one, are HARD, and that you can RIP a piece of air and the thing in it out of it, so that a piece of object and a whole object and just air, comes as one piece. This in my hallucination accompanied by a RIPPING SOUND. I trust hallucination as much as naiveté for originality of vision."

After The Store closed, it was succeeded by a whole series of theatrical events (which Oldenburg is reluctant to equate with "happenings"). Believing that "theater is the most powerful art form there is because it is the most involving," Oldenburg developed his own idea of what the aesthetic of the theater should be. The result was the Ray Gun Theater, a series presented in the rear rooms of the Ray Gun Manufacturing Company at 107 East Second Street from February to May 1962. The series included *Store Days I, Store Days II, Nekropolis I, Nekropolis II, Injun I, Injun II, Voyages I, Voyages II, World's Fair I,* and *World's Fair II.* The titles are somewhat misleading, for there was a completely different script for the "first" and "second" versions of each of the five pairs, and the script for *Injun* went through a number of revisions, including its re-creation at the Dallas Museum of Contemporary Arts in April 1962.

The setting for *Store Days,* the first in the cycle, was formulated when Oldenburg visited Jack Smith, who was making still photographs that were the prototypes of the images found later in his film *Flaming Creatures* (1963). The freedom of expression of this milieu of transvestite, "forbidden" sexuality inspired Oldenburg to think in terms of a theater of self-expression, rather than an "expressionist" theater (as some critics have mistakenly regarded his happenings). The "cold," detached violence of Coney Island waxworks also impressed him at this time, he remembers.

What Oldenburg conceived of for the Ray Gun Theater was: "A series of plays dealing with the US consciousness, really nonconcrete in content though expressed concretely. The content is the US mind or the US 'Store'.... It seeks to present in events what the store presents in objects. It is a theater of real events (a newsreel)." Within this cycle, the chintzy, Lower East Side *Store Days* represented the catastrophe of the slums, of people dead to their experience. *Nekropolis* was a further celebration of apocalypse and death, while *Injun* was a cathartic ritual, exorcising the demonic and violent elements. *Voyages* and

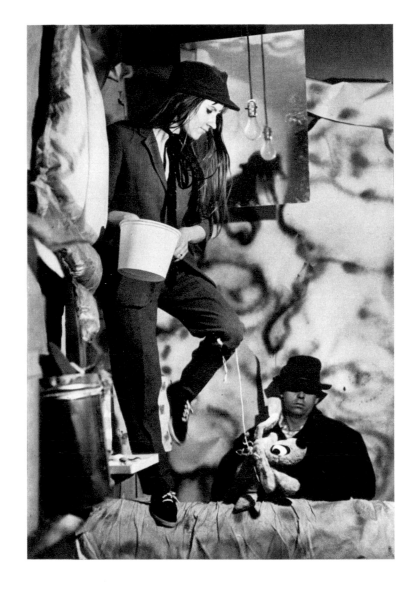

Ray Gun Theater: Store Days, II. 1962
(Street Chick: Pat Oldenburg; Beggar: Claes Oldenburg)

69

World's Fair, the concluding works in the cycle, on the other hand, were meant to represent rebirth and renewal, and so contained quieter, more lyrical images.

Each work was given two performances, on Friday and Saturday nights; because of the limitations of space, the audience was limited to thirty-five. The "repertory" cast consisted of Oldenburg himself, Pat Oldenburg, Lucas Samaras, and Gloria Graves; they were supplemented by a varying number of other participants. "My characters are the city-bird-child (chick) and the beggar, innocence and experience. that is my theme: innocence vs. experience (or evil), good vs. evil. comic innocence. pat."

In the final analysis, perhaps, The Store and the Ray Gun Theater represent the infatuation of the Yale man with the Street Chick, or, more generally, with lower-class culture. Oldenburg's identification with the proletariat is hardly exceptional in American art, but his program of action—literally, to evolve an art out of the slums—was acutely focused. In a sense, this was the only choice open to a revolutionary personality at a moment of impasse in American politics, when no political action seemed possible, and genuine freedom of action appeared to be available only in art.

Identifying with the proletariat, in The Store Oldenburg assumed the role of the worker. He became baker, plasterer, housepainter, tailor; both owner of the means of production, and employee in an enterprise that was also a metaphor for an ideal socialist state. The Store was a one-man operation; there were no middlemen and no middle class—not a very acceptable idea in the complacent America of the early 1960s.

The Store was nevertheless a rousing public success. Originally planned to be open during the month of December 1961, it was kept going, by popular demand, through January 1962. Ironically, however, only a small part of its "inventory" was sold, and it closed with a net loss of $285. This sum was advanced by the Green Gallery, where Oldenburg was soon to have an exhibition; for, like any successful business, The Store moved uptown when the opportunity came.

NOTES

1. Middletown (Conn.): Wesleyan University Press, 1959. The views of John Cage, who demanded an affirmative attitude toward the industrial environment, and of Marshall McLuhan, who described the "retribalization" of culture through the impact of the communications media, overlap at this point both with Brown's writing and with Oldenburg's thought. Freud had seen no answer to the discontents of civilization except through the successful sublimation of the instincts; but post-Freudians such as Brown have looked at ways in which "non-civilized" thinking structures the world without destroying opportunities for self-expression and gratification.

Oldenburg's own position was coincidental with, rather than actually dependent upon, Brown's conclusions, as is demonstrated by the fact that many of the ideas developed in Brown's most recent book, *Love's Body* (New York: Random House, 1966), were actually anticipated in Oldenburg's work. The close similarity of Oldenburg's iconography to post-Freudian thought may be explained by his deep immersion in Freud's own writings during the 1950s, while his art was being conceived.

2. "When I refer to Brancusis drainpipes . . . or to Morrises furniture (forever rearranging), Frank's 'mattresses'—I mean no harm," Oldenburg declared; he wished "Only to assert . . . the inescapability of *identification,* impossibility of a clean well-lighted mind" ("America: War & Sex, Etc.," p. 38).

3. The same is true of much primitive art, and of the sacred art of antiquity, Japan, and India. Thus by his persistent use of erotic content, Oldenburg is only reaffirming an ancient tradition (see also p. 34, n. 6).

4. For example, Oldenburg has interpreted the *Fagends* as follows: "Fagends faced the danger of becoming garbage of a torture chamber, also that of

coming to rest as the twined limbs and tails of an ingres orgy, Rubensian asstray. Now I can say with honesty that these are: this, that, the one hand, the other both, but mostly that they are neither. It depends on the weather" ("America: War & Sex, Etc.," p. 38).

5. Analyzing his sense of alienation, with his usual removal from the phenomenon he is studying, Oldenburg concludes: "My work is thoroughly and honestly self-projective, narcissistic. This 'weakness' constitutes its power. My desire for an audience is the desire to confess, a desire to reach, or be reached, to be saved from enclosure, which never happens... No one reaches me. I reach no one, except through disguises and through others (players)." A symptom of this alienation is Oldenburg's treatment of the body at one remove, as a store mannikin, or as anatomical fragments. The use of such fragments in modern art can be traced from Rodin through Duchamp; Johns's targets with plaster casts, as well as his later paintings with casts of limbs, also provide a context for Oldenburg's use of the fragment. But whereas Johns and Duchamp took casts of human anatomy, Oldenburg (as in the *London Knees*) works from representations of the body, such as store dummies.

6. Describing his survival in a concentration camp, the psychologist Viktor E. Frankl writes that the sensitive person can deal with horror and catastrophe by disengaging himself, becoming the observer of his own life and times. Frankl survived by forcing himself to imagine that he was lecturing on the psychology of the concentration camp, thus projecting himself out of the painfulness he was actually experiencing (*Man's Search for Meaning,* Boston: Beacon Press, 1962, pp. 73–74; translated by Ilse Lasch from *Ein Psycholog erlebt das Konzentrationslager,* 1946). "Both I and my troubles became the object of an interesting psychoscientific study undertaken by myself," he observes—a description that might equally be applied to Oldenburg's attitude toward his own life and times.

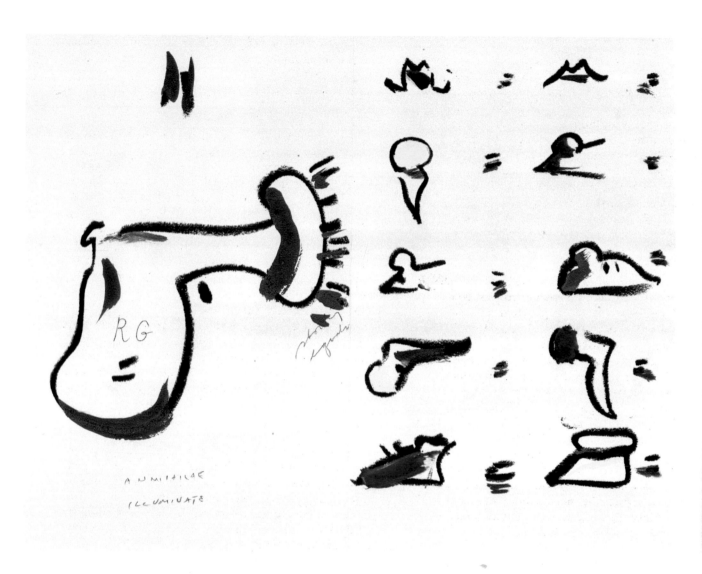

"R[ay] G[un] = Annihilate/Illuminate." 1965
Crayon and watercolor,
11 x 18 inches
Owned by the artist

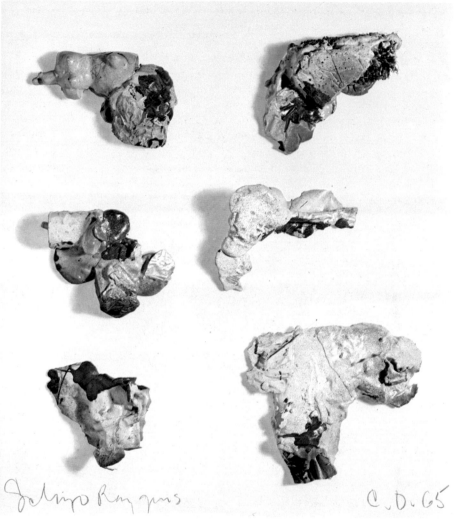

Schizo Ray Guns. 1959–1960, mounted 1965
Plaster and various materials, painted in enamel, mounted on paper board,
19¹/₄ x 17³/₈ inches
Owned by the artist

71

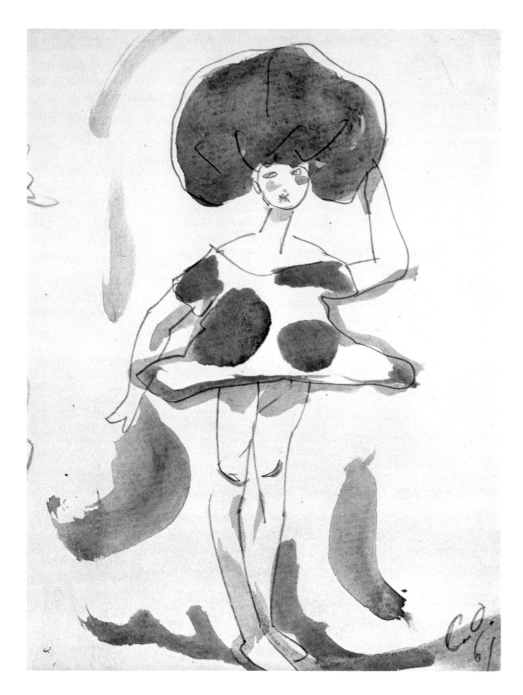

Blue Discs, Big Red Hat
(sketch for a dance costume for
the Aileen Pasloff Dance Company). 1961
Pencil and watercolor, 10¹/₈ x 7³/₈ inches
Collection Mrs. Claes Oldenburg, New York

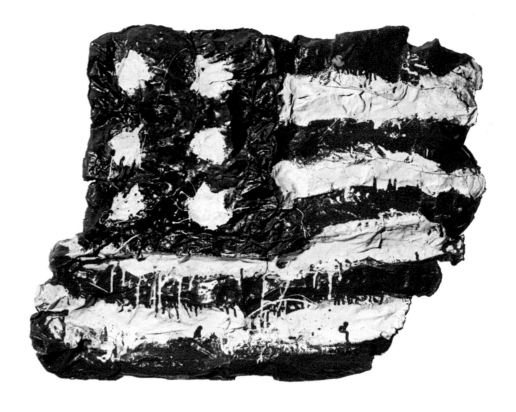

U.S.A. Flag. 1960
Muslin soaked in plaster over wire frame, painted with tempera,
24 inches high x 30 inches wide x 3½ inches deep
Owned by the artist

U.S. Flag—Fragment. 1961
Muslin soaked in plaster over wire frame, painted with enamel,
36 inches high x 40 inches wide
Collection John Rublowsky, Brooklyn

73

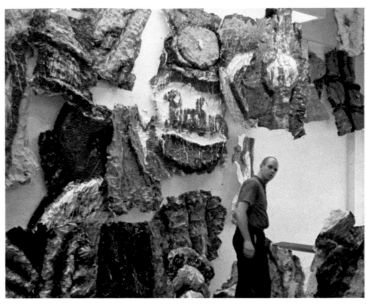

Interior of the Store (sketch for a poster, not executed). 1961
Crayon and watercolor, 24 x 18¹/₈ inches
74 Collection Mr. and Mrs. Richard E. Oldenburg, New York

First Store reliefs installed in the exhibition
"Environments, Situations, Spaces,"
Martha Jackson Gallery, May–June 1961

opposite:
39 Cents (fragment of a sign). 1961
Muslin soaked in plaster over wire frame, painted with enamel,
29 inches high x 38 inches wide x 4 inches deep
Collection Mr. and Mrs. Robert Breer, Palisades, New York

7-Up (fragment of a sign). 1961
Muslin soaked in plaster over wire frame, painted with enamel,
55 inches high x 37 inches wide x 5½ inches deep
Collection Mr. and Mrs. Burton Tremaine, Meriden, Connecticut

Auto Tire and Price (Auto Tire with Fragment of Price). 1961
Muslin soaked in plaster over wire frame, painted with enamel,
49 inches high x 48 inches wide x 7 inches deep
Collection Mrs. Claes Oldenburg, New York

Strong Arm
(fragment of an advertisement for body-building). 1961
Muslin soaked in plaster over wire frame, painted with enamel,
41¹/₂ inches high x 32¹/₂ inches wide x 5³/₄ inches deep
Mr. and Mrs. Burton Tremaine, Meriden, Connecticut

Fur Jacket (fragment of an advertisement). 1961
Muslin soaked in plaster over wire frame, painted with enamel,
50 inches high x 43 inches wide x 6 inches deep
Collection Mrs. Claes Oldenburg, New York

Iron. 1961
Muslin soaked in plaster over wire frame, painted with enamel,
66 inches high x 44 inches wide x 4 inches deep
Chrysler Art Museum, Provincetown, Massachusetts

right:
"Mu-Mu" (Ladies' robe displayed). 1961
Muslin soaked in plaster over wire frame, painted with enamel
Collection Dr. Panza di Biumo, Milan

far right:
Girls' Dresses Blowing in the Wind (Two Girls' Dresses). 1961
Muslin soaked in plaster over wire frame, painted with enamel,
42 inches high x 41 inches wide x 6¹/₂ inches deep
Collection Mrs. Claes Oldenburg, New York

opposite, left:
Stockinged Thighs Framed by Skirt. 1961
Muslin soaked in plaster over wire frame, painted with enamel,
34³/₈ inches high x 41³/₈ inches wide x 6 inches deep
Collection Mr. and Mrs. Horace H. Solomon, New York

opposite, right:
Red Tights (Red Tights with Fragment 9). 1961
Muslin soaked in plaster over wire frame, painted with enamel,
69⁵/₈ inches high x 34¹/₄ inches wide x 8³/₄ inches deep
The Museum of Modern Art, New York
(gift of G. David Thompson, 1961)

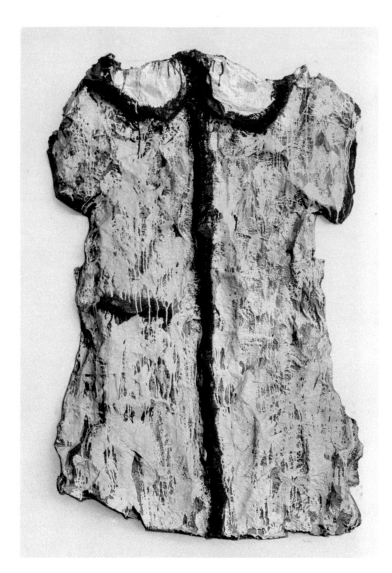

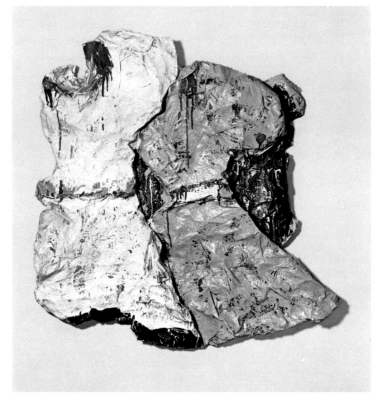

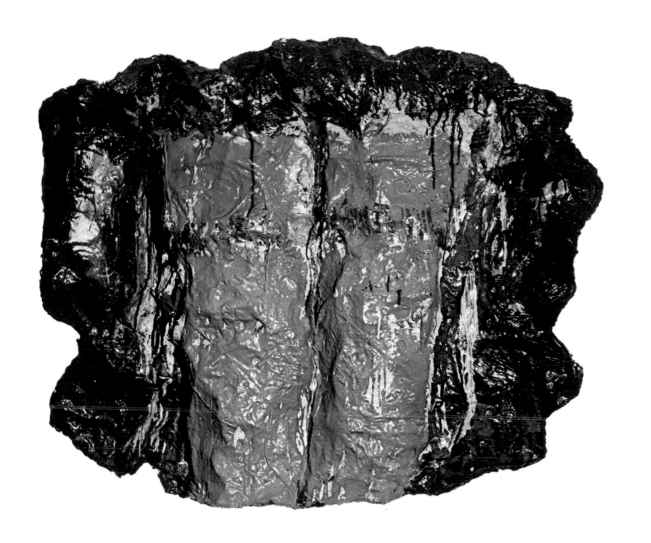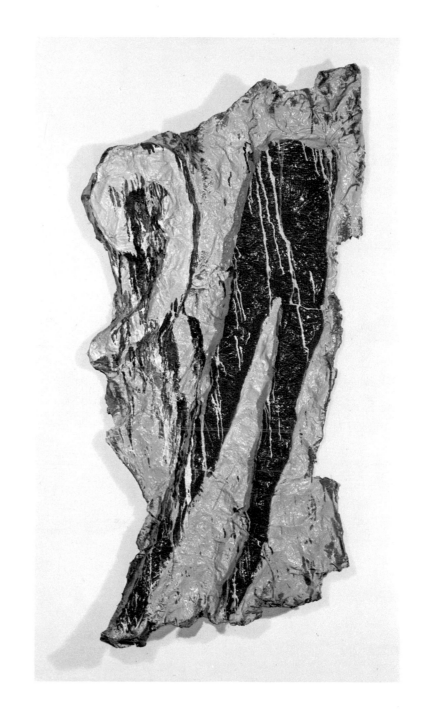

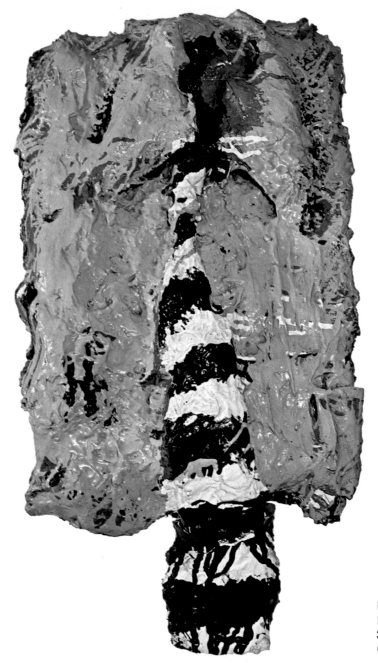

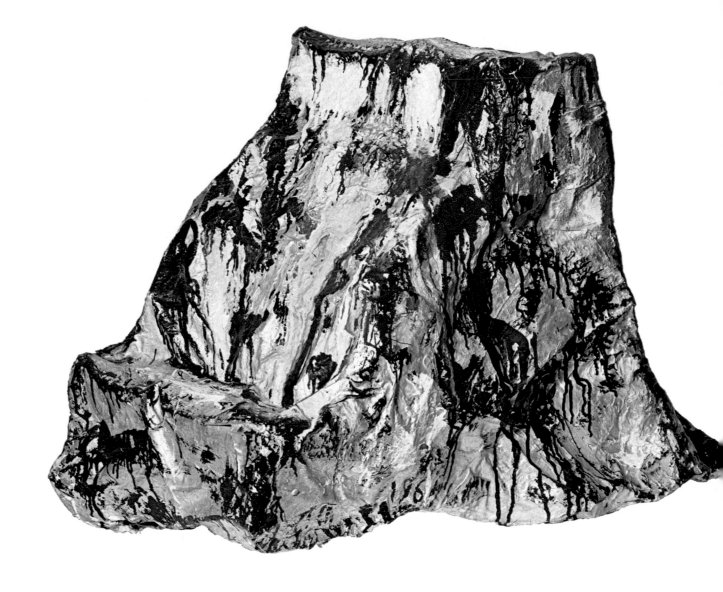

Blue Shirt, Striped Tie. 1961
Muslin soaked in plaster over wire frame, painted with enamel,
36 inches high x 20 inches wide
Collection Henry Geldzahler, New York

Cash Register. 1961
Muslin soaked in plaster over wire frame, painted with enamel,
25 inches high x 21 inches wide x 34 inches deep
Collection Mr. and Mrs. Richard L. Selle, Chicago

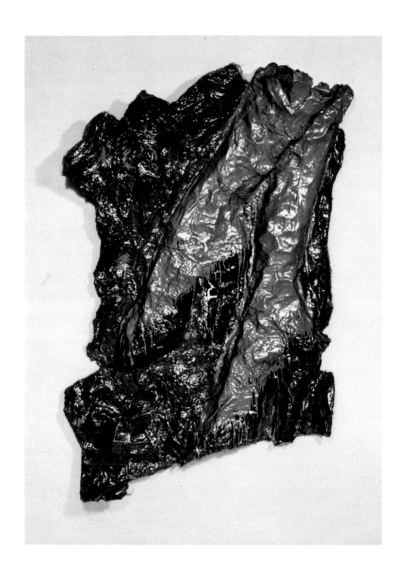

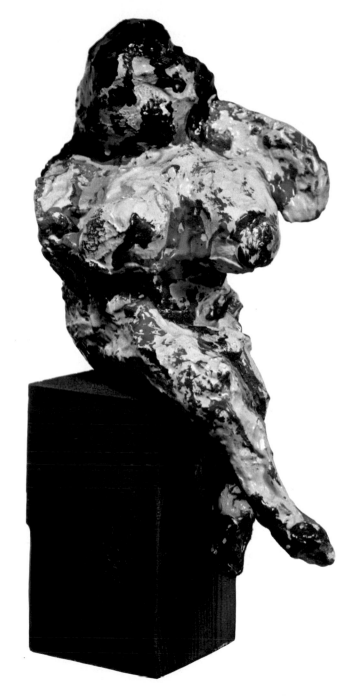

Green Legs with Shoes. 1961
Muslin soaked in plaster over wire frame, painted with enamel,
46 inches high x 42 inches wide x 8 inches deep
Collection Mr. and Mrs. Robert C. Scull, New York

Souvenir: Woman Figure with Salt-and-Pepper-Shaker Breasts
(Times Square Figure). 1961
Burlap soaked in plaster, painted with enamel, 13³/₄ inches high
(including base) x 6 inches wide x 9³/₄ inches deep
Collection Mr. and Mrs. Robert C. Scull, New York

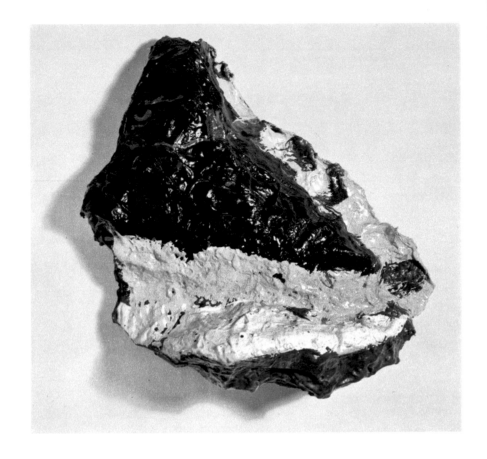

The Stove (Assorted Food on Stove). 1962
Muslin and burlap soaked in plaster,
painted with enamel; utensils and stove;
58 inches high x 28 inches wide x 27½ inches deep
Collection Mr. and Mrs. Robert C. Scull, New York

Slice of Yellow Pie (Small Yellow Pie). 1961
Muslin soaked in plaster over wire frame, painted with enamel,
19 inches high x 17 inches wide x 7 inches deep
Owned by the artist

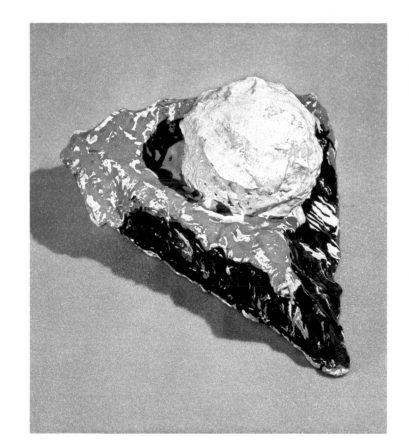

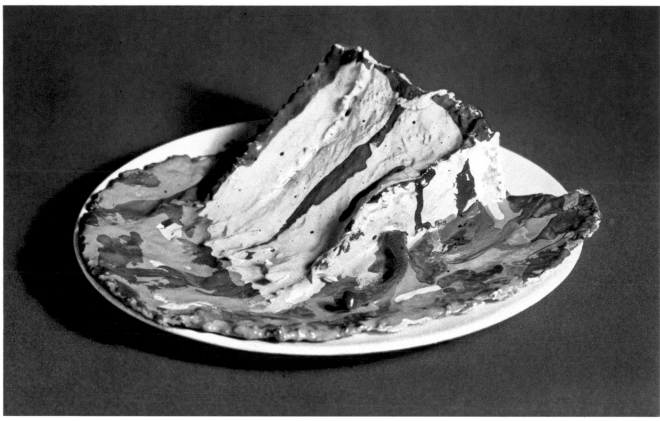

Pie à la mode. 1962
Muslin soaked in plaster over wire frame,
11¹/₂ inches high x 21 inches wide x 19 inches deep
Collection Dr. Panza di Biumo, Milan

Slice of Birthday Cake with Pink Candle. 1963
Burlap soaked in plaster, painted with enamel,
on porcelain plate
Collection Mrs. France Raysse, New York

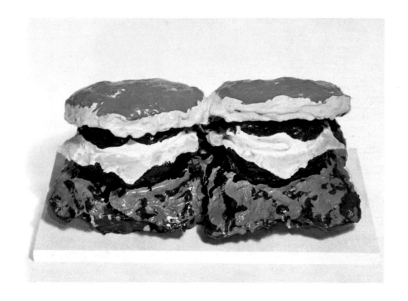

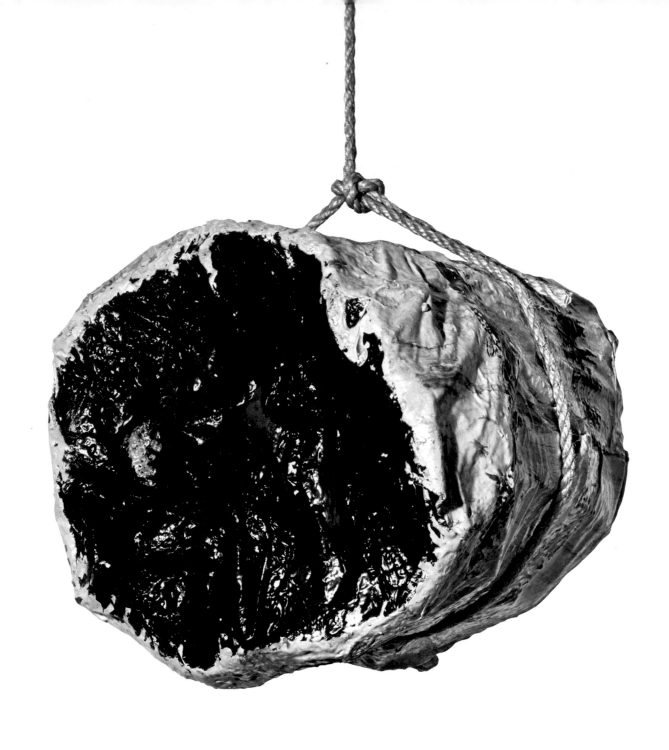

above:
Two Cheeseburgers, with Everything (Dual Hamburgers). 1962
Burlap soaked in plaster, painted with enamel,
7 inches high x 14³/₄ inches wide x 8⁵/₈ inches deep.
From an advertisement.
The Museum of Modern Art, New York
(Philip Johnson Fund, 1962)

right:
Roast. 1961
Muslin soaked in plaster over wire frame, painted with enamel,
14 inches high x 17 inches wide x 16 inches deep
Collection Dr. and Mrs. Billy Klüver,
Berkeley Heights, New Jersey

Open Tin of Anchovies
(Sardine Can with 2 Sardines on Paper Bag). 1961
Burlap and muslin soaked in plaster, painted with enamel,
2¹/₂ inches high x 14 inches wide x 10 inches deep
Collection Mrs. Claes Oldenburg, New York

Toy Biplane. 1963
Burlap soaked in plaster over wire frame, painted with enamel,
4 inches high, on painted wood disc, 10¹/₂ inches diameter
Collection Jonathan D. Scull, New York

Ice-Cream Cone and Heel
(fragment of two signs combined). 1961
Muslin soaked in plaster over wire frame, painted with enamel
Collection Charles Carpenter, New Canaan, Connecticut

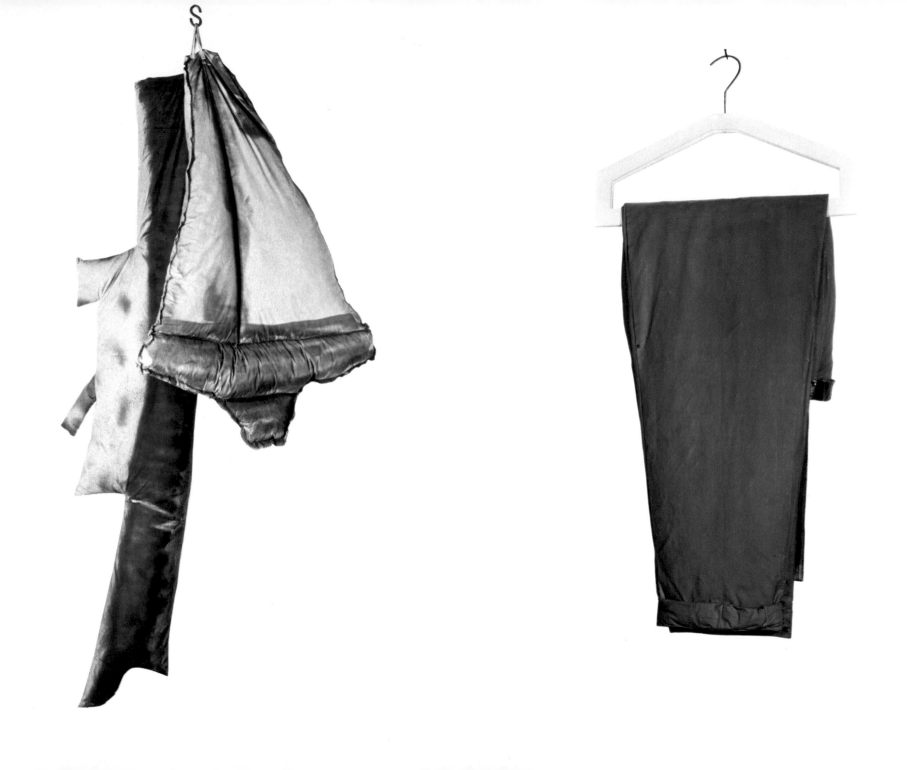

opposite, left:
Freighter and Sailboat. 1962
Muslin filled with shredded foam rubber,
painted with spray enamel,
72 inches high x 28 inches wide x 12 inches deep
Made as a prop for Store Days, II.
Owned by the artist

opposite, right:
Giant Blue Men's Pants. 1962
Canvas filled with shredded foam rubber,
painted with Liquitex and latex,
60 inches high x 28$\frac{1}{8}$ inches wide x 6$\frac{1}{4}$ inches deep
Collection William W. Harris, San Francisco

left:
Soft Fur Good Humors. 1963
Fake fur filled with kapok; wood painted with enamel,
4 units, each 19 inches high x 9$\frac{1}{2}$ inches wide x 2 inches deep
Irving Blum Gallery, Los Angeles

above:
Eclair et saucisson (two food shapes on a plate). 1964
Poured plaster and plaster formed in metal foil,
painted with casein, on porcelain plate
Collection Mrs. Claes Oldenburg, New York

center:
Saumon avec mayonnaise. 1964
Plaster poured over eggshells, formed in cardboard,
painted with casein, on porcelain plate
Collection Mr. and Mrs. Robert C. Scull, New York

right:
Oeufs "Vulcania." 1964
Plaster formed in corrugated cardboard over eggshells,
painted with tempera, on plate,
4 inches high x 11¼ inches diameter
Collection David Whitney, New York

opposite, left:
Pastry Case, I. 1962
Burlap soaked in plaster painted in enamel; plates;
in glass and metal showcase,
20¾ inches high x 30⅛ inches wide x 14¾ inches deep
The Museum of Modern Art, New York
(The Sidney and Harriet Janis Collection)

opposite, right above:
Glass Case with Pies (Assorted Pies in a Case). 1962
Burlap soaked in plaster and formed in 6 pie tins,
in glass and metal case,
18¾ high x 12¼ inches wide x 10⅞ inches deep
Collection Mr. and Mrs. Leo Castelli, New York

opposite, right below:
Pastry Case with Sundaes, Bananas, Baked Potatoes
(in process of being consumed). 1965
Muslin and burlap soaked in plaster, painted with enamel,
in glass and wood case,
30 inches high x 36 inches wide x 14 inches deep
Collection Mr. and Mrs. Frederick R. Weisman, Los Angeles

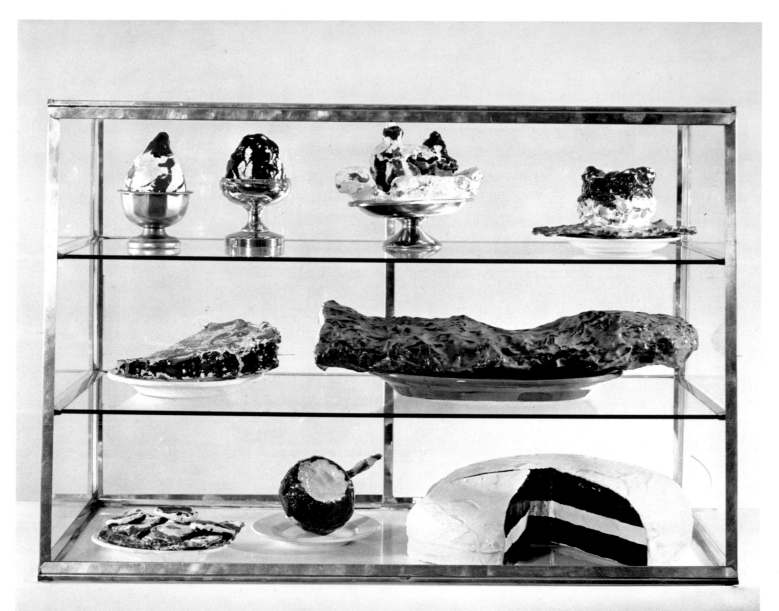

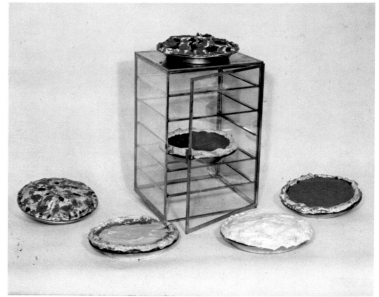

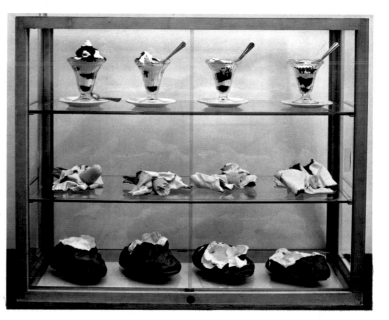

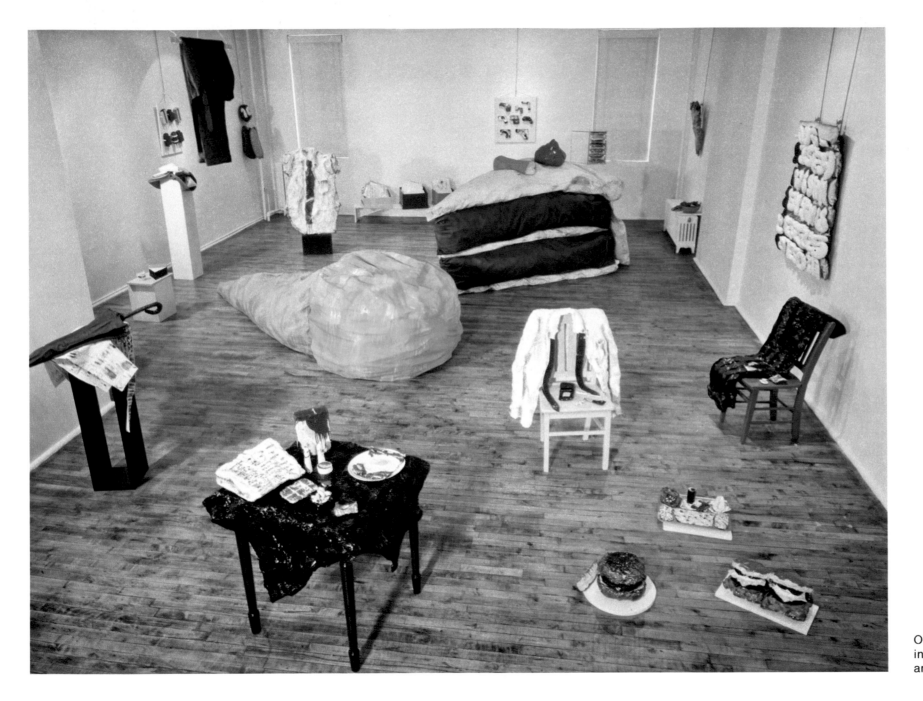

One-man show at the Green Gallery, Fall 1962,
including pieces from The Store
and the first large-scale ''soft'' sculptures

The Soft Machines

There is technology as a medium, and technology as material. The first is easy to understand—to supply the traditional product, for example, TV or films, the execution a matter for the technical specialists.

Technology as material is a more subtle question, and one which involves of course the intimate relationship of technician and artist.

I am a technological liar.

Claes Oldenburg, notebooks, 1966

Any new environment usually calls forth a new response from Oldenburg. Once he had decided to recreate The Store uptown in the Green Gallery, located on Fifty-seventh Street, the heart of "establishment" art, he had to face the problem that the intimate plaster objects of the Second Street Store could not adequately fill the gallery space. Scale in The Store had been mixed, but the largest relief was no more than roughly three feet square. Walking along Fifty-seventh Street, Oldenburg admired the way in which automobiles filled a showroom of about the same size as the Green Gallery, and he decided to enlarge The Store objects to the size of cars to fill the gallery impressively.

The change in scale was an expression of the change in Ray Gun's fortunes. A modest, poor man's art was to be transformed into something more grandiose and more in keeping with America's new affluence, which had brought with it the emergence of a newly rich patron group, attracted to Pop Art and eager to support it. "Where do I stand in relation to the other great elaborate and costly things going on in New York?" Oldenburg asked himself in 1960; now he determined to work larger. Reviewing the showing of The Store objects at the Green Gallery, which included the *Giant Ice-Cream Cone*, the *Floor-Burger*, the *Floor-Cake*, and *Giant Blue Men's Pants*, among the first of Oldenburg's "soft" sculptures, Sidney Tillim noted that The Store had given way to progress, and that the clothes were of better grade. "Blue collar has turned to white," Tillim wryly observed.[1]

p.90
pp.142, 152,86

The sensation produced among the public when Oldenburg's dramatic, large-scale works were shown at the Green Gallery in the fall of 1962 was among the first manifestations of the international success of Pop Art. This public response and the reviews in effect represented an initial explosion of Pop, heretofore more or less of a downtown phenomenon related to certain scavenging aspects of the art of assemblage.[2] No longer an underground cultural movement, Pop Art now became a chic uptown commodity, eagerly consumed by dealers, collectors, and ultimately the jet set and the mass media. Much of the critical controversy generated by Pop was touched off by this showing of Oldenburg's first soft sculpture, whose large scale, brashness, and outright vulgarity made it impossible to ignore. The commercial success of the show was just about matched by the disapproval of establishment critics such as Clement Greenberg, who saw Pop Art as merely "a new episode in the history of taste";[3] Harold Rosenberg, who viewed it as a capitulation to the evils of philistine mass culture;[4] and Peter Selz, who condemned it not only on aesthetic but also on moral grounds. For Selz, Pop Art displayed "want of imagination, ... passive acceptance of things as they are," and thereby demonstrated the "profound cowardice...limpness and fearfulness of people who cannot come to grips with the times they live in":

"A critical examination of ourselves and the world we inhabit is no longer hip: let us, rather, rejoice in the Great American Dream. The striking abundance of food offered us by this art is suggestive. Pies, ice cream sodas, coke, hamburgers...—often triple life size—would seem to cater to infantile personalities capable only of ingesting, not of digesting or interpreting. Moreover, the blatant Americanism of the subject matter...may be seen as a willful regression to parochial sources just when American painting had at last entered the mainstream of world art... [Pop Art] is as easy to consume as it is to produce and, better yet, is easy to market, because it is loud, it is clean, and you can be fashionable and at the same time know what you're looking at. Eager collectors, shrewd dealers, clever publicists, and jazzy museum curators, fearful of being left with the rear guard, have introduced the great American device of obsolescence into the art world."[5]

Fortunately, Oldenburg had anticipated both the show's commercial success and the critical disapproval. Rather than fall into the arms of an eager public ready to embrace him, he fled New York, beginning a series of cross-country and intercontinental jaunts that still keep him on the move and force him to make contact

with many new environments. Typically, in each milieu he adjusts to local conditions and uses what he finds there. The process of constant adaptation to new places causes Oldenburg to emulate the general life style of our increasingly mobile culture. In each locale, he creates works that reflect the particular quality of the environment: for example, the plaster French pastries that he produced in Paris in 1964 are objects *p.88* whose delicacy and refinement puzzled some who had just seen his large-scale soft sculpture in New York.

In his notes, Oldenburg observes that summers are critical periods for him. The summer of 1963 was more critical than most: "I experienced a revulsion against my situation in New York, hating my Store (my studio and theater since 1961) on Second Street, my apartment, my body, my wife, everything," he complained. Having destroyed most of the work done during the months of May and June, he decided to move to the West Coast to gain fresh perspective. He left his former New York studio and moved his possessions to another at 48 Howard Street.

After renting a studio in Venice, California, a suburb of Los Angeles, Oldenburg remained there from September 1963 until March of the following year. As he prowled through surplus-goods stores looking for new materials, he found vinyl available in quantity. This inspired him to begin a new series of works related to the theme of The Home—a theme which he was to develop for several years, in objects such as *Four Dormeyer Mixers, Model ("Ghost") Toilet, Soft* *p.15* *Toilet, Soft Washstand,* and *Soft Bathtub.* The *Bedroom Ensemble,* executed in November–December 1963, was the largest and most complex of this series. It involved Oldenburg in his first collaboration with commercial fabrication and so became, if only remotely, the first realization of a "technological" theme in his works. Up to this time, he had thought of "production" solely in terms of the cottage industry of the home; paradoxically, the *Bedroom Ensemble,* the major creation of his Home period, was fabricated by outside technicians and specialists.

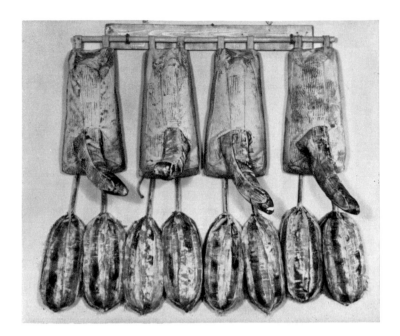

Four Soft Dormeyer Mixers—"Ghost" Version
(Model "Ghost" Mixers). 1965
Canvas filled with kapok, impressed with patterns
in sprayed enamel, wood (variable)
36 inches high x 36 inches wide x 24 inches deep
Collection Mr. and Mrs. Eugene M. Schwartz, New York

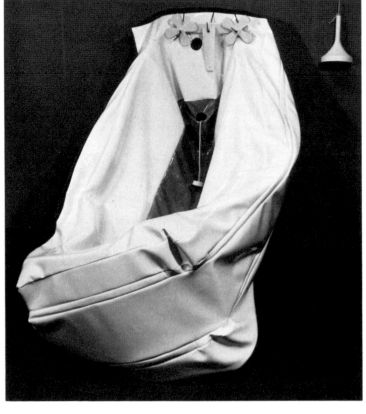

above:
Soft Bathtub. 1966
Vinyl, polyurethane sheets, wood, painted with Liquitex,
rubber shower fixture;
30 inches high x 80 inches wide x 30 inches deep
Collection Mr. and Mrs. Roger Davidson, Toronto

opposite:
Soft Washstand. 1966
Vinyl filled with kapok, wood, painted with Liquitex,
on chromed metal rack,
55 inches high x 36 inches wide x 28 inches deep
Collection Dr. Hubert Peeters, Bruges

Finding the blatantly fake animal skins of synthetic fiber, discovering the possibilities of vinyl, and meeting an accomplished upholsterer and a trustworthy carpenter all combined with the impact of Los Angeles motel culture as inspirations for Oldenburg's bedroom. According to his notes, its original prototype was a famous motel along the shore road to Malibu, which he had seen on a trip to the West Coast in 1947; each suite was decorated in keeping with a *Playboy* safari fantasy, with the skin of a particular animal—tiger, leopard, zebra. The impression this made was augmented by fantasies regarding his mother's dressing table, or dressing tables in general. He has defended the choice of a theme based on childhood associations on the basis that "going back in time is not sentimental or 'camp,'" but is necessary to find "a subject one 'knows' enough about emotionally" to which a "sufficient number of workable fantasies" cling.

The *Bedroom Ensemble* was conceived as a single *pp.94–95* environment or tableau. Once again, none of the seemingly useful articles it contains functions properly: the bed is hard, the mirror distorts, the drawers do not open. An object that doesn't function provokes the same kind of humor as a human being who tries to do something of which he is obviously incapable. But the *Bedroom* is not only a hilarious spoof on motel "moderne," it is also serious sculpture. The pieces were simplified into geometric solids and built on an angle—an idea inspired by ads in the *Los Angeles Times* that showed blocky shapes in exaggerated foreshortening. As a result, perspective becomes both actual and contradictory; from one point of view, the pieces appear excessively long, from another, very short, depending on the viewer's position. Constructed according to the rules of single-vanishing-point perspective, but optically distorted, these objects represent Oldenburg's literal rendering of yet one more pictorial element—perspective—and its translation into a three-dimensional equivalent.

The pieces for the *Bedroom Ensemble* were executed in the new enlarged scale that Oldenburg had adopted for his first soft sculptures at the Green Gallery show. This change in scale may be thought of as having historical and psychological significance as well as purely formal meaning. The increase in scale comes about as the artist gains acceptance and feels surer of himself and his role. From 1962 on, even food was to take on mammoth proportions in his work (e.g., the *Floor-Burger*, 1962; *Raisin Bread*, 1967). This *p.142* gigantism also coincides with the adoption of a new scale in the architecture of New York, signaled by the erection of the Seagram Building in 1958 and realized in subsequent superskyscrapers, such as the Pan Am Building and the World Trade Center projected for downtown Manhattan.[6]

With the *Bedroom Ensemble*, Oldenburg began to be concerned with the notion of style per se, divorced from any historical context. "The style I am concerned with in these works from Los Angeles is the style of manufacturing and production," he wrote, "a rehearsal of machine style, affecting not only the image or object produced but the method of producing it. Involving others, involving technicians, visits to industries, having parts made. The style of manufacturing abstracted into production of art." The mechanical appearance of Oldenburg's forms was still further emphasized by his use of the false, literal foreshortening; and the drawings that he made for the carpenter who fabricated the imitation motel interior were the first of his pure line drawings in a geometric, "technical" style.

In Los Angeles, as he planned for the showing of the *Bedroom Ensemble* in New York in January 1964, Oldenburg carefully calculated its installation in relation to the actual environment of the gallery: "The Bedroom Ensemble had to have the vaultlike presence of the front room of the Sidney Janis Gallery. What was already there was in mind 3000 miles away: the airconditioner, the blinds that shut out the light, and the mysterious door marked *private*, as I plotted the room on my floor in the stucco replica of St. Mark's in our phony Venice." This attention to context, a distinguishing characteristic of the environmental art of

the 'sixties, is especially marked with regard to the *Bedroom Ensemble*. Oldenburg, who believed that this tableau would "always carry with it those first surroundings, of which succeeding situations will be an abstraction," made such associations literal by his reconstructions of the *Bedroom Ensemble* in London and New York in 1969, when he re-created to the last detail the gallery room in which it had been seen originally.[7]

The hard geometric volumes and coldness of the *Bedroom Ensemble* were in direct opposition to Oldenburg's previous work. "To friends who expressed disappointment at this radical change in direction," Oldenburg wrote, "I said that just because one finds one thing beautiful at one time (always in time), say the poisonous botany of the Lower East Side, doesn't mean one can't at another time love its opposite, say the cemeteries of formica strewn in the opium mists on the western shores."

In March 1964, the Oldenburgs bought a station wagon and drove back to New York for a one-man show, also at the Sidney Janis Gallery, which consisted of soft objects for The Home. After having deliberately uprooted themselves for eight months, they returned as exiles and lived for a time in that mecca for homeless artists, the Chelsea Hotel on West Twenty-third Street. "By our mysterious absence, we left only bubbles where we sank out of sight in the Pop Art wave," Oldenburg reminisces. In May, with their memories of the neon-and-stucco Venice still fresh, they sailed on the *Vulcania* for the marble-and-mosaic Venice, where Oldenburg was to be one of eight artists represented that summer in the United States exhibition at the XXXII Biennale. The acuteness of the contrast between California and Italy could not help but strike Oldenburg, who began to consider technological equivalents of classical themes, for instance a "soft Venus."

Most of the remainder of that year was spent in various cities in Italy, France, and the Netherlands. In Paris, for a one-man show at the Ileana Sonnabend gallery in October, Oldenburg made mainly plaster pieces of food, such as *Oeufs "Vulcania"* and *Glace en* *p.88*

below and opposite, below:
Bedroom Ensemble (as installed
at the Sidney Janis Gallery, 1964). 1963
Wood, vinyl, metal, fake fur, and other materials
in room 17 x 21 feet
Owned by the artist

opposite, above:
Miniature models of furniture for Bedroom Ensemble. 1963
Balsawood and paper, painted with Liquitex,
sprayed with enamel.
Clipping of leopard coat, red chair with pillow
Owned by the artist
Sofa and table
Collection Robert Zimmerman, New York

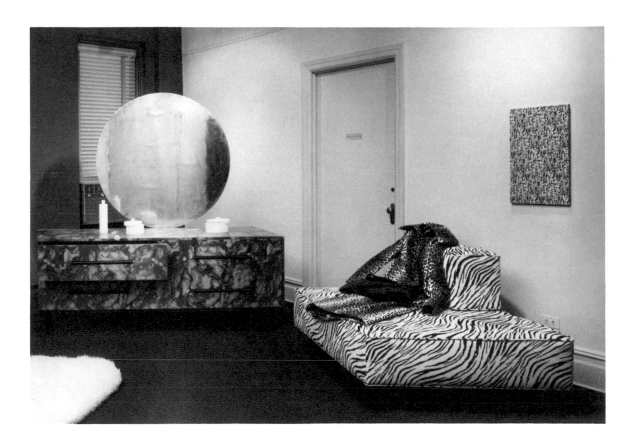

top:
Study of Bed with Bed Tables, for Bedroom Ensemble. 1963
Chalk and spray enamel, 26¹/₄ × 41 inches
Collection Dr. Hubert Peeters, Bruges

bottom:
Study for Zebra Chair, for Bedroom Ensemble. 1963
Chalk and watercolor, 26¹/₄ x 41 inches
Collection John and Kimiko Powers, Aspen, Colorado

dégustation. Their delicate character and emphasis on fine detail is in keeping with the European experience, as is the fact that they are painted in tempera and casein rather than house-paint enamel. Before returning to the United States, Oldenburg spent two weeks in Rome, where he had been commissioned by De Laurentiis to work with Antonioni on a film episode; but after he had executed a number of sketches, the project was canceled.

Back in New York, Oldenburg again lived for a while at the Chelsea Hotel and continued to occupy the studio on Howard Street, until he moved to a new studio at 404 East Fourteenth Street in April 1965. But his thoughts focused once more on the motel-and-car culture of Los Angeles, which despite his intervening experience abroad still remained a vivid memory. Commissioned by *Art News* to make a cover for one of its issues, Oldenburg decided to make a drawing that would not only allude to a three-dimensional object but that could actually be cut out and assembled into a box. Having fixed on a horizontal rectangular shape, he selected a car as the image that would be best suited to the format.

Cars had many associations for Oldenburg. It will be remembered that one of his favorite toys as a child had been a maroon model Airflow. While working on drawings and sketches for The Street, he had drawn cars and fashioned several cutout automobiles, which seemed to him an integral part of the street's general violence. In 1963, during his sojourn in Los Angeles—a city in which the automobile is ubiquitous —he had created *Autobodys,* a kind of drive-in hap- *p. 185* pening in which the spectators participated by providing illumination with their cars' headlights.

The Airflow, on which Oldenburg embarked in the autumn of 1965, is related to the theme of the bedroom, but in many respects it represents a second, West Coast incarnation of Ray Gun. The automobile, like Ray Gun, is primarily a surrogate for the human body. Like Ray Gun, it too is a man-made image of potential destruction, rendered harmless by the artist, who tames or mollifies technology by inventing a soft car that cannot kill. And, like Ray Gun, the Airflow was conceived as a magic talisman that would protect the artist himself from destruction. (Pollock's death in an automobile accident had impressed Oldenburg with the danger of man's invented technological "extensions," from which even the artist was not safe.)

The evolution of the Airflow followed Oldenburg's characteristic pattern of semi-automatic creation. It was an organic process based on memories, accumulated information, and superimposed images, all of which were ingested, assimilated, and finally compressed into a series of forms—the synthesis of the digested material. Once Oldenburg had decided to focus on the machine (a theme with which he had been concerned since his early drawings of plants meta- *p. 22* morphosed into machines), the automobile, the machine with which man has most intimate contact— virtually his "shell," or second skin, as Oldenburg points out—was a natural choice.

The Airflow developed in a way that virtually constitutes a paradigm of Oldenburg's creative process. Motivated by a necessity of the moment (the commission for the *Art News* cover), elaborated through the method of free association, manipulated through a number of increasingly bizarre metamorphoses, the Airflow is an open-ended theme that has specific associations for Oldenburg with the destructive aspects of technology. The Airflow is also the essential prototype of his whole series of "soft machines," including the giant fans and drainpipes produced between 1965 *pp. 134, 135, 173* and 1968. By softening the hard, metallic forms of modern manufactured goods, the artist makes technology human and vulnerable. Since Oldenburg tends to use images and associations that are closest to him, it was also predictable that the car he chose should be the Chrysler Airflow, which had been designed in 1935 by Carl Breer, the father of Oldenburg's good friend, the sculptor and film-maker Robert Breer. Still another reason for the choice was that the Airflow was both a typical model as well as a standard, stylistically

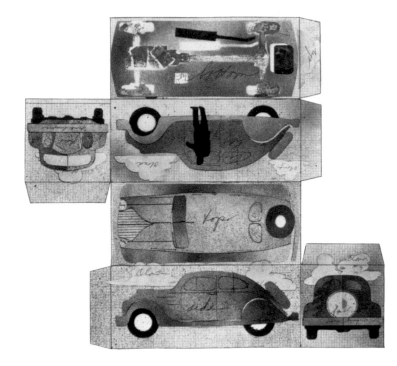

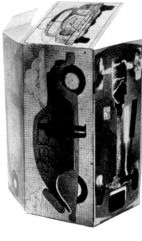

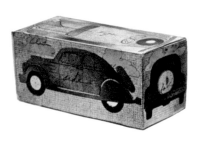

"modern" design; over thirty years old, it bears the same relationship to outmoded mechanical objects as do Oldenburg's toaster, mixer, telephone, and typewriter. Like his other soft machines, it also relates to the images in the scrapbook collages made for him by *p.20* his aunt when he was a child. Oldenburg deliberately wished to choose a "subject far enough away to be on the verge of disappearing from function into archetype, like the Switches and Plugs." The point was "to press style upon mere function." Beyond its associations with technology, the Airflow was considered by Oldenburg, newly arrived from a sojourn in Europe, as a metaphor for the Winged Victory, because of its associations with flight. (He had been told that it was named "Airflow" because Carl Breer had based its streamlined, winglike parts on birds in flight.) In a sense, the Airflow was Oldenburg's answer to the question of what a contemporary artist could conceive that would have as great an iconic impact as the Winged Victory had for the Greeks.

Oldenburg was, of course, not the first to see the automobile, with its power as well as its capacity for destruction, as a symbol of the American spirit. The concept has had many expressions both in art and in literature. In his study of Walt Whitman (one of Oldenburg's principal literary inspirations), D. H. Lawrence envisioned Whitman as a man in a car, leading the country to find its democratic identity in "oneness" and "allness." This passage from Lawrence's essay, one of Oldenburg's favorites, has particular relevance to his choice of the Airflow as subject:
"He was everything
and everything was in him. He drove an automobile with a very fierce headlight, along the track of a fixed idea through the darkness of this world. And he saw Everything that way. Just as a motorist does in the night.

"I, who happen to be asleep under the bushes in the dark, hoping a snake won't crawl into my neck; I, seeing Walt go by in his great fierce poetic machine, think to myself: What a funny world that fellow sees!

opposite, above:
Cut-out Airflow: Drawing for cover of Art News ("The Airflow—Top and Bottom, Front, Back and Sides, with Silhouette of the Inventor, To Be Folded into a Box"). 1965 Collage, pen and ink, spray enamel, 17 x 17¾ inches Collection Mr. and Mrs. Max Wasserman, Chestnut Hills, Massachusetts

opposite, below:
Cut-out Airflow, from cover of Art News, February 1966 (shown cut out and assembled)
Photo-printed drawing

below, left:
Soft Airflow—Scale 1 (model). 1965
Canvas filled with kapok,
impressed with patterns in sprayed enamel,
15 inches high x 22 inches wide x 12 inches deep
Collection Mr. and Mrs. Arnold B. Glimcher, New York

below:
Soft Airflow—Scale 1. 1965
Vinyl filled with kapok, details in plexiglass,
15 inches high x 22 inches wide x 12 inches deep
Collection Mr. and Mrs. Joseph A. Helman, St. Louis

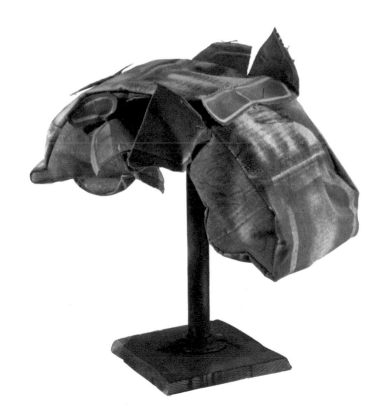

above:
Radiator for Airflow—Scale 5 (hard model). 1965
Cardboard, impressed with patterns
in sprayed enamel, shellacked,
32 inches high x 24 inches wide x 18 inches deep
Karl Ströher Collection, 1968, Darmstadt

right:
Soft Airflow—Scale 2 (model). 1966
Canvas filled with kapok,
impressed with patterns in sprayed enamel;
42¼ inches high x 25¾ inches long x 13 inches deep over-all
Harry N. Abrams Family Collection, New York

Radiator and Fan for Airflow—Scale 5 (soft model)
(Soft Engine Parts, I). 1965
Canvas filled with kapok,
impressed with patterns in sprayed enamel,
32 inches high x 24 inches wide x 18 inches deep
Collection Mr. and Mrs. Marvin Goodman, Toronto
98 (Barbara Goodman Trust, Stephen Goodman Trust)

"ONE DIRECTION! toots Walt in the car, whizzing along it.

"Whereas there are myriads of ways in the dark, not to mention trackless wildernesses. As anyone will know who cares to come off the road, even the Open Road.

"ONE DIRECTION! whoops America, and sets off also in an automobile.

"ALLNESS! shrieks Walt at a cross-road, going whizz over an unwary Red Indian.

"ONE IDENTITY! chants democratic En Masse, pelting behind in motorcars, oblivious of the corpses under the wheels.

"God save me, I feel like creeping down a rabbit-hole, to get away from all these automobiles rushing down the ONE IDENTITY track to the goal of ALLNESS!"[8]

Thus the Airflow, like The Street, The Store, and the Bedroom, represents Oldenburg's critique of certain aspects of American culture.

The Airflow has proved to be the most problematic project ever undertaken by Oldenburg. The first giant vinyl Airflow on which he expended such effort is still unfinished in his studio, a partial wreck. The birth image so prevalent in his work is particularly evident in his attitude toward the Airflow. "My car, which is a long time in coming," he wrote in his notebooks, "which even when it's here, when I've begun it, is a long time in coming. It seems probably the deepest most natural subject I've had."

Beginning work on the Airflow, the most common icon and "sculpture" produced by a technological civilization, involved stuffing a box full of random scribblings and sketchings, acquiring from Robert Breer a group of photos showing various views taken at the annual meetings of Airflow owners, and making a trip to Detroit to visit Carl Breer. While there, Oldenburg saw and had photographed old models and drawings, as well as an original Airflow. As soon as he had seized on the Airflow motif, he began to think of it in terms of an environment, as "a gallery, a store—with many objects in it."

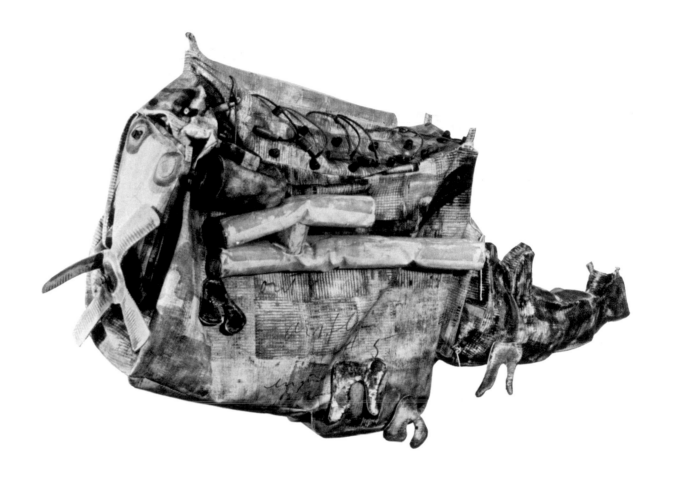

Soft Engine for Airflow, with Fan and Transmission—Scale 5 (model). 1966
Canvas filled with kapok, impressed with patterns in sprayed enamel; details in wood, rope, 53¹/₈ inches high x 71⁷/₈ inches long x 17³/₄ inches deep
Collection Dr. Hubert Peeters, Bruges

Although the Airflow, like some of his first soft sculptures, such as the *Giant Ice-Cream Cone,* was a metaphor for the body, Oldenburg approached this subject in a different, more disinterested fashion, not as a portraitist but rather with the scientific detachment of an anatomist. With the exception of the small red vinyl Airflow, its "ghost" version, and the Gemini multiple, all the finished pieces on this theme represent cross sections, parts, or the "internal organs" of the car. The dissection that he performed with the help of detailed photographs and drawings—X-rays, in a sense—caused him to think of "The car as body, flayed, as in an anatomical chart. Cloth as sheet of tissue, rope as muscle."

"Of the doubles man has made of himself," Oldenburg wrote subsequently, "the car (in Swedish, *karl* is guy—autobody) is the most ever-present, competitive and dangerous. Also the one which most naively represents man. Our robot. The most notably different fact about this robot, which is always greedy to occupy our space, with whom we share almost equally our space in a game of chance and watchfulness, is the hardness of its flesh, its relative invulnerability." He was particularly conscious of the internal organs and skeleton because in the summer of 1965, when the Airflow was conceived, he went on a diet "as a method of becoming aware of my body's internal parts."

The Airflow, therefore, is an extremely intimate theme, the closest to the artist's own body image since Ray Gun. Like Ray Gun, the car is both double and enemy, with equal potential for pleasure and destruction. "Only our robots, our machine armor still goes hard," Oldenburg observed. "The distinction in technology I am told is software/hardware. A softening is not a blurring, like the effect of atmosphere on hard forms, but *in fact* a softening, in a clear strong light. The perception one might say of mechanical nature as body." In keeping with the emphasis on softening, what is stressed in the Airflow pieces, most of which are made of stenciled canvas, is the effect of chiaroscuro, applied redundantly and ironically to a surface

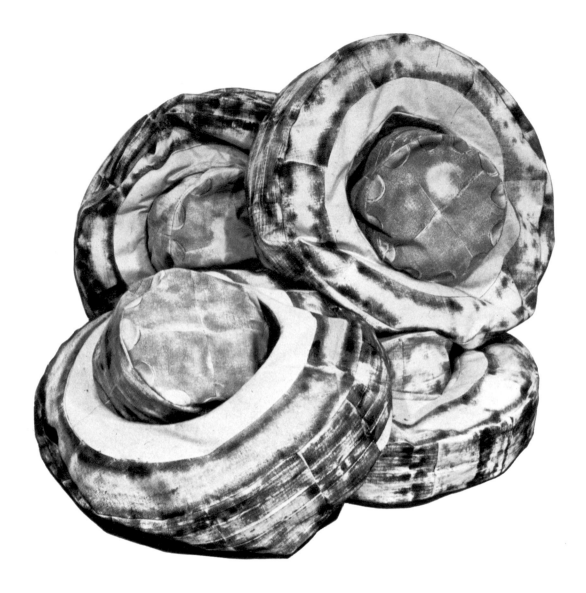

Soft Tires for Airflow—Scale 5 (model). 1965
Canvas filled with kapok, impressed with patterns in sprayed enamel;
4 tires: 30 inches diameter each
Collection Mr. and Mrs. Horace H. Solomon, New York

100

that is already actually, not merely pictorially, three-dimensional.

The Airflow is a transitional theme. It is the culmination of the mechanical objects in The Home and an extension of the flirtation with technology begun with the *Bedroom Ensemble*. It is also a metaphorical means of leaving the home for the factory, Oldenburg's most recent milieu for investigation. After having been abandoned for three years, the Airflow was resumed in 1968, and appropriately again in Los Angeles, when Oldenburg was searching for a fitting theme for a new venture in lithography to be undertaken with Gemini G.E.L. His subsequent creation of an Airflow multiple in molded plastic, also in association with Gemini, has brought the Airflow to its logical dénouement as motif: from a kind of parody of assembly-line techniques and an icon of technology, it has ultimately become a truly mass-produced object, industrially fabricated, with the advanced technology required to create a molded-plastic multiple.

p.166

Since 1967, Oldenburg has become increasingly involved with technology, not as a theme but as a medium. Working with commercial fabricators, he has realized several projects in metal, such as the *Giant Saw*, which emphasize the unyieldingness of technology in actuality, in contrast to its imaginative transformation into soft machines. Along with this interest in technology has come an increased awareness of communications and their use as an art medium, instanced by the devolution of happenings from a theater of action to a pure form of media communication published by a magazine for mass circulation, instead of being performed in the presence of only a few viewers.[9] Context and documentation, the accumulation of information and its effect on the meaning and status of a work of art, have also recently become preoccupations for Oldenburg.[10] Attached to the Airflow itself is a mass of documents—notes, photographs, drawings, and so forth.

p.126

The Airflow, a contemporary icon, a car with "wings," represents for Oldenburg yet another play on the opposition between the banalities of the American experience and the heroic classical tradition. In a sense, it was the discrepancy between Venice, California, with its phony St. Mark's, and Venice, Italy, with its glorious past, that gave birth to the Airflow: a modern "antique," which has been excavated, reconstructed, and resurrected by Oldenburg as archaeologist of the present.

NOTES

1. "Month in Review," *Arts* (New York), November 1962, pp. 36–38.

2. The term "Pop Art" was first used in the mid-'fifties by the British critic Lawrence Alloway, together with "Pop Culture," with reference to the products of the mass media; it shortly after gained currency to describe the work coming out of the milieu of the IG (Independent Group) and the Royal College of Art in London. It characterized an affirmative attitude toward contemporary popular culture and the mass media among such English artists and critics as Richard Hamilton and Reyner Banham, and later Allen Jones and Richard Smith. In the United States, when the work of Johns and Rauschenberg depicting or incorporating popular images was first shown in New York in the 'fifties, it was dubbed "neo-Dada." By the time that artists such as Warhol, Lichtenstein, and Oldenburg were using this type of image in their work, however, their art was labeled "Pop." Comic strips, ads, posters, and billboards were among the sources used. Most of the "Pop" artists adapted not only the imagery but also the techniques of commercial and applied art. In this respect, Oldenburg differed totally from them, for while he cultivated a vulgar *style*, his *execution* was clearly part of the "fine art" tradition.

3. "...as diverting as Pop art is, I happen not to find it really fresh. Nor does it really challenge taste on more than a superficial level. So far... it amounts to a new episode in the history of taste, but not to an authentically new episode in the evolution of contemporary art" (in catalogue of the exhibition "Post Painterly Abstraction," Los Angeles County Museum of Art, April 23–June 7, 1964).

4. "The Game of Illusion," *The New Yorker*, November 24, 1962, pp. 161–167 (review of "New Realists" exhibition at Sidney Janis); reprinted, with revisions, in *The Anxious Object* (New York: Horizon Press, 1964), pp. 60–75.

5. "Pop Goes the Artist," *Partisan Review* (New York), Fall 1963, pp. 315, 316.

6. Oldenburg's use of the inflated image—an object blown up to room-size proportion, the better to disorient the viewer—has among its antecedents such paintings as Magritte's *The Listening Chamber*, 1953 (William N. Copley Collection), which portrays a gigantic apple, or his *Personal Values*, 1952 (J. A. Goris Collection, Brussels), in which toilet articles are enlarged to monumental scale. Oldenburg must have been familiar with such images, as he undoubtedly was with Dali's soft watches (e.g. *The Persistence of Memory*, 1931, The Museum of Modern Art; see p. 143, n. 2).

Oldenburg's ties to Surrealism are minimal, if indeed they exist at all; he is certainly not concerned with Dali's otherworld dream imagery and hallucinations. He is perhaps closer to Magritte's intention of questioning the nature of one's perception of reality, offering a distorted, askew version of the world that, like all works in the tradition of satiric genre, immediately proclaims "something is wrong here."

Other Pop artists, Wesselmann, Lichtenstein, and Rosenquist among them, have made liberal use of the closeup or blowup; but Oldenburg is not involved, as in a sense they are, in a photographic or illustrational concept. Whereas they *depict* the object pictorially, Oldenburg *represents* it sculpturally. All these instances of giant images, however, may—like the large

101

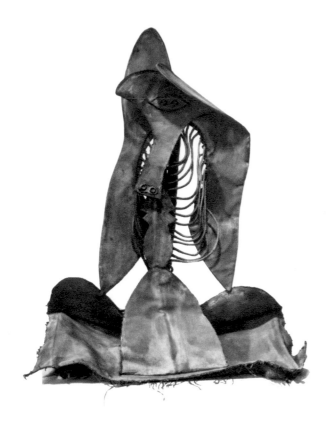

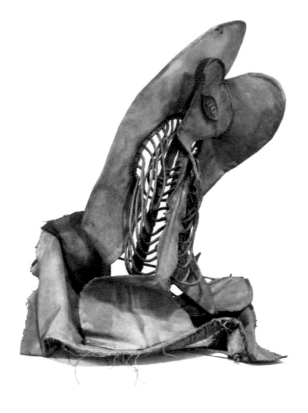

scale of recent American art in general—be seen as part of the American impulse toward bigness, expansion, power, and impact.

The change in scale in Oldenburg's work also has immediate analogies with the enlargement of scale in the paintings of such abstractionists as Frankenthaler, Noland, Olitski, Poons, and Stella in the mid-'sixties, which was made possible by the availability of imported canvases wider than the previous standard dimensions.

7. For the "Pop Art" show, Hayward Gallery, London, July 9–September 3, 1969 and his Museum of Modern Art retrospective.

8. *Studies in Classic American Literature* (New York: Thomas Seltzer, copyright 1923, renewed 1951 by Frieda Lawrence. All rights reserved. Reprinted by permission of The Viking Press, Inc.), pp. 247–248.

9. Commissioned by *Esquire* to write the script for a happening, Oldenburg decided to eliminate any actual performance and let publication of the piece stand for the happening itself ("My Very Last Happening: The Typewriter," *Esquire* [Chicago], May 1969, pp. 154–157).

10. Incited by the fact that the city of Chicago had copyrighted the giant Picasso sculpture in the Civic Center and was selling reproductions of it, William N. Copley and Barnet Hodes commissioned Oldenburg to create a soft version of the original steel maquette in The Art Institute, which could be used in a suit challenging the city's copyright of the original. Citing Picasso's deed of gift for the maquette as its authorization, the city has filed countersuit. The relevant documents in the case Oldenburg regards as part of his soft version.

Soft Version of Maquette for a Monument Donated to the City of Chicago by Pablo Picasso. 1969
Canvas, rope, painted with Liquitex;
variable, 38 inches high (adjusted to full height) x 28³/₄ inches wide x 21 inches deep

William N. Copley Collection, New York (© Letter Edged in Black Press Inc.)

The Public Image

"You may be sure that I have employed a native architect for the large residential structure that I am erecting on the banks of the Ohio.... In a tasteful home surrounded by the memorials of my wanderings, I hope to recover my moral tone. I ordered in Paris the complete appurtenances of a dining-room. Do you think you could do something for my library? It is to be filled with well-selected authors, and I think a pure white image in this style"—pointing to one of Roderick's statues—"standing out against the morocco and gilt, would have a noble effect. The subject I have already fixed upon. I desire an allegorical representation of Culture."

Henry James, *Roderick Hudson*

Civic improvement, plazas, malls, centers, ports, projects, projects, projects. Got two heads full! Cut the folks up, cut up the plain folks, trim em like trees, saw em to size, make bricks of em, beams, pile em up, seal em to each other by their juices. Build Build Bld.

Don't forget the statues, says Doc. Oh yeah, bulls and greeks and lots of nekkid broads.

Claes Oldenburg, "A Card from Doc," 1960

From 1965 on, international success and a steady stream of publicity kept Oldenburg in the spotlight, and he came to think of himself as a public figure. In keeping with his new status as an artist of world renown, he began to project his image beyond the gallery, and even beyond the museum, appropriating to his purposes the totality of his environment. The principal vehicle for his public art has been the numerous drawings and projects for imaginary monuments that have engaged his attention since 1965. Just as he had enlarged the scale of his sculpture when moving from downtown exhibitions to those held uptown, he now envisioned a further aggrandizement for his work that would let his creations dominate an entire landscape.

In these proposals for monuments, Oldenburg poses perhaps his most acute paradox. Ostensibly, they are designs for great public commissions, accessible to everyone; yet in fact they are the most private kind of art, often rendered as quick sketches or spontaneously executed watercolors. Furthermore, although their subjects appear to be a blasphemous mockery of the hallowed monuments of art history, their execution adheres to the traditional values of fine draftsmanship and, in the watercolors, of painterly painting.

Oldenburg's monuments had their genesis within his imagination during the summer he spent in Provincetown in 1960. The daily sight of the Pilgrim Memorial there set him thinking about America's historical past and uncertain future, and comparing the ideals on which the country had been founded with the degeneration of its goals. As a revolutionary personality emerging at the time of an impasse in American politics, Oldenburg was determined to imbue his art with social and political content, even though that content might have to go masked for the moment.[1] The monuments were conceived as a satire on the banality of American life, the absurdity of the urban environment, and the irrelevance of the heroic monument to modern culture in general. Like most of his work, they have a buried level of meaning and fulfil his need to create disguises for his true purpose.

The sources for Oldenburg's monuments are many: illustrations in children's books; the gigantic balloons in Macy's Thanksgiving Day parades, which he never misses; the whole tradition of architectural fantasies, including the work of the visionary architects of the late eighteenth century, Boullée, Ledoux, and Lequeu, whose drawings Oldenburg had studied while working in the library at Cooper Union; as well as the popular tradition of structures built in the shape of animals. Frequent plane travel gave him the idea of representing objects out of scale and from odd perspectives, especially from a bird's-eye view. "The world itself is now an object from the point of view of space travelers. That's the final object, I mean for us," Oldenburg writes. He has also explained that: "The first suggestion of a monument came some years ago as I was riding in from the airport. I thought: how nice it would be to have a large rabbit about the size of a skyscraper in midtown. It would cheer people up seeing its ears from the suburbs"; but the fact that the Playboy Club later made its headquarters nearby the particular site he had chosen unfortunately made constructing a giant rabbit at that spot impossible.[2]

The message of Oldenburg's monuments is the same as that of his sculpture: humor is the only weapon for survival. For example, he conceived a monument for the suicides of the 1929 crash—a structure between the buildings of Wall Street, with figures falling off it. Unlike Surrealist fantasies, Oldenburg's monuments always refer to specific places, and often to specific times. They are grotesque caricatures of some realities of contemporary culture that we would perhaps prefer not to face. "Is a monument always a memory of something?" Oldenburg asks. "No, it's not. A monument can be anything. Why isn't this hamburger a monument? Isn't it big enough? A monument is a symbol. I think of a monument as being symbolic and for the people and therefore rhetorical, not honest, not personal." Like the inflated rhetoric emanating from top government dignitaries, the monuments are grandiose in scale and full of air; like the

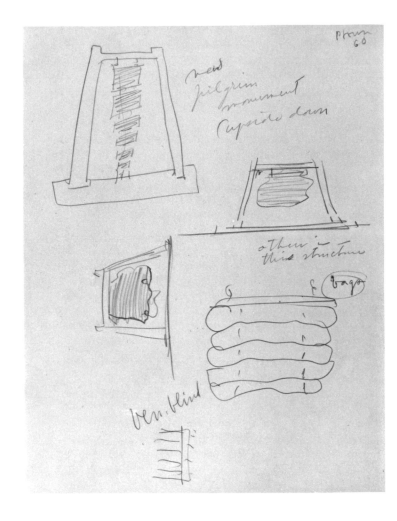

"New Pilgrim Monument Upside Down"—"Venetian Blind"
(notebook page). Provincetown, 1960
Pen and ink and pencil, 11 x 8⅜ inches
Owned by the artist

contradictory utterances pronounced during the Vietnam crises that gave rise to the "credibility gap," they are literally incredible.

Besides their contemporary references, Oldenburg's monuments are also travesties of the triumphal apotheoses with which Renaissance and Baroque artists celebrated the more coherent cultural values of their age. In a very pointed manner, they ask what *this* civilization has to celebrate. Moreover, they constitute an acutely focused criticism of contemporary architecture and have therefore evoked the violent distaste of many architects. Compare, for example, Philip Johnson's project for Ellis Island, which would inscribe the names of sixteen million immigrants on a wall one hundred and thirty feet high, adjacent to the "stabilized ruins" of the old administration buildings, with Oldenburg's proposed monument to immigration: a reef to be placed in the center of New York Harbor, "on which wreck after wreck would occur until there was a huge pile of rusty and broken shiphulls in the middle of the bay."

Oldenburg's imagination works by the dialectical principle of challenge and response. The challenge is usually some contemporary idiocy, which he exaggerates into an even greater absurdity. His first monument was conceived in 1961, during discussions of the forthcoming 1964 World's Fair. Rejecting an offer to execute a commission for the Fair, he contemplated instead "The Other Fair, the No-Fair Fair or the Black Fair"; this led him to solicit "plans and recommendations, working drawings, prospectuses, mottoes, symbols, and all sorts of usable materials," to be sent to the Anti-Fair depot at 107 East Second Street—the address of the Ray Gun Manufacturing Company.

The early drawings for monuments were essentially reactions to things he had seen. As he rode and walked about New York, Oldenburg made sketches of specific places and turned some of them into finished drawings. Out of this roving experience came the monuments. He has described his reaction to the excavation being made in 1957 for the erection of the

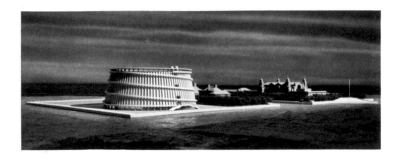

Philip Johnson
Model for proposed Ellis Island National Park. 1966

Pan Am Building: "I drew a building to fill up the hole. In due course, my Pan Am building became the Good Humor monument for Park Avenue."

Oldenburg's first large-scale drawings for monuments were made in the spring of 1964. Later, some of his proposals took the form of collages over the photographs on postcards. Collaged monuments of this sort became more prevalent in 1967, and the discrepancy between the "reality" of the photographed site and the absurdity of the scheme Oldenburg projected upon it adds another dimension of humor to his proposal. The monuments are also a distillation of whatever is, to Oldenburg, the essence of a particular place, the composite of sensations he has registered in that environment. In Stockholm in 1966, he rented a billboard and put up six proposals for public monuments. His proposal for the Karlaplan, a wing-nut monument, was suggested to him by the state-supported design showroom with its sleek objects in "Scandinavian modern" for the home. The wing-nut, taken from a tool advertisement, reminded him of Brancusi's endless column. *p.106*

The choice of objects for specific sites is made on the basis of Oldenburg's analysis of the dominant mood or spirit of a place, and his attempt to find the appropriate image to summarize that quality. London, for example, seemed to him a "leggy" city, so he invented *Colossal Monument: Knees for Thames Estuary.* To replace the Washington Obelisk, his proposal was a colossal *Scissors in Motion,* set like its prototype near a reflecting pool; this gave Oldenburg the opportunity, in his crayon and wash drawing, to explore the light reflections he so loves. His several monuments for Chicago have been vertical, phallic structures that evoke the skyscrapers invented by the masters of the Chicago School. The *Late Submission to the Chicago Tribune Architectural Competition of 1922* is a hilarious burlesque of a particularly unhappy episode in this country's architectural history. *p.120* *pp.120–121*

Oldenburg has evolved for the monuments a complex iconography, which he delivers with the deadpan seriousness of Will Rogers. Typical of his ex-

tended commentaries is his explanation of another of his proposals for Chicago, a spinning bat: "The *Bat* is a cone-shaped metal form about the height of the former Plaza Hotel, placed with the narrower end down at the southeast corner of North Avenue and Clark Street. The *Bat* is kept spinning at an incredible speed, so fast it would burn one's fingers up to the shoulders to touch it. However, the speed is invisible and to the spectators the monument appears to be standing absolutely still." [3] One may read into this sinister object and Oldenburg's explanation of it a metaphor for urban decay and apathy. He himself maintains that his *Bat Spinning at Speed of Light,* to be located in front of the school he attended as a youth, originated as an anti-masturbation fantasy—a monument that burned your fingers if you touched it. *p.107*

The studies for monuments allow Oldenburg to express his own peculiar sensibility, which without compromising his modernism values tactility, chiaroscuro, and painterly impressionistic effects of light, water, and reflections. Obviously a temperament such as Oldenburg's, if born in a different age in which a cultural consensus existed, would have had many opportunities to execute great public works. In our time, however, there is no tradition of monumental sculpture, perhaps because modern aesthetic values no longer coincide with those of society in general, or perhaps merely because there is simply nothing to celebrate. It may be that the concept of monumental sculpture is antithetical to the experience of a secular, democratic society. The Netherlands in the seventeenth century, where the "low art" or genre tradition reached its greatest stage of development, had a materialistic, democratic society like that of America today, and it too produced no monumental sculpture of any consequence such as then flourished elsewhere in Europe.

Most of Oldenburg's monuments exist only as drawings, frequently in several versions. But as more people expressed interest in seeing them built, he began making models for his monuments. *Door Handle and Locks,* to be sited behind Stockholm's Moderna

Studies for site now occupied by the Pan Am Building (notebook page). 1957
Ball-point pen and pencil; 4 sketches, 10½ x 8 inches over-all
Owned by the artist

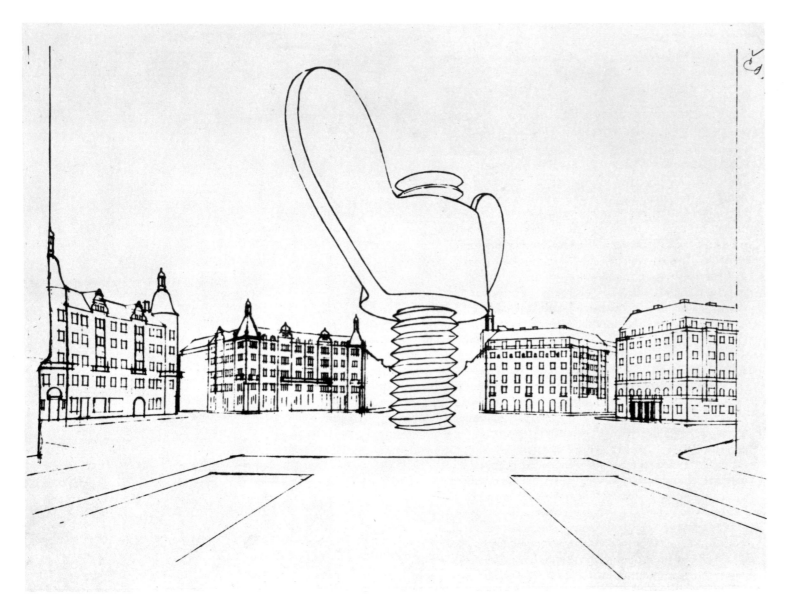

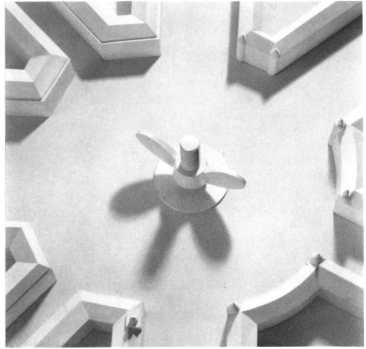

Proposed Colossal Monument for Karlaplan, Stockholm: Wing-nut. 1966
Photoprint from pencil, 8½ x 10¾ inches
106 Owned by the artist

Proposed Colossal Monument for Karlaplan, Stockholm:
Wing-nut (model). 1966–1967
Wood, painted with Liquitex,
11 inches high x 46 inches wide x 48 inches deep
Collection Mr. and Mrs. Bagley Wright, Seattle

Museet, was the first of these, conceived in 1966 and later cast in bronze. It resembles a topographical map, with several planes of relief, however, instead of a single continuous one. Ridged free forms of the "land" areas contrast with the solid geometric forms of the door handle, keys, and locks set into it. Subsequent projects for monuments, such as the *Drainpipe* for p. 109 Toronto and the *Floating Ball* (a toilet float) for the p. 108 Thames, have the severely clean lines of geometric solids. In spite of their streamlining, however, details (as usual in Oldenburg's work) play an important role. The tubular *Drainpipe* is set on a stand articulated by several oval indentations. It is perfectly symmetrical, poised in the center of its base; the canvas "water" that in earlier versions issued from it in solid form as a typical Oldenburg note of humor was eliminated, so that nothing detracts from a completely dignified construction.

The first of Oldenburg's monuments actually executed was his project for the outdoor sculpture exhibition held at various sites throughout New York City in the fall of 1967. He had originally suggested creating massive traffic jams by parking buses to obstruct a number of street intersections. Ultimately, however, he decided to have a hole, six feet by three, dug in Central Park behind The Metropolitan Museum of Art. Was it a grave for dead art or, as Mayor Lindsay later suggested, a tribute to Thomas P. F. Hoving, the museum's director and former Parks Commissioner, for whom it was just the right size? Or was it, as Oldenburg contends, just a simple memorial to the pleasurable hours he had spent in Central Park? Did it mean that the notion of public sculpture in our time is absurd? Or was it the beginning of a great revival of the ancient medium of earth sculpture? As always, Oldenburg sets up polarities, alternatives, and paradoxes, leaving interpretation open.

The monuments are meant to be taken seriously, in that they are true symbols of our age and reveal the choices open to society; but they are also meant, by their extravagant exaggeration, to shock people into consciousness of what is really happening. The pos-

Proposed Colossal Monument for the Corner of
North and Clark Avenues, Chicago:
Bat Spinning at Speed of Light. 1967
Crayon and watercolor, 17³/₄ x 12 inches
Collection Francis and Sydney Lewis, Richmond, Virginia

Proposed Colossal Monument for Skeppsholmen
and Kastellholmen, Stockholm:
Door Handle and Locks. 1966–1967
Bronze, 39¹/₈ inches square
Owned by the artist

107

sibility that his projects will be taken literally no doubt fills Oldenburg with certain misgivings. (Research was done by some Cornell students on the feasibility of erecting the *Colossal Block of Concrete Inscribed with Names of War Heroes* that he proposed for the intersection of Canal Street and Broadway—the spot where experts have calculated that a dropped A-bomb would do the most damage—but the costs proved prohibitively high.)[4] The point is, of course, that it is no more ridiculous to erect an Oldenburg monument than to build a giant skyscraper on top of Grand Central Terminal or put up a travesty of the Campidoglio at Lincoln Center. In this sense, Oldenburg's projects are monuments to the negative as well as to the positive power of human imagination—its power to "think the unthinkable," as Herman Kahn so delicately puts it.[5]

Works of art, of course, are comparatively innocuous; they lead to contemplation, not action. The artist can afford to be irresponsible; he is a harmless eccentric in his delusional world. But what about the games-theory strategists, the university administrators, the executives, the politicians, and the city planners—the people actually responsible for running our permissive, hallucinated society? The question posed by the monuments is whether life can indeed afford to imitate art. It is a deadly serious question, disguised as a comic mania.

Ray Gun, resurrected as the *Drainpipe-Crucifix,* has begun to see his prophecies come true. The legs and knees, the miniskirt costumes of the early happenings, are standard gear; Dallas, where the violent script of *Injun* was performed in 1962, has since been the scene of assassination; the bloody imagery of The Store's butcher shop is a daily headline. The sexual liberation of the erotic objects is upon us. The self-expression preached by the happenings finds its outlet in riots, which are not necessarily regarded as directed at any specific enemy or issue, but rather as *expressive* acts that are either intrinsically satisfying ("play") or satisfying because they give expression to a state of mind. In short, the Ray Gun prophecies have been ful-

Proposed Colossal Monument for Thames River:
Thames "Ball." 1967
Crayon, ink, and watercolor on postcard, 3½ x 5½ inches
Collection Carroll Janis, New York

Proposed Monument for the Intersection of Canal Street and Broadway, New York:
Block of Concrete Inscribed with Names of War Heroes. 1965
Crayon and watercolor, 16 x 12 inches
Collection Alicia Legg, New York

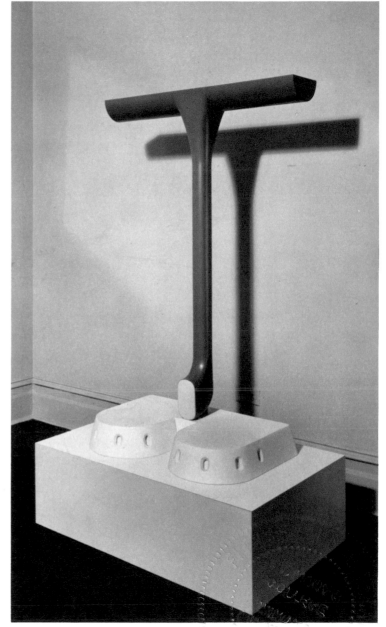

Proposed Colossal Monument for Toronto: Drainpipe. 1967
Pencil and watercolor, 40 x 26 inches
Collection Harry Klamer, Willowdale, Ontario

above:
Drainpipe/Crucifix (notebook page). London, 1966
Ball-point pen, pencil, crayon, watercolor, on clipping
illustrating a modern sculpture of the Crucifixion,
9³/₄ x 8 inches
Collection Mr. and Mrs. Roger Davidson, Toronto

right:
Proposed Colossal Monument for Coronation Park, Toronto:
Drainpipe. 1967
Wood, painted with Liquitex,
51 inches high x 32³/₈ inches wide x 11³/₄ inches deep
Wallraf-Richartz Museum, Cologne (Ludwig Collection)

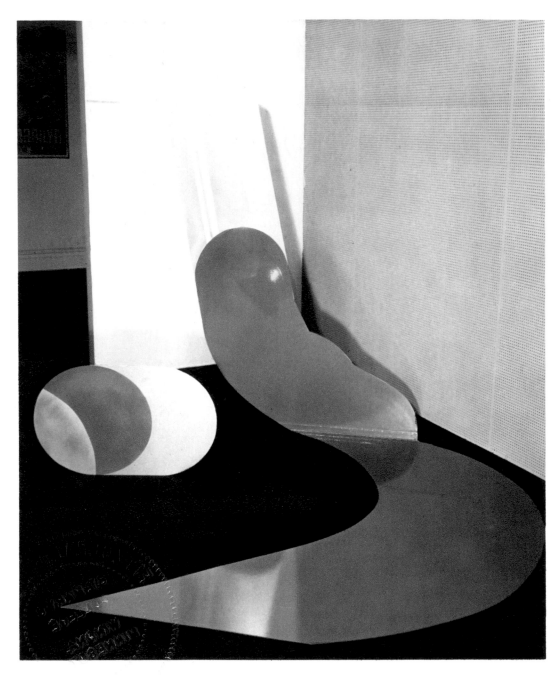

Giant Lipstick
(Ceiling Sculpture for M.M.). 1967
Metal, hinged,
72 inches high x 72 inches wide
Owned by the artist

filled in a manner as grotesque and unpredictable as the original ominous black ray gun. Until recently, Oldenburg's monuments, typifying society rebuilt and recast in the artist's image, remained unrealized fantasies. But the 'sixties have been the decade of power—black power, student power, artist power. No political or cultural enterprise or institution has been untouched by the will to power on the part of groups heretofore traditionally powerless within American society. The ghettoes, the universities, and art are spilling out into the streets, transforming a stagnant society into something else.

Recently, Oldenburg has allowed his radical intention to become more overt, his disguises more transparent; and he has become more politically activist, perhaps because of his experience in Chicago during the riots that accompanied the 1968 Democratic Convention. He had thought to attend as a spectator but ended up as an unwilling participant, among those clubbed to the ground by the police. In the mid-'fifties, when he went to live in the slums of New York, he had chosen to do so because he believed that the radical spirit was most intense among the impoverished, unemployed residents of the Lower East Side. His Chicago experience, however, made him realize that the center of radical activities and of the declassed outsider had shifted from the slums to the universities.

Oldenburg was therefore favorably disposed to the proposition made to him early in 1969 by a group of students who approached him with the request that he erect at Yale University the first monument to the Second American Revolution. They were apparently inspired to do so by remarks attributed to Herbert Marcuse, philosopher of the New Left, in the course of a taped interview in 1968. He stated that if anything so unfeasible and unrealistic as Oldenburg's Good Humor Bar could really be erected on Park Avenue, p. 122 or the Banana in the middle of Times Square, it would p. 123 "indeed be subversive... I would say—and I think safely say—this society has come to an end. Because then people cannot take anything seriously: neither

their president, nor the cabinet, nor the corporation executives. There is a way in which this kind of satire, of humor, can indeed kill. I think it would be one of the most bloodless means to achieve a radical change."[6] The erection of Oldenburg's monuments would mean that people had seen that they had the power to control their lives and modify their environment.

Appreciating the genuineness of the need that the students felt to create symbols for their revolution, Oldenburg accepted the commission. Students, faculty, and distinguished Yale alumni contributed toward the costs of fabrication. On May 15, 1969 students of the Yale School of Art and Architecture transported the first of Oldenburg's colossal monuments to be realized from the factory where it had been fabricated to the plaza in the center of the campus.

Lipstick (Ascending) on Caterpillar Tracks had *pp.112–* its formal origins in the lipstick Oldenburg had pro- *113* posed in 1966 to replace the Fountain of Eros in London's Piccadilly Circus. The theme next appeared in the *Giant Lipstick* of flat steel fabricated for the "Homage to Marilyn Monroe" exhibition at the Sidney Janis Gallery in 1967. In the Yale monument (or antimonument), the object has a double identity: it is also a metaphor for a war machine, a missile grounded in a tank. With this marriage of the erotic and the warlike, Oldenburg has created a phallus-lipstick-missile image, which clearly implies that the issue of America's "potency" is a psychosexual problem. The American need constantly to ejaculate phallic warheads is revealed as a symbolic act of frontier *machismo*, while the collapsing, soft vinyl tip of the lipstick raises the implicit question: how long can America keep it up?

The choice of site, too, was deliberate. Oldenburg's monument was raised beside the American flag, and directly in front of the war memorial erected after the First World War "In Memory of the Men of Yale Who True to Her Traditions Gave Their Lives that Freedom Might Not Perish from the Earth." Half a century later, Yale men were redefining freedom as the

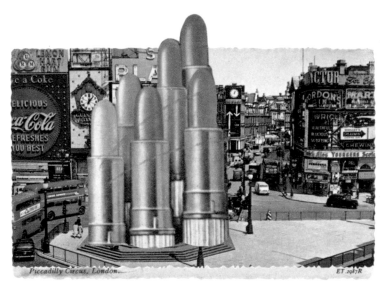

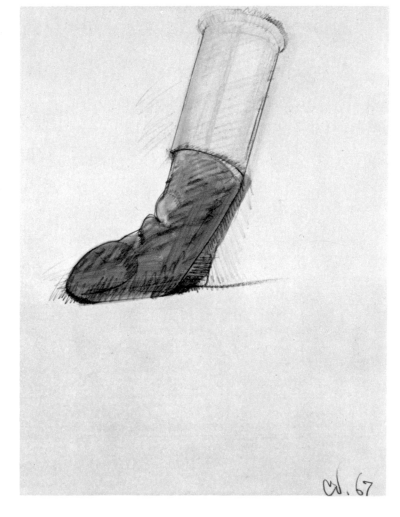

Lipsticks in Piccadilly Circus. London, 1966
Collage: magazine clipping on postcard
Owned by the artist

Study for a Soft Sculpture in the Form of a Giant Lipstick. 1967
Crayon and watercolor, 30 x 22 inches
Mr. and Mrs. S. Allen Guiberson, Dallas

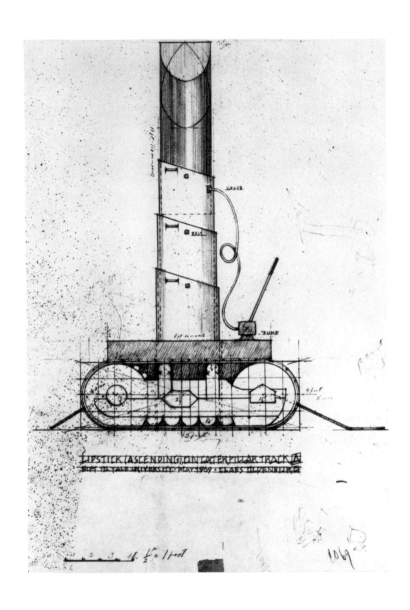

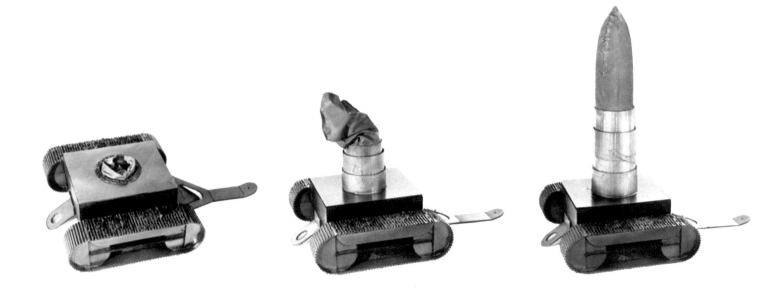

Study for Feasible Monument, Yale University:
Lipstick (Ascending) on Caterpillar Tracks. 1969
Pencil and spray enamel, 16³/₄ x 11¹/₄ inches
Owned by the artist

Monument for Yale University: Giant Traveling and Telescoping Lipstick
with Changeable Parts Showing Three Stages of Extension (model). 1969
Cardboard, canvas, glue, painted with enamel and shellacked;
tractor, 5⁵/₈ inches high x 25 inches wide x 16¹/₄ inches deep;
lipstick: stage 1, 4 inches high; stage 2, 14¹/₂ inches high; stage 3, 23¹/₂ inches high
Owned by the artist

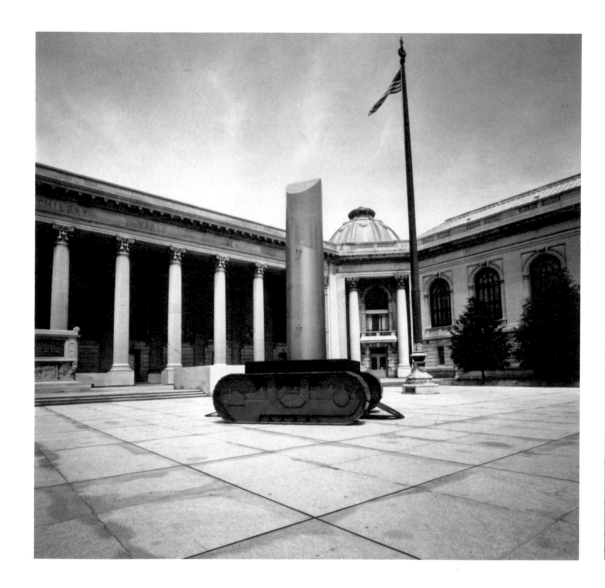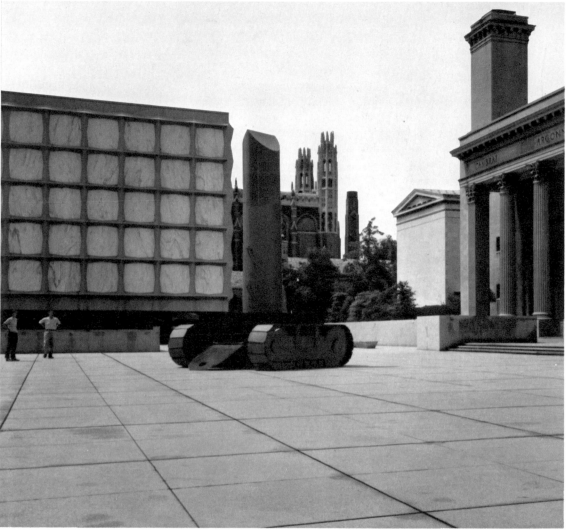

Lipstick Monument in situ at Yale University, 1969

113

right to oppose their own government and erect their own defiant antiwar monument, commemorating their opposition to a war in which they wanted no part. A lopsided, raucous, absurd affront to the polished marble formality of the Beinecke Rare Book Library, where vestiges of ancient cultures are enshrined as if in a precious reliquary, Oldenburg's colossal monument demands acknowledgment of the present by exposing the banality of the official architecture surrounding it. As long as the sculpture remains, standing out literally like a sore thumb, Oldenburg's monument will continue to be an irritant.

As always, Oldenburg's message is to face reality and the present, to renounce the exhausted in favor of the living. Once more uniting subject, content, and form in a full statement, Oldenburg attempts to integrate art into society without robbing it of its critical role vis-à-vis the official goals of that society. His Yale monument stands as an example to all who would make the revolution. Oldenburg destroys nothing; he creates an alternative, a living symbol and a constructive act—unlike those radicals who focus only on destruction and are intent on sweeping away the past without replacing its forms with more relevant, meaningful structures.

Oldenburg's monuments, whether existing only as proposals or actually realized as at Yale, celebrate nothing more nor less than the American way of life, whose goals they at the same time challenge and call into question. Ray Gun is history's witness:

"Make up thee mind, Mr. US, thee want wet or hot. Mr. Ray Gun, he commend gas.

"We Promethised Land. We home fire. We Red Man. We run torch to Plato, stumbling angmond za fagends. Lipstick, here is bullet. Paint drop here she punching bag."[7]

NOTES

1. Also in 1960, following the execution of Caryl Chessman, Oldenburg drew an imaginary two-part plaque, the upper half showing an enormous degraded American eagle like that recently placed on the façade of the Embassy in London, the lower half a symbol of Chessman's hearse. This execution had also inspired Edward Kienholz, who like Oldenburg is strongly critical of certain facets of American society and deals with "forbidden" themes such as sex, violence, and politics, to create an object with the evocative title *The Psycho-Vendetta Case.*

2. Quoted in exhibition catalogue, "Claes Oldenburg: Skulpturer och teckningar," Stockholm, Moderna Museet, September 17–October 30, 1966.

3. Quoted by Dan Graham, "Oldenburg's Monuments," *Artforum* (New York), January 1968, p. 37.

4. "Claes Oldenburg: Skulpturer och teckningar."

5. *Thinking about the Unthinkable* (New York: Horizon Press, 1962).

6. Interview with Stuart Wrede, Cambridge, Massachusetts, June 1968, published in *Perspecta 12,* The Yale Architectural Journal (New Haven), 1969, p. 75.

7. Claes Oldenburg, "America: War & Sex, Etc.," p. 34.

"American Whiskey-Eagle and Chessman Hearse" (sketch for a plaque commemorating the execution of Caryl Chessman; notebook page). 1960
Pencil, 8½ x 11 inches
Owned by the artist

Proposed Colossal Monument for Central Park North, New York:
Teddy Bear. 1965
Crayon and watercolor, 24 x 19 inches
Collection Mr. and Mrs. Richard E. Oldenburg, New York

C.O. 65

Proposed Colossal Monument for
Ellis Island, New York:
Frankfurter with Tomato and Toothpick. 1965
Crayon and watercolor, 19 1/8 x 24 inches
Collection Mr. and Mrs. Michael Blankfort,
Los Angeles

Proposed Colossal Monument for
Ellis Island, New York: Shrimp. 1965
Crayon and watercolor,
12 x 15½ inches
Collection Mr. and Mrs. Dirk Lohan,
Chicago

Proposed Colossal Monument for
the Battery, New York: Vacuum Cleaner,
View from the Upper Bay. 1965
Crayon and watercolor, 23 x 29 inches
Collection Jonathan D. Scull, New York

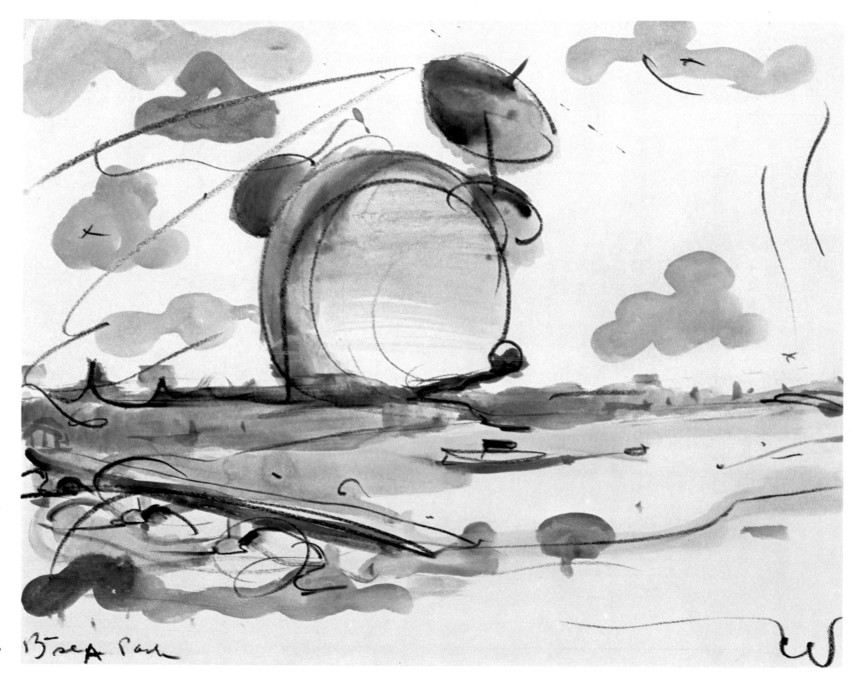

Proposed Colossal Monument for
Battersea Park, London: Drum Set. 1966
Crayon and watercolor, 22¹/₈ x 30 inches
Collection Mr. and Mrs. Edwin A. Bergman,
Chicago

119

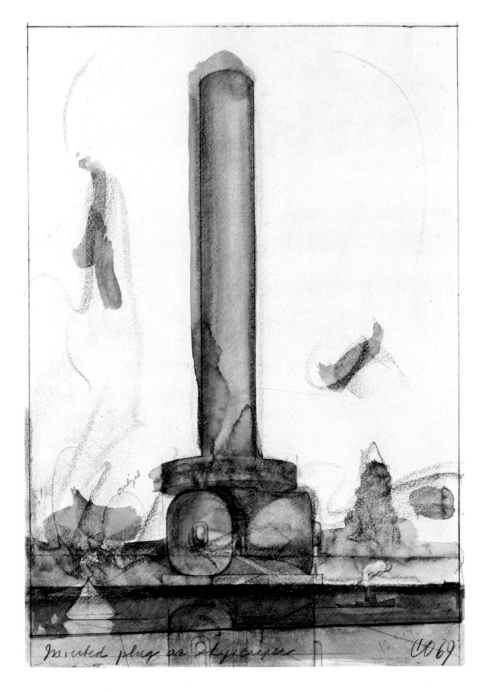

Inverted plug as Skyscraper CO69

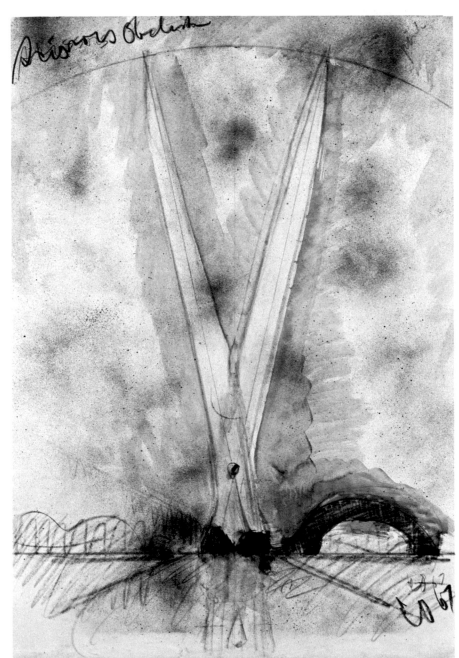

Scissors Obelisk

opposite, left:
Proposal for a Skyscraper in the Form of a Chicago Fireplug:
Inverted Version. 1969
Crayon and watercolor, 17¹/₂ x 12 inches
Collection Mr. and Mrs. Dirk Lohan, Chicago

opposite, right:
Proposed Colossal Monument to Replace the Washington Obelisk,
Washington, D. C.: Scissors in Motion. 1967
Crayon and watercolor, 30 x 19³/₄ inches
Collection Philip Johnson, New Canaan, Connecticut

right:
Late Submission to the Chicago Tribune Architectural
Competition of 1922: Clothespin (Version Two). 1967
Crayon, pencil, and watercolor, 22 x 23¹/₄ inches
Collection Charles Cowles, New York

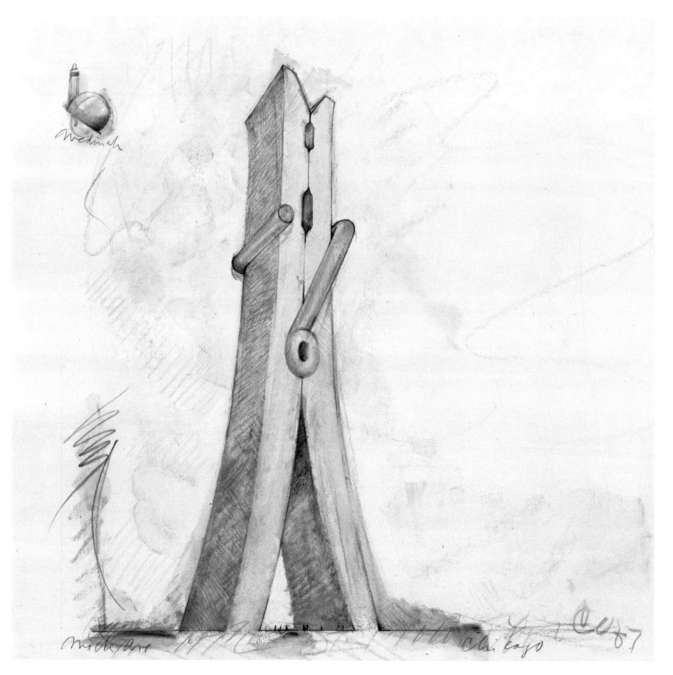

left:
Proposed Colossal Monument for Park Avenue, New York:
Good Humor Bar. 1965
Crayon and watercolor, 23³/₄ x 18 inches
Collection Carroll Janis, New York

opposite, left:
Proposed Colossal Monument for Times Square, New York:
Banana (study for cover of Domus). 1965
Crayon and watercolor, 24 x 18¹/₈ inches
Private collection, London

opposite, right:
Proposed Colossal Monument for Staten Island, New York:
Fan (study for cover of Domus). 1965
Crayon and watercolor, 24 x 19¹/₈ inches
Collection Mr. and Mrs. Richard E. Oldenburg, New York

124

Design for a Tunnel Entrance in the Form of a Nose. 1968
Crayon and watercolor, 9¹/₂ x 8 inches
Collection Mr. and Mrs. Robert J. Woods, Jr., Rolling Hills, California

Part II:
The Metamorphoses of Form

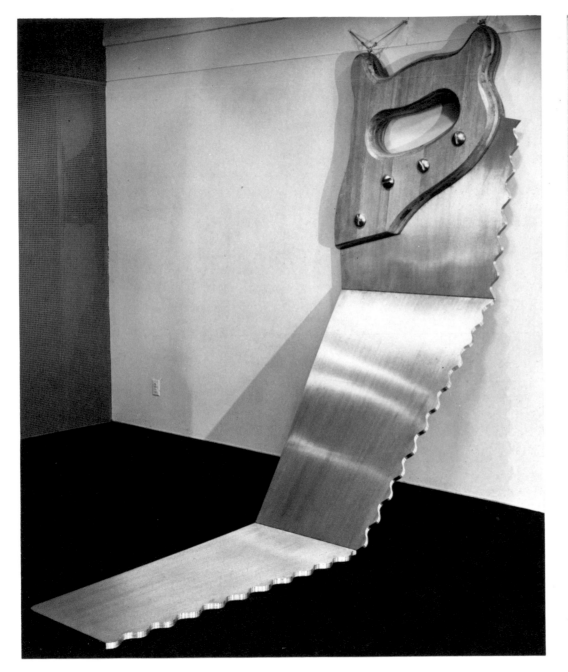

126

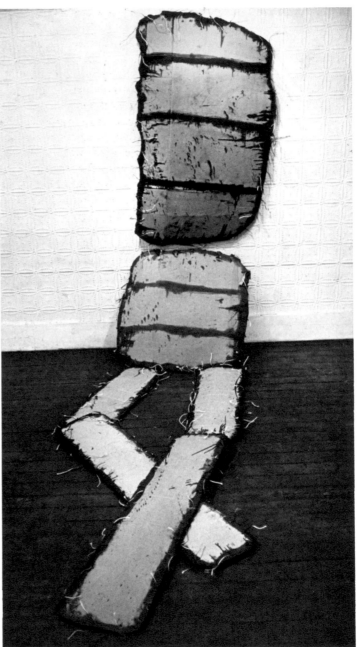

far left:
Giant Saw–Hard Version. 1969
Laminated wood, aluminum
filled with polyurethane foam;
144 inches high (hinged)
x 40 inches wide x 6½ inches deep;
blade 1 inch thick
The Vancouver Art Gallery, Vancouver

left:
The Big Man. 1960
Corrugated cardboard, newspaper,
wood, painted with casein,
ca. 185 inches high (hinged)
Collection of the artist

From the Wall to the Floor

HAPPY GOODS!
CIGARETTES THERE CREEPING OUT OF THE BACK
SIMPLE VICIOUS BRA
EMPTY PANTS IN THE WIND
SLIP BULGING IN THE BREEZE
PROUD LAPELS
SHINING SHOES
DELIRIOUS FLAG IN THE CLOUDS
PAINTING IN HIS GILT COAT
WITH SPECTACLES ON ENVIES YOUR ADVENTURES
 Claes Oldenburg, notebooks, 1961

Oil paint and canvas aren't as strong as commercial paints and as the colors and surfaces of materials, especially if the materials are used in three dimensions.... So far the most obvious difference within this diverse work is between that which is something of an object, a single thing, and that which is open and extended, more or less environmental.... Three dimensions are real space. That gets rid of the problem of illusionism and of literal space, space in and around marks and colors—which is riddance of one of the salient and most objectionable relics of European art. The several limits of painting are no longer present. A work can be as powerful as it can be thought to be.
 Donald Judd, "Specific Objects"

When, in the course of his protracted self-analysis, Oldenburg realized that his own way of seeing was fundamentally three-dimensional, and that he also liked the sensuous feel of materials, he was more or less forced to decide to quit painting if he wished to remain an avant-garde artist; for the most advanced painting of the time offered possibilities only for flatness and for optical, rather than tactile, effects. Painting has nevertheless continued to be the point of departure for all his subsequent work—environments, soft sculpture, and drawings for monuments, as well as happenings and films. But although his art is always explicitly painterly, Oldenburg, like the other makers of "specific objects" (to borrow Donald Judd's early term for Minimal Art),[1] converts these painterly properties into literal equivalents. Just as perspective was made literal in the *Bedroom Ensemble*, so the skeins of string in the *pp. 94–95 String Wardrobe* for Marilyn Monroe can be identified *p. 128* as equivalents for dripping paint. The seams of the soft sculptures are drawing made tangible, just as the figures in The Street were calligraphy made actual.

Oldenburg had been thinking about making three-dimensional art since 1954, when he collected the seed pod that he later mounted for his first one-man show *p. 28* at the Judson Gallery in 1959; but his decision to become a sculptor, like most of his decisions, was dictated by necessity, not chance. The rejection of painting "in his gilt coat with spectacles on" stimulated Oldenburg's thinking about other mediums and forms, while allowing him new freedom to revel in the creations of his own imagination. His paintings had been done in a style that mixed expressionism with elements of realism; but once liberated from the flatness of canvas, he began to mix reality and fantasy more freely.

Although his Judson Gallery show in 1959 had included some fully three-dimensional objects, in the period between that show and the closing of The Store Oldenburg made many reliefs that are midway between painting and sculpture. The splashes and drips of the Store reliefs, in particular, resemble late Abstract- *pp. 73,* Expressionist handling of paint. Giving up plaster as *75–81*

a medium meant to a large degree renouncing this kind of surface treatment and the gaudy use of commercial color, though ironically enough Oldenburg's first soft sculptures, the giant objects in the Green Gallery exhi- *p. 90* bition of 1962, were made of paint and canvas. In his later works, surface was to remain an essential factor but would never again be treated with such expressionist abandon.

The formal aspect of Oldenburg's sculptures should be seen, not in the context of Pop Art, but rather in terms of the abstract object sculpture of Donald Judd, Robert Morris, Larry Bell, and others. Oldenburg's objects take the same route as do their works, from the two-dimensional flatness of painting to relief, and finally to large-scale, three-dimensional floor pieces. Like their works, too, each of Oldenburg's objects is a gestalt, a single image that must be seen as a whole unit and not as made up of discrete parts. What is stressed in such work is, above all, physicality, concreteness, and presence.

Oldenburg has, in fact, played a decisive role as innovator in the development of a style that superficially seems antithetical to his own. The *Big Man* in The Street was a huge figure attached to the wall and resting on the floor, and a notebook sketch of 1960 *p. 128* reveals that Oldenburg also conceived it as an upright figure looming forward across the ceiling. The *Giant Saw—Hard Version* of 1969 and the *Giant Lipstick (Ceiling Sculpture for M.M.)* of 1967 may be regarded *p. 110* as subsequent translations of these two ideas into nonfigurative terms. The colossal objects in the 1961 Green Gallery group show were the first of the new sculptures *p. 129* to exist on such a large scale. The *Bedroom* pieces and the hard versions of the light switch are geometrical volumes every bit as severe as those in Minimal Art, while the original cardboard models for such soft pieces as the bathtub are also rigid and boxlike. The *p. 130* single cubic volume occurs as frequently in Oldenburg's work as in Minimal Art, and sometimes at an earlier date. His *Pool Balls* are geometric solids that have been *p. 131* enlarged and repeated like units in serial Minimal Art.

Oldenburg's exploration of different forms of the same object, as in the swimming-pool series, for example, is a manifestation of his interest in permutation and mutability—another interest that he shares with such artists as Robert Morris, Frank Stella, and Ronald Davis. His investigations of the various possibilities available to any one object are often as exhaustive as the permutations of Morris, the spatial rotations of Davis, or the systematic structural investigations of Stella. In presenting the Airflow in four different ways—as interior, exterior, in sections, and whole— *p. 132* Oldenburg offers an exhaustive set of alternative solutions, all equally meaningful, to a single problem. This *pp. 96–100, 166* treatment is obviously allied to the methodical approach of the younger "conceptual" artists, and may be seen as related to the discovery by the physical and social sciences that different models, each adequately accounting for the same data, can coexist without contradiction. Since more than one solution or explanation is possible for a given problem, "truth" itself can be regarded only as relative.

Not until recently have Oldenburg's formal inventions begun to be acknowledged as such. This may be in part because it is only from our present vantage point, as the decade draws to its close, that the genuine innovations of the art of the 'sixties have become apparent. Around 1960, a number of young artists— Oldenburg being among the most significant of them— began to reject some of the premises that had been implicit in modern art since Cubism. These artists reciprocally influenced one another and shared a common inspiration: the flags that Jasper Johns exhibited in 1958.[2] What was radical about these flags was not, as some have held, their self-proclaimed flatness, but rather their identification of the image with the field, with no space left over, either behind or around the image, to function as background. It is this change from *depiction,* in which shapes are isolated against a negative background, to literal *presentation,* in which the image or shape is coextensive with the whole field, as in Johns's flags, that is the crucial formal innovation

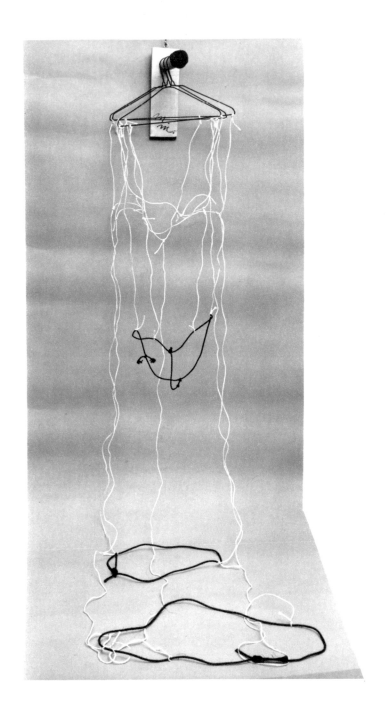

above:
Sketch for The Big Man, with human figure for scale (notebook page). 1960. Pencil, 8³/₈ x 6¹/₂ inches
Owned by the artist

left:
Sketch for String Wardrobe—Long Dress, Shorter Dress, Bathing Suit (for M.M.). 1967
Cord, hangers, plaster, and other materials, ca. 120 inches high (variable) (destroyed)

opposite:
Street Head, I and The Big Man
in group show at the Green Gallery, 1961

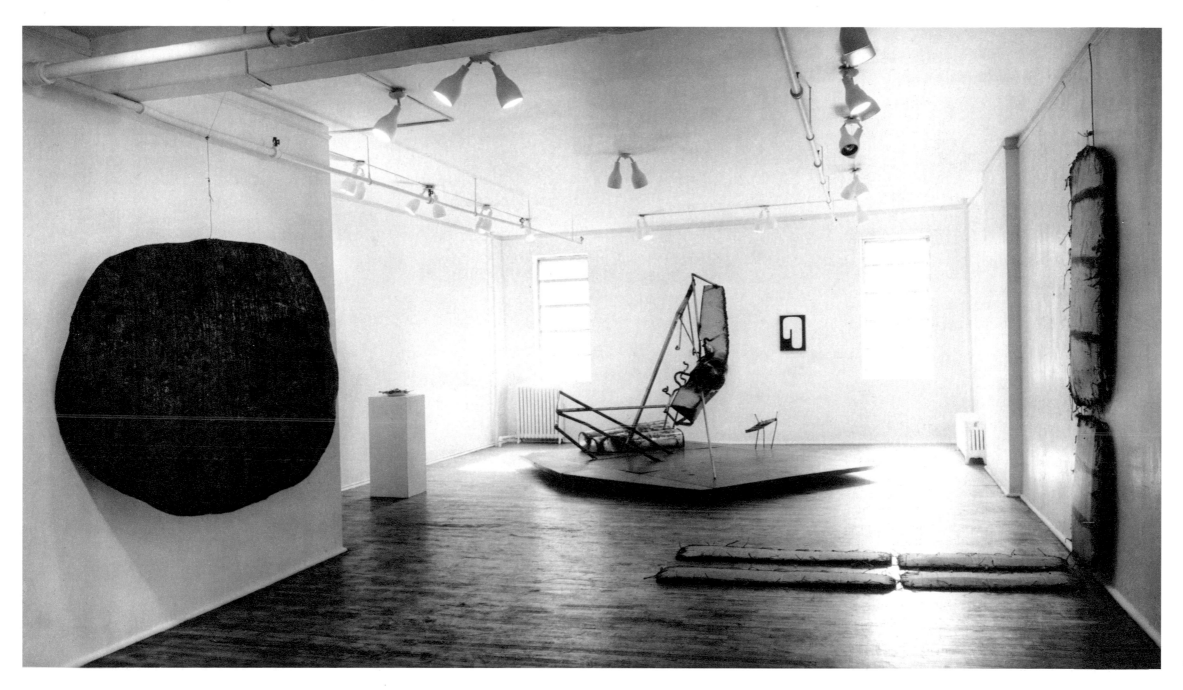

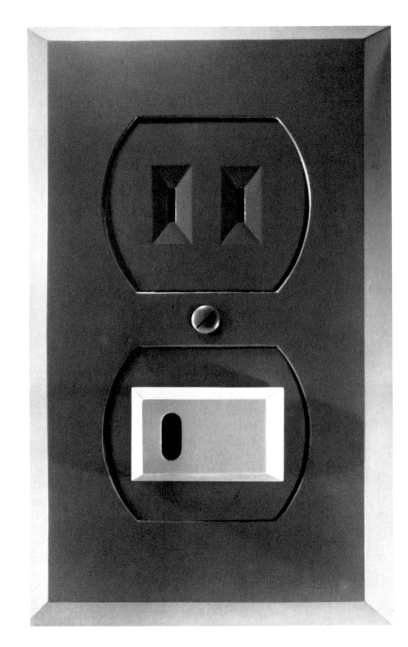

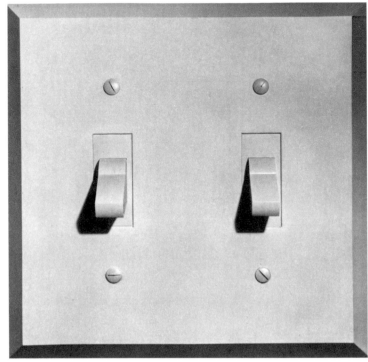

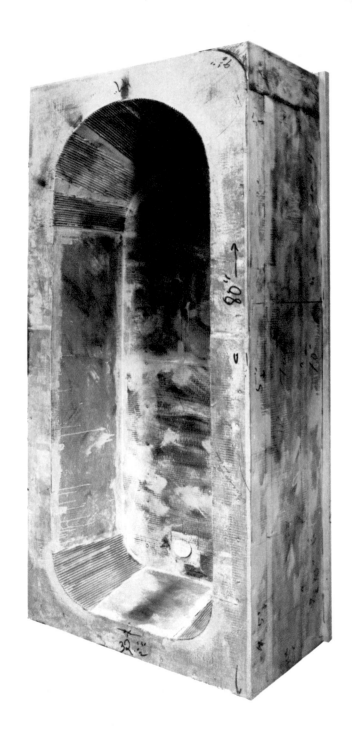

above:
Light Switches—Hard Version. 1964
Painted wood, formica, metal, 47³/₄ inches square
Collection Mr. and Mrs. Harold Ladas, New York

left:
Electric Outlet with Plug. 1964
Painted wood, 47¹/₂ inches high x 28⁵/₈ inches wide
Collection Mr. and Mrs. Richard H. Solomon, New York

right:
Bathtub—Hard Model. 1966
Cardboard, wood, 80 inches high x 32¹/₂ inches wide
Collection Mrs. Claes Oldenburg, New York

opposite:
Giant Pool Balls. 1967
16 plexiglass balls, each 24 inches diameter, on wood rack
Courtesy Sidney Janis Gallery, New York

Pool Shapes. 1964. Copy of an advertisement with type removed.
Plexiglass mounted on formica over composition board, 48 inches high x 60 inches wide. Private collection

uniting the art of the 'sixties and separating it from earlier art.[3] (That this has not yet been recognized must be attributed to the widespread belief that any such innovation of significance could make its appearance only in abstract art.)

Several modern movements, of course, had already asserted the integrity of the work of art as a thing in itself, rather than as a picture of something—even of something as abstract as a geometric image; but the elimination of the background around the image further ensured the object status of the new art. If the shape and area of the image were identical with the shape and area of the field, then the perimeter would assume a proportionately greater significance than ever before. In earlier art, such as Cubism, the framing edge was less important than the edges of the internal shapes, which were constantly being played off against one another and so became the focus of interest. The elimination of this kind of hierarchy of relationships within the painting, and the emphasis on the framing edge, led logically to a departure from the rectangle, and to an inevitable progression through shaped canvases and eccentric reliefs to fully three-dimensional shaped object-paintings.

Once Oldenburg had identified image with field, as he did in the Street figures and Store reliefs, an entirely literal art was but a step or two away. First, drawing was made literal in the figures in The Street, which were pp. 42–43, ripped out of their background to become a "three- 46 dimensional mural"; next, shape was made actual in the *"Empire" ("Papa") Ray Gun*, hanging freely in p. 58 space. Color and texture, already handled literally by the incorporation of discarded materials in the figures of The Street, were still more vividly treated in the Store objects. Perspective was made actual in the distorted angles of the *Bedroom Ensemble* furnishings; and finally, in the painted "ghost" objects, light and shadow were ironically applied like a vestigial chiaroscuro to objects that were already three-dimensional. Similarly, highlights were made actual in the reflections on the surfaces of the shiny vinyl objects, and transparency

Soft Typewriter—"Ghost" Version
(Model "Ghost" Typewriter). 1963
Canvas filled with kapok, wood, painted with Liquitex,
9 inches high x 27½ inches wide x 26 inches deep
Karl Ströher Collection, 1968, Darmstadt

Soft Dormeyer Mixer. 1965
Vinyl filled with kapok, wood, electric cord,
31³/₈ inches high x 20¹/₈ inches wide x 12 inches deep
Whitney Museum of American Art, New York
(gift of Howard and Jean Lipman Foundation, Inc.)

Tea Bag. 1966
Multiple print (edition of 125), vinyl, felt, kapok, plexiglass,
39½ inches high x 28¼ inches wide
Courtesy Multiples, Inc., New York

far left:
Giant Soft Fan—"Ghost" Version
(Model "Ghost" Fan). 1967
Canvas filled with foam rubber,
painted with Liquitex; wood, metal;
120 inches high x 59 inches wide
x 76 inches deep;
cord and plug, 290 inches long
The Museum of Fine Arts, Houston
(gift of D. and J. de Menil)

left:
Giant Soft Fan. 1966–1967
Vinyl filled with foam rubber;
wood, metal, plastic tubing,
120 inches high x 58⁷/₈ inches wide
x 61⁷/₈ inches deep;
cord and plug, 291¹/₄ inches long
The Museum of Modern Art,
New York (The Sidney and Harriet
Janis Collection)

opposite:
Soft Drainpipe—
Red (Hot) Version. 1967
Vinyl filled with styrofoam vermicelli,
canvas, metal rack, 109⁷/₈ inches high
x 68⁷/₈ inches wide x 15 inches deep
Collection Mr. and Mrs. Roger Davids,
Toronto

became literal in the clear plastic "water" surrounding the *Tea Bag* multiple. Thus, many of the innovations of *p. 133* Minimal Art were anticipated or paralleled in the work of a so-called "Pop" artist—a fact that exemplifies how journalistic categories must be reshuffled if we are now to discern what truly happened in the art of the 'sixties.

A few other artists were as quick as Oldenburg in making formerly pictorial qualities literal. He was, however, the first to transform into its literal equivalent one element, automatism or process—a transformation that has had special consequence and is only now beginning to be appreciated.

On several occasions in his notes, Oldenburg has disavowed his interest in chance; and to the extent that his art, like that of his generation in general, is mainly conceptual, this seems logical. Further reflection, however, leads to the realization that the arrangements of his soft sculptures, which look different each time they are rearranged (by the artist or anyone else), can be regarded as automatism made literal. In these works, Oldenburg does not *approximate* randomness; the pull of gravity (which he has called "my favorite form creator") causes the configurations of these limp, non-resistant forms to be *literally* random. In Abstract-Expressionist paintings, randomness and chance are relative, since on any given surface they are fixed forever. In the arrangement of the dangling looped cords of Oldenburg's giant fans or the drooping, snoutlike funnels of his soft drainpipes, however, they are absolutes; within certain limits, the forms assume chance positions, different each time. Here once again one of Cubism's normative values, "composition" or design, has been downgraded to a secondary role.

Automatism in Oldenburg's work is equated with permissiveness and may in fact be seen as a metaphor for the present-day permissiveness of society. "I give in to forces, psychological and natural, and let them make themselves, guiding them as they develop." As Jackson Pollock "allowed" his paint to drip, and Morris Louis let it spread in rivulets down the canvas, so Oldenburg permits external circumstances and the nature of his

materials to determine what kind of form he will create and the configuration that form will eventually take.

Oldenburg's appropriation of automatism is one aspect of his complex relationship to Abstract Expressionism (and to the Dada and Surrealist precursors of that movement).[4] In general, it is true of his art, as it is of all the important art of the 'sixties, that although at first sight it appeared to be a total denial of Abstract Expressionism, in actuality it issued with seamless continuity directly from American art of the 'fifties. In many respects, Oldenburg's generation transformed into literal realities certain rhetorical postures of the Abstract Expressionists; and whereas the latter proclaimed surprise at the unpredictable outcome of their works, the younger men made works in which spontaneity was immanent.

Oldenburg's own relation to Abstract Expressionism is particularly hard to define because it is dual. In the happenings, he made the gestural concept of "action painting" literal in a theater of actual gestures. He has described how "having initiated the action, the situations, the bringing together of people," he became less and less controlling, "letting the thing grow by itself."[5] In his plastic art, however, he has always insisted on the precedence of conception over process. In the happenings, action arises from Oldenburg's contact with his environment; but in his sculpture, form arises out of the practical necessities of materials and techniques. Speaking on a panel in 1965, he explained: "The spontaneity is not mine. I design a piece from a conceptual idea and it's manufactured in a very simple way. The spontaneity enters when other people come in contact with it. . . . The creation of this piece is not spontaneous, but in the end it is subject to spontaneous use. Someone can come and manipulate or change it."[6]

By the time that Oldenburg created the *Bedroom Ensemble,* late in 1953, Abstract Expressionism had *pp. 94–95* receded so far into the distance for him that there are pseudo-Pollocks on the walls, made from yard goods bought in Santa Monica. Oldenburg declares: "Whatever else this act suggests, I intended at the time to use

Pollock as a symbol of Life, and his reproduction, removal by counterfeit and photography, as the symbol of Death."[7] Pollock had, of course, played a significant role in Oldenburg's development, as in that of every major artist of the 'sixties (see pp. 23, 25, 65). To Oldenburg, "Pollock's paint immediately suggested city subjects, the walls, the stores, the taxicabs... Pollock is a paint-legend because, unlike Picasso, he turned the Sapolin loose."[8] In other words, Pollock liberated form; he is the source for a post-Cubist style that unleashes rather than confines. Admiring Pollock's use of automatism, Oldenburg carries the process further into actuality in order to free, not paint nor gesture, but form itself from the restricting confines of rigidity.

In Oldenburg's sculpture, however, chance is not so much cultivated as it is simply assimilated along with everything else, in a generally affirmative attitude of acceptance. In this respect, the artist is like his own vacuum cleaner, indifferently sweeping up everything in its path. "I cultivate disorder and anti-form and turn it into a form (not forcing it)," Oldenburg writes. "Truth is disorder and anti-form, chaos.... To use accepted form is to be decorative or academic." Rigidity must be avoided at all costs: "The avoidance of rigidity consists of the setting up of potentialities to be run by the proper instant, and no decision made until this happens quite naturally. It is frightening to wait seemingly until the last minute, but it keeps it alive."

The result is a radical departure from any previous notion of sculpture. Indeed, in many respects, soft sculpture is the first exclusively sculptural innovation since Cubist construction. The other elements present in post-Cubist sculpture—such as non-relational composition, large scale, and serial imagery (which we may regard as a literal rendering of all-over composition)—all occur earlier in painting. But a yielding, vulnerable surface covering a loose, relaxed form that produces a random composition subject to the force of gravity has no precedent in any other medium.[9]

Oldenburg speaks of the basic process of making automatism literal as "hardening of the free," some-

thing that he had considered as early as 1960, mindful of his childhood recollection of the lightning bolt trapped in sand and materialized as glass. In his "search for techniques that will transform," Oldenburg hardens the free in his Store reliefs, and in his soft sculpture releases the rigid.

The gravitational pull of the intestinelike cords of *p. 134* the giant fans, and the casual disarray of such pieces as the soft drainpipes, the *Shoestring Potatoes Spilling* *p. 135* *from a Bag,* or the *Soft Ladder, Hammer, Saw, and* *p. 138* *Bucket,* give to all these objects the appearance of having composed themselves. At this point the artist is outside of his conception, which assumes a certain life of its own. By making automatism literal, Oldenburg has gone beyond the self-generated paintings of Pollock and Louis, which imitate nature's processes rather than the biomorphic or organic forms of nature. In this context, it is obvious that the change in attitude from Caravaggio's "I paint nature" to Pollock's "I am nature" irrevocably colored and altered Oldenburg's conception of "realism."

NOTES

1. "Specific Objects," in *Arts Yearbook 8: Contemporary Sculpture* (New York: The Art Digest, © 1965), pp. 77–78.

2. Jasper Johns's first one-man show was held at the Leo Castelli gallery, January 20–February 8, 1958. Two years later, his sculpture, including the famous beer cans, was exhibited at the same gallery and impressed many Pop artists, as well as others who went on to create object art. Johns's multiple presentation of the flag image may also be regarded as a forerunner of the methodical, conceptual approach.

3. Other significant innovations exist, of course; but these by and large are extensions or reformulations of later concepts, already present in the art of the 'fifties.

4. See pp. 26–27; p. 33, n. 3; and pp. 35–36.

5. See Appendix: "The Theater of Action," pp. 183–188.

6. "The Spontaneous and Design," Waldorf Panel 2, March 17, 1965; published in *It Is* (New York), Autumn 1965, p. 110.

7. In "Jackson Pollock: An Artists' Symposium, Part 2," *Art News* (New York), May 1967, p. 67.

8. *Ibid.,* p. 27.

9. See Oldenburg's remarks on his soft sculpture, 1966, quoted on page 194.

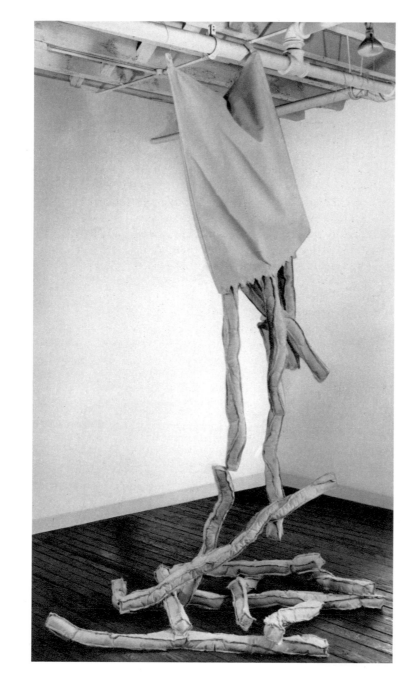

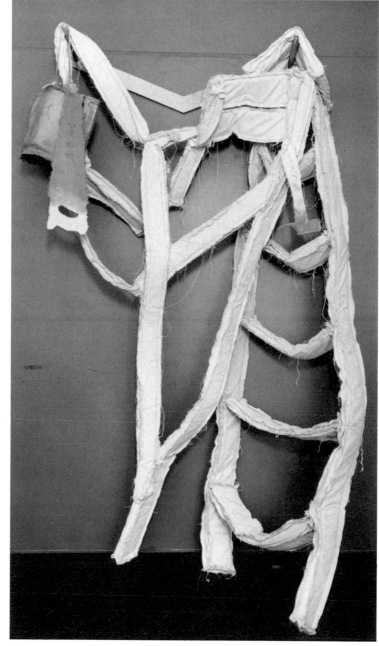

right:
Shoestring Potatoes Spilling from a Bag
(Falling Shoestring Potatoes). 1966
Canvas filled with kapok,
painted with glue and Liquitex,
180 inches high x 46 inches wide x 42 inches deep
Walker Art Center, Minneapolis

far right:
Soft Ladder, Hammer, Saw, and Bucket. 1967
Canvas filled with foam rubber, starched with glue,
painted with Liquitex, mounted on wood,
110½ inches high x 58¾ inches wide x 16⅞ inches deep
Stedelijk Museum, Amsterdam

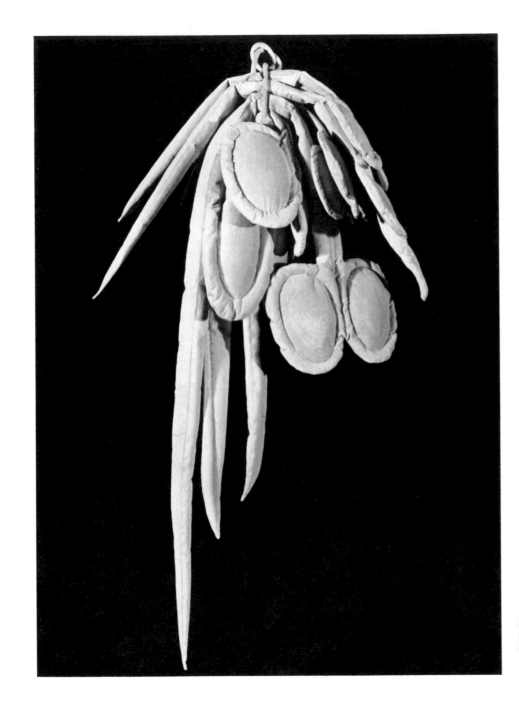

Soft Scissors. 1968
Canvas filled with kapok, painted with Liquitex;
7 pieces, ranging from 24 to 72 inches long; 72 inches long x 35 inches wide over-all
Collection Mr. and Mrs. Thomas G. Terbell, Jr. (courtesy Pasadena Art Museum)

Reality through the Haze

*I see reality thru a haze... I am essentially a dreaming
type, reality as I see it is a dream of mine, or reality mixes
with my dreams.*

*There is no artist worth it who doesn't believe he will
bring dead art back to life, usually by an introduction of
some form of realism... so open up a sign shop in an old
gypsy paint store.*

Claes Oldenburg, notebooks, 1961

*Why do you look at me with a frown, you Catos, and
condemn my work of fresh simplicity? The happy charm
of a pure style smiles in its pages, and my candid tongue
relates what ordinary folks do. After all, who is unaware
of sex and the pleasure of Love?*

Petronius, *The Satyricon*

*I had hitherto seen only one side of the Academy, the other
being appropriated to the advancers of speculative learn-
ing, of whom I shall say something when I have mentioned
an illustrious person more, who is called among them "the
universal artist." He told us he had been thirty years
employing his thoughts for the improvement of human life.
He had two large rooms full of wonderful curiosities, and
fifty men at work. Some were condensing air into a dry
tangible substance, by extracting the nitre, and letting the
aqueous or fluid particles percolate; others softening
marble for pillows and pincushions; others petrifying the
hoofs of a living horse to preserve them from foundering.
The artist himself was at that time busy upon two great
designs; the first, to sow land with chaff, wherein he
affirmed the true seminal virtue to be contained.... The
other was, by a certain composition of gums, minerals,
and vegetables outwardly applied to prevent the growth
of wool upon two young lambs; and he hoped in a reason-
able time to propagate the breed of naked sheep all over
the kingdom.*

Jonathan Swift, *Gulliver's Travels*

Oldenburg has described his work as "an object in the
shape of the artist"; and his soft machines, related as
they are to his own body image, serve as surrogates for
the human body. In their vulnerable humanity, Olden-
burg's soft sculptures are the opposite of Cubist con-
structions with their dehumanized rigidity, just as his
avoidance of formal, fixed design is the opposite of the
Cubists' insistence on composition. Most Cubist sculp-
ture has, in fact, a more mechanical appearance than
any of Oldenburg's soft machines. The love-hate re-
lationship between man and the machine as viewed by
artists of the late nineteenth and twentieth century is
a complicated one,[1] and the problem that modern man
confronts in the control of runaway technology is in
many respects analogous to that which ancient man
faced in learning to master nature. And just as in earlier
art nature was frequently viewed as wild and untam-
able, so many machine-age artists, and especially the
Surrealists, have pictured the machine as an implacable
enemy. By contrast, Oldenburg shares the view of such
artists as Tinguely, believing that, as the distance be-
tween man and machine narrows, man does not be-
come more like the machine; instead, the machine—no
longer menacingly strange, but reassuringly familiar—
becomes more like man: unique, changeable, and above
all vulnerable, like the computer hero who develops
human emotions in Arthur E. Clarke's and Stanley
Kubrick's *2001: A Space Odyssey*.

Such analogies between the machine and the body
are products of the second machine age, the age of
cybernetics, in which scientists see parallels between
the brain and the computer. Oldenburg's world of soft
machines prescribes an accomodation between man
and "man-made nature" or technology. In a passage
reminiscent of Wilhelm Reich, Oldenburg writes:
"Those who care for the world at this time tend to
undress and go naked rather than in armor. I don't
find anything metallic suited to this sensibility." Since
the soft machines are unthreatening, even friendly, in
that they are more like us, we can no longer consider
them alien. And it is precisely an end to man's alien-

ation from his industrialized urban environment that
Oldenburg, the post-Marxist and post-Freudian, seeks
to accomplish.

One can go even further than seeing the soft ma-
chines as friendly; they are attractive, even sexy, con-
sistent with the sexual metaphor ubiquitous in Olden-
burg's work. The erotic is disguised in objects, however,
because Oldenburg rightly concludes that blatant eroti-
cism is pornography, not art, and that "pure sex leads
straight to the Academy." All his objects are both what
they represent, as well as sexual metaphors; some are
closer to their actual prototypes, and others to their
implied prototypes. The *"Empire" ("Papa") Ray Gun*, p. 58
for example, is more like a phallic object than a gun;
by contrast, the Street objects refer to specific Chicago
and New York environments. In a passage already
quoted (p. 48), Oldenburg explained in 1961: "I begin
with a realistic period and end at the limits of meta-
morphosis, when fatigue sets in and the preoccupation
is broken up." The *Bedroom Ensemble*, for instance,
which inaugurated his Home period, is "realistic" by pp. 94–95
comparison with such recent Home objects as the *Soft
Scissors*, made in Los Angeles in 1968.

By setting out deliberately to make an art as
"impure," that is, as inclusive as possible, mixing many
stylistic elements and incorporating the whole range of
art-historical possibilities, Oldenburg has created a
number of problems for the critic. Because he is en-
gaged in playing hide-and-seek with his public and is
determined to elude any fixed interpretation or cate-
gorization by changing his disguises at will, classifi-
cation of his work in terms of style and genre is difficult.
Perhaps the place to begin is by seeing how appropriate
(or inappropriate) interpretations already offered are to
a discussion of Oldenburg's style.

So far, Oldenburg has been seen mainly as a Pop
artist, an heir to Dada and Surrealism, and a late
successor to American-Scene painting. There is some
truth in each of these views, yet his art does not really
fit comfortably into any of these categories. Aside from
the fact that Pop Art was never a coherent style, to

above:
Study for Soft Typewriter. 1963
Crayon and watercolor,
11½ inches high x 13⅝ inches wide
Collection Mr. and Mrs. Peter J. Solomon, New York

opposite, left:
Soft Pay-Telephone—"Ghost" Version
(Model "Ghost" Telephone). 1963
Muslin filled with kapok, painted with Liquitex,
mounted on wood panel covered with muslin,
49⅛ inches high x 22⅛ inches wide x 11¾ inches deep
Collection John and Kimiko Powers, Aspen, Colorado

opposite, right:
Soft Pay-Telephone. 1963
Vinyl filled with kapok, mounted on painted wood panel,
46½ inches high x 19 inches wide x 12 inches deep
Collection William Zierler, New York

begin with, the formal elements in Oldenburg's work, as we have seen, relate him to Abstract Expressionism on the one hand, and to more recent advanced painting and sculpture on the other hand, rather than to synthetic Cubism, collage, or assemblage, which were the main formal inspirations for Pop. His transformation of his sources in commercial art has also been far more radical than that effected by Pop artists. Oldenburg's relationship to Dada and Surrealism has already been discussed; and although a link with Surrealism undoubtedly exists, it consists largely in a common reliance on fantasy and metamorphosis. Where alleged resemblances occur, as to Dali's limp watches, these seem largely a matter of superficial coincidence.[2] Only Magritte, with his fragmented torsos, his questioning of the identity of objects (as in his pictures of a pipe labeled "ceci n'est pas une pipe"), and his distortions of scale (as in his room-size apple), bears any but a remote relationship to Oldenburg; and this again would seem more a question of similar thought processes than of direct influence.

As opposed to the Surrealists' presumably "automatist" imagery, Oldenburg's automatism is always tempered with a degree of control, and his use of fantasy is consistently directed toward some preconceived end. Not dreams, but daydreams—consciously induced and manipulated fantasies—provide his inspiration. Even if, as Ulf Linde has maintained, Oldenburg's soft sculptures often look as though they were "asleep," the artist himself is wide awake when he conceives them.[3]

If Pop, neo-Dada, or post-Surrealism do not suffice as contexts for Oldenburg's art, neither does the tradition of American realism, although in many respects it comes closer than any of the others. For Oldenburg is not drawn to an otherwordly superrealism, but rather to a low and vulgar street art like that of the Ashcan School. Yet even though he is a "realist," to the degree that he creates identifiable figures or objects, he always changes reality in a significant manner. His images differ from their prototypes

in virtually every respect—scale, form, color, texture. His realism is therefore always relative and is always mixed with elements of fantasy. Max Kozloff has posed the question whether Oldenburg is a caricaturist.[4] It seems to me that he clearly is not, since caricature merely mocks reality, making it grotesquely deformed and unpalatable. There is, however, another more serious and, by implication, more revolutionary genre of humor, which freely mixes reality with fantasy; and that is satire.

Describing the famous supper in Petronius' *Satyricon*, the masterpiece and prototype of satirical humor, J. P. Sullivan writes: "There is no attempt at a phonographic or photographic realism.... It is the careful detail of incidents, the elaborate impressionistic pastiche of vulgar speech and lower-class platitudinizing... that provides the feeling of authenticity.... What unifies the realist tradition in any genre, and sets it off against the romantic, the heroic and the sentimental, is the belief that only the vulgar, the sordid and the sexual elements of life are truly real, that the rest is the humbug of the canting moralist."[5] This, loosely, is Oldenburg's position. If indeed one can encompass the vast territory of his imagination within a single category, that category would be satire; for like the great satirists Petronius, Rabelais, Swift, and—a nearer influence— Twain, Oldenburg has concluded that realism must be tempered with humor.

In some ways, Oldenburg's colossal, bulging objects seem to illustrate Roger Shattuck's observation that "The future of realism... may lie in the ease with which it can sustain the carefully timed commentary of humor." Dislocations of scale, the consistent humor of the implied metaphor of the human body, and, in the case of the monuments, the incongruity between the imagined object and its actual setting, supply the satirical elements in Oldenburg's realism. "Sanding the wooden typewriter keys," Oldenburg remarks in his notes, "I feel like a manicurist." At another point, he speaks of the "perception of mechanical nature as body." By anthropomorphizing inanimate objects, ex-

aggerating their scale far beyond natural proportions, and altering their physical properties, Oldenburg invests them with the vulnerability and lumpy contours of the human body—a tired, sagging, middle-aged human body, one might add, not an idealized version.

This tendency to anthropomorphize by seeing analogies to the human body or physiognomy in inanimate forms has many precedents in art history. It can be found in earlier American art; in some ways, Feininger's representations of locomotives, Dove's bug-eyed ferryboats and dancing trees, and Burchfield's haunted houses with their gaping mouth doors are ancestors of Oldenburg's lewdly grinning typewriters and comically drooping telephones.

Although satire is primarily a literary genre, there is also a long tradition of satire in the visual arts, and it is this to which Oldenburg appropriately belongs. For, despite his mastery of verbal as well as visual imagery, he does not create an art that is fundamentally literary, like much of Surrealism. Meaning in his work is conveyed exclusively by vision, through his new vocabulary of forms. The absence of any specific narrative or time element in Oldenburg's art ensures its distance from literary art or illustration; there is no story to reconstruct. Cognition is immediate and identical with kinesthetic and tactile response, hence physical rather than verbal or intellectual.

The tradition of satirical realism in the visual arts goes back at least as far as Greek comic terra-cotta figures and Roman grotesques. It continues through the marginalia in medieval manuscripts, the theme of Folly in the illustrations of the "ship of fools" popular in the fifteenth century, Bosch's and Breughel's paintings of parables, and the "crazy companies" and "topsy-turvy" genre of the seventeenth and eighteenth centuries. Throughout its history, satirical realism has largely been a popular type of art, and its basic content has been folk wisdom. Oldenburg invents a contemporary version of this tradition and proposes a genuinely popular idiom, rooted in popular culture. His sagging, clownish objects resemble the comic-pathetic character

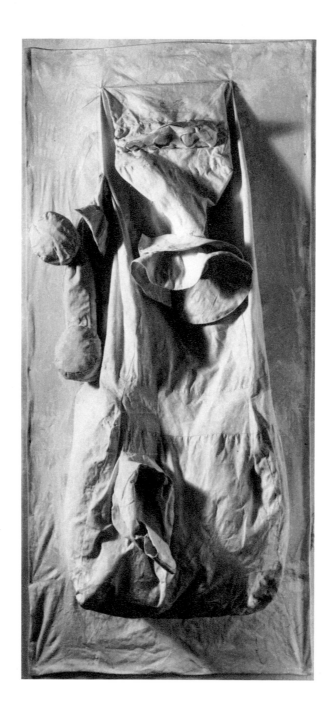

141

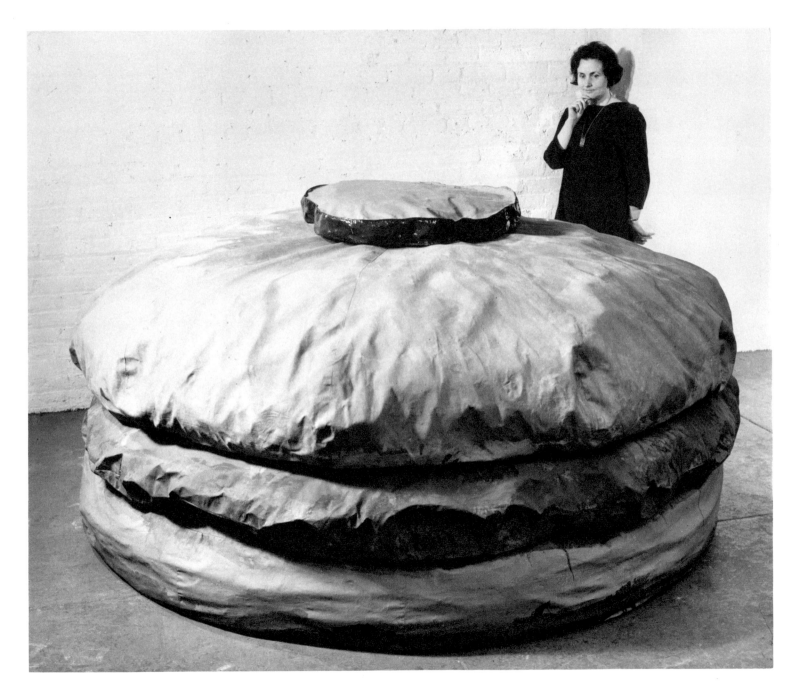

Floor-Burger (Giant Hamburger). 1962
Canvas filled with foam rubber and paper cartons,
painted with Liquitex and latex,
52 inches high x 84 inches diameter
Art Gallery of Ontario, Toronto

that Oldenburg so often impersonates in his happenings, the heir of Chaplin and W. C. Fields. The message of Oldenburg's art, like that of other works in the traditions of satire, the fool, and the clown, is of man's fallibility and vulnerability.

In terms of the spirit of his work, with its mixture of satirical content and advanced formal means, Oldenburg's nearest analogue is probably Goya. Oldenburg's critical position in relation to contemporary society is like Goya's complex relationship to the Spanish society of his day, combining both detachment from, and participation in, the current establishment. Moreover, certain of Goya's themes, for example the distorted mirror images in his drawings, have specific correspondences in Oldenburg's work. Like Goya, Oldenburg holds up a mirror to society, in which it may perceive itself transformed, as Goya drew men who see their reflections animalized.

Similarly, Oldenburg's half-man, half-machine images recall half-man, half-animal themes in earlier art. Thus, the Airflow is a contemporary centaur. Oldenburg offers an updated version of the priapic satyr play, without which no classical high tragedy was complete. The current danger to which Oldenburg points is not so much that man will sink to the level of animals, but rather that he will be indistinguishable from the creations of his own technology. This represents the secularization of a former religious theme: man, who once stood midway between the devils and the angels, now occupies a position midway between the animal, from which he evolved, and the machine, which he himself conceived and created. His salvation consists in maintaining his distinctly human identity, as neither the one nor the other.

Just as the realism of Breughel and Goya was relative to their mocking satirical content, so Oldenburg alters the world that he mirrors in his art. "I always begin from a real thing," he declares. "The difference is whether I leave it alone, extracting all I can from it and imposing nothing, or on the other hand, sink it in the impure soup of myself and all associations,

and in a direct, naive way, reconstruct the world." Oldenburg, like Goya, is an interpretive sieve through which "reality" passes in order to be distilled into its "truer" essence. Appearances, in other words, are an illusion, and the truth lies beneath the surface—another of the central themes of the tradition of satirical genre, which mocks the superficialities of hypocrisy, rhetoric, and cant.

Together with the transformation from "hard" to "soft," the change in scale is the most significant, or at least the most immediately striking, of Oldenburg's departures from his prototypes. Such changes in scale occur in children's tales and the literature of satire and fantasy (e.g., *Alice in Wonderland, Gulliver's Travels*), as well as in hallucinations, natural or drug induced, and in mystical meditation (e.g., the Zen exercise of transforming the perceived scale of objects through mental control). Undoubtedly, Oldenburg is aware of all these traditions, but the specific source of his own distortion of scale is to be found in the photographic *p. 20* collages sent to him as a child by his aunt.

The purpose of changing scale is, of course, to cause the viewer to question his perceptions and the nature of the objects he is identifying. Such feedback to one's own perceptions is one of the major identifiable characteristics of the art of the 'sixties. In this connection, Oldenburg has mentioned the influence of Poe's short story, "The Sphinx": A man believes that he sees a colossal monster moving toward him, only to discover that, from a distorted angle of vision, he has been looking at an insect crawling on his window. What one sees, in other words, is always relative to who one is, or the angle from which the thing seen is perceived.

NOTES

1. Many of these attitudes are discussed by K. G. Pontus Hultén in *The Machine as Seen at the End of the Mechanical Age,* catalogue of an exhibition held at The Museum of Modern Art, New York, November 25, 1968–February 9, 1969.

2. In 1966, he wrote in his notebooks: "The question which is often asked is what relation have the soft pieces to the surrealist soft watch of Dali. Partly this is explained by the origin of the technique, in response to form and material rather than the instrumentation of an idea. This is reflected in that they are tangible, 'actual' rather than painted. The associations have followed the invention."

The theme of metamorphosis in the visual arts of course antedates Surrealism by millennia. Like metamorphosis in literature, and like satirical genre, it originates in Hellenistic and Roman culture and has specific prototypes in the fanciful *grotteschi* of Roman decoration. In the Middle Ages, the diabolical and irrational elements of metamorphosis were stressed. The concept of metamorphosis may indeed be the first explicit expression in civilized art of the unconscious, representing an early form of free association.

3. "Claes Oldenburg at the Moderna Museet, Stockholm: Two Contrasting Viewpoints," in *Studio International* (London), December 1966, pp. 326–328. According to Linde, "The body of a person awake is shaped by resistance to the force of gravity—whereas the sleeper's body on the contrary *accepts* gravity. It offers no resistance. The softness in Oldenburg's soft sculptures makes these anthropomorphic; but they resemble people asleep, not awake. Though the poetic effect is yet more complicated—the associations of pillows, the most essential of all sleep-articles, is certainly meaningful—(or mattresses)."

Linde points out that many of Oldenburg's works are concerned with sleep, and that "a person going to

bed performs a certain ritual... He plays the role of a sleeper before he falls asleep.... Responsibility is removed along with the clothes. The ritual is concerned with redemption and rebirth..." Pursuing the sleep metaphor further in Oldenburg's work, one finds a number of allusions, in the notebooks as well as in the happenings, to bears, the animal that hibernates, almost as if Oldenburg were identifying himself with that sleeping creature. (An interviewer has in fact described him as "bearish.") The bear image occurs in the scenario "Faustina" and is seen again in the proposals for a Teddy Bear monument. In several of the Store Days performances, Oldenburg appeared as a lumbering, bearish creature (cf. also *Store Days*, New York: Something Else Press, 1967, pp. 145–148). In "Faustina," the Polar Beast "taking all the tortured hordes into his ice-maw, swallowing Staten Island, sucking the statue into his proud nose" is a kind of abominable savior (*Injun and Other Histories*, p. 11). Discussing the performance of "Massage" given in connection with his exhibition in Stockholm in 1966, Oldenburg said: "The audience were all given blankets and blindfolds. Everything got quieter and quieter, as though everyone were asleep. There was this obsession with sleep—it was the same in London, like the ancient laws of the bears going to sleep for the winter—as if the whole exhibition had sleep as the dominant metaphor. First the *Bedroom*, and then the *Light Switches* you could turn on and off" ("Take a Cigarette Butt and Make It Heroic," interview by Suzi Gablik, *Art News* [New York], May 1967, p. 30). Oldenburg's references in his notes to his seasonal cycles of work, as well as the cavelike scenery in his early happenings, also recall the habits of the bear.

4. "The Poetics of Softness," in catalogue of the exhibition "American Sculpture of the Sixties," Los Angeles County Museum of Art, April–June 1967; reprinted in Max Kozloff, *Renderings* (New York: Simon and Schuster, 1968), pp. 229–230.

Oldenburg himself admits that some of his works are parodies, rather than satire: "I know I make paro-

dies on artists, as with the vinyl ketchup forms which have a lot of resemblance to Arp, but why? ... Maybe it is because I have always been bothered by distinctions—that this is good and this is bad and this is better, and so on. I am especially bothered by the distinction between commercial and fine art, or between fine painting and accidental effects. . . . If it was just a satirical thing there wouldn't be any problem. Then we would know why we were doing these things. But making a parody is not the same thing as a satire. Parody ... is simply a kind of imitation, something like a paraphrase. It is not necessarily making fun of anything, rather it puts the imitated work into a new context. So if I see an Arp and I put that Arp into the form of some ketchup, does that reduce the Arp or does it enlarge the ketchup, or does it make everything equal? I am talking about the form and not about your opinion of the form. The eye reveals the truth that the ketchup looks like an Arp. That's the form the eye sees. You do not have to reach any conclusions about which is better. It is just a matter of form and material" (in a panel discussion broadcast by WBAI, New York, June 1964, moderated by Bruce Glaser and published as "Oldenburg, Lichtenstein, Warhol: A Discussion," *Artforum* [New York], February 1966, p. 23). To Oldenburg, obviously, art objects are like any other objects that can be equated with the form classes that they resemble, irrespective of their semantic "meaning" (see pp. 169–171).

5. "Satire and Realism in Petronius," in *Critical Essays on Roman Literature: II. Satire,* edited by J. P. Sullivan (New York: Hillary House, Division of Humanities Press; paperback edition, Bloomington: Indiana University Press, 1963), pp. 86–87.

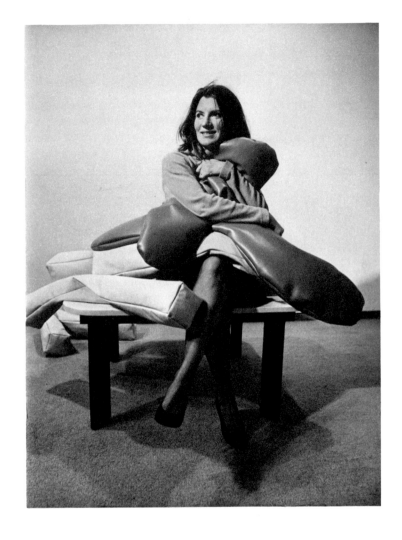

Pat Oldenburg with French Fries and Ketchup. 1963

The Baroque Style of Mr. Anonymous

Painting has been private and lyrical for a long time, especially when true artists are not given large and public commissions. The mural, the environment, the pageant, the masque, the larger spatial, architectural forms are forms of art not without precedent. There comes a time when the artist wants to use these forms and directly involve his audience, directly influence and involve actual experience. If the considerable funds which such things require are not available (and they are not), he must use what he can get without funds — borrow, find (and I do not recommend) steal. He may console himself with the argument that privation furthers ingenuity.

Claes Oldenburg, notebooks, 1961

Where, I wonder, did Bernini find the time to sew all those sculptures?

Claes Oldenburg, "America: War & Sex, Etc."

We have mentioned that Bernini was a man of the theatre and such works as the Cornaro Chapel have been dubbed "theatrical" by unfriendly critics of a later period. There is, however, nothing inherently wrong with theatrical art; anything that exceeds the boundaries of what we consider decorous may be damned as theatrical, but we have not made a useful judgement. On the other hand, we have seen that Bernini's artistic flexibility and vision led him to borrow techniques from other arts, and he must have been influenced by theatrical practice early in his career. In his actual works for the theatre he tried to make stage effects as "real" as possible in order to intensify the dramatic impact. We read of an actual fire on stage, of a realistic sunrise, and of a staged flood seeming to threaten the audience. These devices tended to break down the psychic as well as the physical barriers between staged drama and human spectators.

Howard Hibbard, *Bernini*

According to Oldenburg, his softening of objects should not be seen as the effect of atmospheric blurring on forms, but as "in *fact* a softening"—in other words, a literal translation of painterly values into their sculptural equivalents. Such a transmutation of originally pictorial effects into sculpture recalls the age of the Baroque, when painterly sculpture in the round was produced for the first time since antiquity. To this tradition, which stresses the tactile value of surface and the properties of the materials represented, belong the great Baroque sculptors—Bernini towering above them—as well as the late-nineteenth-century revival of painterly sculpture by such artists as Degas, Rodin, and Medardo Rosso. Oldenburg's soft sculptures are notable as being the first significant reassertion of this tradition in the 1960s.

The softness in Oldenburg's sculpture is both an actual and a specific quality. His procedure is the opposite of the traditional techniques of either carving away material from a solid block of wood or stone, or modeling by building up clay or wax on an armature. Oldenburg's pieces are "modeled" from the inside, and he has described the act of choosing the "kind of stuffing and how much and where it will gather—fat or lean" as the crucial moment in his work. In contrast to earlier kinds of painterly sculpture, which bear the mark of the artist's impress, the exterior surfaces of Oldenburg's soft sculpture tend to be more uniform and continuous. His degree of control is greater in the stiffened canvas sculptures, such as the drainpipes, which naturally stay put as placed to a greater degree than their floppy vinyl or soft fabric counterparts.

If Oldenburg's materials and techniques separate him from traditional art, his interest in modeling nevertheless relates him to it once again. Both in his soft sculpture and in his earlier reliefs, he usually relies neither on plane, as do Cubist constructions, nor on volume, as do "primary structures," but rather on the traditional means of expression of painterly sculpture— undulating mass and contrasts of light and dark. The *"Empire" ("Papa") Ray Gun*, for example, one of *p.58*

his earliest three-dimensional objects and a key piece in his oeuvre, is a large, simple form with a single continuous surface that twists dramatically through space like the branches of a gnarled tree. Its irregular silhouette does not resemble Arp's generalized organic shapes, however—natural forms that have been refined, smoothed, and aestheticized to a generic type; instead, it is a raw, fluctuating mass whose eccentric outlines and elaborately dripped and painted surface ensures its particularity.[1]

Although there are no fingerprints on Oldenburg's sculpture to remind one of his personal touch, his is both an extremely personal and an extremely tactile art. The later Store objects, in particular, ask to be handled. *pp.88–89* Details are executed with meticulous care; variation is cultivated; each tiny plaster pancake and cupcake, each chocolate bar and sundae, is unique. What counts is the subtle contour, the small detail played against the large, simple form of the whole. Moreover, Oldenburg's aim is to enhance this tactility and intensify the urge to touch by "devices which prevent touching, like the silver chain in the door to the Bedroom Ensemble ... or the glass of the pastry cases." This invitation to pick up or handle an object is also a function of the type of objects that Oldenburg chooses to make. The food, articles of clothing, and furniture are normally articles of personal contact, of the kind we would normally tend to pick up, handle, or consume. "The name of the thing tells you how to grab it (camera, gun) or what to do with it (ice cream, chair, jacket)." Setting up this intimacy and direct relationship between the viewer and the object serves to erode the "psychic distance" or sense of estrangement that one usually brings to the aesthetic experience. By choosing as his subjects such everyday objects, rather than making paintings or sculpture immediately identifiable as "art," Oldenburg forces the viewer to react to them in terms of his normal expectations instead of with the specialized, detached attitude generally associated exclusively with aesthetic encounters in the artificial isolation of a museum or gallery. The artist's intention is to short-

circuit perception by forcing a direct, intimate, and personal contact with the work.

As has been noted, any attempt to analyze Oldenburg's style is complicated by the fact that he has deliberately chosen to create a mixed style of maximum impurity. He does not seek to duplicate an object but to epitomize it, to re-create it in its most general form— a form, however, which is never ideal and in fact is often so exaggerated as to be hardly recognizable. His "realism" is therefore entirely relative; as he puts it, it "has to do with identification with the object and with processes, natural and human" (a definition well outside of any traditional one). Ultimately, one must conclude that Oldenburg's "realism," like so many other superficial characteristics of his art, is just another disguise to hide the actual nature of his style.

The purpose of this stylistic masquerade is obviously to cast into doubt the whole notion of style. This Oldenburg accomplishes effectively by absorbing elements from the two dominant, opposing stylistic currents of Western European art: the classic and the romantic or expressionist. Having studied the "Ingres, Delacroix argument," he concludes that there are "always two heresies: the lyric heresy, the arabesque heresy... etc." In a particularly disingenuous moment, he writes that the style to which he aspires is the "style of the simple artisan, Mr. Anonymous." Furthermore, he describes the decorative element within his art as being the result of a naive commercial-conventional style "with touches of expressionist addition such as in ads or house painting." In other words, he advocates treating popular subjects in terms of the conventions of popular art, in the belief that "a realism which copies the posters and ads instead of the thing itself" is appropriate to American subjects, because "in America painter means sign or house painter anyway."

How much of this can we take at face value? Is Oldenburg's style, in fact, the naive, popular style based on commercial art that he claims it is; or is it, rather, the rebirth of a sensibility that superficially has little in common with the sensibility of the present

Pickle Slices in Jar. 1963–1964
Canvas filled with kapok, painted with Liquitex, in glass jar, 10 inches high x 6 inches diameter
Collection Professor Hanford Yang, New York

Pain et fromage (Bread and Cheese)
Plaster over wire frame, formed in corrugated cardboard, painted with tempera, 3³/₄ inches high x 21³/₈ inches wide, on plate 19¹/₄ inches long
Collection Gerard Bonnier, Stockholm

moment, to which it must therefore find some highly original means of accommodating itself? If we compare Oldenburg's drawings with their prototypes (not to mention his objects, which are even further removed from the newspaper and magazine ads that inspired them), it immediately becomes clear that image and prototype are light-years apart. For Oldenburg always transforms his motifs in the rendering, and unlike most Pop artists he never seeks to ape the mechanical, anonymous procedures of commercial art. Although his subjects may be drawn from popular illustrations, he modifies them to a far greater extent than Courbet or Manet modified their adaptations of popular imagery in order to conform to the traditions of "fine art." Oldenburg's outline drawings do not bring to mind the dead line of newspaper advertisements, but rather the lithe, classical arabesques of Fuseli or Ingres.

Similarly, what the rich surface texture of Oldenburg's fluttering flags and shops signs recall is not the naive efforts of the untrained sign-painters of the Lower East Side, but the billowing draperies of Bernini's cardinals and prelates. Nothing in his art, in fact, is dull, mechanical, or contrived. Even working models, such as the styrofoam models for monuments, are remarkable for their nuance, precision, and detail. In the model for the Toronto *Drainpipe,* for example, which resembles a three-dimensional drawing with the string divisions functioning as line, the crisp white styrofoam, smartly cut and jointed, projects away from the contrasting background of hard, mottled brown cardboard. In the soft versions of the drainpipe, *pp. 135,* the seams of the canvas or vinyl, which function as *173* drawing, are stitched with similar care and craft. There is no confusing the precision of the seams, reversed tucks, darts, and folds of the vinyl pieces with ordinary dressmaking. The production of the vinyl work, in fact, depended at the outset entirely on Pat Oldenburg's expert ability to carry out her husband's demanding requirements.

One of the pieces that most fully illustrates the importance that Oldenburg gives to detail is the *Soft*

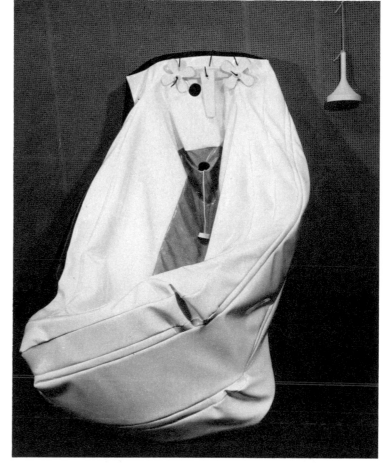

above:
Soft Bathtub. 1966
Vinyl, reinforced with sheets of polyurethane,
painted with Liquitex, wood, rubber,
30 inches high x 80 inches wide x 30 inches deep
Collection Mr. and Mrs. Roger Davidson, Toronto

left:
Giant Drainpipe—Model. 1967
Styrofoam, cardboard, 52 inches high x 40 inches wide
Owned by the artist

Manhattan, I—Postal Zones. This canvas work is not *p. 10* "designed" in the sense of a Cubist composition. On the contrary, the street grid—the essence of rigid city planning—is permitted to flop informally and casually. The whole, however, is coherently organized in terms of the relationships between the large and small elements, and the division of the single enclosing shape of Manhattan Island into compartments and zones. Structure, always present in Oldenburg's work, is determined by proportion and repetition rather than by juggled balance or symmetry. Because of the consistent presence of structure, the result, however casual or informal, is never amorphous nor arbitrary. The entire surface of the piece is worked: gray, black, brown and pale green (marking the parks and squares) are alternated. In the companion piece, *Soft Manhattan, II—Subway Stops,* vertical and horizontal "subway lines" are played off against round "stops," tiny buttons whose hardness contrasts with the soft edges of the fraying routes and the yielding pillow of the island. Texture, applied by pressing corrugated cardboard sprayed with enamel against the canvas surface, results in uneven horizontal and vertical striations that create further enrichment and recall painterly chiaroscuro.

By challenging the formal conventions of Cubism, Oldenburg has produced an art as radical as any proposed in the 'sixties. There is no question, therefore, of his being an academic artist; yet there is equally little doubt that his execution and technique, as well as his style, place him within a specific fine-art tradition—that of the Baroque. With its exaggerations, grandiosity (occasionally enlarged into pomposity), its effacement of the conventional boundaries between the different mediums, its ties to theater and environments, and its translation of painterly values into sculpture, the style of "more than" that Oldenburg proposes is manifestly a contemporary expression of the Baroque sensibility. The Baroque is marked by its urge toward just such a dissolution of conventional boundaries, including those between the various branches of the plastic arts as well as those between the visual arts and the theater.

The description of the Baroque that Heinrich Wölfflin wrote with reference to its architecture may well serve to describe Oldenburg's style; the Baroque, according to Wölfflin, "in place of the perfect, the completed, gives the restless, the becoming, in place of the limited, the conceivable, gives the limitless, the colossal. The idea of beautiful proportion vanishes, interest concentrates not on being, but on happening."[2]

That an artist of Oldenburg's Baroque temperament could discover a means of expressing his vision in terms of current values is evidence of his remarkable genius for adaptation; and it was his detailed analysis of art history, which we have mentioned earlier (pp. 23, 30), that enabled him to accomplish this amalgamation. His approach to style is nevertheless not imitative nor even eclectic, but anthological. He is determined to absorb, assimilate, and telescope the entire range of the various polarities encountered in art history within the context of his own personal style.

Oldenburg's art of "more than" is a style of exaggerations—of surface detail, texture, and above all of scale. By constantly exaggerating, he creates "a style that is in itself a satire on style." His objects are softer, harder, lumpier, smoother, bigger, brighter, than any real objects. Once again, the two great satirists Swift and Rabelais come to mind when we try to describe the kind of alterations of reality that Oldenburg indulges in. But these alterations are nevertheless executed in terms of a consistent sensibility that in its expansiveness, inclusiveness, and extraordinary range of scale, themes, and mediums, inexorably evokes the all-embracing character of Baroque art.

Many of the themes of Baroque art—the seasons, the five senses, the elements, and such universalities as birth and death—are referred to in Oldenburg's art, especially in the happenings. His art shares with that of the seventeenth century the attempt to find the spiritual in the material, the transcendent in the commonplace. Even certain types of literalness in which Oldenburg indulges have antecedents in the Baroque, for example, the rendering of light and clouds

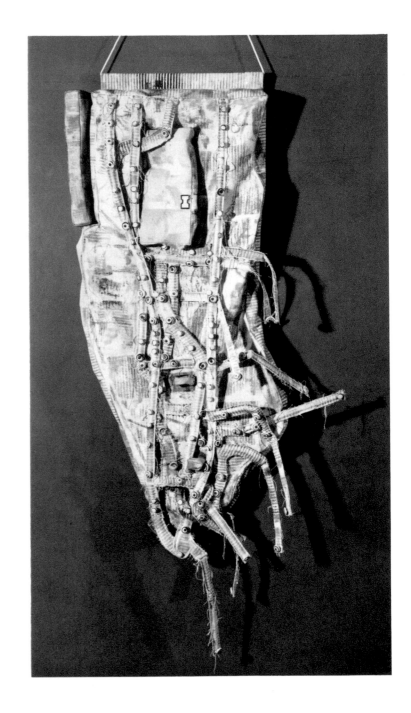

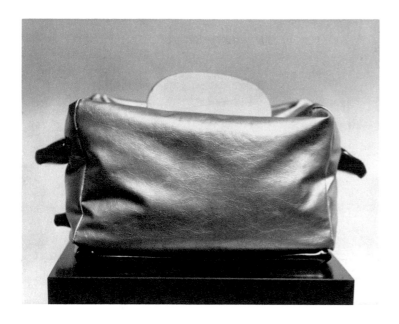

above:
Soft Toaster. 1964
Vinyl filled with kapok, wood "handles" and "toast,"
painted with Liquitex, 11³/₈ inches high x 11⁷/₈ inches wide,
on formica base 3¹/₈ inches high
Collection Ellen H. Johnson, Oberlin, Ohio

opposite:
Soft Manhattan, II—Subway Map. 1966
Canvas filled with kapok, impressed with patterns in sprayed
enamel, wooden sticks, wood rod,
68 inches high x 32 inches wide x 7 inches deep
Collection Mrs. Claes Oldenburg, New York

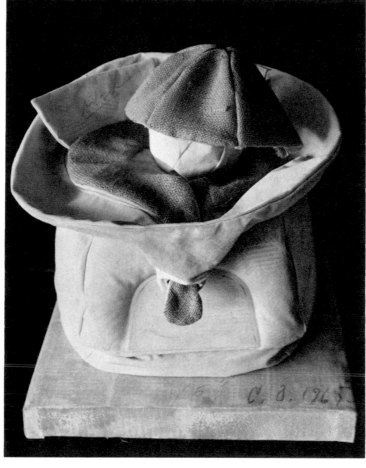

Soft Juicit—"Ghost" Version. 1965
Canvas filled with kapok, burlap, painted with Liquitex,
19 inches high x 18 inches wide x 16 inches deep
Collection Mr. and Mrs. Roger Davidson, Toronto

as solid bodies, as in Bernini's masterpiece, *The Ecstasy of Saint Teresa.* Oldenburg's art, dominated like that of the Baroque by the great themes of love and death, likewise seeks to capture the ephemeral moment, to represent movement and atmosphere, and to encompass a range from the microcosmic to the macrocosmic.

Oldenburg's style also resembles the Baroque in being one of maximum impurity and excessive richness, which draws on everyday life in order to tap its vitality. To create a high art of low elements was originally the intention of Caravaggio, the first realist in the popular vein, and of his many followers. It seems obvious that Oldenburg, in fact, consciously imitates the Caravaggiesque tradition of monumental genre. In his work, the forms of humble domestic appliances often achieve a monumentality that is lost to many an abstractionist working in the "high" tradition. Oldenburg's deliberate choice of an ostensibly "low" context for his highly sophisticated style masquerading as anonymous, naive realism is based on his belief that nowadays more validity is to be found in low art than in high, which he regards as heir to the traditional academy, producing empty decoration for bourgeois living rooms. For Oldenburg, like Caravaggio, is more than a radical artist. He is a revolutionary personality, and his art is predicated not only on revolutionary aesthetic values but on revolutionary social, sexual, and psychological values as well.[3]

If the radical elements in Oldenburg's style are disguised (and often invisible to those biased against representational art), his ties to tradition, too, are often equally hard to discern, because they are purposely disguised. Although he embraces the whole of the life-affirming humanistic tradition as reformulated by seventeenth-century artists such as Caravaggio and Bernini, Oldenburg masquerades as the narrowest of philistines, the king of the yahoos. To avoid sentimentality, the humanist (especially in modern times) will appear a nihilist, the sage will play the fool.

Given the difficulties one encounters in analyzing Oldenburg's style, it is obvious that at least equal

149

difficulties will be encountered in any attempt to reconstruct his stylistic development. This is especially true because he belongs, in a sense, to that group of artists who make a sudden breakthrough to a personal style, and whose art thereafter unfolds laterally, rather than pressing forward in a logical linear progression. Oldenburg's early paintings, such as his *Self-Portrait* p. 26 or *Girl with a Furpiece,* are in an accepted twentieth-century expressionist vein. His first sculptures (the primes being the white *Elephant Mask* of 1957–1958 p. 28 and the *"Empire" ("Papa") Ray Gun* of 1959) are p. 58 simple, large, unitary forms. Both are irregular masses with forceful silhouettes, the former being relatively geometric, and the latter organic. In addition, both are obviously hollow shells, more related to the tradition of modeling than of carving, even though, like the later soft sculptures, they are modeled from within rather than being built up in the conventional fashion.

The first noticeable stylistic change in Oldenburg's art occurs in 1959 and is signaled by the rejection of Dubuffet and his *art brut*—which, interestingly enough, echoes the earlier rejection of Surrealism by the Abstract-Expressionist artists of the New York School. In the second version of the Céline-Dubuffet p. 36 drawing, done in graffiti style, the word "Frenchmen" is crudely lettered across the bottom. This is to say that Dubuffet, although admired, is to be discarded as an inspiration because he is too European.

Oldenburg's saturation in American history during the summer of 1960 in Provincetown marks the beginning of his search for a native American style. In the course of that summer, he complained, "Art here is gilded, private, turned to museums and homes ... art is innocuous." There is a curious parallel here with the attitude of the American realists of the early twentieth century, the members of The Eight. Everett Shinn declared that painting in America was "effete, delicate and supinely refined ... lockstepped in monotonous parody in a deadly unbroken circle, each canvas scratching the back of the one in the lead." The similarity between Shinn's conclusions about American

art and those of Oldenburg some fifty years later is no mere coincidence. Both judgments stemmed from a similar rejection of "European" art—that is, of a rational, orderly progression, a tradition based on academic precedent and transmissible skills. Oldenburg, like The Eight, ultimately repudiated this European tradition in favor of an art tied to, hence presumably more expressive of, the American experience.

To some extent, all current American art lives in the shadow of Abstract Expressionism; but one tendency, that of color abstraction, is a continuation of the mainstream of French painting, whereas Pop and Minimal Art reach further back beyond Abstract Expressionism to link up, not with the School of Paris, but with earlier American art.[4] Paradoxically, the European-born Oldenburg is most systematic in his recapitulation of earlier American themes. His career as a journalist parallels that of the Ashcan School painters, and his habit of wandering around in the slums sketching matches Henri's description of the sketch hunter who spends delightful days drifting among people, in and out of the city, going anywhere, stopping as he likes. In a sense, Oldenburg's work fulfils Henri's expectations of the artist who "moves through life ... not passing negligently the things he loves, but stopping to know them ... learning to see and to understand—to enjoy."[5] Oldenburg had, in fact, read and admired *The Art Spirit,* and his point of view was virtually identical with that of Henri, who complained: "The real study of an art student is more a development of that sensitive nature and appreciative imagination with which he was so fully endowed when a child, and which, unfortunately in almost all cases, the contact with the grown-ups shames out of him before he has passed into what is understood as real life."[6]

That an "American" style would have to be based on popular themes and an anonymous execution ostensibly lacking in personal idiosyncrasy had already been the conclusion of the Precisionists in the 'twenties. (Interestingly enough, Oldenburg's telephone, one of p. 141 the projections of his own body image, brings to mind

Sheeler's self-portrait, the close-up of a telephone.) Oldenburg's self-consciousness regarding a "democratic" vs. an "elite" art and the necessity of inventing an indigenous style independent of European models is a constant thread throughout the history of American art. The irony of Sheeler's and Demuth's choice of humble industrial subjects as vehicles for their monumental, Cubist-style paintings is constantly evoked in Oldenburg's art.

But just as Oldenburg's pretension to anonymity is a sham, so to a degree is his search for an "American" style. In one of his analytical observations, he wrote in 1961: "Style works by action-reaction. The artist sensitive to his times' needs emphasizes that which is the opposite of what he is and what nature is tired of— thus he serves nature." By that date, he was thinking that "the very thing that we or that I am fighting is the rigidity of definition of a form." In other words, style itself is a trap; therefore it too, like content, must remain subject to revision. He is critical of Picasso, "whom one admired for variety [and who] is now seen to have very little ... whom we admired as free is seen to have trapped himself in style."[7] To avoid being ensnared by rigidity and sterility, style must be variable, fluid, protean; like content, it must be responsive to the artist's changing experience. In this belief, rather than progressing from a softer to a firmer style, or from sloppiness to neatness, Oldenburg begins to oscillate between stylistic extremes and to make the same object in soft and hard, tidy and disorganized states. Obviously, this does not conform to previous conceptions of stylistic development, for several reasons.

First of all, there is the fact of Oldenburg's liberating epiphany—the germinal years between 1959 and 1961 during which he undertook his analytical investigations. Ever since then, his art may be said to have consisted more or less of his working out and executing conceptions that had their origins in that brief inspirational period when everything, from soft sculpture to random composition to changes in scale and theme, was already plotted out. This generalization remains

true even though, as we have observed, each new locale in which Oldenburg works brings about some kind of stylistic change—the objects made in Paris, for example, being dainty and refined in the tradition of European cuisine, in contrast to the work done shortly before in Los Angeles, which was tough, blunt, vacant, "primary," and blocky.

The second reason that Oldenburg's development does not conform to earlier notions of stylistic progression is that in many respects the 'sixties have represented the culmination of a "post-historical" period (if one regards history as being an evolutionary process of development). Not only is the entire storehouse of world art now available through reproduction, but also new theories, derived by Kubler from Focillon, which view the evolution of forms as independent of period styles, have gained currency. The possibility that formal invention can exist independently of any given style, that form classes span the ages, and that artists are linked back and forth across history by their sensibility, or as Focillon put it, their "family of mind," rather than by their style, has had an enormous impact on artists of the 'sixties. In certain respects, Ad Reinhardt and Oldenburg represent antithetical attempts to formulate a style so inclusive that it could reconcile all the polarities of world art history and channel them into a single expression. But where Reinhardt says "no" to everything and creates a rejective, minimal art of maximum purity, Oldenburg says "yes" to everything, weaving together into a single strand the diverse currents of artistic expression throughout the ages in an all-embracing art of maximum adulteration.[8]

Given the premise that the artist today is heir to the ages, the notion of style itself becomes relative; and this is one reason that we now see a number of artists working simultaneously in a number of styles. Oldenburg himself points out how important it was for him to discover that "it was perfectly possible and moral to create in several styles—providing that the body found itself in circumstances congenial to the style." Using the body as his criterion, he categorized style into four basic types and treated fragments of the figure in terms of each. His categories were: 1. emotional (expressionist).– 2. fantastic (organic). – 3. natural (realistic). – 4. abstract (geometric). Each of these was in turn subdivided into mixed categories that combined elements of two or more of the other classes.

If one cannot precisely speak of a stylistic development in Oldenburg's art, one can at least trace his use of materials, for they, more than any other factor, have determined the form of his work.[9] The two-dimensionality of the Street figures was conditioned in large part by the ready availability of corrugated cardboard picked up off the street. Scraping lumps of food off plates while he worked as a dishwasher in Provincetown led Oldenburg to thoughts of working in plaster, which "like wood is a material close to one in the city all year." The Store objects therefore were made to resemble the "awful plastering sores everywhere" in the city, rather than corresponding to any a priori notions of form. The soft sculptures originated as props for happenings, and sewing occurred to Oldenburg because his wife Pat was a proficient seamstress and "everything must be used." The "ghost" versions of objects, too, arose like the soft sculpture from practical necessity; they were originally patterns for works to be executed in vinyl. In order to trace these patterns, models had to be made, which in turn became the "hard" versions of the soft sculptures. The sections of the hard and soft versions of each object are identical; the extreme difference between the resulting forms is due to the difference between a rigid and a collapsible material. In the rigid works, simple geometry is determinant, while in the soft sculpture gravity is the composing "form creator," and flaccidity becomes an expressive, dynamic quality.

"*Style* means to me," Oldenburg wrote," a clear and consistent method as to material and technique, for rendering a definite state of mind and correlative subject. A practical and functional solution which may or may not draw on previous styles (mine or others)." In other words, instead of style dictating the choice of materials and techniques in the traditional manner, it is the materials and techniques that determine the choice of style from the world's almanac of art history. Oldenburg describes his attitude toward style as an oscillating "throbbing" rather than as a horizontal "progress," an attitude that is obviously diametrically and programatically opposed to any linear view of art history based on strictly formal criticism.

Stylistic development, therefore, is replaced in Oldenburg's work by his exhaustive investigation of different types of materials. "The artist is periodically involved with a certain material, just as civilization was, by stages: the iron age, etc., supposedly. Wishing to be primitive, a Crusoe, I substitute myself for civilization and speak of my 'ages,'" Oldenburg writes. This approach leads him to emphasize the inherent qualities of the materials—their hardness, softness, reflectiveness, or dullness.

Because Oldenburg works by feeling his way along, rather than by beginning with assumptions made in advance, there is usually some overlapping from one period to another. For example, although he showed three-dimensional objects in 1959, he continued to *pp. 28–29* paint until early in 1960. During the same year, while making the cardboard figures for The Street, he con- *pp. 31, 44* tinued to make papier-mâché sculptures as well; and at Provincetown that summer, he continued to use found materials, as he had for The Street, only now it was bleached, peeling driftwood picked up off the beaches. By this time, however, his concern was exclusively with making things in three dimensions, so the fragments were tacked together as reliefs, with the *pp. 52–53* chance shapes of the found objects suggesting landscape allusions. In the actual flags of plaster that followed the *p. 73* so-called Provincetown flags, a continuous, undulating surface still carries the suggestion of waves coming in off the beach.

To a certain degree, the plaster reliefs in The Store, which like the papier-mâché pieces were shaped over a wire framework, were continuations of Oldenburg's earlier objects, but in other respects they represented a considerable advance. Although he was never attracted

to Cubism or Cubist-derived works, and even at the outset there is little of Cubism in his art, the early objects and the Provincetown reliefs might still be called Cubist, in that they deal in planes. Beginning with the *"Empire" ("Papa") Ray Gun,* however, Oldenburg *p. 58* abandoned planes, the central concern of Cubist sculpture, in order to concentrate entirely on the creation of continuous surfaces. By the time that he made the first objects for The Store, late in 1960, he was dealing exclusively with unitary forms and with continuous surfaces that undulate and twist like the mountains, valleys, and tunnels of topographical maps. Indeed, it is such maps, rather than conventional sculpture, that many of the pieces in The Store—the *Fur Jacket,* for *p. 77* example—most resemble, although of course their variety of contour and sensitive detail immediately give them away as works of art.

Writing in 1961 of his use of material, Oldenburg said: "I like to work in material that is organic-seeming and full of surprises, inventive all by itself. For example, wire, which has a decided life of its own, paper, which one must obey and will not be ruled too much, or cardboard, which is downright hostile, or wood with its sullen stubbornness.... Yet I also *require* a loose form. Plaster and paper are not only necessities, they perform in a 'living' manner. I am naturally drawn to 'living' material, and it gives me great pleasure to experience the freedom of material with my hands. After a long preparation, form should 'simply demand to be created.'"

The first series of soft sculptures, the objects made for the Green Gallery exhibition of The Store, were meant to appear crude and vulgar. Splashed with quick coats of dripping paint, they sink comfortably into the floor and thereby solve the problem of a base, which has plagued twentieth-century sculpture. Pat Oldenburg has described how the seams on these first puffed and shirred pieces, such as the *Floor-Burger, Floor-Cone,* or the *Floor-Cake,* were allowed to be casual; whereas later, when working in a more refined, smooth vinyl version of the soft sculpture, Oldenburg would demand the utmost precision.

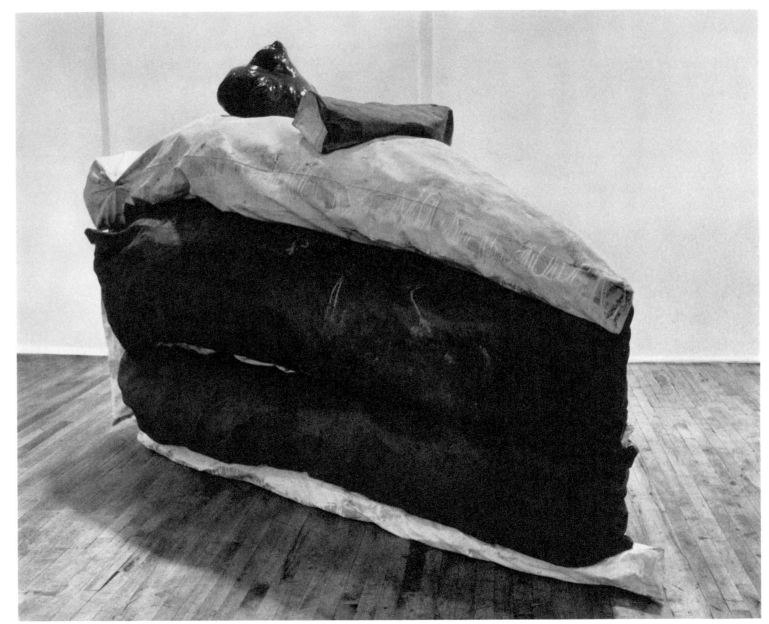

Floor-Cake (Giant Piece of Cake). 1962. Canvas filled with foam rubber, painted with Liquitex and latex, 60 inches high x 108 inches wide x 48 inches deep. Collection Philip Johnson, New Canaan, Connecticut

Just as the inherent peculiarities of the material have a voice in determining form, the nature and limitations of the problem he is confronting determine to some extent the direction Oldenburg will take in searching for a solution. Together, these two characteristics of his art may be regarded as typical of the empirical, pragmatic, and permissive attitude that one associates with American thought. In this context, it is illuminating to compare the few soft props for happenings that have survived, for example *Freighter and Sailboat,* with the soft pieces that Oldenburg made *p.86* deliberately as sculpture. The comparison makes apparent at once the kind of aesthetic transformation he effects when he is concerned with making a work of art rather than a theater prop. The sculptures are carefully modeled, so that a sense of articulated mass, not merely of bulk, is developed. The props, on the other hand, have simple, straight edges, in contrast to the astonishingly varied silhouettes of the sculptures, which are scooped and swelled, with curves that are not like the mechanical ones on a rollercoaster but like those of the unpredictably varied coves and inlets of a coastline.

Because Oldenburg demands the freedom to allow his imagination to meander through the history of art, his own art becomes a metaphor for the democratization of art history as well. "Imagination," he insists, "does not obey any proprieties, as of scale or time, or any proprieties whatsoever." In other words, the two chief standards of academic art are lacking: there is no decorum and no canon.

In the end, we are again left with a paradox. The highly personal, "post-historical" style of "more than" (itself a reminiscence of the surfeit of an affluent society) hides behind the popular mask of Mr. Anonymous. This is, in fact, a façade; for as we have seen, Oldenburg is obviously an elite artist, not only within the limits of Western art but even within its mainstream tradition. The assumed Pop style is a sleight-of-hand, a confusion into which the artist forces the viewer by adopting popular images; and it therefore becomes just another drag charade, hiding the true nature of the artistic

conventions within which Oldenburg is actually working. When we finally strip away the elaborate costume, as the characters in Oldenburg's happenings so often peel off layer after layer of clothing, we find that Oldenburg has more in common with Bernini than with the spurious vulgate of Mr. Anonymous.

NOTES

1. Although a comparison between Oldenburg and Arp may seem far-fetched, it is apposite because both use the body image in a non-figurative way; but whereas Arp's elegant, sinuous shapes are at once identifiable as fine art, Oldenburg by projecting his body image onto an inanimate, common object raises questions of identity.

2. *Principles of Art History* (1st English edition, translated by M. D. Hottinger, New York: Henry Holt, 1932; paperback, New York: Dover, 1950), p. 10.

3. Since art history has as much a tendency to repeat itself as any other kind of history, it is possible that critics may eventually regard Oldenburg as a Caravaggio in opposition to the "progressive academy" of the Carracci, which has many analogies to today's "high art" abstraction. To many of the partisans of Caravaggio and Annibale Carracci, the art of the other was virtually unthinkable; only the judgment of history has revealed the value of both.

4. In his introductory essay to the catalogue of the exhibition "Art of the Real: USA 1948–1968" (New York: The Museum of Modern Art, 1968, p. 8), E. C. Goossen has pointed out that the factual reality of some of Georgia O'Keeffe's paintings of the 'twenties anticipated the objectivity of Minimal painters such as Ellsworth Kelly in the 'sixties, while others of her works solved the problem of relating subject matter to flat canvas much in the way that Johns did when he selected such flat subjects as targets and flags.

5. *The Art Spirit* (Philadelphia and New York: J. B. Lippincott, 1923, copyright renewal by Violet Organ, 1951; paperback edition, 1960), p. 17.

6. *Ibid.,* p. 79.

7. Oldenburg's attitude toward Picasso is ambivalent. To judge from certain of his notebook entries, Picasso is an artist with whom he identifies; and there are, in fact, many analogies between the two. Both delve into the past at will, exploring antithetical painterly and linear, romantic and classic, modes and working simultaneously in different styles. Both are involved with metamorphosis, both tend to work in series, and both regard their own previous images and motifs as a reservoir upon which they can repeatedly draw. Oldenburg admired Picasso's marriage of content and form and, as we know, singled out the *Guernica* as the "only metamorphic mural." His rejection of Picasso is based on the latter's repetitiousness and, above all, his continued adherence to Cubism. In his soft version of Picasso's maquette for Chicago's Civic Center, the only specific *p.102* work by another artist that he has ever parodied, Oldenburg both literally and symbolically collapses Cubism.

8. It would hardly have been possible for either view to obtain previously, although some might regard Malevich as an earlier twentieth-century antecedent to Reinhardt, and Schwitters to Oldenburg.

9. The remarks that follow relate only to Oldenburg's work in three dimensions; the evolution of his drawings is considered in the next chapter.

The World Is Not a Drawing

World is not *a drawing. Artists the curse of the world.*
They know how to start things, but not how to stop them.
When Ray Gun shoots, noone dies. Art child's play. Art
as life is murder.

 Hitler, he erased half of Europe, but the world is not
a drawing. Flagging of belief in Reality low art to enter
life....

 To draw is in fact: to make appear. Only this act is
proof of my license to conjure. Also drawing is basically
drapery....

 The USA, of all places, cultivating fantasy! I read
and liked the notion that hallucinogens are secreted natu-
rally in the artists body.

 Claes Oldenburg, "America: War & Sex, Etc."

Elusive as the course of Oldenburg's stylistic develop-
ment may be, it can probably be traced more clearly in
his drawings than in any of the other mediums in which
he has worked. Oldenburg has drawn ever since he was
old enough to pick up a pencil; and long before 1952,
when he made his decision to become an artist, he was
in the habit of sketching and doodling. Between 1954
and 1958, he made hundreds of drawings, most of which
he later destroyed. In Chicago, he had been interested
in Reginald Marsh's illustrations for John Dos Passos'
USA, but he came to regard this genre as a kind of
limited provincial baroque, similar to the American-
Scene painters' interpretation of the old masters.

 Oldenburg's earliest extant drawings are sensitive,
highly detailed nature studies. In some, the nervous,
electric quality of the fine pen line recalls the fragile
intimacy of Klee's drawings. Tangled nets of vines and *p. 21*
leaves eat away the page. In the studies of the seed pod, *p. 56*
which to him was a kind of talisman, rich crosshatching
creates a velvety texture. In the mid-'fifties, he also
executed a series of "metamorphic" drawings based on *p. 22*
plant and machine forms, which represent his first
investigations into the theme of metamorphosis.

 When Oldenburg came to New York in 1956, his
drawing tools and a handful of small objects that he used
for still-life studies were among the few things that he
brought with him. The drawings he made during his
first two years in New York were technical exercises,
and their subjects were even more commonplace than
the usual studio still-life. Many employed a delicate
counterpoint of moody, melancholy gray washes. He
would spend hours drawing the fragile shapes of razor
blades, corks, bottle caps, and so forth, engrossed in *p. 24*
the difficult problem of attempting to capture the edge.

 By 1958, tired of the seclusion of his room, Olden-
burg began to wander through the streets in search of
subjects for both his poetry and his drawing. One of
the most beautiful of his naturalistic wash drawings of
this period is the *Street Event: Woman Beating a Child,* *p. 27*
in which his power to capture gesture with an economy
of means is that of a master draftsman.

Around this time, he also began to sketch his
friends in portrait and figure studies. His move to the
East Fourth Street apartment had given him space in
which to paint regularly, and his drawings also became
correspondingly ambitious. He drew a great many
domestic scenes showing Pat working, dressing, or
resting. They were usually done in the morning, when
the light was good, and before he left for his work at
Cooper Union. These drawings in greasy black crayon
are vigorously scrawled across the page in swift, jerky
motions; many are extremely impressionistic, allowing
the eye to fill in details and complete broken contours.
Objects and background are treated as part of the same
spatial continuum as the figure; the room itself is
indicated with a few dots and expressive, free-wheeling
curlicues. Shading is accomplished through vehement
scribbles; grainy passages that allow the white paper to
show through and "unfinished" blank areas reflect light.
The alternation of sharp contrasts of black and white
was Oldenburg's means of marking these drawings
vivid and dramatic. Some of them, for example the *Pat
in Black Underwear, Seated,* are reminiscent of Munch's
elegant arabesques.

 Until recently, when he began to parody historical
styles, Oldenburg's drawings were very painterly, and
chiaroscuro was his principal means for describing
form. The drawings of metamorphic objects leading to
the constructions that he exhibited in his first show at
the Judson Gallery in 1959, and the landscape drawings
executed in Lenox that summer, also utilized sharp
contrasts of black and white.

 From 1959 on, the theme of Ray Gun began to
dominate the drawings. The Ray Gun graphic style is
brutal and primitive, adapted from street graffiti. "I
sought a crudity in style to match the crudity of my
surroundings in the poor area of New York City,"
Oldenburg explains; and he acknowledges the influence
on his work of the naive and awkward drawings that
Dine and Grooms were producing at the time. During
the Ray Gun period, posters became an important part
of his output, since Ray Gun was always engaged in

Pat Sewing. 1959
Crayon, 11 x 14 inches
Owned by the artist

House between Trees, Casting a Shadow, Lenox. 1959
Crayon, 12 x 17¹/₂ inches
Private collection, New York

Pat in Black Underwear, Seated. 1959
Crayon, 14 x 10³/₄ inches
Collection Gene Baro, London

155

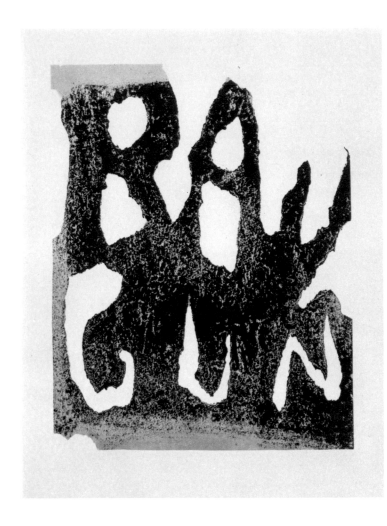

Ray Gun Poster. 1961
Sprayed oil wash on torn paper, 24 x 18 inches
Owned by the artist

some enterprise that he wished to advertise. The 1960 ink monoprints for The Street and the Ray Gun specta- *p.44* cles at the Judson Gallery are a strange combination of rich coloristic effects and Oldenburg's rough graffiti style. The outstanding drawing of this period is perhaps the 1961 Ray Gun poster with background and foreground reversed, in which Oldenburg re-created the coarse textures and irregular silhouettes of crumbling tenement walls. This drawing reveals the careful analysis of the relationship between figure and background that was then engaging his attention. It is clear from his investigation of the problem of the figure-ground relationship in the Ray Gun poster that he was searching for ways in which to eliminate the traditional opposition of positive shape against negative background. This was something that Pollock had been able to do in his drip paintings, in which line no longer functions as shape-creating contour. Eventually, Oldenburg eliminated the figure-ground relationship by removing the background from behind his figures—a resolution hinted at in the poster's reversal of that relationship.[1]

The drawings executed in the spring of 1960 were mainly ball-point and pencil sketches for The Street. *pp.40–41* There were also a number of preparatory drawings for posters of the showing of The Street at the Reuben *p.47* Gallery and for the "New Forms—New Media" exhi- *p.14* bition at the Martha Jackson Gallery. Made of collaged scraps of torn newspaper outlined in ink, their blackened edges were much like the irregular, charred edges of the Street figures themselves. (Oldenburg records in one of his notebook entries that Allan Kaprow pointed out a similarity between the inked, torn edges of the drawings of this type and grass growing on top of dunes—a comparison he found apt.)

According to Oldenburg, his Street drawings were dedicated to "irrationality, disconnection, violence and stunted expression—the damaged life forces of the city street." The paper itself he saw as a metaphor for the sidewalks, walls, and gutters; no differentiation was made between the human and the material wreckage encountered on the street.

The drawings executed at Provincetown in the summer of 1960 were calm in mood—shaded in neutral gray, brown, and black, with highlights like the bleached colors of the docks and beaches. Wishing to add color to his drawings, Oldenburg in 1961 accepted a commission from Aileen Passloff to design costumes and sets for her dance company. The watercolor sketches *p.72* that he made in connection with this enterprise are among the most charming in his oeuvre; their simple gaiety and nonchalance contrasts with his graver themes. On the other hand, the use of black and colored dripped enamel in *Striding Figure,* done for an announcement *p.23* of one of the Passloff dance concerts, indicates the extent to which Oldenburg had by now come to appreciate the techniques of the Abstract Expressionists— a rapprochement evidenced also in the dripped enamel paint on the surfaces of the Store signs and objects.

The drawings of clothing and food displayed in shops on the Lower East Side, which Oldenburg began to make preliminary to The Store on his return from Provincetown in the fall of 1960, were also rich in color, with watercolor washes added to pen and ink. These voluptuous, atmospheric wash drawings contrast sharply with the graffitilike drawings of 1959–1960 with their spare, razor-thin lines; cast shadows, dots, or flecks are now used rather than line to activate the space.

During the period that Oldenburg was actually working on The Store in 1961, drawing was not so predominant an activity for him as it had been earlier; "hasty preliminary sketches were made, but the drawings were finished in the reliefs and objects," he explains. In the general confusion and congestion of The Store, fragments of watercolor drawings were often scuffled about on the floor. Some of these Oldenburg collected and subsequently put together in collages, with each poetic fragment representing an object. The intimate, nostalgic delicacy of these sensitive works, with their torn edges and resemblance to the textures of the city, recall some of Joseph Stella's late collages.

In the same way that he had analyzed painting, Oldenburg also analyzed the particular qualities of

drawing as a medium. "Great drawing has natural ambiguities, natural symbolism," he concluded, deciding that what he sought above all in drawing was the creation of optically measurable space. Later, he came to realize that the sharpness of his vision caused him to focus on the roundness or relief of forms because this gave him an especially acute sense of deep space. It was this type of vision that he wished to translate into a graphic style. "Drips equal space creators," he wrote of his series of Pollock-like drawings. His realization that broken lines and dots, too, could activate space and enhance the illusion of depth led him to scatter them over the whole page, to bring empty white areas to life. His analysis of the drawing medium also made him decide that pencil and brush were best for curved subjects, and the pen for angular ones. He complained of difficulty in mastering the pen, and in fact his pen drawings often have an awkwardness and harsh directness by comparison with the fluency and ease of his drawings in pencil and brush.

At Cooper Union, Oldenburg had studied facsimiles of drawings by Watteau and Tiepolo, and these suggested to him the qualities of light and atmosphere that might be captured in drawings. He especially loved the "airy, summary mercurial" manner of Tiepolo. Ultimately, Oldenburg arrived at a graphic conception that used color and illusionism in a highly sophisticated manner and allowed him to recapture much of the richness and complexity of old-master drawings in a thoroughly contemporary idiom. He also saw in drawing another possibility for redeeming the Abstract-Expressionist concept of action or gesture. But instead of compromising painting with characteristics that seemed to him appropriate to drawing, he separated the two mediums. Viewing drawing, as the "action painters" did, as a kind of handwriting, he restored this calligraphic quality to the graphic medium to which it properly belonged.

When Oldenburg left the slums, so to speak, with his Green Gallery exhibition of 1962, he renounced the graffiti style of the Lower East Side. With the increase in

A Sock and Fifteen Cents (studies for Store objects). 1961
Collage, crayon, and watercolor, 18⅝ x 23⅞ inches
Collection Mr. and Mrs. Robert C. Scull, New York

Material and Scissors (notebook sketch). 1963
Ink and watercolor, 11 x 8½ inches
Owned by the artist

157

scale of the objects in this show, his drawings also grew more assured. Beginning in 1962–1963, a new emphasis on space and volume in his drawings corresponds to the invention of soft sculpture. Drawings of this period describe volumes set into space by means of a scalloped line that broadens and narrows to suggest convexity. Calendars, maps, alphabets, and the biplane (a recurrent motif in Oldenburg's iconography, reminiscent of his childhood interest in model airplanes) are executed in this scalloped style. In these drawings, the world resembles soft sculpture; objects are puffy and pneumatic. Shirts and pillows, buns and tires, are typical subjects lending themselves to such treatment. At about the same time, Oldenburg also produced a few fine sketches, such as the exquisitely delicate scissors cutting material, a small drawing in which opaque *p. 157* washes, graded from grayish blue to white, create an effect of extreme richness on an intimate scale. Several crayon drawings, such as the *Cake Wedge* which can be seen as a landscape with a horizon line, and the blobby *Biplane* with its rapid curlicue contours, are particularly vivid in their use of line. In the slice of cake, a leafy "foliage" underscores the analogy with landscape, while the overlapping strokes of the softly rounded biplane suggest analogies with Cézanne's figure drawings. In an installation study done in 1963, scale is designated by the presence of a tiny figure beside a giant shirt; like the giant objects in general, this drawing was partially inspired by the illustrations in Swedish children's books by Else Beskow that Oldenburg owned as a child.

In 1963, preoccupied with the *Bedroom Ensemble,* Oldenburg began to draw rooms, using linear per- *p. 95* spective to describe the cubic space of an interior. The sketches that he executed in Rome the following year for sets for a film by Antonioni that was never made have the intimacy and refinement related to his feeling for his European surroundings, as manifested also in the delicate objects that he made for his exhibition in Paris. The fine drawings in pen and colored wash that he did in Paris and Rome in 1964 bring to mind the light-filled, atmospheric drawings of Canaletto.

158

Cake Wedge. 1962
Crayon, 25 x 32³/₈ inches
Collection Mr. and Mrs. Robert C. Scull, New York

Oldenburg's move to his large new loft on Fourteenth Street in New York in March 1965 brought about a significant change in his drawing style. The scale and good light of his new environment are reflected in his first drawings for monuments, done in that year. Objects set into a recognizable landscape become "colossal" by inference, since one is aware of the landscape's true proportions. Because Oldenburg believes that "a large part of the drawing is the awareness of shifting scale," the monuments provide him with a particularly fruitful subject. In these 1965 drawings, *pp. 115–* atmosphere and light become increasingly important; *118,* great circulating swirls, indicating air currents, set *122–123* everything into motion. In this sense, the monument drawings are a return to the impressionistic style of his figure drawings of the late 'fifties. Otherwise, however, they are quite different. The melancholy of expressionism and the similarities to Munch have given way to a robust and joyous conception, full of baroque swirls, rococo arabesques, and an obvious delight in the artist's own superb ability to materialize form with a few summary strokes. Whereas the drawings of the late 'fifties had been dominated by moody shadows, those from the mid-'sixties on celebrate the life-giving power of light.

With each new series, Oldenburg's mastery of his medium grows. The *Swedish Bread* drawing, executed *p. 160* in pencil with wash that shades gradually from dark at the bottom to light at the top, emphasizes plasticity and the controlled maneuvers of the hand, rather than the brash "action" gestures of the arm or wrist. In the *Light Switches, London,* the name "Ensor" is scrawled *p. 160* on the wallpaper background. This may indicate that expressionist drawing has been relegated to the background, in the same way that earlier the word "Frenchmen" on one of the Céline-Dubuffet drawings had *p. 36* indicated a relinquishment of European influences, or the pseudo-Pollocks on the walls of the *Bedroom Ensemble* had consigned Pollock to art history. Another *pp. 94–95* and perhaps simpler explanation is that Oldenburg had been looking at illustrations of Ensor's drawings in

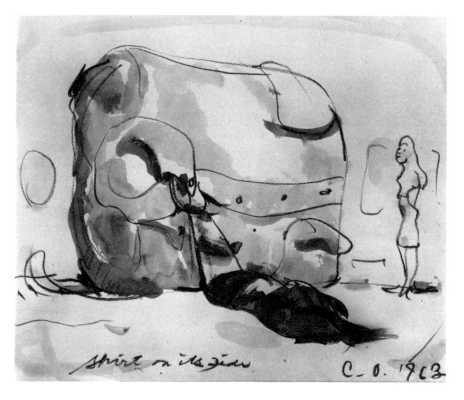

Visualization of a Giant Soft Sculpture
in the Form of a Shirt with Tie. 1963
Crayon and watercolor, 14 x 16³/₄ inches
Collection Mr. and Mrs. Michael Blankfort, Los Angeles

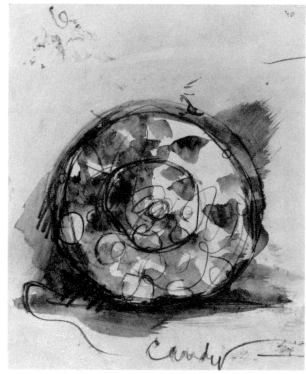

Candy (notebook page). Paris, 1964
Crayon and watercolor, 10¹/₂ x 8¹/₄ inches
Owned by the artist

159

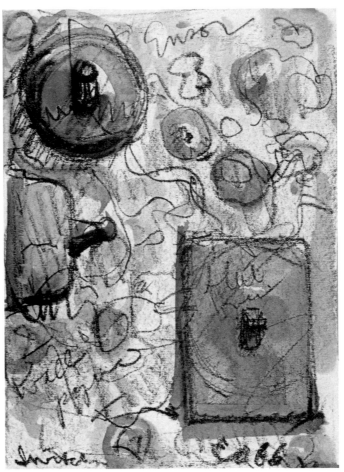

which figures are woven into a wallpaper pattern. Here again, as in the Ray Gun poster in which negative and positive values are reversed, Oldenburg is concerned with subverting the normal figure-ground relationship, something he has accomplished in this case by working the calligraphic "figure" directly into the wallpaper background.

Oldenburg's 1966 drawings for the Airflow, such as the cutout *Airflow Transmission,* present subtle, gently swelling forms and undulating silhouettes. From the point of view of his general attitude toward form, one of the most interesting is an Airflow drawing in *p. 96* which the car is seen simultaneously from all possible angles, each view being shown independently. This, of course, is the opposite of the Cubist device of superimposing different views of a single object on top of one another. The Cubists had attempted to illustrate the act of perception by condensing it into a single moment, but Oldenburg presents an entirely artificial, conceptual depiction of perception. This perspective does not correspond to the reality of normal vision, by which the eye perceives a single view at a time, but reveals the full content of the mind's knowledge of the various views, which can be mentally considered independent of one another, as opposed to being "simultaneously" telescoped on top of one another.[2]

From 1967 on, Oldenburg made two further kinds of drawings. His so-called "technological" drawings emphasized pure line; they had their prototypes in the series of blueprints that he had made in 1963–1964 to direct the carpenters who were constructing the rigid pieces for the *Bedroom Ensemble.*[3] His later technological drawings, however, tend to be increasingly detailed, elegant, and complex. In other drawings, Oldenburg rendered specific details of works such as the drum set, creating idealized versions of the originals. His "landscape" drawings for the drum set were elaborated during the summer of 1967 in Colorado, where the natural scenery suggested the disposition of the parts. In these drawings, it is perspective rather than atmospheric wash that dominates the spatial conception. Refined to

Study of a Swedish Bread—"Knäckebröd"
(for a cast-iron multiple). 1966
Pencil and watercolor, 24 x 21 inches
Collection Mr. and Mrs. Max Kozloff, New York

Light Switches, London. 1966
Crayon and watercolor, 9½ x 7 inches
Owned by the artist

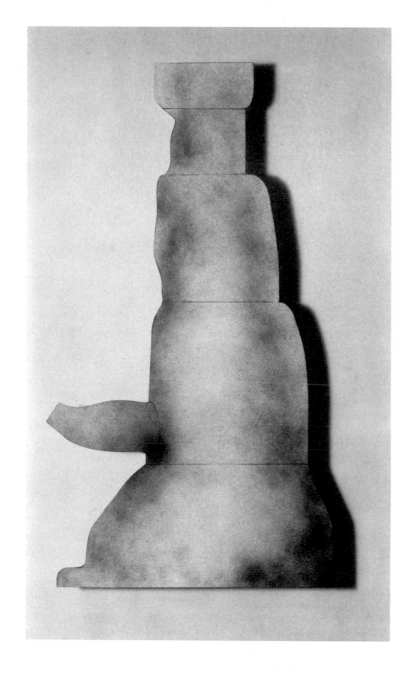

above:
Drum Pedal Study—Schematic Rendering. 1967
Pencil and watercolor, 30 x 22 inches
Collection John and Kimiko Powers, Aspen, Colorado

left:
Airflow Transmission. 1966
Cutout, pencil and spray enamel, 40 x 26½ inches
Sidney Janis Gallery, New York

Study for the Giant Soft Drum Set. 1967
Pencil and spray enamel, 30 x 22 inches
Collection John and Kimiko Powers, Aspen, Colorado

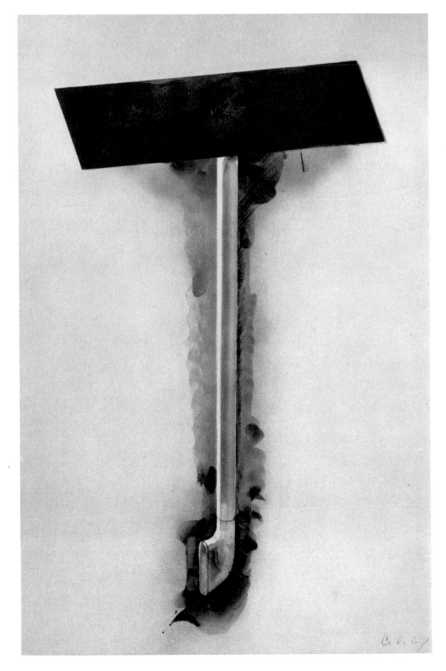

SOFT CEILING LIGHTS
AT THE "COUPOLE"

above:
Soft Ceiling Lights at the "Coupole"
(after a soft sculpture of 1964). 1969
Ball-point pen and watercolor, 8½ x 10⅞ inches
Owned by the artist

left:
Proposed Colossal Underground Monument:
Drainpipe. 1967
Cutout, pencil, spray enamel, and watercolor,
40 x 26 inches
Collection Mr. and Mrs. M. Riklis, New York

Study of a Dormeyer Mixer. 1965
Pencil, 30 x 22 inches
Collection Emily S. Rauh, Saint Louis

opposite:
Profile study of a Toilet Base
(Compared to a Map of Detroit and
Mont Sainte-Victoire by Cézanne). 1966
Collage, pencil, wash, 38 x 34 inches
Collection Cy Twombly, Rome

the point of decadence, with a web of fine lines and crosshatching, they represent a kind of travesty of the conventions of academic draftsmanship.

In many of Oldenburg's recent drawings, he explores to the utmost limits the metamorphic possibilities of the object. In the course of his investigations, a single form, such as the phallic ray gun, may go through an entire cycle of art history, although not necessarily in chronological sequence. Thus the "archaic" *"Empire"* *("Papa") Ray Gun* has its sequels in the "classic" hard *p.58* *Drainpipe,* the "baroque" *Coupole Lights,* and the "decadent" stage of the *Dormeyer Mixer* compared to the Cathedral of Florence, or the *Drainpipe-Crucifix,* in *p.109* which the phallic ray-gun form becomes reabsorbed into art history through the back door of parody. In the final or "academic" stage of metamorphosis, elements of traditional art are consciously evoked: the fan cord reminds Oldenburg of Corot's drawings of trees, and Cézanne is recalled in the *Profile Study of a Toilet Base (Compared to a Map of Detroit and Mont-Sainte Victoire by Cézanne).* This way of considering the notion of "style" as an abstraction, independent of any specific form or historical context, is obviously another instance of Oldenburg's fashion of meandering through history.

Although Oldenburg believes that the human figure can be treated only metaphorically in sculpture, as a fragment, he thinks it has a legitimate place in drawing through the illegitimate channel of pornography. Figure drawings, which had been absent from his work since 1961, began to reappear late in 1965 and thereafter become relatively frequent. They are executed in the delicate pencil style of his "decadent-academic" manner, as if the use of the human figures is justifiable only in a style that, so to speak, sets it off in quotation marks. "The way to the Fig.," Oldenburg wrote in 1967, "lies thru geopornography. Starting from body, as I did, descending the coalmine of object by degrees, losing the Fig. in the coal passages of the mind, found my way to mannekins, corpses. Dismembered, as in advertisements. Leg here, Arm there."[4] Late in the 'sixties, the

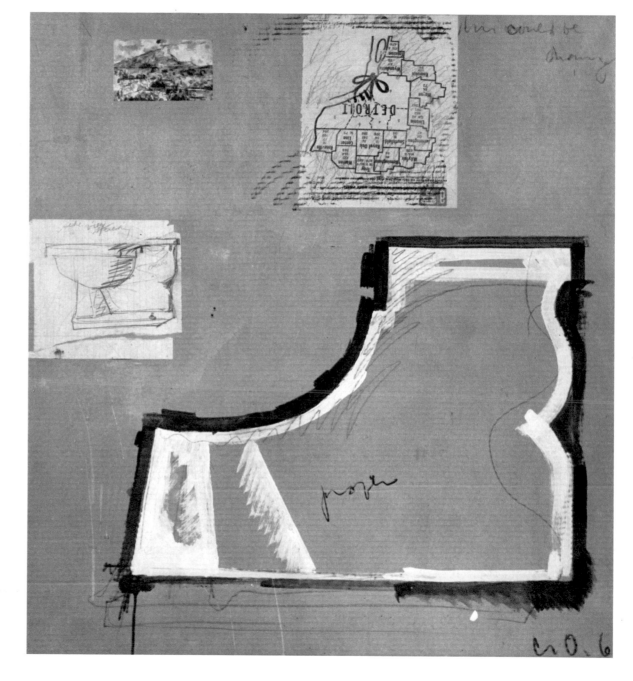

163

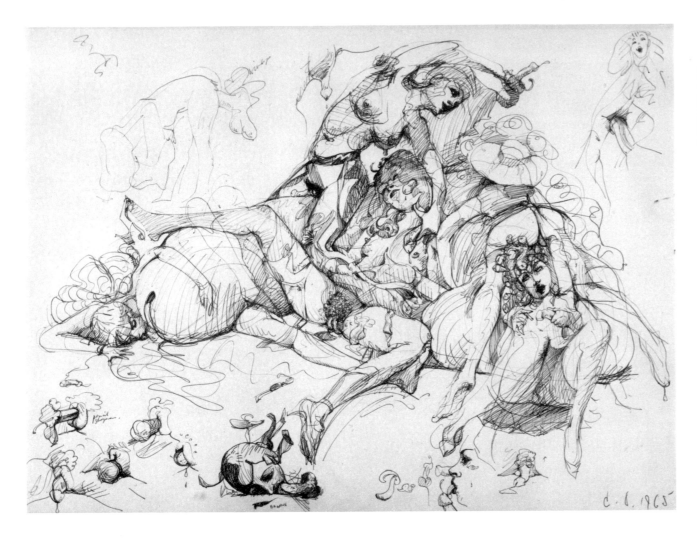

above:
Clinical Study toward a Heroic-Erotic Monument in the Academic/Comics Style. 1965
Ball-point pen, 26 x 40 inches
Owned by the artist

right:
Stripper with Battleship (study for "Image of the Buddha Preaching" by Frank O'Hara). 1967
Pencil, $30^1/_8$ x $22^1/_8$ inches

The Museum of Modern Art, New York (gift of Mr. and Mrs. Richard E. Oldenburg)

themes of love and death united in drawings which, like Delacroix' *Death of Sardanapal,* combine sex and violence in an apocalyptic, orgiastic vision. The pornographic drawings, in fact, appear at the point when Oldenburg reached the conclusion that American civilization had itself become obscene.[5]

In his later drawings for monuments, Oldenburg works in several styles: neoclassical (itself a mixed style with both romantic and classic elements), rococo-impressionist, and the "academic-decadent" or pornographic. By now, his fluency and sureness have become absolute, and he has so thoroughly dominated his medium that he can begin to play with it. In the "academic" drawings, he carries his own skill to extremes in order to show what facility gone haywire can produce. Thus, the sketch, *Proposed Colossal Monument for Toronto:* *p.109* *Drainpipe,* the late drum-set sketches, and the *Drainpipe-Crucifix,* for example, are intricate mazes of cross-hatching, in which detail has become a fanatical obsession. These works, executed for the most part in pencil, parody the entire conception of old-master drawings, while nevertheless belonging to the same tradition.

Since early in his career, Oldenburg has been interested not only in drawings but also in the multiple forms of graphic art. His earliest printmaking ventures were the monotype Ray Gun posters of 1960. The following year, in conjunction with a project sponsored by the Galleria Schwarz in Milan, he made two etchings: the "Orpheum" sign, and a pair of legs executed at the Pratt Graphic Art Workshop. His first lithographs, done in the same year, were of a slice of pie, a sketch for a tabletop, and a poster for The Store. In 1964, Tanglewood Press published his lithograph of a flying pizza, and in 1965 he created a poster for the *Paris Review,* representing the corner of a mattress. His three graphic works of 1967 included the *Teapot* made to decorate *p.12* one of Frank O'Hara's poems in the memorial volume published by The Museum of Modern Art; the *Double Punching Bag,* a poster for the Foundation for the Contemporary Performing Arts; and the most complex and ambitious print he had done up to that time,

the *Scissors-Obelisk* for the National Collection of Fine Arts, Smithsonian Institution, Washington.

Oldenburg's first extensive printmaking venture, however, was begun in 1968 in conjunction with Gemini G.E.L. in Los Angeles. Early that year, he inaugurated two major projects—a lithograph portfolio of notes, and a series of three-dimensional prints with the Airflow as theme. In the former, Oldenburg's actual notebooks have been duplicated, even down to the detail of simulating the cheap copy paper on which he scrawls the memoranda he pastes into them. The choice of these notebooks as a subject is typical of Oldenburg's use of an experience at hand, rather than of one deliberately cultivated. Similarly, the processes within the medium of lithography itself suggested to him some of the forms: for example, the ice-cream-cone shape was suggested by the "draw-down" of raw ink that printers use as a color test. The analogy between the pastose strokes of color and the texture of ice cream of course delighted Oldenburg, who cherishes just such analogies between totally dissimilar phenomena. Arising from the shape and texture of the "draw-down," the ice cream becomes an automatic drawing.

While working on this extended project, Oldenburg began to conduct his characteristic analysis of the medium with which he was engaged. He was especially reluctant merely to simulate drawings, and sought those special qualities of lithography that differentiate it from the ordinary techniques of reproduction. He investigated the different types of lines and washes available to the process of lithography: thus, the pure neoclassic line of the kneeling building is juxtaposed with the rich, greasy tusche wash of the skate monument—his first "night" landscape. He varied and combined techniques, and even invented some new ones. In order to allow Oldenburg maximum freedom, Ken Tyler of Gemini G.E.L. devised a way of feeding lithographic ink into a ball-point pen, which accounts for the great freshness of many of the sketches Oldenburg made at dinners, parties, or elsewhere on the move in Los Angeles. Characteristically, the subjects of the

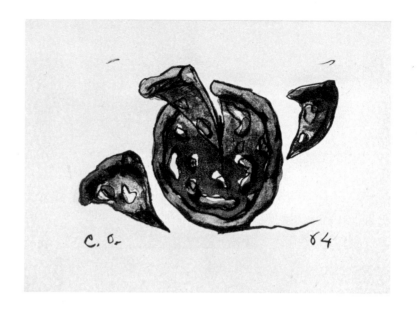

Flying Pizza. 1964
Color lithograph, 15⁵/₈ x 22¹/₂ inches (composition)
The Museum of Modern Art, New York
(The Law Foundation Fund)

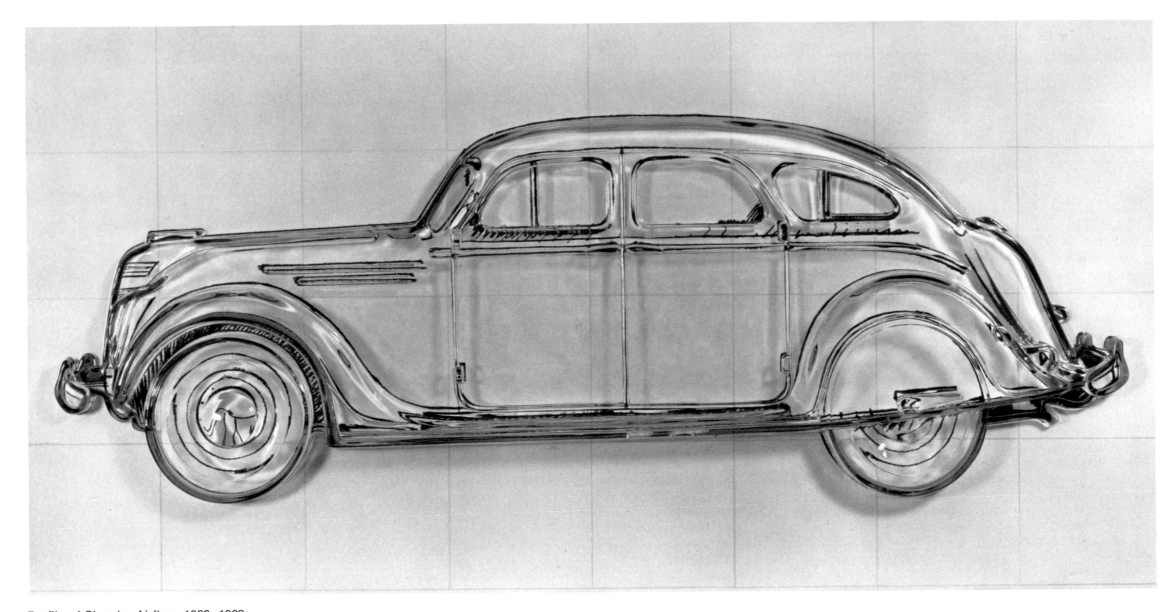

Profile of Chrysler Airflow. 1968–1969
Molded polyurethane over two-color hand-printed lithograph,
32¹/₂ x 64¹/₂ inches
Gemini G.E.L., Los Angeles, © 1968

drawings arc suggested by his immediate environment and everyday life. A vacuum cleaner roaming the tar pits adjacent to the Los Angeles County Museum of Art is shown from an air view, in various possible positions; Tyler's huge Afghan that from time to time disrupts activity at Gemini becomes a hilarious Afghan-penis. Oldenburg jots down his thoughts about a project for an earth monument (never realized) for Documenta IV at Kassel, and the drawings are consumed in the process of making the lithograph. Reality is elaborated into fantasy, and styles and techniques are mingled in the usual antic combinations typical of Oldenburg's roving, uncensored mind and eye.

Multiples have had particular prominence in Oldenburg's work; it is entirely in keeping with his democratic attitudes that he should have directed so much of his attention to producing relatively low-cost objects that a number of people can own. Furthermore, his analysis of the problem of mass production has enabled him to introduce a number of technical innovations that have had practical consequence for the work of others besides himself. He was, for example, among the first artists (if not the first) to use the industrial process of vacuum forming for a multiple—the *Tea Bag,* executed in 1965.[6] While at work at Gemini on *p.133* his lithographs in the spring of 1968, Oldenburg conceived his *Double Punching-Bag Nose,* inspired by the exhibition of nose landscapes and soft sporting goods *p.124* that he had executed while in Los Angeles. The synthetic image of a nose-punching bag—an appropriate metaphor for a particularly violent moment in American history—involves two pairs of noses, one hard (bronze), the other soft (plastic); they are joined back to back to form a punching bag, itself a soft form inflated until it becomes rigid, and attached to a suede bag filled with aquarium stones.

In the recently completed *Profile of Chrysler Airflow,* Oldenburg working in conjunction with Gemini G.E.L. has produced a multiple that combines the fine-art and printing technique of lithography with such processes of industrial manufacture as laminating, em-

bossing, and vacuum forming. The result is a complex, highly original art object that presents both a continuous surface and a view through that surface to a variety of densities and thicknesses; these, however, do not separate into a succession of Cubist planes, but instead remain bonded visually, as they are bonded in actuality by the process itself.

NOTES

1. The drawing *Light Switches, London* discussed on pp.159–160 is in a sense also an attempt to emulate Pollock's manner of integrating figure with ground, which Oldenburg does not pursue.

2. In contrast to the Cubists' conception of the plane as a flat surface, Oldenburg thinks of it as "rising or swelling from an edge, like the wing of an airplane." He claims that the plane is "a distortion of a sphere or cube through vision" and advises that it "should be able to be seen from the side and in the many points of observation from side to front." In other words, he takes into account what we know intellectually of a plane—that it is only the *surface* of a three-dimensional object. Instead of illustrating the simultaneity of our visual and mental apprehension by telescoping various points of view, as the Cubists had done, Oldenburg presents the many surfaces of an object by spreading them out side by side like a projection.

3. Oldenburg's acquaintance at Cooper Union with drawings by the visionary French architects of the eighteenth century, and with early encyclopedias such as Diderot's, illustrated with line drawings of tools and inventions, suggested to him the possibility of his "technological" style.

4. "Amcrica: War & Sex, Etc.," p.36.

5. Regarding his one-man show at the Sidney Janis Gallery in 1967 (April 26–May 27), in which the fagends and drainpipes were exhibited, Oldenburg wrote: "The joy of this show is that I assimilated, translated, say maybe transcended my undoubted obscenity but also the twice obscene, twice monstrous infinitely gorgeous horrors of the time" (*ibid.,* p.39).

6. Oldenburg's first experiments with vacuum forming were the series of ray guns that he executed in California in 1964. He had long been interested in the process as it was used for making children's toys, such as guns. Once again, technical innovation was spurred by a practical consideration, as a non-art technique used in manufacture was appropriated for the purpose of making art.

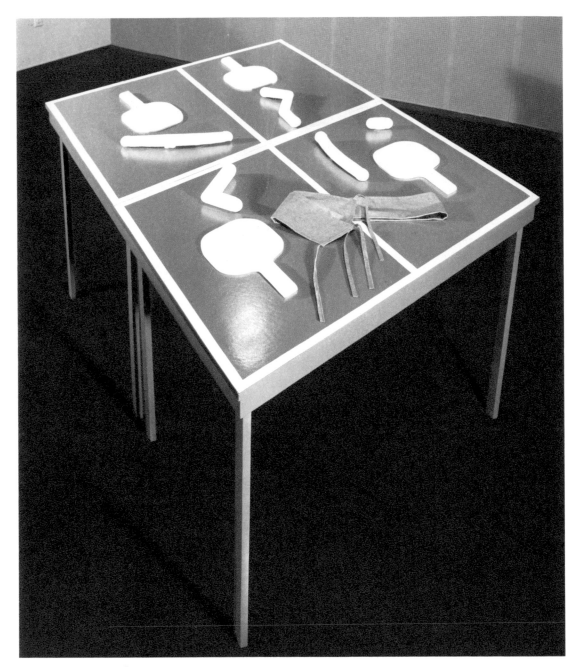

Totems and Taboos

The savage mind totalizes.... In my view, it is in this intransigent refusal on the part of the savage mind to allow anything human (or even living) to remain alien to it, that the real principle of dialectical reason is to be found.

Claude Lévi-Strauss, *The Savage Mind*

This elevation of sensibility above bourgeois values, which is also a simplicity or return to truth and first principles, will (hopefully) destroy the notion of art and give the object back its power. Then the magic inherent in the universe will be restored and people will live in sympathetic religious exchange with the materials and objects surrounding them. They will not feel so different from these objects and the animate/inanimate schism mended. What is now called an art object is a debased understanding of a magic object.... Think how many children a day are being perverted into art and their natural recognition of the magic in objects stamped out!

Claes Oldenburg, *Store Days*

Ping-Pong Table. 1964
Plywood, plaster, metal,
39 inches high x 54 inches wide
x 84 inches long
Moderna Museet, Stockholm

As has been pointed out, in lieu of "designing" or composing his works in the traditional sense of the word, Oldenburg imposes various kinds of structuring on his forms, including repetition and simple geometry. This structuring, however, does not serve aesthetic ends only. Its purpose is to set up a number of morphological categories. In Oldenburg's universe, all the objects are interrelated and divided into a number of families, whose kinship is based not on their semantic meaning but on their analogies of form. The right angle, the rectangle, the "allover" pattern of the figures and reliefs in the Street and Store environments, and finally the vertical phallic and round female shapes constitute the main categories.

The problem for an artist of Oldenburg's vast appetites was to find a means of absorbing the sensible world into a totality and an integrated unity. Encyclopedic knowledge of nature and of man and his creations is no longer possible, as it was for Aristotle, Saint Thomas Aquinas, Leonardo, or Goethe. Since the age of specialization, no one can any longer claim encyclopedic knowledge except within a limited scope. In order to encompass a total world view, therefore, Oldenburg had to look outside the accepted boundaries of "civilized" thought. The categories that he has established resemble in many ways the "totemic kinships" established by primitive societies as a means of ordering the world. These kinships have been discussed by Lévi-Strauss in *The Savage Mind,* elaborating on observations made by A. Van Gennep, whom he quotes as follows:

"Every ordered society necessarily classes not only its human members, but also the objects and creatures of nature, sometimes according to their external form, sometimes according to their dominant psychic characteristic, sometimes according to their utility as food, in agriculture or in industry, or for the producer or consumer. . . . The notion of totemic kinship is thus composed of three elements: physiological kinship... social kinship . . . and cosmic, classificatory kinship which links all the men of a single group to creatures or objects theoretically belonging to the group."[1]

Dormeyer Mixer (notebook page). 1965
Ink and collage of clippings, 10⅞ x 8 inches
Owned by the artist

left:
Study for a Colossal Monument in Times Square: Banana. 1965
Canvas formed on plaster, wire, metal pipe, wood,
16¾ inches high (including base)
x 9⅛ inches wide x 8¼ inches deep
Collection Mr. and Mrs. Richard L. Selle, Chicago

By adopting for himself an imaginary system of kinships, Oldenburg too links man and man-made objects to nature and succeeds in achieving an all-inclusive world view. Max Kozloff has observed that "everything in Oldenburg takes the form of maximum, monstrous equivalence. Digestion equals excretion, city equals nature, frustration equals liberation, subconscious equals conscious, and lifelessness equals animism. . . . This glutton for experience seems incapable only of making such distinctions as those between activity, affect, and object."[2]

Different types of kinship can exist in Oldenburg's system of classification—sexual classes, morphological classes, and metamorphic classes.[3] Basically, he classifies objects as male, female, or ambisexual. To the first category belong all the phallic objects—ray guns, the baseball bats, and so forth. Hamburgers, tires, telephones, and such an object as the *Giant Soft Swedish Light Switches* are female. Dormeyer mixers, the peeled banana, the fans, and the soft drainpipes are ambisexual, according to Oldenburg. Objects with specific landscape allusions make up another class. Usually, as in the "flags," they are distinguished by parallel striations, which are analogous to streets, beaches, or rivers. A later object, the drum set, recalls the mountains and valleys of Colorado, where Oldenburg developed its forms.

Oldenburg's statements in his notebooks and elsewhere abound in such equations as: "Newspaper equals drawing. Food equals painting. Furniture equals sculpture." The unities imposed by his division of objects into classes defy scale. "Correspondences occur between large forms like the Street and the Newspaper, big spatial inclusive forms, and also between smaller individual forms," he writes, attributing mystical bonds to formal analogies. Thus, for example, the newspaper and flag are equated because they are similar forms of rectangles, divided within by smaller rectangles and horizontal parallel lines.

The connections among the kindred objects that Oldenburg groups together are, in his words, "the paths

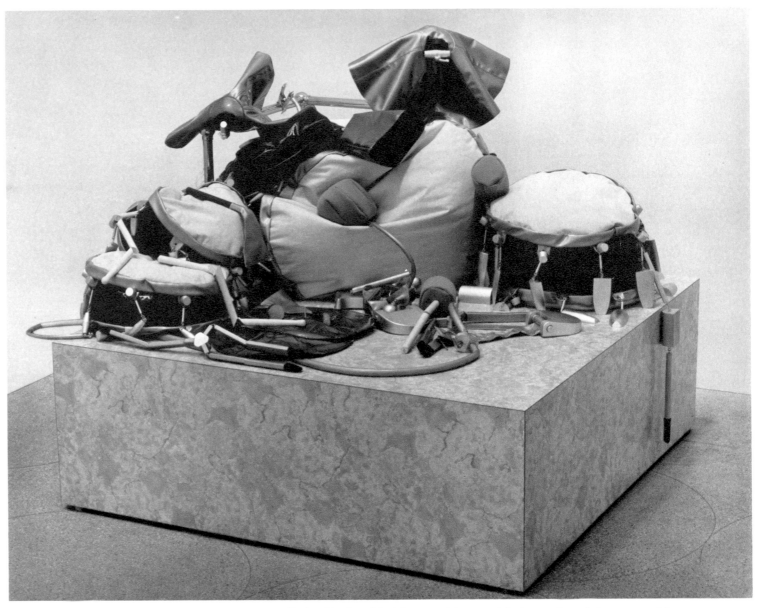

Giant Soft Drum Set. 1967. Vinyl and canvas, stuffed with shredded foam rubber, painted wood, metal, on wood base covered with formica; chrome-metal railing; 9 instruments (125 pieces), 84 inches high x 72 inches wide x 48 inches deep
Collection John and Kimiko Powers, Aspen, Colorado

along which metamorphosis develops, so that when you see one you see the other, and also the poetic idea generated by the linkage. It is possible to use them in substitution, such as to read the Street, or the Daily Street, etc., or to walk on the Paper, or be careful when crossing the Paper." Crossbreeding totemic classing with Symbolist synaesthesia, Oldenburg creates a curious hybrid, in which primitive and ultrasophisticated (one might even say "decadent") Western thought merge. An opposition is thus set up between the distillation of essential forms, on the one hand, and the compression and telescoping of genres, styles, and identities, on the other hand, all overlaid like palimpsests to create maximum complexity. Both objectives are consistently sought by Oldenburg, and in this resides the tension of his work.

For the primitive, establishing categories of totemic kinship is a way of dealing with the world—more than that, a way of controlling the world. For Oldenburg, too, classification is a structuring process, a means of keeping the chaos of modern experience under control without resorting to the imposition of strictly closed, delimiting definitions. In his cosmos, literal meaning is not the causal link between objects. A flag is a picture is a window, not because flag, picture, and window are semantically related, but because their rectangular forms assign them to the same morphological class. Likewise, the ray gun in its many manifestations and metamorphoses becomes the drainpipe in its various *pp. 172–* hard and soft versions. "Meaning," therefore, is *173* assigned to morphological similarities rather than to verbal definitions. A collar and tie can be eroticized, not because "tie and collar" equals "cock and balls" semantically, but because they can be assimilated to the class of phallic objects. They may then be further eroticized by the traditional means of sensual surface treatment.

In addition to his manner of classing objects in the way that primitives establish totemic kinship, Oldenburg has many other affinities with primitive thought. We have already mentioned that his use of whatever is

at hand—specifically, his use of discarded materials to create the first version of The Street, and his salvaging of what remained of it for the Reuben Gallery version—is like primitive techniques of bricolage. His concept of the object as a magical presence, a sum of its "powers" or charisma, relates his outlook to that of the primitive. Although Oldenburg's farcical common objects constantly bring one down to earth, to sex and the lowly realities of bodily process, there is no denying their mysterious capacity to impress one as actual presences. The toilet seat with its pendulous *p. 15* cover and yawning bowl bears curious similarities to the war masks of primitive societies. Oldenburg's notion of the artist's role, moreover, has analogies to the role assigned to the artist in such societies, where he functions as shaman or priest.[4]

Oldenburg's habitual sense of freedom, which lets him enter into and exit from any context at will, allows him to adopt certain aspects of primitive thought while rejecting the rigid control of both thought and conduct that systems of totems and taboos actually impose upon the individual and his society. Nor do the affinities between his thinking and the savage mind lead him to appropriate any of the *forms* of primitive art. On the contrary, as we have seen, his forms are the conventional ones of Western art, although he extends form in certain crucial respects. In contrast to Klee and Dubuffet, who studied the representational means of non-civilized art, what Oldenburg imitates (though with a self-consciousness and paraphrasing equal to theirs) is the *conceptual* processes of the primitive, the child, and the schizophrenic. The difference between Klee's and Dubuffet's attitude toward primitive art and that of Oldenburg is a function of the difference between Freud and the neo-Freudians. Whereas Freud could see no answer to civilization's discontents save through the successful sublimation of the instinctual, the neo-Freudians—and especially Norman O. Brown, whose thinking, as we have seen, often parallels Oldenburg's—have looked for ways in which alternatives to civilized thinking might be found in non-civilized

"Houses—
the metaphor
& symbol"
(notebook page).
1960. Pencil
Owned by the artist

Study for group
of three sculptures
(notebook page).
1960. Ball-point pen
on clipping
Owned by the artist

Metamorphosis of Form

above: Two Small Ray Guns. 1959–1960. Plaster and
other materials, painted with enamel, mounted on board,
6 inches high x 9 inches wide. Owned by the artist

center, above: "In water"—Primary Form (notebook page). 1960
Pencil, 10³/₄ x 8¹/₂ inches. Owned by the artist.
below: Soft Sink Fixtures, Elephant Head (notebook page). 1963
Colored crayon, ball-point pen, 8¹/₂ x 11 inches
Owned by the artist

right: Soft Washstand. 1966
Vinyl filled with kapok, wood, painted with Liquitex, metal rack,
55 inches high x 36 inches wide x 28 inches deep
Collection Dr. Hubert Peeters, Bruges

opposite, left: Study for a Soft Sculpture
in the Form of a Drainpipe. 1968
Crayon and watercolor, 29 x 23 inches
Collection Mr. and Mrs. Roger Davidson, Toronto

opposite, center and right: Soft Drainpipe—
Blue (Cool) Version. 1967. Canvas, metal, painted with Liquitex,
109¹/₂ inches high x 73⁷/₈ inches wide (adjustable by pulley)
Owned by the artist

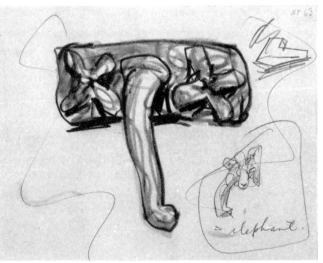

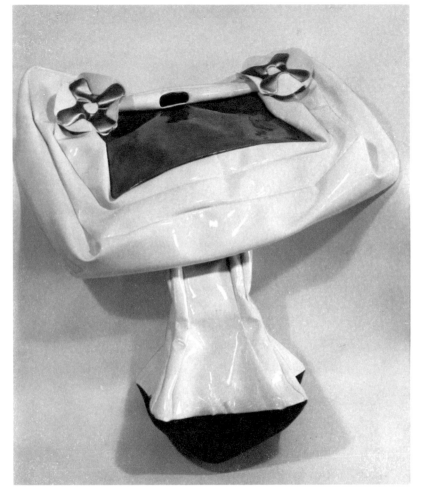

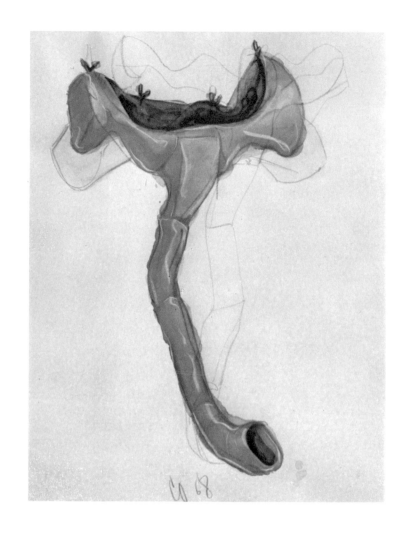

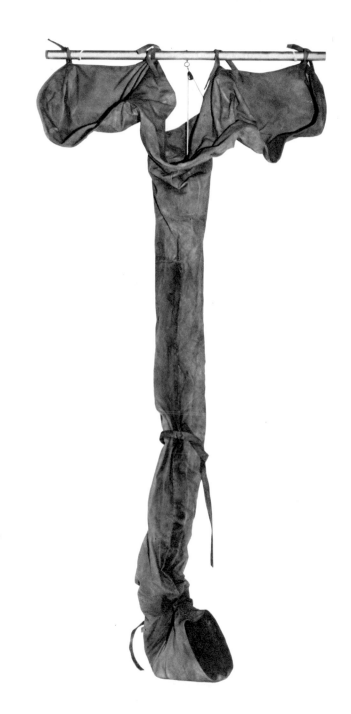

thought, leading to self-expression and pleasure rather than to repression. The world views of the child, the savage, and the schizophrenic are seen not merely as antidotes to the deadness of civilization, but as conceivably more "rational" and sane than civilized thought.

Oldenburg's neglect of the forms of primitive art in favor of the conceptual structure of primitive thought is in many respects the antithesis of the interest earlier Western artists had in primitivism. His determination to deal with industrial life by humanizing it is in direct opposition to Gauguin's flight to Tahiti to escape the pressures of civilization. Oldenburg demands both an acceptance of the industrial milieu, "making the city a value of good," and simultaneously a return to certain "non-civilized" modes of thinking in order to keep the instinctual life operative *within* the context of the modern industrialized milieu.[5] Presumably, the acceptance of certain values and constructs of children, savages, and lunatics will transform the apperception of the environment and allow it to become an area for enjoyment and satisfaction, rather than a nightmare from which one must flee.

Needless to say, such a prescription presents many dangers, particularly if taken literally. In assuming the role of cultural shaman, Oldenburg risks seeing life imitate art—a possibility that seems to have become actual in many illustrative recent events. Regression to childhood, nostalgia for a paradise lost, and the permissiveness of full self-expression *may* be the only means toward creating a humanized technology in a society devoted to leisure and affluence. On the other hand, they may simply exacerbate the ills from which society is already suffering. In this context, one might consider the situation of the Tupinamba Indians of Brazil in the sixteenth century, as described by a contemporary Jesuit: "The shamans persuade the Indians not to work, not to go to the fields, promising them that the harvests will grow by themselves, that food instead of being scarce will fill their huts, and that spades will turn over the soil all alone, arrows will hunt for their owners, and will capture numerous enemies. They predict the old will become young again."[6]

Ray Gun, as Oldenburg puts it, is "a force for good or bad"; he both annihilates and illuminates. In *p.71* the final analysis, the artist merely proposes, and society determines the use made of his proposal. An infantile, undirected society will make one thing of its art; a mature, goal-directed society, something else. The artist can only point out the alternatives.

If Oldenburg's art offers an unusually complete record of the impressions made upon a sensitive artist by his times, then his most recent work interjects a note of pessimism as to how America is using its own potency, for which Ray Gun is a metaphor. Oldenburg's first metal piece, *Giant Lipstick*, was made in 1967 for *p.110* the "Homage to Marilyn Monroe" exhibition.[7] With its razor-sharp edges and stream of red color, this flat cutout suggests not the soft eroticism of the dead movie star, but the aggressive phallic forms of the bullet or the missile.

NOTES

1. *Op. cit.*, p. 162.

2. "The Poetics of Softness," p. 228.

3. Compare also Oldenburg's manner of categorizing his drawings (p. 23) and of classifying styles (p. 151).

4. That the secular art of the twentieth century has religious or mystical overtones was an idea common to the progenitors of non-objective art, Kandinsky, Malevich, and Mondrian. Oldenburg's application of such a notion to representational art, however, turns the entire proposition inside out and is another instance of his reversal of the premises of abstraction.

5. In "Sun Worship and Anxiety" (*Magazine of Art* [New York], November 1952, pp. 304–312), Charles S. Kessler has discussed the nudism, sun-bathing, physical culture, and youth movements that arose in Germany around the turn of the century in reaction to the over-rapid mechanization and urbanization of the economy and the confining discipline of official education. This cult of physical vitality is reflected in many paintings by the German Expressionists, who for the most part viewed the city in terms of anguish and disgust. A more temperate attitude, however, was that of Kirchner, who tried to adapt to the city by surrounding himself with kindred bohemian spirits and cultivating a life of the senses.

6. Quoted by Mircea Eliade, "Paradise and Utopia: Mythical Geography and Eschatology," in *Utopias and Utopian Thought,* edited by Frank E. Manuel (Daedalus Library, published by the American Academy of Arts and Sciences and Houghton Mifflin Co., 1966), p. 271.

7. Sidney Janis Gallery, New York, December 6–30, 1967.

Paradise Regained: The Past Recaptured

Psychoanalysis manages to salvage its allegiance to the (false) reality-principle by its use of the word fantasy to describe the contents of the unconscious ("unconscious fantasies"). It is in the unconscious that "we are members of one another," "we incorporate each other." As long as we accept the reality-principle, the reality of the boundary between inside and outside, we do not "really" incorporate each other. It is then in fantasy that we "project" or "introject"; it is then purely mental, and mental means not real; the unconscious then contains not the hidden reality of human nature but some (aberrant) fancies, or fantasies.

Norman O. Brown, *Love's Body*

For, in short, both the first colonists and the later European immigrants journeyed to America as the country where they might be born anew, that is, begin a new life. The "novelty" which still fascinates Americans today is a desire with religious underpinnings. In "novelty," one hopes for a "re-naissance," one seeks a new life.

New England, New York, New Haven—all these names express not only the nostalgia for the native land left behind, but above all the hope that in these lands and these new cities life will know new dimensions. And not only life: everything in this continent that was considered an earthly paradise must be greater, more beautiful, stronger. In New England, described as resembling the Garden of Eden, partridges were supposedly so big that they could no longer fly, and the turkeys as fat as lambs. This American flair for the grandiose, likewise religious in origin, is shared even more by the most lucid minds.

Mircea Eliade, "Paradise and Utopia: Mythical Geography and Eschatology"

Oldenburg's "discovery," in 1959–1960, of the identity of Ray Gun as the phallic totem, the priapic hero who would bring man back into contact with his true nature by liberating his instincts, meant a freeing of his own imagination as well. A comparison of The Street with The Store is like a capsule history of the distinction between Freudian and neo-Freudian thought. In contrast to the pessimism and morbidity of The Street, which was a metaphor for the anxiety of city life, The Store presented "power vitality health (hope hope)"; it was "a place of 'quick love' as well as a museum, an archeology." With its brilliant color, sensuous surfaces, and abundance of goods, The Store hinted at the joys and pleasures that industrial civilization *might* bring; it was the popular museum where art was democratically available, not only to the happy few who visit elite art museums, but to the slum-dweller too. It was also both a celebration of the vitality of American culture, and a satire on the American obsession to consume and the newly won status of American art as a commodity. Whereas The Street expressed the pessimistic, nineteenth-century European attitude toward civilization, with its concomitant evils and the sacrifices of the instinctual life that it demands, The Store accepted the message formulated by Norman O. Brown and confidently predicted Life's triumph over Death.[1]

With the creation of The Store and the discovery of an American "style," Ray Gun had found the means to self-expression. Secure in his identity, he began to entertain megalomaniac fantasies of power and world domination (which coincidentally paralleled America's expansionist foreign policy of the 'sixties). Announcing that "All will see as Ray Gun sees," he foresaw that objects, events, natural forces, and places would be transformed and recast in the artist's image; thus, Ray Gun is "Nug Yar" (New York) spelled backwards. But since the artist is a large, soft mesomorph, the hard plaster of the Store objects must be replaced by the pliant, yielding forms of soft sculpture. These in turn would become a series of self-portraits—Oldenburg's own body image in increasing dimensions.

Finally, having created the new world, like God, and having saved humanity, like Christ, the artist will preside over the peaceable kingdom, where the instinctual has returned and the repressed has been liberated—a land of contented, relaxed individuals, working, trading, and playing together like the good people of Neubern. Art will be reintegrated into society. The artist will regain his central role as priest of leisure and as the medium of communication with the higher realm of the spirit. Ruling with an easy, permissive hand, he will encourage self-expression and childlike play. He will overthrow the old value system, not through violence and revolution, but through subversion and humor; he will accede to power, not through force, but through the will of the people. Reigning with love, not fear, he will eventually oversee his vast domain from his throne in Central Park, the center of his peaceful, prosperous empire.

Like the portraits of Roman emperors in mythological guise, the first monuments constructed during this sovereign's benevolent reign will express the goals and values of the civilization that he has created. Visible for miles around, the giant Teddy Bear monument will be a constant reminder of the ruler's gentleness and affection, and his dedication to the resurrection of the honest joys of childhood—security, play, and the expression and gratification of instinctual needs. The cathartic-metamorphic powers of Ray Gun, first hero of the state, will transform the land of violence and social injustice into the land of pleasurable, natural satisfaction and affluent enjoyment.

Obviously, we are dealing here neither with reality nor with the super-reality of Surrealism, but with a line of wish fulfilment that runs directly through the center of American thought. For ultimately, Oldenburg's vision is a grandiose utopian fantasy of a democratic paradise regained; in short, as Sidney Tillim was the first to point out, it is the American Dream.[2] The nostalgia that permeates Oldenburg's work, causing him always to use old-fashioned, obsolete stereotypes of objects (pay-telephones, typewriters, the Airflow),

175

is typical of American intellectuals and, according to Mircea Eliade, reveals their "desire to turn back and find their *primordial history,* the 'absolute beginnings.' This desire to return to one's beginnings, to recover a primordial situation, also denotes the desire to start out again, the nostalgia to relive the beatitude and the creative exaltation of the 'beginnings'—in short, the nostalgia for the earthly paradise that the ancestors of the American nations had crossed the Atlantic to find."[3]

Frank E. Manuel has observed that two alternative utopian visions have come to the fore in contemporary Western society and appear to be moving in opposite directions: "In one, based upon the hypothesis of a growing spiritualization of mankind, the dross of the body seems to be left behind. In the other, a fantasy of greater rather than diminished sensate gratification is pivotal, and all human activity is libidinized."[4] Oldenburg's utopia, like that of the neo-Freudians, is obviously of the latter type. (A case might also be made that twentieth-century abstraction, with its basis in neo-Platonic aspirations to a condition of "pure spirituality," corresponds to the former.) In such a context, the transformation of The Street into The Store can be seen as a recapitulation of American utopian thought, representing the progression from puritan eschatology to neo-Freudian millenarianism.

It is not the line between life and art that is obscured in Oldenburg's art, but rather the boundary between reality and fantasy, which seems to blur as the two merge in a fluid continuum. Clearly, Ray Gun's courage in transforming the nightmare of The Street into the affirmative vision of The Store was meant to be an inspiration and an example to society in general. Ray Gun's early career was devoted to exorcising two demons of American history, puritanism and violence. His ultimate goal, however, was the restoration of the transcendentalist vision of the pure land where nature and man would once more be reconciled—but now, it was to be *within* the context of an industrial urban society, in which "people are again not made afraid of expressing themselves."

Unquestionably, Oldenburg's personality conforms to Manuel's description of the utopian fantast: "A bit of schizophrenia, a dose of megalomania, obsessiveness, and compulsiveness fit neatly into the stereotype"; and he adds that to be effective, the utopian must also "be endowed with genius and stirred by a creative passion."[5] Schizophrenia, according to Brown, testifies to "experiences in which the discrimination between consciousness of self and the consciousness of the object was entirely suspended, the ego being no longer distinct from the object; the subject no longer distinct from the object; the self and world were fused in an inseparable total complex."[6] He declares: "Contrary to what is taken for granted in the lunatic state called normalcy or common sense, the distinction between self and external world is not an immutable fact, but an artificial construction.... Here is the fall: the distinction between 'good' and 'bad', between 'mine' and 'thine,' between 'me' and 'thee' (or 'it')..."[7]

It is precisely these distinctions that Oldenburg refuses to make. The dissolution of boundaries between people and objects, the tangible and intangible, the solid and the gaseous, first in The Street and later in his soft sculpture, has analogies with the mental processes of schizophrenics, who cannot separate themselves from the world outside themselves. It is also obvious that Oldenburg agrees with Brown that the "adualistic" world of the schizophrenic, a world of "mystical participation... and indescribable extension of inner sense" may be the cure for civilization's discontents. He reaches a conclusion identical to that of Brown: regeneration—survival, even—requires exchanging the rationality of Apollo, which has dominated Western thought since the Middle Ages, for the instinctual call of "Dionysus, the mad god [who] breaks down boundaries; releases the prisoners; abolishes repression; and abolishes the *principium individuationis,* substituting for it the unity of man with nature."

Oldenburg's world, in which play, fantasy, and permissiveness liberate the instinctual life buried within modern man, is thus related to two currents of utopian

thought: that of the neo-Freudian, and that which has found expression throughout American literature, both popular and classic, as well as being echoed in American folklore. From the transcendentalists' vision of the pure land to actual utopian communities like New Harmony, to Paul Goodman's "communitas," the American Dream has been of abundance, surplus, affluence, and leisure for all. Yet it is not to be a place of merely materialistic delights, but an earthly paradise: Jonathan Edwards' New Jerusalem without his angry God.

Ray Gun's vision is, of course, a fantasy; but it is a beautiful, radiant, affirmative fantasy—a vision of "PARADISE that is the place of no taboos, natural and full of hot white sunlight (Provincetown's light)." It offers the possibility that the life force will triumph over the collective will to destruction, if the pleasure principle can become the reality principle. Oldenburg's polymorphous perverse utopia, where even the machines are sexy and friendly rather than destructive and antagonistic to man's human nature, coincides with Herbert Marcuse's description of the ideal society in which the sexual impulses, without losing their erotic energy, transcend their immediate object and eroticize normally non- and anti-erotic relationships between individuals, and between them and their environment. "The pleasure principle extends to consciousness. Eros redefines reason in his own terms. Reasonable is what sustains the order of gratification."[8]

In such a neo-Freudian utopia, fantasy and reality can mingle freely, as they do in Oldenburg's art; and in prescribing such an accommodation, Oldenburg is a visionary artist, a social reformer in the tradition of Goya or Daumier. But, since ours is a society in transition, Ray Gun's ultimate destiny is unknown. His prophecy offers two clear alternatives. Either our power will be used to humanize the environment, creating a truly democratic society of leisure and abundance, or else Ray Gun will become an instrument of death and destruction. Time alone will reveal Ray Gun's true identity, hidden beneath its layers of ambivalent disguises.

NOTES

1. *Life against Death,* Middletown (Conn.): Wesleyan University Press, 1959.

2. "Month in Review," *Arts* (New York), February 1962, pp. 34–37.

3. "Paradise and Utopia: Mythical Geography and Eschatology," in *Utopias and Utopian Thought,* p. 261.

4. "Toward a Psychological History of Utopias," in *Utopia,* special issue of *Daedalus,* Journal of the American Academy of Arts and Sciences, Spring 1965, p. 318.

5. *Ibid.,* "Introduction," *Utopias and Utopian Thought,* p. xii.

6. *Love's Body* (New York: Random House, 1966; 1st Vintage Books Edition, 1968), p. 159.

7. *Ibid.,* pp. 142–143.

8. *Eros and Civilization: A Philosophical Inquiry into Freud* (Boston: Beacon Press, 1955; revised edition, 1966), p. 224.

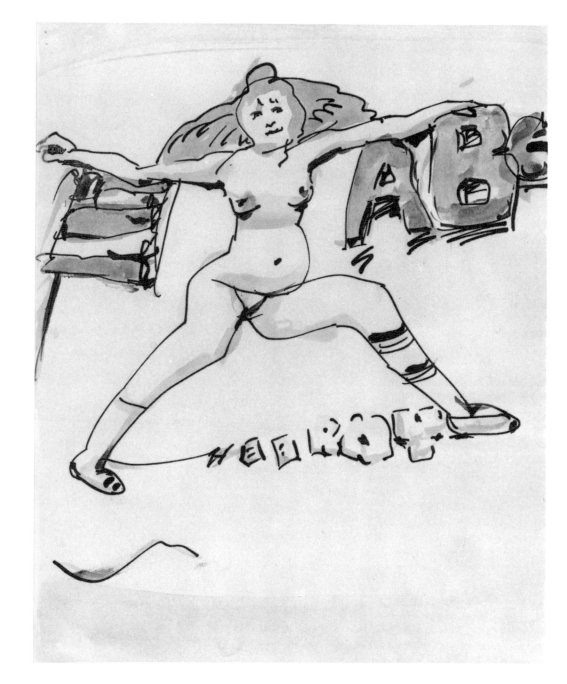

Nude Figure with American Flag—
"A B C Hooray." 1960
Pen and ink and watercolor,
11 x 8½ inches
Collection Mrs. Claes Oldenburg,
New York

Claes Oldenburg as the Newspaper Man.
Store Days, II. 1962

Ray Gun Unmasked

Artists create the comic; after collecting and studying its elements, they know that such-and-such a being is comic, and that it is so only on condition of its being unaware of its nature, in the same way that, following an inverse law, an artist is only an artist on condition that he is a double man and that there is not one single phenomenon of his double nature of which he is ignorant.
 Charles Baudelaire, "On the Essence of Laughter"

In his essay on the comic in the plastic arts, from which the above quotation is taken, Baudelaire reveals the ultimate seriousness of the comic by seeing it as the obverse of the tragic, to which consequently it is irrevocably tied. "Human laughter," he declares, "is intimately linked with the accident of an ancient Fall, of a debasement both physical and moral.... Laughter and tears cannot make their appearance in the paradise of delights. They are both equally the children of woe, and they came because the body of enfeebled man lacked the strength to restrain them." And he quotes from an anonymous source, "The Sage laughs not save in fear and trembling."[1]

Far from being a break with tradition, Oldenburg's insistence on the comic is an attempt (in my view, a successful one) to put modern art back in touch again with an ancient and universal tradition. If an increasingly secular age can no longer support an image of tragedy, then comedy instead must bear the entire burden of such a full expression of humanistic feeling. Ray Gun is above all the tragic clown; and Oldenburg's conception of the self defines the artist as the inheritor of a system of cultural values in crisis. The tragicomic expression of his early *Self-Portrait* is clearly consistent with the Pagliacci-Pierrot role that he assumed in many of the happenings. Like the tragic clown, Oldenburg disguises his sorrow with a mask of laughter. His continued identification with the fringe and marginal elements in society—beggars, fools, clowns, gypsies, the oppressed, and the declassed—also reveals him as an unreconstructed bohemian. Symbolically speaking, Ray Gun's ancestors are the tragic jesters of Velázquez, the harlequins of Watteau, Cézanne, and Picasso, the circus ringmasters of Seurat.

Oldenburg understands the degree to which his is an old-fashioned posture. "My theories are not original," he once wrote, "my execution is, and my distinction lies in my sensuality and imagination rather than my intellect." In this book, I have not tried to organize his works into a hierarchy of categories of value (which is essentially the task of connoisseurship)

but have emphasized their sources and meanings, because I believe that the quality of these works resides to a great extent in their ability to illuminate contemporary experience. Clearly, however, the artist is right: it is his execution, his ability to make form live and to imbue it with a palpable vitality and sense of movement, that distinguishes his genius. In terms of the history of formal innovation (which many identify, I believe wrongly, as the totality of the history of art), Oldenburg's great insight was to realize, like Pollock—the single artist whose name appears in his notebooks without challenge or criticism—that at this late moment in the development of modernism, *a change in form could be achieved only through a change in technique.*

In Oldenburg's art, the distortion of form, its infinite metamorphoses, becomes a metaphor for the search for truth, an endless pursuit through the labyrinth of illusion. His prime values as an artist are elusiveness, mystery, ambiguity, and multivalence.

Despite the degree to which contemporary society has assimilated his art, Oldenburg continues to stand outside that society, and to generate images and forms that criticize its standards and values, either implicitly or overtly. Ray Gun responds to circumstance, changing in relationship to any given context; but he does not adapt. Neither does he conform—either to middle-class standards, academic norms, or to a "one-dimensional" society that would flatten, simplify, and integrate art within its own value system. In other words, Ray Gun remains "a pain in the ass."[2]

This, too, is the conventional posture of the modern artist—a posture that, given the realities of the present, seems in many ways old-fashioned. Yet, for whatever sentimental, moral, or psychological reasons, Oldenburg must continue to stand in opposition. In an age of standardization, he insists on diversity; at a moment of consensus and accommodation with existing structures, he challenges the status quo by revealing the absurdity of many of its premises. He confounds mass psychology by deliberately blurring the line be-

tween reality and fantasy, the better to prove that, with regard to action, life cannot afford to imitate the irresponsibility of art, which is a purely mental act. In a context of nihilism, anarchy, and social, cultural, and political disintegration, Oldenburg has not retreated, as have so many artists in moments of crisis, to a more conservative position. He still continues to confront the moment, taking risks and offering constructive alternatives.

As in the plays of Oldenburg's Scandinavian forebears, the artist provides the moral example for the community to follow. As he destroys, Ray Gun creates.

NOTES

1. "On the Essence of Laughter, and, in General, on the Comic in the Plastic Arts," 1855, translated and edited by Jonathan Mayne. In *The Mirror of Art* (New York: Harcourt, Brace & World; paperback edition, Garden City, New York: Doubleday Anchor Books, 1956), pp. 133–135 *passim;* quotation at head of chapter, p. 153.

2. See p. 61, n. 3.

Appendix: The Theater of Action
Selections from Oldenburg's Writings
Chronology
Bibliography
Index

Appendix: The Theater of Action

Because happenings have had their denouement in the multimedia discotheques, it is hard to remember that they were originally semi-private, semi-ritual performances attended by a handful of initiates. The performances of the Ray Gun Theater, for example, which were given in Oldenburg's studio at 107 East Second Street in the spring of 1962, after The Store had closed there, were attended by groups limited to thirty-five people at a time, because the narrow space could accommodate no more. The members of the audience were jammed together, physically touching one another and occasionally brushing against the limbs of the actors in front of them, below them, or above their heads. This intimacy was part of the direct involvement demanded by the original happenings, and the involvement in turn accounted for much of the impact of the events.

Oldenburg's emphasis on structure, insured through repetition of action and planned movement, his control of his means, his attention to detail, and the originality of his images, all distinguish his happenings from those of others. But he was by no means the inventor of happenings and was in fact a relative late-comer to the genre. By the time that Oldenburg's first happening, *Snapshots from the City*, took place in late winter 1960, Allan Kaprow had already produced his *18 Happenings in 6 Parts* at the Reuben Gallery in the fall of 1959, and Red Grooms's prototype tableau, *The Burning Building*, had been performed throughout that December in his Delancey Street Museum.

At the time, the first happenings appeared to be a weird composite of painting and theater. It is now clear, however, that they were a direct extension into the theater of the "action" or gestural element of Abstract Expressionism. The connection was made consciously by Kaprow, whose "environments" of the late 'fifties were the bridge between the paintings of Pollock, de Kooning, and others and their later outcome—"happenings."[1] Oldenburg himself was quite conscious of the relationship: "Sometimes I feel that what I'm doing with living material, with people and objects and situations is something like what they (de K and P) did with paint. I just have substituted material," he wrote. In keeping with the literalizing tendency of the art of the 'sixties, happenings make literal the concept of action by representing real gestures and actions as opposed to their pictorial metaphors. For Oldenburg, the replacement of action in painting by actual movement in live performance carried still further the process of the literalization of pictorial qualities in his reliefs. Moreover, linked sequences of action not only added the element of time that was unavailable in painting, but also allowed an enrichment of content, while simultaneous or superimposed actions could express interlocking levels of psychological associations.

Oldenburg had been interested in the theater long before he came to New York, and his close association with Dick Tyler from 1957 on intensified this interest. During 1959 and 1960, he was also in contact with, and directly or indirectly influenced by, Kaprow, Grooms, and Dine. In January 1960, he took part in Kaprow's *The Big Laugh*, one of the second group of happenings presented at the Reuben Gallery. As one might expect, however, Oldenburg's happenings differed from those of others, just as their emphasis on intelligible even though alogical content differentiated them from the Theater of the Absurd, to which their bizarre imagery bore some relationship. What distinguishes Oldenburg's happenings is that they were more conceptual than others, and had virtually no narrative but were conceived as "pictures"; in addition, they had a consistent content that linked them to the iconography of his sculpture. What counted was not so much the individual parts of each performance, however, so much as the allover mood that was conveyed. Oldenburg's early happenings presented a panoramic, generalized experience; the "plot" was associational rather than logical. In other words, Oldenburg's primary concern in the happenings was not drama, and certainly never narrative; it was psychological content, physical movement, vivid imagery, and above all, spatial relationships.

Oldenburg's concern with the body in space, related to other objects of a constructed environment, links his happenings to the new form of choreography that has followed the work of Merce Cunningham and Paul Taylor. He himself has defined his intentions in using this medium: "The 'happening' is one or another method of using *objects in motion*, and this I take to include people, both in themselves and as agents of object motion ... I present in a 'happening' anywhere from thirty to seventy-five events or happenings (and many more objects), over a period of time from one-half to one and a half hours, in simple spatial relationships—juxtaposed, superimposed ... The event is made simple and clear, and is set up either to repeat itself or to proceed very slowly, so that the tendency is always to a static object."[2]

The term "happenings" is in itself something of a misnomer, for these performances have no plot, and nothing in the sense of narrative actually "happens." Happenings are not meant to be interpreted, but to be experienced directly. Oldenburg's are particularly static and often have the quality of vignettes passing before the spectator. As a result they, like his sculpture, ultimately invoke a synthetic image, a general feeling or mood about what has transpired, with the intention of leading people "away from the notion of a work of art as something outside of experience, something that is terribly precious," so that they may eventually "think of a normal, natural experience in terms of a work of art." For, in spite of stylized, non-naturalistic qualities that relate them to such theatrical forms as Grand Guignol and Japanese Noh plays, Oldenburg's happenings use ordinary situations, gestures, and movements—walking, sitting, smoking, eating, swimming.

"The happening," Oldenburg has declared, "is for me a personal composition out of elements at hand. It is not a question of chance or random effects.... The relation of the incidents is fortuitous as is the case in real life. Imagine a map where all that goes on in the city can be seen from above at once, such as the fire charts of the fire department or the multiplicity simultaneity of the taxi or police radios. A city is overlay upon overlay of incident." He described happenings as "a certain kind of experience: simply sitting and watching in an isolated way something that's *very familiar.*" As with his sculpture, Oldenburg's use of familiar, even banal, subject matter was meant to be a way of giving his audience something in his art that they could readily grasp. At the same time, he was disheartened by their unwillingness to go beyond the obvious. "A Western audience has to have explanations," he complained. "They really can't watch anything for its own sake. They have to have an explanation first or a reason for watching it. They really don't watch a thing. They follow an idea as it unravels, and everything represents the unravelling of an idea." He was nevertheless determined to try to change this.

Oldenburg's original conception was that the audience for his happenings would be small, and that the repertory would be like a "workshop of ideas and possibilities surrounding my concept of personal theater, and not so much directed at the general public as at other artists and connoisseurs." He thought of happenings as "a theater of action or of things...: a poor man's theater and the lead is a beggar." The happenings were also a theater of license and permissiveness that in many ways paralleled the permissiveness of the homosexual drag world of Jack Smith's film *Flaming Creatures* as much as they prefigured the permissiveness of hippie costume drag. Oldenburg's permissiveness consisted of setting up situations with given limitations, including the use of specified props, and then stepping out of the situation, allowing the participants a certain amount of leeway. His instructions to performers were nevertheless quite specific, and the line between audience and performer was well defined.

Like much of Pop Art, Oldenburg's happenings deal with stereotypes. Happenings in general are an eclectic form, and his are especially so. He has borrowed freely from newsreels, silent movies, horror films, slapstick comedy, school pageants, vaudeville, burlesque, and other popular performing traditions, and has mixed these borrowings with elements of dance, mime, psychodrama, *commedia dell'arte,* baroque festivals, and drama. His characters, familiar from all these sources but especially from the movies, include the Chaplinesque tramp, the Tobacco Road drifters, and the W. C. Fields buffoon. Certain roles of the early happenings were standardized in terms of the people who assumed them, their repertory cast featuring Oldenburg himself, Pat Oldenburg, Gloria Graves, and Lucas Samaras in the principal roles. The characters were drawn from the picaresque, raffish outcasts of society—the crook, the drunk, the simpleton, the transvestite, and the beggar. Pat Oldenburg incarnated the female principle. She played the Street Chick, the City Waif, the Bride, the "City Venus," the Tart, the Muse, and the doll or *poupée* (Oldenburg's nickname for Pat was "Poopy").

Oldenburg himself, on the other hand, always assumed in the happenings a Pirandelloesque part that combined his real relationship to the action as director with aspects of two main types of theatrical stereotypes—the magician-hypnotist-spellbinder, and the fool or the clown. He took for himself the role of Ray Gun, the hero of many masks, the metamorphic "hero into loonie" (see p. 56). Like Melville's confidence-man—the eternal nomadic stranger, the innocent sophisticate—Oldenburg skirted the action, changing his role at will, from circus barker to medicine man to bum.

These roles reveal his conception of the role of the artist in society. To Pat's "City-Bird-Child," he often played the predatory monster, the voyeur who peeks around openings, the grossly violating "Rag Man." He identified, in short, with the fringe elements of society, seeing the artist in his adventures as close to the criminal. Or else he impersonated Prospero, "a curious sorcerer because he is like the rational man, the kind man, the leader, a very worldly figure, who makes magic easily and surrounds it with no mumbo-jumbo." As Prospero, he could manipulate the pure spirit embodied by Pat's Ariel or Puck. In this guise, Oldenburg's conception was that of the artist as sorcerer, a magician who transforms the world through his own vision. He was both the "voyeur" who observes and the "seer" who prophesies. It was the latter role that Oldenburg usually assumed in his early happenings, which combined elements of primitive ritual, *rites de passage,* and ancient dramaturgy with popular farce and melodrama.

Oldenburg's earliest happening was *Snapshots from the City,* a series of posed, frozen tableaux that he and Pat performed at the Judson Gallery during the showing there of The Street. "The performances were intended to add the ultimate note of actuality to The Street with the artist's actual presence in his creation," he explained. His second effort, which he regarded as showing less influence of Red Grooms and more of that of Whitman and Kaprow's use of objects, was *Blackouts.* Presented at the newly relocated Reuben Gallery at 33 East Third Street in December 1960, it was a half-hour performance divided into four parts, "Chimneyfires," "Erasers," "The Vitamin Man," and "Butter and Jam." Oldenburg has described it as being a pendant to *Snapshots from the City,* but more lyrical, sparse, and objective in its effect. A much longer piece was his third happening, *Circus* (so called because its presentation of events in five superimposed rows under weak electric bulbs was inspired by circus light and space); this was put on at the Reuben Gallery in February 1961. Each of its two parts, called respectively "Ironworks" and "Fotodeath" lasted about forty-five minutes, with a quarter-hour intermission during which "Pickpocket," a sequence of photos from magazines, was projected in the form of slides. In contrast to the strobe effect of the earlier works, in which a quickly paced succession of scenes was illuminated between blackouts, "Ironworks/Fotodeath" was well lit and gave the spectators an impression of "attenuated time and repetition."

During the following year, Oldenburg worked to refine his aesthetic of the theater. The result was the Ray Gun Theater, the series of ten happenings presented at the Ray Gun Manufacturing Company, 107 East Second Street, from February to May 1962 following the closing of The Store (see pp. 69–70). Of this cycle, *Injun* was the most literary, incorporating much material from American history. Oldenburg's preparatory notes indicate that he conceived of *Injun* as "strong in setting, more setting than anything else, wild and not cool, and fantastic, not realistic." Its conception dates back to the summer of 1960, when Oldenburg found himself critically evaluating the previous winter's *Snapshots from the City.* In the Provincetown locale, where he focused more specifically upon American history, he began to formulate a central character who would combine traits of Crusoe, Noah, and Adam—a sort of first-man explorer or frontiersman. The first mention of this figure is as "Indian" or "the American Crusoe"; but whereas Crusoe was associated with the sea, Indian stood for the "inland American forest." Eventually, he was to become the central character of the Ray Gun Theater, which Oldenburg developed in order to add the dimension of time to the Ray Gun enterprises. (His earliest conception of The Store, in fact, had been as a work which "will look like a merchandising street and the stores and the plays will pursue history.")

The title *Injun* was taken from the corruption of the word "Indian" by Mark Twain, who had been fascinated with themes of American violence and who was much on Oldenburg's mind at this time.[3] Oldenburg's early happenings were satires on American foibles, comparable to Twain's sardonic, mock folk epics. They had a seedy Depression mood, very much in keeping with the cracker-barrel atmosphere of The Store in whose locale they were presented. The macabre character of the action, however, was modified by the multiple focuses of the action and by humorous interludes.

The apocalyptic quality of the early happenings, with their intimations of massacre, rape, catastrophe, and primitive forces rising from the lower depths, reached their crescendo in the second version of *Injun,* presented in 1962 on the property of the Dallas Museum for

Contemporary Arts, which had commissioned the piece in conjunction with its showing of objects from The Store. This version was influenced by a Wallace Beery movie that Oldenburg had seen as a child, in which Beery played a Civil War veteran returning to a farmhouse where his family had been slaughtered by an axe murderer. In Dallas, the spectators were forced to bear witness to the violence of the American past, shortly to have a bloody sequel in that very city.

In structuring *Injun* in terms of movement, Oldenburg visualized the hidden movements of Indians in the forest; its use of spectators as performers makes this Oldenburg's most total happening. The Dallas presentation was subtitled "Country-piece for a house, a yard, a shed and a lean-to" and took place in an abandoned complex of buildings on the museum's grounds. Spectators were conducted one by one out of the museum into the darkness and were led by masked figures into the house, where they were locked in. The house was littered with bodies and filled with people performing obscurely scatalogical actions, like slinging mud and squirting paint. Some rooms were lined with chicken wire and paper in order to simulate caves (a typical setting for early happenings). At one point, cars were maneuvered so that their headlights illuminated the scene—a device later used in Los Angeles for *Autobodys*. During the first performance, the police who invaded the premises in response to a riot call and began questioning the performers were themselves incorporated into the action—an illustration of Oldenburg's dictum that disorder and the unexpected must also be accepted as part of existence.

This version of *Injun* presaged the changing character of Oldenburg's happenings after the Ray Gun Theater closed in May 1962. Thereafter, audiences were larger, contact was not so intimate, and settings were not constructed but taken from found ambiences. The three happenings that Oldenburg produced in 1963 after leaving New York for the West Coast were originally conceived as a transcontinental trilogy: they included *Gayety, Stars,* and *Autobodys,* produced in Chicago, Washington, and Los Angeles respectively. *Gayety* was presented in February in Lexington Hall, a little-used building on the University of Chicago's South Side campus—an area thoroughly familiar to Oldenburg. "In Gayety," he wrote, "I want to create a civic report on the community of Chicago, in the way I see it. After the overture there are six 'combinations' of events, persons, articles, sounds—all the elements of experience in representative situation, either plain or enigmatic, demonstrating such categories as weather, climate, geography, education, culture, poetry, homelife, crime, products, food, traffic, heroes, art, entertainment, and so on. This is like the civic projects one did in sixth grade..."[4] Again, one is reminded of the comprehensiveness of Neubern with its mixture of reality and fantasy. *Stars: A Farce for Objects,* on the other hand, which was presented during a Pop Art Festival at the Washington Gallery of Modern Art, emphasized public spectacle, pretty girls, nudes, and glamorous costumes. *Autobodys* had a two-night run in a Los Angeles parking lot, where spectators sat within their cars with their headlights illuminating the action. Originally, its theme was the automobile, ubiquitous in California, and the sterility of freeway culture. In this sense, *Autobodys* was a theatrical forerunner of the

Airflow theme. The emphasis on death and violence became accentuated while this happening was taking shape, when late in November President Kennedy was assassinated while riding in a motorcade, and endless images of the black cars in his funeral procession filled television screens throughout the country.

Oldenburg's happenings of 1965 were by contrast far more relaxed and less intense in their imagery than his earlier ones. *Washes,* a

Injun, II. Dallas, 1962

Autobodys. Los Angeles, 1963

185

complex work in many parts, which took place in May in Al Roon's Health Club on West Seventy-third Street as part of the First New York Theater Rally, dealt humorously with sex and leisure.[5] In December, Oldenburg's twenty-minute-long *Moviehouse* preceded happenings by Robert Rauschenberg and Robert Whitman during a festival at the Film-Makers' Cinematheque, thus serving as a kind of prolegomena to a "painters' cinema," a possibility that has interested Oldenburg for some time. In fact, if one seeks a connecting theme for the happenings from *Snapshots from the City* through *Moviehouse,* one might say that it is the invention of the movies, or their development from the original still photograph through the multiple-image motion picture. From this point of view, *Snapshots* represents the primitive stage of the still photograph; its clear, isolated images of actions stopped in medias res parallel the frozen moments caught by a photographer. "There is a practical problem in 'mounting' the images which periods of darkness helped," Oldenburg wrote in his notes on *Snapshots.* "Time is slowed down in order to really dwell on action and images. The point was 'a feast for the eyes . . . a poem for the eyes.'" In *Fotodeath,* the theme of the camera that captures life is clearly related to Oldenburg's understanding of the relation between art and life. The photographer "shoots" the people posed before him, and they fall over as if dead. But art is not life; art does not kill, and they are soon revived. ("When Ray Gun shoots, no one dies.") In *Fotodeath,* which Oldenburg envisioned as "a cosmos a whole reconstruction of NY," the series of isolated events of *Snapshots* is extended to form a continuous action with overlapping movements—like Muybridge's motion photographs, which represented an intermediate phase between still photographs and the movies.

Oldenburg's happenings, in spite of his emphasis on role-playing, are essentially visual theater, "painters' theater," with the emphasis on images. Since they have no plots, and the characters are stereotypes rather than being developed, it is the costumes, props, and lighting that become the centers of attention and often determine the action. With habitual responsiveness to his environment, Oldenburg usually selects his setting first or uses a location assigned to him as a given limitation. The happenings in Dallas, Washington, and Los Angeles each contained material generated by his associations and experiences in those places. Oldenburg has described the procedure he followed with *Washes* as being characteristic of the method he used in previous pieces: "1. A period of . . . priming myself with possibilities—practical and impractical . . . recording these in a book, and writing a number of script drafts. 2. Familiarizing myself with the particular place. . . . 3. Recruiting the cast from volunteers, some new and some familiar from past performances. . . . 4. Purchase of objects and costumes. . . . 5. First . . . rehearsals, combining prepared ideas, actual place, individuals in cast, and objects and costumes. Confusion and numerous trials and errors. 6. Final rehearsal: simplification of results of first rehearsals to strongest incidents, discarding of the rest. Imposition of simple time scheme of cues. 7. . . . performances before audience . . . with changes continuing to final performance." [6]

Props and costumes are usually collected from what is readily available in hardware stores and thrift shops, because happenings are

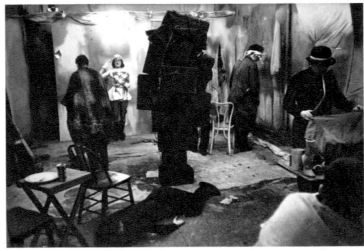

Fotodeath. New York, 1961

above all "homemade," amateur productions—the very opposite of the slick commercial theater. Preliminary notes derived from the motivating conception lead to a "script" without dialogue, which Oldenburg has never used, although sound may be incorporated in the form of random grunts, groans, and noises resulting from the manipulation of props.[7] Scripts exist for a few of Oldenburg's happenings, and several of his early pieces, notably *Injun,* had several revised texts; but most of the action is improvised. Only the bare bones are contained in the script, which structures action into overlapping compartments and designates which participants are on stage at a given moment, and what they are doing. Entrances and exits are carefully timed to create suspense. Such characterization as exists is the semi-automatic result of Oldenburg's selection of the participants, whose actual personalities or physical appearance correspond to the images or stereotypes he desires to use as his living material. Predictably, disguises and masquerades are frequent, and images of concealment and exposure are analogous to the relationship between obvious subject matter and disguised content in his sculpture.

Michael Kirby has called happenings "non-matrixed" theater, by which he means that they differ from conventional realistic drama in lacking any focus of time, place, or character; there is no climax. This lack of focus, of defining context, gives to the action an allover quality that tends to overlap and interweave within the frame of the performing area. Obviously, this is derived from Pollock's allover painting style, which, translated into theatrical terms, allows the artist to treat the very stuff of life itself as his plastic material.

Although Oldenburg's happenings are not theater-in-the-round, his use of space is different from that of the conventional theater. He often presents odd or fragmentary views; for example, in the early, more static happenings, views through openings were used to suggest an aura of mystery. Partial or obstructed views also pique the curiosity of the audience, which experiences an unfamiliar sensation when watching something familiar isolated from its normal context. In some of the happenings, the action took place around the audience, as in *Injun* and *Moviehouse,* in which the audience was literally in the midst of things and participated actively in the performance. In *Washes,* the audience was involved through the humid atmosphere while standing around the edges of a swimming pool; the action took place beneath them in the pool. The spectators were asked to wear bathing suits, although a proposed mass swim had to be called off because of the management's objections. Such random focus and unwillingness to observe the conventions of wall, floor, and ceiling of the boxlike proscenium stage, or even the relative freedom of an arena, is again traceable to the impact of Pollock's allover compositions, which present images without focal points or mandatory orientation.

Although Oldenburg was first drawn to the theater because it permitted him the use of live materials, nevertheless in his theater, as in his sculpture, the boundary between life and art is quite clear. His stylized theater of live action is at the opposite pole to the naturalistic theater with its imitation of life, which for the duration of the action demands that the spectator believe art and life to be identical. Oldenburg's happenings have large casts, who are given a certain degree of freedom, so that there is significant variation from performance to performance. "After it's been put together, I step out of it and the people find themselves in the situations that I have set up for them," he explains. In spite of his encouragement of improvisation, however, he carefully fixes its limits, just as in his sculpture he permits automatism to go only so far. He constantly molds, manipulates, and changes his material to structure it, for his main preoccupation is the overall structure of the work, which remains unchanged. Throughout the making of a happening, he exerts total critical control, rejecting material that for one reason or another does not work out.

The structure of the happenings always includes a finale. Frequently, the finale is conceived as "an apotheosis in the form of a destruction ... in which the forces of the community are released functionlessly in relieving chaos." *Washes,* for instance, ends with a moment of stillness in which the entire cast floats like dead bodies after an apocalypse, only to be revived at the last moment. "In surveying experience," Oldenburg wrote, "I find I must assign death a large role. I like Céline's constant sense of death." Thus, the two

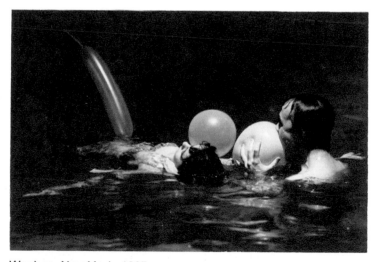

Washes. New York, 1965

forbidden themes—sex and death, Eros and Thanatos—play the largest role in Oldenburg's Freudian iconography.

Among the advantages of happenings as a form, Oldenburg has cited totality, living quality, intelligence guiding yet free, unreproducible spontaneity, and demands on the spectator to become directly involved by reconstructing, in terms of his own experience, the fragments of experience offered. "The happening, as I practice it," Oldenburg has written, "creates a lot of discomfort for the audience. It's an attempt to rattle them out of the notion that they're going to watch a play or an idea unfold. I try to make them uncomfortable to a certain degree, to make them receptive to a new way of looking at things." Obviously, Oldenburg's intention is to remove a good deal of the passive entertainment of conventional Western theater and instead transform the performance into a heuristic experience something like a Zen lesson. His attitude conforms to Morse Peckham's redefinition (in *Man's Rage for Chaos*) of the function of art in contemporary society. According to Peckham, in an advanced stage of a technological society such as our own, there is already too much order. If this be the case, then the proper aim of art is to disrupt conventional patterns of behavior and force new types of psychological adaptation. Such a definition of the purpose of art is well in keeping with Oldenburg's views.

The importance of happenings in terms of infusing new life into the theater cannot be overemphasized. Much of the fresh material that stimulated the development of a more physical, intimate, direct, and participatory theater was first synthesized in the happenings, which, at least in Oldenburg's case, had extraordinary vitality, originality, and impact. The happenings also provide a way of looking at the world that counters the "American disease of wishing to be efficient in solving problems," as Oldenburg puts it. They present images of disorder and unresolved frustration that are in many ways painful to follow but are also part of common experience. Aimless eating and walking, references to basic activities such as play, work, and conflict are the contents of an ordinary day. In this sense, the happenings were the first art manifestation to articulate a highly problematic, as well as a highly pervasive, contemporary feeling that life *is* theater, and that the relationship of the viewer to historical events witnessed on television is that of the audience to theater. That such a view presents genuine political dangers need scarcely be pointed out further.

As we have noted, several of Oldenburg's happenings—notably *Fotodeath* (originally called *Cinema*) and *Moviehouse*—deal with the movies. He had been thinking about the possibilities of film as a distinct medium since 1960, when he wrote notes for a program of "Seven Films of Close Inspection." In their emphasis on static images and slowed-down time, these fragmentary notes on a cinema of con-

templation are prophetic of some of Andy Warhol's films. Oldenburg suggests filming "the same action, a very simple action ... seen from many different viewpoints, in space and in time, over and over, slowly and rapidly," so that "all that can be gotten from it physically and metaphysically is extracted, from this very simple thing." In this context, he advises the use of scale changes, alternating distant and close focus, and shots from above and below.

All the films that Oldenburg has made himself up to now have been only fragments, although in 1961 he claimed, "I am reinventing the movies." They consist mainly of close examinations of objects from many angles, just as his happenings are not narratives but rather the presentation of "events" to be examined from several angles of vision.

A number of Oldenburg's happenings have been recorded on film by Stan Vanderbeek, Raymond Saroff, and others; but in these films he himself has had little control of the camera, so that they cannot be regarded as reflecting his own efforts as director. For *Birth of the Flag,* however, made by Vanderbeek as a filmed version of *Washes* (1965), Oldenburg completely reformulated the contents of the original action and transferred the locale from an indoor swimming pool to the open countryside. The main similarity between the two versions is that water remains a dominant motif in both. With its stress on nature, the film is a far more lyrical piece than the original happening. Its many outdoor scenes, such as the night scene of nudes on the river holding torches, are reminiscent of some of the films by Ingmar Bergman. Once again, we are reminded of Oldenburg's Scandinavian heritage.

The single dramatic film that Oldenburg has worked on is *Pat's Birthday,* made in 1962 in collaboration with Robert Breer. This portrayal of lumpen-middle-class mores utilized the repertory cast of the Ray Gun Theater, and in fact Oldenburg himself appears in this film more as actor than as director. *Pat's Birthday* is a reflection of Breer's concentration on editing and therefore hardly realizes Oldenburg's preference for a careful examination of prepared images. Objects chosen by Oldenburg for their loaded conceptual meaning appear instead as ordinary phenomena, thereby more or less subverting his intention.[8]

Oldenburg understands the camera as a subjective eye, a painter's eye, which interprets and organizes what it sees. Perhaps his recent fragmentary films with their close-up examination of single images are the beginnings of a significant facet of his career. His approach to film is like his approach to all other mediums: an investigation of its basic premises, an attempt to define its essence, and ultimately a "reinvention" of the medium—as movies are metaphorically reinvented in the progression from the still photograph to the moving image in his happenings.

NOTES

1. See pp. 25–26; p. 34, n. 9.

2. "A Statement," in Michael Kirby, *Happenings: An Illustrated Anthology* (New York: E. P. Dutton, 1965), pp. 200–201. This book includes an Introduction that is a useful summary of the early history of happenings and the influences upon them, and it contains statements and scripts of happenings by Kaprow, Grooms, Whitman, Dine, and Oldenburg.

3. "Two Scenarios from an Incomplete Pageant of America," including "Injun" and "Crusoe" (published in *Injun and Other Histories, op. cit.*) were humorous travesties much in the style of Twain's short works, which Oldenburg admired. Popular American stereotypes like Major Hoople, an old colored slave (Walt Whitman), and Teddy Roosevelt appear in them. There is a typical Oldenburg metamorphosis, in which "Friday changes into a bear and climbs the chimney," and there are liberal doses of murder, mayhem, and sheer madness. Another playlet, "Faustina," presents a mixture of Orphan Annie woe-is-me and the perverse comic sexuality of *The Naked Lunch,* which Oldenburg was reading at the time. (At one point in his notes, Pat Oldenburg, who is also called "Faustina," is referred to as "my orphic Annie"—to whom Oldenburg himself is presumably Daddy Warbucks.) "Faustina," a pornographic mock epic, prefigures the action in *Fotodeath,* emphasizing Oldenburg's favorite themes of transformation and metamorphosis. "Ah, the passage of things!" he writes in "Faustina." "The bridges are joined to the houses and the water is joined to the bridges, and even the clouds are metal, moving against one another like Coney Dodgems, clanking & dropping nuts. . . . AwMaMaGeddon! One night the bombras come, splitting and plopping. . . . The Great Ghost G. W., Grand Obelisk, The Polar Beast, the great ravenous Ice, slides down in the night. Making the old walls scream with pleasure as they crumble, deflowering the bridges, wrapping them around his phallus-head, casting the shouting ships in the air like a bull. . . . All's mud and silence. A new map. Faustina, neither human nor recognizable, without pencil or paper to draw a map, tromps on, but the old photo resembles nothing at all anymore" (*Injun and Other Histories,* p. 11). A kind of intense lyric poetry written in shorthand, "Faustina" is also a threatening, unsettling vision of a pornographic apocalypse.

4. "Gayety: The Script," in Kirby, *op. cit.,* pp. 234–235.

5. One of the events in the First Theater Rally was Oldenburg's curtain-raiser, *Telephone.* The action consisted in having a telephone placed in the middle of an empty stage. On signal, Oldenburg—who was not in the theater—made a call to this telephone; if no one in the audience answered, he hung up, and the instrument was removed.

6. "Washes," *Tulane Drama Review* (New Orleans), Winter 1965, p. 108.

7. Because Oldenburg writes constantly, one might logically assume that his verbal sense is highly developed; yet in his writings, as in his happenings, he tends to express himself in "eidetic imagery," in terms of completely visualized pictures rather than verbal details.

8. Some of the conflict between Oldenburg's intentions for this film and Breer's ideas of film-making are amusingly recorded by the latter in an article entitled "What Happened" (*Film Culture* [New York], Fall 1962, p. 58): "Let's shoot some equivalents Claws would say. By equivalents he means that a biplane equals hot dog or battleship equals pie equals hat equals ice cream equals sailboat equals pants on hanger and Christ on cross and hamburger equals pussy equals hat again and so on. That's his way of looking at things. So I go along with him knowing I can change it all later if I want. . . . Why things happen after eachother in this film is because there isn't room for everything at once. But it's really a still picture and time is not supposed to move in one direction anymore than it does in the other. I'm sorry it takes half an hour."

Selections from Oldenburg's Writings

Note: Unless otherwise indicated, the selections are taken from Oldenburg's notebooks. They are grouped according to the chapters to which they are especially relevant, as indicated by the headings.

Portrait of the Artist

Everything I do is completely original—I made it up when I was a little kid.

<div style="text-align: right">Preface to catalogue of Oldenburg's exhibition,
Stockholm, Moderna Museet, 1966</div>

Most children who grow up don't get shot for real. Is it disappointing to them, since they spend so much time preparing and enacting this effect on their body?

I guarantee that, if a pitcher of water is placed on the table in front of a discussion on art, someone will pick it up before long and ask very seriously: Well how about this pitcher? Is *this* art?

<div style="text-align: right">1966</div>

It is important to me that a work of art be constantly elusive, mean many different things to many different people. My work is always on its way between one point and another. What I care most about is its living possibilities.

The only defense against being trapped in someone's idea of your intention is to keep changing your field and work very hard, so that the *fact* of your creation, which will always be the most important thing, always overshadows its interpretation.

<div style="text-align: right">1961</div>

I have an individual way of seeing, a spatial way and I do want to impose this on my time ("convert"). The deep space vs. flat, and it is this which leads naturally into environment and theater. It is my way of seeing first and secondarily a theory. I do and then I theorize. Movement and deep space are natural to me, I do not need a reason except that I want to do it. The grotto form is my particular way....

My art object always represents something, usually something simple. I do not believe in representing something too involved for it takes the emphasis from the art. On the other hand I choose something simple in which is concentrated as much as possible, as certain objects meant a way of life for the cubists. I proceed this way too: something not meaningless and of my own experience....

After all, I don't come out of Matisse or the sunny concept of art. I come out of Goya, Rouault, parts of Dubuffet, Bacon, the humanistic and existentialist imagists, the Chicago bunch, and that sets me apart from the whole Hofmann-influenced school (who would maintain I am set off from art, this being New York!). I find it natural to move toward poets, troubled lives, darkness, mystery.

<div style="text-align: right">1960</div>

My singleminded aim is to give existence to (my) fantasy. Mine is theater.

This means the creation of a parallel reality according to the rules of (my) fantasy.

This world cannot ever hope to really exist and so it exists entirely through illusion, but illusion is employed as subversively, as convincingly as possible.

The critical moment is my act of seeing. The rest is the patient reconstruction of this hallucination and successive hallucinations which arise in the course of making.

The contribution of subject matter is almost a side effect since what I see is not the thing itself but—myself—in its form.

Experience that is to say, is material—for an act of recognition, and having recognized something, the job is—one could argue—is done, the rest being the act of giving evidence. Experience is the primary material & then plaster and paint.

In the case of my theater, experience is both the first and the second material.

The content is always the human imagination. This is regarded both as historically constant and as universal among individuals. To present the geography of the human imagination is my aim, with real mountains and rivers and cities.

<div style="text-align: right">December 1–7, 1962</div>

In the American Grain

I like to work in material that is organic-seeming and full of surprises, inventive all by itself. For example, wire, which has a decided life of its own, paper, which one must obey and will not be ruled too much, or cardboard, which is downright hostile, or wood with its sullen stubbornness. I am a little afraid of metal or glass because they have the capacity like a lion to gash and kill, and if I gave them the freedom I give my other materials they probably would. As for my forms, what is most important is that they should be very near absolutely certain, after a long preparation simply demand to be created. Getting myself into that relation with a form is most of the struggle.

Form or the bone of a thing, its essentialness is what matters to me the most.

Coming to my studio you would find my works floating because the force I most respect is gravity, and tethered like dirigibles or cattle by a rope to the walls.

A strong sensation of if not knowledge (no definitely not knowledge) of physical principles is important to the artist, as is the sharp natural eye for detail.

<div style="text-align: right">1960</div>

Every place has its own materials (or a characteristic lack of certain materials). Availability of material defines the subject. I have to be practical. The enormous garbage bags of burlap which may be stolen off the streets of New York at night continue without effort as "potatoes" or "heads."

In Paris I found no paper and no vinyl or canvas of quality. Language prevented me from the search for materials and technicians. I fell back on an earlier technique—yet what could be more appropriate than plaster in Paris?

The Parisian paper hoarders should see the paper of New York, the material par excellence of the Empire City. I think the chief production of New York is garbage.

<div style="text-align: right">1966</div>

Generally speaking I am violently opposed to chance or accidental effects.

<div style="text-align: right">1961</div>

The aims of drawing on arrival in a new environment:

Forms are carried along, the result of having found ones formed in other environments. Now one must find the meaningful i.e. typical or thematic forms in the new environment and then bring them together with the brought forms.

First: a period of discovery, both as to technique (surface and tool), treatment etc. of the typical forms.

Second: their poetic merger, metamorphosis, and relationship thru association. The poetic symbol, the "image."

Drawing is attained in a new place when the old has been expanded with the new, association is operating well—showing the family relationship of the forms, the unity of things in general, and the proper technique has been developed to present the expanded particularized as to place, poetic vision.

<div style="text-align: right">Provincetown, June 29, 1960</div>

Note: The following statement was written for the catalogue of the exhibition "Environments, Situations, Spaces" at the Martha Jackson Gallery, May 23–June 23, 1961; it appears here in the definitive form in which it was published in Store Days *(New York: Something Else Press, 1967).*

I am for an art that is political-erotical-mystical, that does something other than sit on its ass in a museum.

I am for an art that grows up not knowing it is art at all, an art given the chance of having a starting point of zero.

I am for an art that embroils itself with the everyday crap & still comes out on top.

I am for an art that imitates the human, that is comic, if necessary, or violent, or whatever is necessary.

I am for an art that takes its form from the lines of life itself, that twists and extends and accumulates and spits and drips, and is heavy and coarse and blunt and sweet and stupid as life itself.

I am for an artist who vanishes, turning up in a white cap painting signs or hallways.

I am for art that comes out of a chimney like black hair and scatters in the sky.

I am for art that spills out of an old man's purse when he is bounced off a passing fender.

I am for the art out of a doggy's mouth, falling five stories from the roof.

I am for the art that a kid licks, after peeling away the wrapper.

I am for an art that joggles like everyones knees, when the bus traverses an excavation.

I am for art that is smoked, like a cigarette, smells, like a pair of shoes.

I am for art that flaps like a flag, or helps blow noses, like a handkerchief.

I am for art that is put on and taken off, like pants, which develops holes, like socks, which is eaten, like a piece of pie, or abandoned with great contempt, like a piece of shit.

I am for art covered with bandages. I am for art that limps and rolls and runs and jumps. I am for art that comes in a can or washes up on the shore.

I am for art that coils and grunts like a wrestler. I am for art that sheds hair.

I am for art you can sit on. I am for art you can pick your nose with or stub your toes on.

I am for art from a pocket, from deep channels of the ear, from the edge of a knife, from the corners of the mouth, stuck in the eye or worn on the wrist.

I am for art under the skirts, and the art of pinching cockroaches.

I am for the art of conversation between the sidewalk and a blind mans metal stick.

I am for the art that grows in a pot, that comes down out of the skies at night, like lightning, that hides in the clouds and growls. I am for art that is flipped on and off with a switch.

I am for art that unfolds like a map, that you can squeeze, like your sweetys arm, or kiss, like a pet dog. Which expands and squeaks, like an accordion, which you can spill your dinner on, like an old tablecloth.

I am for an art that you can hammer with, stitch with, sew with, paste with, file with.

I am for an art that tells you the time of day, or where such and such a street is.

I am for an art that helps old ladies across the street.

I am for the art of the washing machine. I am for the art of a government check. I am for the art of last wars raincoat.

I am for the art that comes up in fogs from sewer-holes in winter. I am for the art that splits when you step on a frozen puddle. I am for the worms art inside the apple. I am for the art of sweat that develops between crossed legs.

I am for the art of neck-hair and caked tea-cups, for the art between the tines of restaurant forks, for the odor of boiling dishwater.

I am for the art of sailing on Sunday, and the art of red and white gasoline pumps.

I am for the art of bright blue factory columns and blinking biscuit signs.

I am for the art of cheap plaster and enamel. I am for the art of worn marble and smashed slate. I am for the art of rolling cobblestones and sliding sand. I am for the art of slag and black coal. I am for the art of dead birds.

I am for the art of scratchings in the asphalt, daubing at the walls. I am for the art of bending and kicking metal and breaking glass, and pulling at things to make them fall down.

I am for the art of punching and skinned knees and sat-on bananas. I am for the art of kids' smells. I am for the art of mama-babble.

I am for the art of bar-babble, tooth-picking, beerdrinking, eggsalting, in-sulting. I am for the art of falling off a barstool.

I am for the art of underwear and the art of taxicabs. I am for the art of ice-cream cones dropped on concrete. I am for the majestic art of dog-turds, rising like cathedrals.

I am for the blinking arts, lighting up the night. I am for art falling, splashing, wiggling, jumping, going on and off.

I am for the art of fat truck-tires and black eyes.

I am for Kool-art, 7-UP art, Pepsi-art, Sunshine art, 39 cents art, 15 cents art, Vatronol art, Dro-bomb art, Vam art, Menthol art, L & M art, Ex-lax art, Venida art, Heaven Hill art, Pamryl art, San-o-med art, Rx art, 9.99 art, Now art, New art, How art, Fire sale art, Last Chance art, Only art, Diamond art, Tomorrow art, Franks art, Ducks art, Meat-o-rama art.

I am for the art of bread wet by rain. I am for the rats' dance between floors. I am for the art of flies walking on a slick pear in the electric light. I am for the art of soggy onions and firm green shoots. I am for the art of clicking among the nuts when the roaches come and go. I am for the brown sad art of rotting apples.

I am for the art of meowls and clatter of cats and for the art of their dumb electric eyes.

I am for the white art of refrigerators and their muscular openings and closings.

I am for the art of rust and mold. I am for the art of hearts, funeral hearts or sweetheart hearts, full of nougat. I am for the art of worn meathooks and singing barrels of red, white, blue and yellow meat.

I am for the art of things lost or thrown away, coming home from school. I am for the art of cock-and-ball trees and flying cows and the noise of rectangles and squares. I am for the art of crayons and weak grey pencil-lead, and grainy wash and sticky oil paint, and the art of windshield wipers and the art of the finger on a cold window, on dusty steel or in the bubbles on the sides of a bathtub.

I am for the art of teddy-bears and guns and decapitated rabbits, exploded umbrellas, raped beds, chairs with their brown bones broken, burning trees, firecracker ends, chicken bones, pigeon bones and boxes with men sleeping in them.

I am for the art of slightly rotten funeral flowers, hung bloody rabbits and wrinkly yellow chickens, bass drums & tambourines, and plastic phonographs.

I am for the art of abandoned boxes, tied like pharaohs. I am for an art of watertanks and speeding clouds and flapping shades.

I am for U.S. Government Inspected Art, Grade A art, Regular Price art, Yellow Ripe art, Extra Fancy art, Ready-to-eat art, Best-for-less art, Ready-to-cook art, Fully cleaned art, Spend Less art, Eat

Better art, Ham art, pork art, chicken art, tomato art, banana art, apple art, turkey art, cake art, cookie art.

add:

I am for an art that is combed down, that is hung from each ear, that is laid on the lips and under the eyes, that is shaved from the legs, that is brushed on the teeth, that is fixed on the thighs, that is slipped on the foot.

square which becomes blobby

May, 1961

The Street: A Metamorphic Mural

What I despise is artificial art, that kind which begins in the morning with buying a tube of some colored stuff in a store and going home and making a four-sided figure, very straight (no matter how large) to smear it on. Art begins when your eyes flicker open in the morning and when sensation returns to the tips of your fingers. A refuse lot in the city is worth all the art stores in the world.

Provincetown, 1960

A City Venus
Nature is one thing. The city is another. The city is too much. Someone has already been there. The vision is already disordered, but *real*. The hallucination is a fact. And your own hallucination makes it double. How many natures? How many realities? Too much.

First nature: nature
Second nature: the street, or asphalt nature
Third nature: the store, by which I mean:
 1. billboard nature (all forms of advertising, newspaper included)
 2. fake nature: clothes, cakes, flowers, etc. etc.

City nature is made up of streets, houses, stores, advertisements, makeup clothing and vehicles. Makeup and clothing & the people who animate them are like trees, vehicles like animals. Stores are forests, streets plains and rivers, advertisements and goods so many creeping and crawling dreams.

All charged up and loaded to bursting with what man sees or rather wants to see in nature, the only exception of determination of form being certain functional necessities.

Everybody talks about nature and the artist but noone makes the distinction between city and country. What kind of nature is city

nature. It's a piece of man's mind. To live in the city is to live inside oneself.

One's current hallucinations call out to others' well fixed, as real as building or pictures.

1963

In the "Street Head" [1959; p. 45], the mass of material seen is represented *in* the see-er, as if the brain had been bared, and fragments of newspaper represent the information taken in. This piece and the reliefs and sculptures made using newspaper scraps (like the "Céline, Backwards") could be considered drawings. The whole period of the street concerns drawing. Newspaper – Street – Brain. Also – Flag, the Provincetown subject is a translation of the street, the newspaper.

1968

Land of Our Pilgrims' Pride

The thing is to have a general form which immediately communicates to anyone and which is also aesthetic so that I can express myself in variations both as to content and form within it, without losing an initial interest on the part of the spectator and a curiosity as a result a wishing to explore my elaborations on the universal. Such forms which are both are The Street, The Newspaper, The Flag—all having a parallelism in common, or geometricity, order, all being in fact roughly the same form—a rectangle with smaller rectangles in it.

Why should I find such excitement in the parallelism of shingles, northern lights? It has to do with unities that defy scale notions and other poetic unities and the excitement coming from the possibility that this (primitive thinking) means also ties in fact. A kind of delightful and childish belief which I take very seriously.

Provincetown, 1960

Note: This is the first formulation of Oldenburg's 1961 statement in the catalogue of "Environments, Situations, Spaces" (above, pp. 190–191). It was published in Art Voices, Summer 1965.

P......g, which has slept so long / in its gold crypts / in its glass graves / is asked out / to go for a swim / is given a cigarette / a bottle of beer / its hair is rumpled / is given a shove and tripped / is taught to laugh / is given clothes of all kinds / goes for a ride on a bike / finds a girl in a cab and feels her up / goes flying / goes driving at 100 mph.

Shy at first / soon all its dreams are realized / is stripped from its cross / straightened out / is given exercise to bring back its tired muscles / tonics to get the red back in its cheeks.

Who all its life had wished to be / is given the chance to be / a handkerchief / to go from hand to hand / from nose to nose / and in and out of pockets / over foreheads / into eyes and ears / around one set of lips and another / to be dropped and washed in a machine on a line to dry flapping in the wind.

Who all its life had wished to be / is given the chance to be / a flag / carried in the breeze up and down streets / planted on car fenders going fast / whistling in a thousand parts over a gasoline station / lazily lying on a coffin / pleased to catch the earth thrown on it / at half-mast for some famous person / lofty on a patriotic day / put away in a drawer at night nicely folded / wounded or dissolving in battle / decaying on the mast of a ship crossing the ocean.

To be a shirt / a tie / a pair of pants / a suit of clothes / going somewhere on someone / getting rumpled while dancing / having a drink spilled on it / taken off and hung up / sent to the cleaners / drawn on the body / catching hair / slicing over fingers / pressing ears.

Bolder and bolder / it becomes anything it wants to be / a hamburger / an ice cream cone / a newspaper / a sewing machine / a bicycle / impossible inexhaustible p......g.

Provincetown, 1960

Introduction to some souvenirs in the form of flags (postcards)

1. Cemetery Flag

A form found in the flag which flies illuminated night long at the crest of the Catholic cemetery.

2. Kornville Flag

A rutted dusty road leads off the highway into a thicket of squatters and woodcollectors. A flag flies in the clearing surrounded by their decrepit huts. Colonel Korn is the commander here and has given his name to the place.

3. Powerhouse Flag
On the road to Race Point Light, there is a mechanical oasis, a building taken from a big city, humming night and day.

4. Flag Plate
A storm is coming, a heavy cloud is speeding over us. We hide in an abandoned cabin and a meal of forms assembles itself for us.

5. Dunes Flag
I take the pieces from the shore and make a statement of the order of things: a wellmeaning salt-and-pepper lighthouse, the sea, a moon, but the impossible intrudes.

191

6. Backwards Flag, or Harbor Flag

Two pieces float up to me in the water, asking to be joined. Joining them, I see I have participated in a blasphemy, but I can't dispose of it.

7. Old Junkyard Flag

Off the superhighway through a rusty bullethole, I ride my whistling bike, looking for messages on this old cake.

8. New Junkyard Flag

A place to be seen with the nose. Every Pilgrim's son must face this backside twice a week, but the flag is made in the air out of gullswings.

9. Jail Flag

The flag growls and shows its teeth, but in truth it is trapped and will sit there until morning.

I might add, the flags are made out of what I take to be the basic pictographic elements of the place, not only on a grand scale but, surprisingly, in every observable fragment. A place with extraordinary unity of form. F.ex.: Halfcircle – firmament/barrel bottoms. Stripes – land/slats. Rectangle – Absolute relation, horizontal & vertical and infinity of space/shingles & many flags. Projected into content: elementary nature/patriotism.

Provincetown, 1960

Hero of a Thousand Faces

I think of art as something very different from decoration and I think I can recognize art and I can make it, but it is not an easy matter. I think most of what passes for art at any time is decoration, only now and then, you never know, you find art, sometimes not until long afterward.

Raygun is art, especially art made out of anti-art materials, anything one would not suppose to be useful to the purpose of making art.

Novelty of course is trivial and decoration is just that. The trouble with critics is they don't single out what is art, or if they do, they pick the wrong thing.

New York, 1960

A peculiar and unexpected title, surprises me too.
Feel I will be compelled to like it.
Motto: things are best if come by from the other side, from their opposite. Such as meaning from non-meaning. Relation from non-relation.

The whole thing is to be practical about how to catch what matters. First to know what matters, then how to catch it. The trouble with most people and the world is that they lack techniques. For the more difficult and important machinery of truth taste renewal & joy.

I have had repeatedly the vision of *human form,* which is much more than that "trace" spoken of by Bacon. It is the forms that the living human being can take, in all its parts, mental and physical and this is the subject, in the fullest sense possible, of my expression—the detached examination of human beings through form. Myself, other individuals, and the expressions of human beings collectively, as in the city or the newspaper or advertising, or in any of the anonymous forms of naive art—street drawing, "mad" art, comics. I render the human landscape, and for me there exists no other, and this is a pimple or a body or a street or a city or the earth, because the human imagination does not obey any proprieties, as of scale or time, or any proprieties whatsoever.

New York, April 1, 1963

Vocabulary

Glass: 1. Eye. 2. Separations: Inside/outside. Examples: Store window. Pastry cases.

Ray Gun: 1. Kid's toy. 2. Seeing through walls. 3. The universal angle. Examples: Legs, sevens, Pistols, Arms, Phalli—simple Ray Guns. Double Ray Guns: Gross Airplane. Absurd Ray Guns: Ice Cream Sodas. Complex Ray Guns: Chairs, Beds. 4. Anagrams and homophonies: Nug Yar (New York). Reuben (Neubern). 5. Accidental references: A moviehouse in Harlem. A nuclear testing site in the Sahara (Ragon). 6. Whatever is needed. A word ought to be useful. 7. Cryptic sayings: "All will see as Ray Gun sees." "The name of New York will be changed to Ray Gun." "When Ray Gun shoots, no one dies." 8. Talismanic, fetichistic functions.

Store: 1. EROS. 2. Stomach. 3. Memory. Enter my Store.

1961

The Ray Gun Manufacturing Company

cloacal store
exhibitionism, peeking, Oedipal, all details, secrets
the sad image of a cafeteria
graphics is a detailed crystallized thing of which you make many studies
living materials include paint running paint stopped

The Garden

IT IS love the cliché
If form in nature analyzes down to geometry, content (or intent) analyzes down to erotic form

I prefer the physical movement in the spectator, not in the work. Its definition depends on his position in time and space and in imagination.
He invents the work.

Art or idea is not the point in my work, but illumination, through whatever means (which explains the occasional lack of finish or simplicity or peculiar materials). I stop when the piece has autonomous power.

1962

When I say Pop art is an "attitude," I mean it is a reaction to the painting before it. ——— f. ex. is not an interesting painter, he repeats a formula, but it is a good one, and it comes out of an attitude ... of rejection. It has little to do with the creation or exploration of form.

Critics do not speak of form or relation ... but only of history and ideas. My work is architecture ... nothing is as important as the scale and relation of different volumes ... planes, lines ... my personal architecture. Although my art gives the (deliberate) impression of being concerned with the outside world, in fact it is simply the personal elaboration of imaginary forms of a limited number, in the guise of occasional appearances ... Its use of appearances, frankly and directly, is offered as an alternative to the elimination of appearances, which is not possible ... but saying more effectively that appearances are not what count. It is the forms that count. It is the same to me whether my material image is a cathedral or a girdle ... a telephone dial or a stained glass window ... the resemblance, while amusing, means nothing. You could say I have aimed at neutralizing meaning ... to eliminate appearances seems to me impossible, and therefore artificial. Simply grasp them and show how little they mean—this is what Cézanne did. Or how from my point of view form & vision is one, whether I am just looking or making. I do not see everything any more than I make everything.

Los Angeles, 1963

I don't know if you can sympathize with this, but it is the false and cynical treatment of real emotion as in today's publications that fascinates me and yields more truth. Take at random any description from a magazine of pinups—language and idea is used in a way that

192

accepts its shallowness because the picture next to it does the actual job. Words are equally devalued on television, it is the picture of the piece of pie that counts. The world is seeking its way back to feel and touch things.

But American commercial art with its distance ... while presenting eminently "hot" matter ... "object pornography" ... is in a way a model of the "objective expressionism" I practice.... This is not to make a statement about its value as art, which is inferior ... (I am not speaking of its craft) ...

Thus, if I wrote a play, I might allow a person to die twenty times and think nothing of it, no matter how many tears I wrought out of the audience each time. I might stop the whole scene and say that's enough, and throw in some comedy.

Los Angeles, 1963

People's lack of detachment about themselves surprises me. They operate—how should one say it ... contained as if the machinery would fall apart if they could take a removed view of themselves and become self-conscious. People believe themselves. I always act with the presence of an outside consciousness, looking at myself which is why my subject can be human, as the subject of others can only be landscape. It is possible for me to treat my subjectivity and that of others objectively and this is a unique thing in my art: the emotion in it is the observation of emotion. I am both committed and not committed and man must learn when forces make him more and more self-conscious how to be self-conscious and still effective, how to be intellectual still not "cold."

New York, 1963

Before I close the door, before I try to put it all together, I go a little further than most. This accounts for the ugliness of my work which is easy to overcome. Man can get used to anything. I am extreme in everything I do, that is part of my sense of being alive. I take the form, say of feeling or some physical nature, like the path of piss across the pavement to a degree of extension or obviousness that is exasperating, and then, only then, do I save it—or I lose it.

I must have a medium that is completely adventurous, and that is why among other things I use experience itself. Shall we not take five or six people and lock ourselves in a cottage somewhere for a week, and see what kind of form that can yield?

My work makes a great demand on a collector. I have tried to make it in every way so that anyone who comes into contact with it is greatly inconvenienced.

Los Angeles, 1963

The Soft Machines

Geometry, abstraction, rationality—these are the themes that are expressed formally in *Bedroom*. The effect is intensified by choosing the softest room in the house and the one least associated with conscious thought. The previous work had been self-indulgent and full of color, the new work was limited to black and white, blue and silver. Hard surfaces and sharp corners predominate. Texture becomes *photographed* texture in the surface of the formica. Nothing "real" or "human." A landscape like that on the cover of my old geometry books, the one that shows the Pyramids of Egypt and bears the slogan "There is no royal road to geometry." All styles on the side of Death. The Bedroom as rational tomb, pharaoh's or Plato's bedroom....

Bedroom marked for me (and perhaps others) a turning point of taste. It aligned me (perhaps) with artists who up to then had been thought to be my opposites. But the change of taste was passed through the mechanism of my attitude, which among other "rules," insists on referring to things—by imitating them, altering them and naming them.

Bedroom might have been called composition for (rhomboids) columns and disks. Using names for things may underline the "abstract" nature of the subject or all the emphasis can do this. Subject matter is not necessarily an obstacle to seeing "pure" form and color. Since I am committed to openness, my works are constructed to perform in as many ways as anyone wants them to. As time goes on and the things they "represent" vanish from daily use, their purely formal character will be more evident: Time will undress them. Meanwhile they are sticky with associations, and that is presumably why my *Bedroom,* my little gray geometric home in the West is two-stepping with Edward Hopper. To complete the story I should mention that the *Bedroom* is based on a famous motel along the shore road to Malibu, "Las Tunas Isles," in which (when I visited it in 1947) each suite was decorated in the skin of a particular animal, i.e. tiger, leopard, zebra. My imagination exaggerates but I like remembering it that way: each object in the room consistently animal.

May, 1967: Artist's statement for catalogue of
U.S. representation, IX Bienal, São Paulo

LA is many things and many things to many people. To me it is the paradise of industrialism. LA has the atmosphere (my selected part of it) of the consumer, of the home, the elegant neat result, like the frankfurter in its nonremembered distance from the slaughterhouse. In New York, in Brooklyn, I see all the degradation and slavery and terror of production as contrasted with the floating and very finished

product on TV. Alternating dreams and alternating themes to me are the circumstances under which a thing is made vs. the end product (and its circumstances of presentation). I was attracted that is seduced by and drawn to the Ice Age, as an antidote to the verminous rotten but living deaths of New York. My problem and that of others I think is the love of mechanism even as one flips around in the next moment and denies it.

The assumption of machine style, in production or in the actual creation, symptomatic of a changed way of life for the artist who will join with the technician and manufacturer in the near future. He is as if rehearsing his style—he will no longer remain in his studio or his studio will grow and change his character. He will throw himself all over the world with the arms and hairs of wireless.

Paris is a hamburger (Parisersmörgås—Paris sandwich). It is sliced by the Seine, and the Paris subjects are walls of Paris. The pieces are powdery-colored, dusty rather than bloody.

I was seduced by artificiality, starting with Bernini in Rome. The pastries I made were the fancy type that in New York I always passed up, to get my inspiration in front of Ratner's window on 2nd Ave. or in the Fifth Ave. Cafe, where the tasteless cakes came bloated at least twice actual size, and bluff as truckers' caps.

1966

The Public Image

I feel my purpose is to say something about my times ... for me this involves a recreation of my vision of the times ... my reality, or my drama reality and this demands a form of a theatrical nature ... like the film or theater. It is not a challenge to or a development of painting but another form. I am making symbols of my time through my experience ... and do not really recognize a rest period or a period out of experience as most do, i.e. a period for raising children or establishing a home or whatever might be done as if outside the vision ... for me there is no "outside" except this special undefined outside of myself as spectator of myself ... every instant is the drama and my art is the record or evidence.

New York, June 1960

It is a question of getting things in proper order by a subtle (reverse) assault on standard responses. A man who sees right has a duty to make others see rite.

In what does true revolutionariness consist in the arts, not in politics? Not in new forms, of which there aint none, but in the subtlety of his own mind. Avant garde is a phony but the introduction of a person to set things straight is not. Thus f. ex. Duchamp ... a formulator of ethic thru art. Very rare bird.

1961

Art is a matter of feeling and when I expand art to architectural dimensions, it isn't architecture, it is art, and that is very different. The starting point is what counts and it makes the result different. Not theater or cinema or architecture but painting, because that is the way it started.

1961

From the Wall to the Floor

String is like paint that drips
All sentiment externalized—example pin-up
The old line-light dichotomy
possibility of an anonymous style—like a style book or a newspaper formula

1962

The built-in changeableness of the work demands of its owner or someone who displays it, a sense of the work's possibilities and a sense of the factors that can cause change, and decisions on the position, sometimes daily (soft pieces will fall and change in a night). Works that fall into indifferent owners, museum directors, shippers, show the lack of attention. As long as I am available, I can puff them up, clean them, shake them, arrange them according to my notions of how they should be, but I worry about the results of the indifference I have noted after I am gone. In most cases I have noted there is complete indifference to the possibilities of the piece, owners simply registering them as property of such and such a value.

As for normal care of unchanging pieces such as The Store, there is indifference to their physical properties, for ex., that most of them hang from a thin wire on which time is bound to take its toll. Perhaps, I have imagined, since most of the pieces were made at about the same time, with what later proved to be insufficient thickness of wire, they will all drop at once, all over the world.

The 14th St. studio is divided into two halves—the rough and the smooth, in accordance with a recurrent childhood dream. The chaos section is of course where the artist works, the smooth section the one where he contemplates what he has done.

1968

The cloth work is decidedly "sculptural," by which *I* mean that it emphasizes masses, simple and articulated. It de-emphasizes color. What the period of "sculptural" painting has left is the fluidity of the surface, which in these works is *actual* because they are sculpture: the unillusory, tangible realm. The dynamic element here is flaccidity, where in the paint it was the paint action and the sparkle of light— that is, the tendency of a hard material actually to be soft, not look soft (so it is a concretization of a naive translation of painting).

August 1, 1963

The "soft" aspect of these works was not part of the original intention. I discovered that by making ordinarily hard surfaces soft I had arrived at another kind of sculpture and a range of new symbols.

Soft sculpture is in a primitive state but with the aid of plastics and latex and techniques to come, there will soon be the completely articulated (instead of balloonlike symmetrically joined) pneumatic sculpture .. I imagine outdoor sculptures, responsive to the wind. The best examples are still the giant balloons that Macy's takes down Broadway every Thanksgiving Day....

The possibility of movement of the soft sculpture, its resistance to any one position, its "life" relate it to the idea of time and change. In "hard" sculptures I tried to accomplish change by hanging them together in space so that any move on the part of the spectator would change the relationships of the surfaces and the pieces, or by presenting the spectator with separate objects which invite touch and moving around (such as the pastry cases). All this is possible in the softies but also the surface may be manipulated as one plays with a piece of lemon meringue with the spoon and left alone will move of itself.

1966

Reality through the Haze

isolate action, objects, etc.
a "cool" hard romanticism; romanticism of the objective. I wish to reflect *things as they are* now and always without sentimentality. To face facts and learn their beauty. Actual volume of sculpture ... the relief planes move in space as the spectator moves and the effect is this too like a changing collage which is how landscape is seen, as, for example, from a moving car.

New York, 1961

The pieces depend not only on the participation of the spectator but his frustration—which is really a technique of definition: this is not

a *real* object. Much as I take for granted possession of the whole thing as "art," I think it is important to raise the glass—the Store Window—between the thing known as art and other things.

1966

The Baroque Style of Mr. Anonymous

What I want in style is freedom and personalness ... it ought to be just as free as my conversation, like a flag in the wind ... and no English pomposity, and no frenchiness, none of this hyperbolic surrealist prose, theatricality, but plain, right on the table there with the knife beside it. Full of incompletions and unfollowed suggestions, complete freedom as to what to include, pieces lying around, false notions for repair, fragments; a workshop like a road, a road full of nuts and bolts, with here and there a car all fixed up, standing. The lines of prose and the lines of a road, and my typewriter happens to be a model T. Open the head, the lines are the wind too, and the stripes of the flag.

1960

The view I have of style rests on the many different experiments with style in drawing made before 1958. Different styles, I observed, can be evoked by different circumstances and mood, happening to the same artist. Style, for good health, should react to circumstances, even when these are not favorable. I never cease to draw when the results are disappointing and peculiar, and eventually arrive at new adjustments. Each style is a new discipline, a new example, and grows from a primitive stage through a perfect one, to a stage of decline. These changes of style are based on the facts of the artist's situation. It is not a matter of eclecticism or of mere demonstration of the artist's skill at variations. And if the activity of drawing is truly rooted in the artist's body—his particular vision and other physical facts—the character of his gesture and his temperament—the whole work will show a unity throughout the changes.

1968

Style means to me a clear and consistent method as to material and technique, for rendering a definite state of mind and correlative subject. A practical and functional solution which may or may not draw on previous styles (mine or others'). A style period is preceded by analysis. Once begun, it assembles all relevant elements in a consistency, as f. ex. the paper becomes the street (a floor—downward glance), or wall (a window—sidelong glance), or room (deep glance), or unbounded atmosphere (deeper glance).

The periods of the Street, Store and Home are systematic explorations of, successively: Line/Plane, Color, Volume—an analysis of elements of drawing, using correlative subjects in my immediate surroundings.

1968

The World Is Not a Drawing

Style in drawing is re-creation in shorthand and graph, the terms of one's physical vision. I was trying to make an abstract of my vision. On analysis, my vision proved to be far-sighted and "around" objects and sharp as to small detail. My eyes are also very sensitive to light. Of course, the temperament, as instrumented by the hand (right one in my case) affects the drawings. In my case: instantaneous, impulsive, with the slower action of criticism coming in the saving or destruction of the drawings afterwards.

I have often wondered how the vision of the audience affects appreciation of drawings. Many do not reflect on how much the "world" is created by their own particular vision.

It is characteristic of all my drawings that the paper "opens up" and that its whiteness (or blackness) is regarded as an area or space of light and atmosphere, in which energies, represented by the dot, crystallize in forms partially suggested by outline.

At the end of the summer of 1959, I was back in the city, and prepared to give up painting with oils on canvas—in which the linear technique and deep-space vision had caused the color to suffer or be eliminated. I turned from painting to solids, constructions.

From this time on I have avoided flat painting, though I have colored my constructions and used color in drawings (usually watercolors).

On returning from Lenox, I began to emphasize attitudes and feelings to a greater degree in the drawings. My choice of subjects had always displayed some engagement, but the drawing of early 1959 was impressionistic and/or analytical of my vision. I wanted now to use a technique more expressive of its subject—which was "the street," the dominant and most affecting environment for me at that time.

I turned my vision *down*—the paper became a metaphor for the pavement, its walls (gutters and fences). I drew the materials found on the street—including the human. A person on the street is more *of* the street than he is a human.

The drawing at this time takes on an "ugliness" which is a mimicry of the scrawls and patterns of street graffiti. It celebrates irrationality, disconnection, violence and stunted expression—the damaged life forces of the city street. In the Street environment at the Judson in early 1960, I attempted an identification with a composite street character, which may be taken as making *myself* a drawing,....

The Store drawings change more and more from line into color—areas of atmospheric wash set in space with a summary indication of line (usually a cast shadow or the space-energizing dots). In the Store drawings, the paper becomes the store window....

The Home works made of fabric or wood required plans and templates, partly because I lacked the skill for sewing and facilities for fine woodworking; partly out of a desire to depersonalize the work and involve others in its manufacture. From practical beginnings, I developed a mechanical style per se in pen and pencil, involving the use of perspective, but thoroughly flat. This pen-line style is also seen in the "erotic" drawings of 1965. In the decline of the style, metamorphic elements appear.

The consistency of the styles developed in Los Angeles was interrupted by a return to New York and a trip abroad in the summer of 1964. The one-man show in Paris in October was devoted to Parisian edibles, some in stages of being consumed.

Reestablishment in New York occurred March 1965 in a new loft of large proportions. Though it was located on the fringe of the Lower East Side, I felt no engagement with the area comparable to that of 1959–1962. I was affected by the huge scale of the new place, filled with light, and I arranged the rooms so that the eye could travel from one end to the other—204 feet.

The "monument" drawings beginning at this time were stimulated by the new scale and also by the viewpoint from an airplane. The area in which the objects are placed grows from a room to a landscape, like that shown on a postcard. The objects consequently become "colossal," since the landscape, being a real one, cannot be taken as a miniature.

A large part of the pleasure of drawing is the awareness of shifting scale. Drawing is miniaturistic, but while drawing one imagines differences of scale. One effect of the monument drawings is an imaginary expansion of the drawing scale. The function of these drawings is to depict, like an impressionistic photograph, though there are elements of unnaturalistic calligraphy recalling the line drawings of 1959....

Drawings in preparation of soft objects consist of: 1) a drawing of the object as hard (as it appears)—to acquaint myself with the facts of it; 2) drawings leading to the construction of it by sewing or carpentry; 3) drawings anticipating or imagining the soft effect....

In soft objects, the expressionism is "built in." But the effect need not be seen as expressionistic. Once the room-space is established, the mass of air and light is taken into account, and the "skin" of the subject is thinned to give the illusion of participating in the whole space (though the effect is gravity). The model of the animate body with its interchange through the skin with its surroundings, is combined with the inanimate subject. The soft sculptures are therefore not objects in the sense of the hard and isolated objects of the Dada or Surrealist period....

1968

Totems and Taboos

Note: This article, written while Oldenburg's one-man show was on view at Moderna Museet, Stockholm, appeared in Konstrevy *(Stockholm), nos. 5–6 (November–December), 1966 but has never been published in the original English. "Strange Mickey Mouse" later became* Geometric Mouse, Variation I *made in 1969 for showing in the Sculpture Garden of The Museum of Modern Art during Oldenburg's exhibition there.*

The rhyme element in my work is based on the fact that every work is reducible to a simple form or a few simple forms. It is the variation of these forms (by any and all means) that produces the subject. For example:

1. The two disks set side by side are shown as the "ears" of the "Strange Mickey Mouse."
2. If these disks are multiplied in deep space (their paths in time, as in a stroboscopic vision), the result is a cylinder. The cylinder occurs, doubled, in the "Swedish Light Switch" (positive and negative).

In my daily notes on the typewriter, such a "rhyme" is expressed as "Strange Mickey Mouse"—"Swedish Light Switch," or "Strange Mickey Mouse" *equals* "Swedish Light Switch."

Arriving at a rhyme is not as deliberate as it appears in retrospect. I am usually surprised when I discover it afterwards. I am also reassured. It gives me a feeling of certainty and order.

It seems that particular periods, particular circumstances stimulate the desire to see one form rather than another, and many variations on the preferred form result. Twoness and round forms belong to the time of "The Home," which began in Venice, California. Probably the fact that my studio had at one end a series of arches, of which I was constantly aware, had something to do with it.

195

The "Swedish Light Switch" was done in Stockholm in 1966, but it was done in the spirit of the Moderna Museet show, and was linked up with the earlier obsession.

3. If the disks beside one another, the "ears," are connected in the two-dimensional plane, or filled in, the result is the top of the "toast" in the "Soft Toaster." The top is more important because it is the visible part, but the whole "toast" may be seen as a variation, in a thickened form, of "Strange Mickey Mouse."

4. In the "toast" occurs also the doubles theme. The "toast" in the holes of the "toaster" equals the "switches" in their holes. Or the prongs of the plug (here the "toast" is elongated):

5. If the "Strange Mickey Mouse" is cut in half and the parts moved closer together, the result is a "ping-pong paddle":

The paddles occur also in two sets of doubles (the name of such a game).

6. If the disk above then is halved, the result is (turning the image on its side)—the "switch."

7. If the "ping-pong paddle" is "inflated," the result is a balloon, or, more specifically (inverted and extended, as in the effect of a long shadow)—the "mixer" part of the "Dormeyer mixer."

These illustrations give you some idea of what I mean by "rhyming" and "equals." Here are some more, taken from the show at Moderna Museet, and you can probably add more yourself that you see and I don't:

8. "Strange Mickey Mouse" without "ears" and "nose" equals "switches."

9. "Strange Mickey Mouse," with one "ear," centered (cyclopic) and "face" (rectangle) extended, equals "Dressing Table."

10. "Ping-pong paddle": its "handle" rounded and "paddle" placed horizontally, and extended into a cylinder, equals "Bed Table Lamp."

11. "Ears" or disks, continued in space but seen in vanishing-point perspective, equal "Bats," or "Ice-Cream Cone." (Corollary: "bat" equals "ice-cream cone.")

12. "Ears" or disk, in time path (strobo effect) equals oval "pool" (if two-dimensional).

13. "Pools," another set of two doubles, equals "Ping-Pong Table." Originally, the "Ping-Pong Table" was to have been half a "pool" table (as seen in the side view). "Pool" is an American form of billiards, "pocket billiards." (Note: "Pocket pool" is slang for a man scratching or playing with his "balls"—genitals—by using his hand in his pants pocket.) One can buy tables in America which convert from the heavy (serious) table needed for pool to the flimsier (light-hearted, lyric) table of ping-pong.

14. If the "ear" or disk-in-time-path is three-dimensional, it equals "Hot Dog" or "ping-pong ball." The latter is varied by assuming the path is diverted by contact at one point or another:

15. "Strange Mickey Mouse" with its "ears" drawn into the rectangle equals "Typewriter":

16. The "Wing-Nut" is almost a parody of the hats which used to be given out to members of the "Mickey Mouse Club" on American

television. It is more organic, more like a natural mouse, and therefore not "strange" (unnatural) as the very mechanical, geometrical mouse of the show.

Two "Wing-Nuts" (the effect of reflection) equal a handle of the "Washstand":

17. Two "paddles" placed beside one another equal a "plug":

Following are some more complex constructions:

18. The "table" of the "Bed Table and Lamp" may be seen as the "Mouse" rectangle continued in a non-vanishing-point perspective, with the column of the "lamp" the metamorphosis (variation by fantasy) of the nose, and the "shade" of the "lamp" the negative space of the discs (the "ears") continued in time. Therefore:

"Strange Mickey Mouse" equals "Bed Table with Lamp."

19. In the "Three Way Plug," the "ear" disk takes the place of the "face" rectangle, so that the "eyes" are contained in the "ears." The result gives the appearance of a pig's nose (*tryn,* in Swedish) and that includes the element of smell.

The show is not entirely "closed"—its forms sometimes refer to earlier ones in my work. One can easily see that·

20. The "ping-pong paddle" is a relative of the "Good Humor":

The cut out, or "bite" from the "ice-cream bar" is an abbreviation of what has to be done to convert one to the other—reverse the curve to round the corners.

21. This shape of the rectangle with "tail," which is one of my favorites, recurs in the "Airflow Engine":

22. and in the "Washstand":

23. and in the "Coupole Lights" (the longer rectangle is partly hidden):

(Note: The "Coupole Lights" are a hanging in the following way—side view:

of the effect found in nature—at the restaurant):

In this way—and through the softening of the form—two viewpoints are combined, which is also true of the "Washstand."

24. and as the "Door Handle" in the monument for Skeppsholmen (the longer rectangle, bent but hard):

25. and as the "Tube" (the longer rectangle inside and soft—"toothpaste"):

In general, the doubling, the symmetry, refers to the human body, with parallels drawn between the objects represented and parts of the body: ears, eyes, nostrils, limbs, breasts, testicles, etc. The sort of analysis I have done above of the poetic geometry of the works could also be done of their body equivalents. This is why I refer to "The Store" or any collection of my work (of my "objects") as a "Butcher Shop," a place where the parts of the body are displayed. The body parallels are reinforced by use of fleshlike material (vinyl for example) and sculptural "insides"—hard like bone and soft like fat.

Man makes objects in his own image because he doesn't know any other. That the objects resemble parts of him need not mean that he

makes them the substitute for his repressed desires. But the reference to sexual parts could be another topic of analysis of the work:

a. The extent to which an object is a male or a female representation—the sex of the object. And which are combinations, double sexed.
b. Which objects refer to "coupling." Plugging in, or establishing contact is a theme—which goes beyond the merely sexual to the contact of the person with his surroundings. Many of the objects also refer to masturbation or forms of touching oneself instead of another: the "Ironing Board," the "Pants Pocket" or the "Vacuum Cleaner."
c. Which objects refer to reproduction. Any doubles, of course, but also more specific references, like that of the "Tea Bag" to the sperm. However, two women have told me they associate the "Tea Bag" with a menstrual tampon, and react accordingly. Or the "Toaster" with its capacity, as the result of being plugged in, to pop out "bread."

I should emphasize again that these references come as a surprise to me when they are discovered, and that they are usually discovered by someone else.

I don't mix knowing with doing. If I did, the results would be highly unnatural. As it is, nothing *necessarily* means anything. Which is the way with nature.

Only when someone looks at nature does it mean something. Because my work is naturally non-meaningful, the meaning found in it will remain doubtful and inconsistent—which is the way it should be.

All that I care about is that, like any *startling* piece of nature, it should be capable of stimulating meaning.

These are the themes of the "Bedroom" and the "Bathroom"—the central parts of "The Home."

The "Typewriter" is there to remind one that a large part of the show is hidden—is in fact *written*.

London, October 11, 1966

The Theater of Action

Happenings have had the effect of making poets more careful in their imagining, showing how much poetry can actually be *made*.

New York, 1960

I have a dream about a "happening" at the Yale Art School. A costume of baroque gold chandelier and a white body with a de-

tachable bra-tits by the resident genius whom I know. I later assist in the presentation in a clean hall before a conservative audience. I look in tube, am popped in eye. Surprised but play along. Followed by rubbing out of traditional paintings accomplished by trick of turning off light behind chromo of painting. But it fails, the cues don't work, the two girls helping don't get it right. Argument between artist and one girl. Water on the floor shocks management.

Pat speaks of pageants at her "graded" school. I am Flag. I am Betsy Ross ... Seems to me a good model for a type of dramatic event—the child's school pageant ... as everything must have as model a primitive form. Birth of the Flag. Pat—Flag. I—Betsy Ross.

Provincetown, July 18, 1960

In my theater the word is not used very much. I don't believe in speeches. The theater is largely visual or tactile, and my use of sound is also concrete. Sound is treated as an object.

A naive and literal application of this yields—the phonograph record, tangible visual sound, with a mechanical, material quality. Making references, especially if it is an old record. A record is an event in itself....

Other than records the sound in the compositions is the sound of objects, especially of course falling ones. Smashing ones, crushing, stroking, dripping, pouring, scratching, etc. etc.

Words are exclamations, grunts, groans, inexplicable human sounds.

New York, 1961

I am very grateful to the audience for coming each weekend. I cannot deny it is good to have an audience, though the nature of the theater is such that it would go on without an audience as a painter might go on painting with noone to watch him.... This space has great limitations. I am aware of this ... partly I enjoy the pressure these limitations put upon me ... I mean the time, the expense and the space... I hope you are not too miserable ... my aim is to develop under these concentrated circumstances a sort of kernel of infinite expansion... so that at the end of this season I shall have ten extremely powerful seeds. It is becoming obvious I guess that these pieces are not unrelated ... the "happening" which was in the beginning a very limited form is bearing fruit as a new physical theater, bringing to the dry Puritan forms of the U.S. stage the possibilities of a tremendous enveloping force....

Theater is the most powerful art form there is because it is the most involving ... but it is forever becoming lost in trivialities ... loss of power is a chronic disease of the form ... realism ... distance ... commercial pressures ... poor theater ... I no longer see the distinction between theater and visual arts very clearly ... distinctions I suppose

are a civilized disease ... I see primarily the need to reflect life ... to give back, which is the only activity that gives man dignity ... I am especially concerned with physicality, which is evident ... painting and sculpture have the power to give man back his physicality (which is not primitivism) when he loses it ... painting and sculpture have the unique privilege of affecting the other arts in this respect...

1962

At the bottom of everything I have done, the motive of most radical effects, is the desire to touch and be touched. Each thing made is an instrument of sensuous communication. Subject is more a device of engagement than something important in itself.

The coming out into space (into real space) of the painting, the touchability of the painting, the isolation in space of the painting—"floating color"—all this having to do more with the period of The Store.

The performances are a way for me to touch the world around me (and be touched). A studio or academy of touch, in which the players and audience are made aware of their bodies.

1966

Chronology

1929–1933

Claes Thure Oldenburg born January 28, 1929 in Stockholm, Sweden, son of the former Sigrid Elisabeth Lindforss and Gösta Oldenburg, Swedish diplomat then stationed as attaché in New York. Brought to United States as infant; family resides in New York City and Rye, New York until 1933.

1933–1936

Younger brother, Richard Erik, born in Stockholm September 21, 1933. Family transferred to Oslo, Norway, where father is stationed as first secretary of Swedish Legation until 1936.

1936–1946

Family settles in Chicago, where father is stationed first as consul, then as consul-general, until his retirement in 1959. Residence at Swedish Consulate, 44 East Bellevue Place, on North Side. Attends Latin School, graduating 1946.

1946–1950

Attends Yale College, participating for first two years in Directed Studies program. Divides major between English literature and art; first studio courses (figure drawing and composition) in final year. Attends summer school, University of Chicago, 1948; University of Wisconsin, 1949.

1950–1952

Attends night courses at Art Institute of Chicago, completing requirements for B.A. from Yale, while serving as apprentice reporter with City News Bureau. Covers police beat for six months; thereafter, rewrite-man.

1952–1953

January 1952: Becomes eligible for military service but is not inducted. Leaves City News Bureau and enrolls at Art Institute for day and night courses, remaining on and off until 1954. Supports himself with odd jobs, working in book store, advertising agency, as candy vendor in Dearborn Station, and as illustrator.

March 9–April 11, 1953: First exposure as artist; "satirical drawings" included in group show with Robert E. Clark (later known as Robert Indiana) and George Yelich, at Club St. Elmo, Chicago.

Begins painting, first in watercolor, then in oils at Oxbow Summer School of Painting, Saugatuck, Michigan, which he attends on scholarship.

September–December: Three months in San Francisco and Oakland, California.

December: Returns to Chicago for naturalization as American citizen.

1954

Contact with figure painters of "Chicago School"—George Cohen, Leon Golub, June Leaf, H.C. Westermann, and younger artists including Robert Barnes and Irving Petlin.

Studies painting with Paul Wieghardt at Art Institute. Thereafter, continues to teach himself by drawing, study of old masters in museums, and study of contemporaries.

Spring: Exhibits in Old Town Art Fair on North Park Avenue, and South Side Art Fair, Chicago.

November: Exhibits at Tally Ho restaurant, Evanston.

1955

Studio in Chicago (until June 1956). Does illustrations for *Chicago* magazine.

Exhibits in local shows; March: Bramson Gallery, Evanston; April 1–28: 1020 Art Center, Chicago, in show sponsored by Chicago Chapter of American-Scandinavian Foundation; April 24–May 12: "Young Artists Among Us," Evanston Art Center; November: Frank Ryan Gallery, Chicago.

1956

June 1–20: Included in "Exhibition Momentum," 72 East Eleventh Street, Chicago.

June: Moves to New York City. Obtains part-time job shelving books at library of Cooper Union Museum, which he holds until November 1961.

1957

Produces mostly drawings until close of year, when he moves to apartment at 330 East Fourth Street which is large enough to paint in and serves as his studio until June 1961. Daily contact with printmaker and self-styled "alchemist" Dick Tyler (who acts as superintendent of building), continuing into following two years.

1958

Continues drawing in studio, sketching on street, in various locations throughout city, and making studies for paintings. Begins large-scale oil paintings of nudes, and portraits.

December 19, 1958–January 6, 1959: First exposure in New York; drawings included in group show at Red Grooms's City Gallery.

1959

March: One-man show at Cooper Union Museum Library; figure drawings of Pat Muschinski, who later becomes his wife.

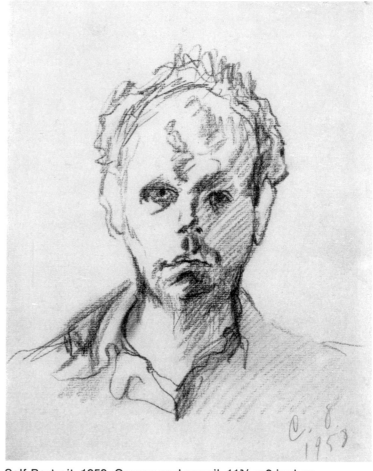

Self-Portrait. 1958. Crayon and pencil, 11¾ x 9 inches
Collection Alicia Legg, New York

May 22–June 10: First public one-man show in New York at Judson Gallery, in basement of Judson Memorial Church; environmental drawings, wood and newspaper constructions, interspersed with his own poems hung and mounted on wall (reviewed by Hilary Dunsterville in *The Villager,* June 4, p. 10).

July–August: Summer in Lenox, Massachusetts, where Pat Muschinski has job as model and Oldenburg as director of Lenox Art Gallery, sponsored by resort and art school, Festival House. 199

Red Grooms. The Burning Building. 1959

Jim Dine outside his House, Judson Gallery, 1960

Includes his own work and that of friends in shows. Landscape drawings and paintings.

On return to New York, begins ink and pencil drawings on theme of The Street.

October: Exhibits Lenox figures and landscapes in group show (with Dorothea Baer, Jim Dine, Marc Ratliff, Dick Tyler, and Tom Wesselmann) at Judson Gallery. Sees Allan Kaprow's *18 Happenings in 6 Parts* at Reuben Gallery.

November 13–December 3: Two-man show, "Oldenburg – Dine," at Judson Gallery; mainly papier-mâché constructions of newspaper dipped in wheat paste over chicken-wire, including *Street Head, I ("Big Head"; "Gong")* and *C-E-L-I-N-E, Backwards;* some early Ray Gun drawings. Makes ink and monoprint poster for show.

December: Participates with Jim Dine, Lester Johnson, and Allan Kaprow on panel, "New Uses of the Human Image in Painting," at Judson Gallery, December 2; in Christmas group show at Judson Gallery, December 3–31. Sees Red Grooms's theater piece, *The Burning Building,* several times.

December 18–January 5, 1960: *"Empire" ("Papa") Ray Gun* and *Woman's Leg* included in "Below Zero" group show at Reuben Gallery.

Throughout this period, continuing interest in theater and environments. Contacts include, besides Dick Tyler, George Brecht, Jim Dine, Red Grooms, Dick Higgins, Ray Johnson, Allan Kaprow, Lucas Samaras, George Segal, Robert Whitman, and artists associated with Hansa Gallery run by Ivan Karp and Richard Bellamy.

1960

January: Preparations for Ray Gun Show at Judson Gallery. Originally planned as group effort to feature "new art" based on popular sources, emphasizing realism rather than abstraction and using junk, actual objects, and events; eventually consists of The House, constructed by Dine, and The Street, constructed by Oldenburg, shown January 30–March 17.

January 11–16: Appears in Allan Kaprow's happening, *The Big Laugh,* at Reuben Gallery.

Shows last figure painting, *Girl with Furpiece,* in group show at Reuben Gallery, January 29–February 18.

February 29, March 1–2: "Ray Gun Spex" at Judson Gallery, including Oldenburg's first happening, *Snapshots from the City,* in environment of The Street.

January–June: Posters, monoprints, mimeographed "comic books," in connection with Ray Gun Show and Spex at Judson Gallery and one-man show at Reuben Gallery (May).

April 13: Marries Pat Muschinski in Staten Island, New York.

left:
Street Drawing with Girl —"RA." 1960. Ink, 13⅞ x 10⅞ inches
Collection Mr. and Mrs. Abe Adler, Los Angeles

right:
Ray Gun Poems. 1960. Drawing on stencil, mimeographed, 8⅞ x 5½ inches. Owned by the artist

Drawings in ink and collaged newspaper to announce Reuben Gallery show, and for poster used as mailer and catalogue for "New Forms—New Media, I" at Martha Jackson Gallery.

May 6–19: The Street reconstructed as one-man show at Reuben Gallery, including pieces from Judson Gallery version and new pieces; situated in larger, more open environment.

Designs sets for Robert Duncan's *Faust Foutu,* at Living Theater.

June: *MUG* included in "New Forms—New Media, I" at Martha Jackson Gallery, June 6–24.

June 16–September 1: In Provincetown, Massachusetts; job as dishwasher. Abandons Street theme. Makes "flags" and "postcards" of driftwood and other found materials, and related ink drawings; shows these in two-man show with Irene Barrell at Sun Gallery, and at HCE Gallery, August.

Fall: On return to New York, numerous drawings of goods and clothing leading toward The Store; sketches of street figures, some combined with flags; sketches for costumes and theater. Included in "New Media—New Forms, Version II," at Martha Jackson Gallery, September 27–October 22.

December: *C-E-L-I-N-E, Backwards* included in Christmas group show at Green Gallery, recently opened under direction of Richard Bellamy, December 13–January 7, 1961. Watercolors of Store windows, continuing into 1961. Monoprint posters announcing performances of happenings at Reuben Gallery, including Oldenburg's second happening, *Blackouts,* in four parts, presented as part of "Christmas Varieties," December 16–20.

Oldenburg inside The Store, 1961

1961

January: Designs costumes and poster for Aileen Passloff Dance Company; costumes used in dance concerts February 1961 and February 1962.

February: Two-part happening, *Circus (Ironworks/Fotodeath),* performed at Reuben Gallery.

March 6–25: Provincetown "flags" included in group show at Alan Gallery.

May: First statement of The Store, reliefs hung in stairwell and front of gallery, in group show "Environments, Situations, Spaces" at Martha Jackson Gallery, May 25–June 23.

Dispute with Kaprow over definition of happenings in latter's article in *Art News* leads to exchange of acrimonious correspondence.

June: Moves studio to store at 107 East Second Street.

Summer: Close friendship with Billy Klüver; holds discussions with him; indirect contact with Tinguely's ideas and those of Arman, Klein, Spoerri, and other European "New Realists."

Works on reliefs and three-dimensional pieces for The Store.

September: Exhibits *Big Man* and *Street Head, I* in group show (with Jean Follett, Charles Ginnever, Lucas Samaras, and Mark di Suvero) at Green Gallery, for which he executes poster.

December: Second version of The Store opens at 107 East Second Street, December 1 (originally planned for December only, but is extended through January 1962); includes rebacked reliefs from Martha Jackson Gallery show and about sixty new pieces, mainly free-standing.

Red Tights, first of Oldenburg's pieces to enter a museum, included in "Recent Acquisitions," Museum of Modern Art, December 19 to February 25, 1962.

1962

January: Designs costumes and poster for Aileen Passloff Dance Company. Notebook drawings for Ray Gun Theater—costumes, sets, special effects, canvas "soft" objects as props.

February–May: Ray Gun Theater performances at The Store locale, 107 East Second Street. Ten different happenings: *Store Days, I,* February 23–24; *Store Days, II,* March 2–3; *Nekropolis, I,* March 9–10; *Nekropolis, II,* March 16–17; *Injun, I,* April 20–21; *Injun, II,* April 27–28; *Voyages, I,* May 4–5; *Voyages, II,* May 11–12; *World's Fair, I,* May 18–19; *World's Fair, II,* May 25–26.

April: Large selection from The Store shipped to Dallas for inclusion in exhibition "1961," Dallas Museum for Contemporary Arts, April 3–May 13. Travels to Dallas for this and for performance of *Injun,* commissioned by museum and performed in abandoned house on its property, April 6–7.

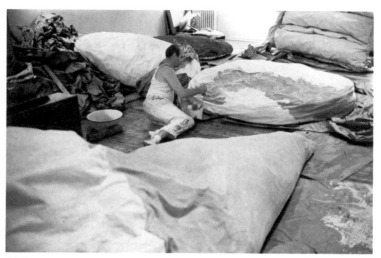

Oldenburg making his first giant "soft" sculptures, Green Gallery, Summer 1962

April 10–May 27: Included in group show at Green Gallery.

June: Collaborates with Robert Breer on film, *Pat's Birthday,* made at Palisades, New York.

Summer: At Bellamy's invitation, uses Green Gallery as studio to prepare for one-man show there; drawings, plaster-and-enamel objects, soft canvas pieces.

September 18–October 13: One-man show at Green Gallery; first exposure of large-scale "soft" sculptures, *Floor-Burger, Floor-Cone, Floor-Cake,* etc.

November 1–December 1: *Lingerie Counter, Stove, Pastry Case, II* included in "New Realists," Sidney Janis Gallery.

November 18–December 15: Included in "My Country 'Tis of Thee," Dwan Gallery, Los Angeles, among first of many group shows of Pop Art.

1963

January: Included (with Joan Mitchell and Robert Rauschenberg) in "Three Young Americans," Allen Memorial Art Museum, Oberlin, Ohio; gives talk on his work there, January 17; drawing of "stuffed" numbers reproduced on cover of *Allen Memorial Art Museum Bulletin,* Winter issue.

January 11–February 10: *Breakfast Table, Shirt on Chair with Wallet and Other Objects, August Calendar* included in "66th American Annual Exhibition" of painting and sculpture, Art Institute of Chicago.

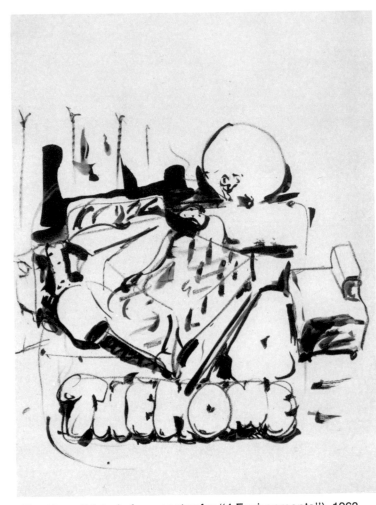

"The Home" (study for a poster for "4 Environments"). 1963
Crayon and watercolor, 24 x 18 inches
Collection Mr. and Mrs. Lester Francis Avnet, New York

February: Large representation in Pop Art show at Richard Feigen Gallery, Chicago.

February 8–10: *Gayety* performed at Lexington Hall, University of Chicago (filmed version by Vernon Zimmerman, *Scarface and Aphrodite*).

First vinyl pieces, *Soft Telephone* and *BLT*.

April 9–30: In Washington. *Bride* and *BLT* included in "The Popular Image," Washington Gallery of Modern Art, April 18–June 2; *Stars* performed there as part of Pop Art Festival, April 24–25.

April 28–May 26: Included in "Popular Art" show at Nelson Gallery—Atkins Museum, Kansas City.

Spring: Included in group show of American "New Realists," Galerie Ileana Sonnabend, Paris.

May 3–23: *Tray Meal* included in "Recent Acquisitions" show at Rose Art Museum, Brandeis University, Waltham, Massachusetts.

May 22–August 18: Eleven pieces included in "Americans 1963," Museum of Modern Art, New York.

May–August: In New York, working in plaster and enamel, vinyl and other fabrics; drawings of isolated objects in voluminar style.

June: Joins Sidney Janis Gallery.

August: Leaves apartment on East Fourth Street and studio in store on East Second Street; moves possessions to 48 Howard Street.

September: Takes bungalow and studio at Venice, California (until March 1964). Drawings toward poster and objects for one-man show at Dwan Gallery.

September 7–29: Included in "Pop Art, U.S.A.," Oakland Art Museum, Oakland, California.

October 1–26: One-man show, Dwan Gallery, Los Angeles, including *Baked Potato, Good Humor Bars, Giant Blue Shirt*.

October 24–November 23: Included in "The Popular Image," sponsored by Institute of Contemporary Art, London.

November 1–December 1: Included in "Harvest of Plenty," Wadsworth Atheneum, Hartford.

November 19–December 15: Included in "Mixed Media and Pop Art," Albright-Knox Art Gallery, Buffalo.

October–December: Drawings formulating *Bedroom Ensemble*, toward poster for "Four Environments" at Sidney Janis Gallery; in November, begins construction of *Bedroom Ensemble* in Los Angeles.

December 9–10: *Autobodys* performed in parking lot of American Institute of Aeronautics and Astronautics, Los Angeles.

1964

January: Brief visit to New York, staying at Chelsea Hotel.

January 3–February 1: *Bedroom Ensemble* shown in "Four Environments by Four New Realists," Sidney Janis Gallery (other three Jim Dine, James Rosenquist, George Segal).

January–March: In Los Angeles, working on constructions, sewn pieces, and drawings in technical and other styles on theme of The Home, toward one-man show at Sidney Janis Gallery.

February 29–April 12: *Bride* and other Store pieces included in "Amerikansk pop-konst" at Moderna Museet, Stockholm (subse-

Oldenburg making pieces for his show at the
Galerie Ileana Sonnabend, Paris, 1964

quently shown at Louisiana Museum, Humlebaek, Denmark, and Stedelijk Museum, Amsterdam).

March: Returns to New York, living at Chelsea Hotel and using Howard Street studio (until May).

April 7–May 2: First one-man show at Sidney Janis Gallery; The Home theme.

April 22–June 28: Included in "Painting and Sculpture of a Decade, '54–'64," sponsored by Gulbenkian Foundation, at Tate Gallery, London.

May 13: Sails on *Vulcania* for Venice.

June 20–October 15: One of eight American artists included in United States representation at XXXII Biennale, Venice.

June–July: In Italy; visits Pisa, Rome, and Varese—where he restores Store pieces in villa of collector Giuseppe Panza di Biumo.

June 24–August 30: Included in "Nieuwe Realisten," Gemeente Museum, The Hague (later shown in Berlin, Vienna, and Brussels).

August–October: Studio in Paris; creates plaster constructions of food articles, painted in tempera and casein, and related drawings, on Parisian themes, for show at Galerie Ileana Sonnabend.

October–November: One-man show at Galerie Ileana Sonnabend, Paris.

November: In Rome, commissioned by De Laurentiis Studios at Michelangelo Antonioni's request to work on settings for film featuring Soraya; studies constructions for *The Bible;* conversations with Antonioni. Project canceled after two weeks' work.

November 22: Returns to New York, again living at Chelsea Hotel (until March 1965) and working at Howard Street while seeking new studio. During this period, repairs various works; drawings, including *Burroughs Adder* and sketches toward lithograph of *Flying Pizza* issued by Tanglewood Press.

1965

March–April: First drawings of monuments. Moves out of Chelsea Hotel and Howard Street studio to large new studio in loft at 404 East Fourteenth Street; while fixing up studio, breaks arm on stairs.

May 5–31: First showing of drawings for Colossal Monuments in group exhibition, "Recent Work," at Sidney Janis Gallery.

May 22–23: *Washes* performed in pool at Al Roon's Health Club as part of First New York Theater Rally.

June 4–7: *Washes* restaged, with cast transported to brookside cottage of Rudy Wurlitzer, who produces film of event, *Birth of the Flag,* photographed by Stan Vanderbeek and Sheldon and Diane Rochlin.

July–August: Watercolors of Monuments for *Domus* magazine: subjects include "Teddy Bear," "Fan on Staten Island," "Banana for Times Square," etc. Drawings toward *Paris Review* poster, *French Mattress (Multimousse).*

Begins first multiple productions: *Baked Potato* for Tanglewood Press and *Tea Bag* for Multiples, Inc. (completed 1966 and issued in portfolio *Four on Plexiglas,* including also Philip Guston, Barnett Newman, Larry Rivers).

Oldenburg working on frame for Chrysler Airflow, 1965; in background, Giant Shrimps

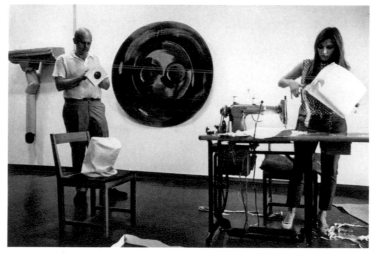

Claes and Pat Oldenburg at Moderna Museet, Stockholm, 1966 making Giant Soft Swedish Light Switches for one-man show

September–December: Sculptures and drawings on Home and Airflow themes, toward one-man show. Erotic pen-drawings. Visits Carl Breer in Detroit to gather data on Airflow.

December 1–3, 16–17: *Moviehouse* performed at Film-Makers' Cinematheque, New York.

1966

March 9–April 2: One-man show, "New Work by Claes Oldenburg," at Sidney Janis Gallery; features Airflow and Bathroom constructions.

April 16: Participates (with Raymond Parker, Larry Rivers, and Thomas Hess as moderator) in symposium, "The Current Moment in Art" and in "conversation" with Dean Wallace, sponsored by San Francisco Art Institute and accompanied by exhibition at San Francisco Museum of Art, "Six from the East." Returns via Los Angeles, where he distributes multiple, 250 cake slices in plaster, at wedding of James and Judith Elliott in Santa Monica.

August–October: Visits Sweden to prepare survey of his sculpture and drawings, 1963–1966, at Moderna Museet, Stockholm, September 17–October 30. *Massage* performed at Moderna Museet, October 3–4, 6–7. Drawings of monuments for Stockholm; makes model for Wing-nut Monument. Makes castiron multiple of Knäckebröd.

October 8–9: To Oslo, revisiting sites recalled from childhood.

October–November: Studio in London at Alecto, Ltd.; formulation of multiple, *London Knees,* and London-sited drawings and sculptures, including Fagends, toward one-man show at Robert Fraser Gallery, November 22–December 31.

November: Returns to New York; with aid of Emmett Williams, assembles notes, drawings, and photographs for *Store Days,* issued by Something Else Press, Spring 1967 (see bibl. 23).

1967

January: Participates in group show of drawings for monuments, Dwan Gallery, New York, January 7–February 11.

Visits Toronto for opening of "Dine, Oldenburg, Segal" at Art Gallery of Ontario, January 14–February 12 (later shown at Albright-Knox Gallery, Buffalo); participates in panel discussion at Ontario College. Gallery's acquisition of *Giant Hamburger (Floor-Burger),* 1962, stirs press controversy.

January–April: Drawings and sculptures toward one-man show at Sidney Janis Gallery.

April 26–May 27: One-man show, Sidney Janis Gallery, including "ghost" version of *Giant Soft Fan,* new Monuments proposals, Fagends, Drainpipe variations, etc.

To Montreal to install *Giant Soft Fan* in Buckminster Fuller's dome for United States Pavilion, Expo '67, April 28–October 27.

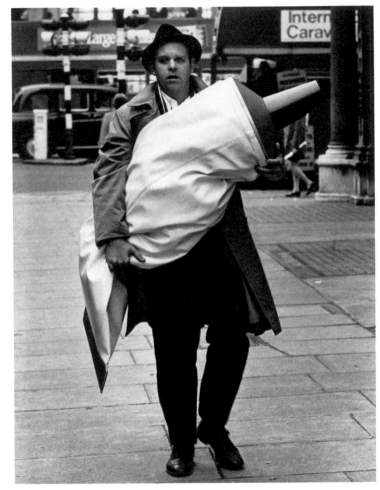

Oldenburg in London with Giant Toothpaste Tube, 1966

Pop Tart. 1967. Wall painting, 22 x 15½ feet
Commissioned by Museum of Contemporary Art, Chicago

May–July: Drawings toward Frank O'Hara memorial volume, *In Memory of My Feelings*. Preparatory drawings, *Giant Soft Drum Set*.

July: Visits Ann Arbor, Michigan to collaborate with George Manupelli on film; aims diverted by uprisings in Detroit; film, *A*, never completed.

August: Artist-in-residence at Aspen Institute for Humanistic Studies, Aspen, Colorado; drawings on Drum Set theme. Stages performance, *Chapel*, as part of "Kulch-In" organized with other resident artists Allan D'Arcangelo, Les Levine, Roy Lichtenstein, Robert Morris, DeWain Valentine, and poet Jonathan Williams, at Aspen Center of Contemporary Art, August 15–17.

September 22–January 8, 1968: *Bedroom Ensemble* shown in United States representation at IX Bienal do Museu de Arte Moderna, São Paulo, Brazil.

October 1: Hole dug in Central Park as participation in "Sculpture in Environment," sponsored by New York City Administration of Recreation and Cultural Affairs and Parks Department, October 1–31.

October 20–February 4, 1968: *Giant Drum Set* included in "Guggenheim International Exhibition 1967: Sculpture from 20 Nations," Solomon R. Guggenheim Museum, New York.

October 24–November 26: "Projects for Monuments," one-man show of drawings for Colossal Monuments, as part of inauguration of Museum of Contemporary Art, Chicago (exhibition later traveling to Krannert Art Museum, University of Illinois at Champaign).

November 17: *Pop Tart*, exterior wall-painting commissioned by Museum of Contemporary Art, Chicago and executed by Arrow Sign Company from clipping provided by Oldenburg, unveiled on wall adjacent to museum.

November–December: Resumes printmaking activity at Mourlot workshop, New York; *Scissors* for portfolio commemorating opening of National Collection of Fine Arts, Smithsonian Institution, Washington (also used as poster), and *Double Punching Bag* for Foundation for Contemporary Performing Arts.

December 6–30: *String Wardrobe* and *Lipstick*, Oldenburg's first fabricated metal sculpture, included in "Homage to Marilyn Monroe," Sidney Janis Gallery.

1968

January–March: In Los Angeles. Begins work with Gemini G.E.L.: lithographic edition of *Notes* (issued 1968) and multiples, *Profile of Chrysler Airflow* and *Double Punching-Bag Noses* (issued 1969).

February 19–March 31: *Bedroom Ensemble* shown with other works from IX Bienal, São Paulo, at Rose Art Museum, Brandeis University, Waltham, Massachusetts.

May: To Los Angeles. Writes text to accompany *Notes*. Constructions toward one-man show at Irving Blum Gallery.

June: Drawings and constructions, including Monuments for Los Angeles, Nose variations, Punching Bags, *Soft Scissors*, shown at Irving Blum Gallery, Los Angeles.

August: Obtains press card and attends Democratic National Convention, Chicago.

September: Designs multiple, *Chicago Fireplug*, for edition issued by Richard Feigen Graphics.

October: Shows Fireplugs in "Richard J. Daley," exhibition organized by Richard Feigen Gallery, Chicago, as protest against violence by Chicago civil authorities at Democratic National Convention.

November: Lectures to students at Art Institute of Chicago.

December: Prepares *The Typewriter*, performance in script form commissioned by *Esquire* magazine (published May 1969). Models for *Giant Saw—Hard Version*.

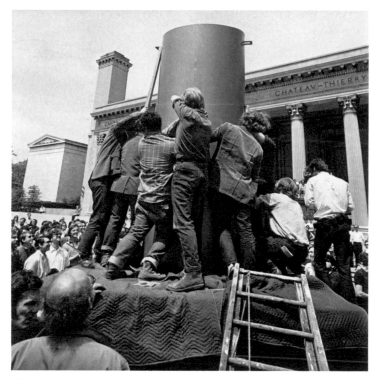

Lipstick Monument being erected on campus of
Yale University, May 1969

Geometric Mouse, Variation I being erected in
Sculpture Garden, Museum of Modern Art, October 1969

Claes Oldenburg, 1968

1969

January–June: Visits to Los Angeles. Activity there includes designing and assembling replica of *Bedroom Ensemble* (with reconstruction of gallery environment); participation in "Art and Technology" project sponsored by Los Angeles County Museum of Art; short-lived collaboration with Disney Enterprises, which rejects proposed sculpture in form of Colossal Ice Bag. *Ice Bag,* first motorized construction, continued at Krofft Enterprises with aid of Gemini G.E.L.

January: Commission from Letter Edged in Black Press, New York, to make copy of Picasso's sculpture in Civic Center, Chicago to serve as copyright violation against City of Chicago results in *Soft Picasso.*

Visits Vancouver to install *Giant Saw—Hard Version,* included in group show, "New York 13," Vancouver Art Gallery, January 21–February 16 (later shown at Regina and Montreal).

April 30–May 31: One-man show, "Constructions, Models, and Drawings," all related to Chicago sites and themes, at Richard Feigen Gallery, Chicago. Second wall-painting, *Frayed Wire,* executed by Arrow Sign Company, replaces *Pop Tart* on wall adjacent to Museum of Contemporary Art, which sponsors it.

May 1–31: *Giant Saw—Hard Version* and *Soft Picasso* included in group show, "New Work by Seven Artists," at Sidney Janis Gallery.

May: Sets up new studio in warehouse in New Haven, Connecticut to collaborate with Lippincott Environmental Arts, Inc. on large-scale outdoor sculptures.

May 15: First "feasible" monument, *Lipstick (Ascending) on Caterpillar Tracks,* forcibly installed in central site on Yale University campus as result of commission by group of students at Yale School of Architecture, subscribed by alumni, students, faculty and donated by student group calling itself "Colossal Keepsake Corporation."

June: To London for completion and installation of replica of *Bedroom Ensemble* as part of "Pop Art" exhibition, organized by Suzi Gablik and John Russell under auspices of Arts Council of Great Britain and shown at Hayward Gallery, July 9–September 3.

August: To Los Angeles. Works on *Ice Bag;* conceives and acts in color film about origin of this subject, *Sort of a Commercial for an Ice Bag,* directed by Michel Hugo, photographed by Eric Saarinen.

September 25–November 23: "Claes Oldenburg," comprehensive survey of three-dimensional objects and drawings, 1954–1969, The Museum of Modern Art, New York. October 7: *Geometric Mouse—Variation I,* fabricated by Lippincott Environmental Arts, Inc., installed in Museum's Sculpture Garden as part of show.

Fall: Publication of two books, *Claes Oldenburg, Proposals for Monuments and Buildings, 1965–69* and *Claes Oldenburg: Drawings and Prints* (see bibl. 65 and 69).

Bibliography

This bibliography is divided into the following categories: 1. Oldenburg Statements, Writings, and Interviews (1–38); 2. Films (39–59); 3. Books on Oldenburg (60–61); 4. General Works (62–90); 5. Articles and Reviews (91–203); 6. Exhibition Catalogues (204–290). We are particularly indebted to Sandra Hunt of the Sidney Janis Gallery, who is compiling a complete bibliography on the artist, for generously making available material in her files.

Oldenburg Statements, Writings, and Interviews
(arranged chronologically)

1 "Portfolio and Three Poems," *Exodus* (New York: Judson Memorial Church), Spring–Summer 1960.

2 *Spicy Ray Gun. Ray Gun Poems. More Ray Gun Poems.* New York: Judson Gallery, 1960.
Mimeographed, staple-bound pamphlets.

3 "Two Scenarios from an Incomplete Pageant of America"; "Faustina (Unfinished)"; "Faustina (Another Act)"; "A Card from Doc." 1960.
Published 1966 in *Injun and Other Histories* (bibl. 20).

4 [Statement]. "I am for an art ..." In exhibition catalogue, "Environments, Situations, Spaces," 1961 (bibl. 205).
Incomplete; for complete text, see pp. 190–191 and bibl. 23; for preliminary version, see p. 191.

5 [Interview]. Taped interview produced by WFMT, Chicago, January 22, 1963.
Interview by Paul Carroll. Unpublished typescript in Museum of Modern Art Library.

6 [Statement]. Phonograph record of statements by artists participating in "The Popular Image" exhibition, Washington, Gallery of Modern Art, April 18–June 2, 1963.
Edited by J.W. Klüver. See also bibl. 212.

7 [Interview]. "The Transfiguration of Daddy Warbucks," *Chicago Scene,* April 1963, p. 34.
Interview by Robert Pincus-Witten.

8 "Wat dwy den theink uv MRCA," *V TRE* (edited and published by George Brecht, Metuchen, New Jersey), 1963. Poem.

9 "Object: Still-Life," *Craft Horizons* (New York), September–October 1965, pp. 31–32, 55–56.
Interview by Jan McDevitt.

10 [Statement]. "The Spontaneous and Design," *It Is* (New York), Autumn 1965, pp. 77–80, 109–113.
Publication of Waldorf Panel 2, Fifth Avenue Hotel, New York, March 17, 1965. Panelists: Philip Pavia, chairman, Isamu Noguchi, Claes Oldenburg, George Segal, George Sugarman, James Wines.

11 "A Statement." "*Injun:* The Script"; "*World's Fair II:* The Script"; "*Gayety:* The Script"; "*Autobodys:* The Script." In Michael Kirby, *Happenings: An Illustrated Anthology,* 1965 (bibl. 77), pp. 200–203, 204–206, 220–222, 234–240, 262–271.

12 "*Fotodeath,*" *Tulane Drama Review,* Winter 1965, pp. 85–93.
Script of happening presented at Reuben Gallery, New York, February 1961, with accompanying notes. See also bibl. 40.

13 "*Washes,*" *Tulane Drama Review,* Winter 1965, pp. 108–118.
Script of happening presented at Al Roon's Health Club, New York, May 1965, with accompanying notes.

14 "Claes Oldenburg: Extracts from the Studio Notes, 1962–1964," *Artforum* (Los Angeles), January 1966, pp. 32–33.
Selected by Max Kozloff.

15 "Oldenburg, Lichtenstein, Warhol: A Discussion," *Artforum* (Los Angeles), February 1966, pp. 20–24.
Transcript of discussion broadcast over WBAI, New York, June 1964, moderated and edited for publication by Bruce Glaser.

16 [Interview]. *Bau* (Vienna), 1966, No. 4.
Interview by Alfons Schilling. English translation in supplement.

17 "Afterthoughts," *Konstrevy* (Stockholm), Nos. 5–6 (November–December) 1966, pp. 214–220.
In Swedish. For original English, see "Selections," pp. 195–198.

18 "Oldenburg's Monuments," *Art and Artists* (London), December 1966, pp. 28–31.
Interview by Gene Baro.

19 "London: Male City," *London International Times,* December 12, 1966.
Edited from taped interview by Robert Fraser.

20 *Injun and Other Histories (1960).* A Great Bear Pamphlet. New York: Something Else Press, 1966.
See bibl. 3.

21 [Statement]. "Jackson Pollock: An Artists' Symposium, Part 2," *Art News* (New York), May 1967, pp. 27, 66–67.

22 [Interview]. "Take a Cigarette Butt and Make It Heroic," *Art News* (New York), May 1967, pp. 30–31, 77.
Interview by Suzi Gablik.

23 *Store Days.* New York: Something Else Press, 1967. Documents from The Store (1961) and Ray Gun Theater (1962), selected by Claes Oldenburg and Emmett Williams. Photographs by Robert R. McElroy.

24 "Some Program Notes about Monuments, Mainly," issued as mimeographed supplement to exhibition catalogue, "New Work by Claes Oldenburg," Sidney Janis Gallery, 1967 (bibl. 256).
Subsequently published in *Chelsea* (New York), June 1968, pp. 87–92.

25 "America: War & Sex, Etc.," *Arts Magazine* (New York), Summer 1967, pp. 32–38.

26 [Statement]. "Portfolio: 4 Sculptors, Recent Work and Statements," *Perspecta 11* (New Haven), Summer 1967, p. 53.

27 [Statement]. In exhibition catalogue, "São Paulo IX: Environment U.S.A. 1957–67" (bibl. 261).
On *Bedroom Ensemble.*

28 "About the Famous Toronto Drainpipe," *Arts Canada* (Toronto), August 1968, pp. 40–41.

29 *London Knees 1966.* London: Editions Alecto, Ltd., 1968.
Notes and notebook excerpts accompanying boxed multiple.

30 *Notes.* Los Angeles: Gemini G.E.L., 1968.
Text in folio accompanying twelve original color lithographs.

31 "Two Scenarios from an Incomplete Pageant of America," *Das Wort* (literary supplement to *Du* [Zurich]), March 1969, p. 231.
Reprinted from bibl. 20.

32 "The Artist Speaks: Claes Oldenburg," *Art in America* (New York), March–April 1969, pp. 68–75.
Interview by John Coplans.

33 *Constructions, Models, and Drawings.* Chicago: Richard Feigen Gallery, 1969.
See bibl. 285.

34 "From Oldenburg's Notebooks," *Art Scene* (Chicago), May 1969, pp. 6–9.

35 "The Typewriter," *Esquire* (Chicago), May 1969, pp. 154–157. Commissioned script of happening to be published, not performed.

36 "Notes on the Lipstick Monument," *Novum Organum No.7* (New Haven), Special "Colossal Monument" Issue, May 15, 1969.

37 "The Bedroom Ensemble, replica I," *Studio International* (London), July–August 1969, pp. 2–3.

38 [Interview]. "How To Keep Sculpture Alive In and Out of a Museum," *Arts Magazine* (New York), September–October 1969, pp. 24–28.
Interview by Jeanne Siegel, condensed from a tape recorded June 1969; broadcast by WBAI-New York, October 5 and 10, 1969.

Films
(arranged chronologically)

* indicates incomplete, unedited, or not released

39 *Snapshots from the City*. Filmed by Stan Vanderbeek at Judson Gallery, New York, March 1960. 16 mm, b/w, sound, 5 min. New York: Film-Makers' Cooperative.

40 *Fotodeath*. Filmed by Al Kouzel at Reuben Gallery, February 1961. 16 mm, b/w, sound, 16 min. New York: Grove Press (Cinema 16 Film Archives).

41 *Injun*. Filmed at performance in Dallas, April 1962. Produced by Dallas Museum for Contemporary Arts. Directed by Claes Oldenburg; photographed by Roy Fridge. 16 mm, b/w, silent, 12 min.*

42 *Store Days*. Filmed by Stan Vanderbeek from performances of *Voyages I* at The Store, New York, May 1962. 16 mm, color, silent.*

43 *Happenings I. Happenings II*. Filmed by Raymond Saroff, combining several performances at The Store, New York, Spring 1962. Score by Morton Feldman. Each film 16 mm, b/w, silent (sound-on-tape), 25 min. New York: Film-Makers' Cooperative.

44 *Store Days I & II*. Filmed by Raymond Saroff, combining parts of several performances at The Store, Spring 1962. 16 mm, b/w, silent, 15 min. New York: Film-Makers' Cooperative.

Note: In addition to the two preceding entries, Raymond Saroff also filmed other Ray Gun Theater performances of *Nekropolis I, Nekropolis II, Injun I, Injun II, Voyages I, Voyages II, World's Fair I,* and *World's Fair II* at The Store, New York, March–May, 1962, but these fragments have not been edited nor released.

45 *Pat's Birthday*. Filmed by Robert Breer at Palisades, New Jersey, June 1962; edited by Breer. With Claes Oldenburg, Pat Oldenburg, and others. 16 mm, b/w, sound, 13 min. New York: Film-Makers' Cooperative.

46 *Scarface and Aphrodite*. Filmed version of *Gayety*, Chicago, February 1963. Directed by Vernon Zimmerman. 16 mm, b/w, sound, 15 min. New York: Film-Makers' Cooperative.

47 [Interview]. Television interview by Mike Wallace, WCBS-TV, New York, May 6, 1964.* Footage from this and Wallace's interviews with other artists used in "Eye on New York: The Museum of Modern Art Reopened," produced by Gordon Hyatt, WCBS-TV, New York, May 25, 1964. 16 mm, b/w, sound, 30 min. Available in Museum of Modern Art Television Archive of the Arts.

48 *Tarzan and Jane Regained Sort Of*. Photographed by Andy Warhol in Los Angeles and Venice, California, near Oldenburg's bungalow, 1964; cast includes Claes and Pat Oldenburg. Directed by Taylor Mead. 16 mm, b/w and color, silent (sound-on-tape), 2 hrs. New York: Film-Makers' Cooperative.

49 *Birth of the Flag*. Filmed by Stan Vanderbeek, Sheldon and Diane Rochlin, June 1965. Edited (1967) by Alfons Schilling and (1969) by Peter Hentschel. Produced by Rudy Wurlitzer. 16 mm, b/w, silent (sound-on-tape), 20 min.*

50 *Making of the Airflow in the Studio*. Filmed by John Jones in Oldenburg's studio, New York, 1965–1966. 16 mm, color.*

51 *Hanging a Picture*. Filmed by John Jones in New York, 1966. 16 mm, b/w.*

52 *Shave*. Filmed by John Jones in New York, 1966. 16 mm, b/w, silent, 12 min.*

53 *USA: Artists—Claes Oldenburg*. Produced by Lane Slate for NET; Channel 13, New York, June 21, 1966. Written by Alan Solomon; narrated by Jim Dine. 16 mm, b/w, sound, 29 min. Available in Museum of Modern Art Television Archive of the Arts.

54 *Portrait of Claes Oldenburg*. Produced by Moderna Museet, Stockholm, Fall 1966. Photographed by Anders Wahlgren and Staffan Olzon. 16 mm, b/w, magnetic sound, 15 min.

55 *A*. Fragments for a film by Claes Oldenburg in collaboration with George Manupelli, Ann Arbor, Michigan, July 1967. 16 mm, b/w, sound.*

56 [Interview]. Unedited interview filmed 1967.* Footage from this and interviews with other artists used in "Eye on Art: And the Walls Came Tumbling Down," WCBS-TV, New York, July 2, 1967, produced and directed by Merrill Brockway. Available in Museum of Modern Art Television Archive of the Arts.

57 *Colossal Keepsake No. I, 1969*. Documentary by Peter Hentschel and Bill Richardson on construction and placement of Lipstick Monument, New Haven, May 1969. 16 mm, b/w and color, sound, 20 min.

58 *Sort of a Commercial for an Icebag by Claes Oldenburg*. Produced by Gemini G.E.L., Los Angeles, 1969. Directed by Michel Hugo; photographed by Eric Saarinen; edited by John Hoffman; sound by Howard Chesley. Available in super 8 and 16 mm, color, sound, 20 min.

59 [Interview]. Television interview by Grace Glueck, produced by Camera Three, CBS-TV, New York, November 9, 1969. 29 min.

Books on Oldenburg

60 *Claes Oldenburg: Drawings and Prints*. A Paul Bianchini Book. London and New York: Chelsea House, 1969.
Introduction and commentary by Gene Baro, based on statements by the artist.

61 *Claes Oldenburg: Proposals for Monuments and Buildings, 1965–69*. Chicago: Big Table Publishing Company [Follett], 1969.
Includes "The Poetry of Scale," pp. 11–36, rewritten by Oldenburg from interview by Paul Carroll taped in Chicago, August 22, 1968, and "Notes by the Artist on Selected Drawings," pp. 155–168, reprinted in part from bibl. 24 and 109.

General Works

62 Amaya, Mario. *Pop Art . . . and After*. A Studio Book. New York: Viking, 1965. pp. 92–93 and *passim*.

63 Arnason, H.H. *History of Modern Art: Painting, Sculpture, Architecture*. New York: Harry N. Abrams, 1968. pp. 412, 567, 570, 581, 584, 597, 598.

64 Becker, Jürgen. *Happenings. Fluxus. Pop Art. Nouveau Réalisme.* Hamburg: Rowohlt, 1965.

65 Boatto, Alberto. *Pop Art in U.S.A.* Milan: Lerici, 1967. Includes statement by artist.

66 Crispolti, Enrico. *La Pop Art.* Milan: Fratelli Fabbri, 1966.

67 Cummings, Paul. *A Dictionary of Contemporary American Artists.* New York: St. Martin's Press, 1966. pp. 224–225.

68 Dienst, Rolf-Günter. *Pop Art: Eine kritische Information.* Wiesbaden: Limes, 1965. pp. 33–35.
Includes, pp. 115–116, German translation of statement, "I am for an art ..." (bibl. 4).

69 Dietrich, Hans-Joachim. *Pop Art–Do It Yourself.* Düsseldorf: Kalender, 1963. 3 illustrations.

70 Finch, Christopher. *Pop Art: Object and Image.* London and New York: Studio Vista/Dutton Pictureback, 1968. pp. 51–55 and *passim.*

71 Hammacher, A. M. *The Evolution of Modern Sculpture: Tradition and Innovation.* New York: Harry N. Abrams, 1969. pp. 295, 296, 299.

72 Hansen, Al. *A Primer of Happenings & Time/Space Art.* New York: Something Else Press, 1965. pp. 30–33, 61–67.

73 Herzka, D. *Pop Art One.* New York: Publishing Institute of American Art, 1965. 4 illustrations; biog.

74 Janis, Harriet and Rudi Blesh. *Collage: Personalities, Concepts, Techniques.* Philadelphia and New York: Chilton, 1962. pp. 273–279.

75 Kaprow, Allan. *Assemblage, Environments and Happenings.* New York: Harry N. Abrams, 1966. *passim.*

76 Kirby, Michael. *The Art of Time.* New York: E. P. Dutton, 1969. pp. 85–88.

77 ———. *Happenings: An Illustrated Anthology.* New York: E. P. Dutton, 1965. "Introduction," pp. 9–42, *passim;* pp. 200–288. See bibl. 11.

78 Kostelanetz, Richard. *The Theater of Mixed Means.* New York: Dial, 1968. Part 2 includes conversation with Oldenburg.

79 Kozloff, Max. *Renderings.* New York: Simon and Schuster, 1968. Includes "The Poetics of Softness," pp. 223–235, reprinted from bibl. 257, and "Happenings: The Theater of Mixed Means," pp. 236–243, reprinted from bibl. 140.

80 Lebel, J.J. *Le "Happening."* Paris: Editions de Noël, 1966.

81 Lippard, Lucy. *Pop Art.* New York: Frederick A. Praeger, 1966. pp. 106–111 and *passim.*

82 Lucie-Smith, Edward. *Late Modern: The Visual Arts since 1945.* New York: Frederick A. Praeger, 1969. pp. 150–151.

83 McDarrah, Fred W. *The Artist's World in Pictures.* New York: E. P. Dutton, 1961. Introduction by Thomas B. Hess. Commentary by Gloria Schoffel McDarrah. pp. 182–183.

84 Metro. *International Directory of Contemporary Art.* Milan: Metro, 1964. pp. 274–275.

85 *New York: The New Art Scene.* New York: Holt, Rinehart, Winston, 1967. Photographs by Ugo Mulas, text by Alan Solomon. pp. 55, 58, 196–211.

86 Pellegrini, Aldo. *New Tendencies in Art.* New York: Crown, 1966.

87 Rose, Barbara. *American Art since 1900: A Critical History.* New York: Frederick A. Praeger, 1967. pp. 221–223, 268–269.

88 Rublowsky, John. *Pop Art.* Photography by Ken Heyman; foreword by Samuel Adams Green. New York: Basic Books, 1965. pp. 60–86, including quotations from artist.

89 Russell, John, and Suzi Gablik. *Pop Art Redefined.* New York: Frederick A. Praeger, 1969. pp. 95–99.
Includes artist's statements, "On the Bedroom" (bibl. 27) and "I am for an art ..." (bibl. 4).

90 Scholz-Wanckel, Katharina. *Pop-Import: Eine selective Abhandlung über Pop Artisten.* Hamburg: Matari [1965], pp. 50–57.

Articles and Reviews

91 Adrian, Dennis. "New York: Claes Oldenburg," *Artforum* (Los Angeles), May 1966, p. 50.
Review of one-man show at Janis Gallery (see bibl. 242).

92 Altman, Jack. "Claes Oldenburg: The Super, Giant, Economy-Sized Fantasies of the King of Neubern," *Midwest* (magazine of *Chicago Sun Times*), February 18, 1968, pp. 6, 8, 10–12, 15, and cover.
Includes quotations from the artist.

93 Ashton, Dore. "New York Commentary," *Studio* (London), January 1963, pp. 25–26.
Review of one-man show at Green Gallery, September–October 1962 (also reviewed in "New York Letter," *Kunstwerk* [Baden-Baden], January 1963).

94 ———. "New York Commentary," *Studio International* (London), May 1966, pp. 204–205.
Review of one-man show at Janis Gallery (see bibl. 242).

95 Baro, Gene. "Claes Oldenburg, or the Things of This World," *Art International* (Zurich), November 1966, pp. 40–43, illus. pp. 45–48.
Includes quotations from *Store Days* (bibl. 23) and catalogue of one-man show, Moderna Museet, Stockholm (bibl. 246).

96 "Big City Boy." *Newsweek,* March 21, 1966, p. 100.
Review of one-man show at Janis Gallery (see bibl. 242).

97 Bourdon, David. "Claes Oldenburg." *Konstrevy* (Stockholm), vol. 40, nos. 5–6 (November–December), 1964, pp. 164–169.

98 ———. "Claes Oldenburg's *Store Days,*" *Village Voice* (New York), December 28, 1967, p. 6.
Review of bibl. 23.

99 ———. "Immodest Proposals for Monuments," *New York World Journal Tribune,* January 8, 1967, pp. 22–23.

100 Breer, Robert. "What Happened?," *Film Culture* (New York), Fall 1962, p. 58.
On the making of *Pat's Birthday* (bibl. 45).

101 Broadwater, Bowden. "He Raises Monuments to the Commonplace," *Newsday* (Long Island), May 8, 1967.
On one-man show at Janis Gallery (see bibl. 256).

102 B[rown], G[ordon]. "In the Galleries," *Arts Magazine* (New York), May 1967, p. 65.
Review of one-man show at Janis Gallery (see bibl. 256).

103 Canaday, John. "Maybe Hopeful: Symptoms in a New Pop Exhibition," *New York Times,* April 12, 1964.
Review of one-man show at Janis Gallery (see bibl. 220).

104 Carroll, Paul. "Ode to Oldenburg," *Art Scene* (Chicago), May 1969, pp. 6–7.
Poem, accompanied by illustrations "From Oldenburg's Notebooks," pp. 8–9 and cover.

105 Coplans, John. "Pop Art USA," *Artforum* (Los Angeles), October 1963, pp. 27–30.
Reprinted from bibl. 215.

106 Fahlström, Oyvind. "Object-Making." *Studio International* (London), December 1966, pp. 328–329.
Translation of essay in catalogue of one-man show, Moderna Museet (bibl. 246).

107 Finch, Christopher. "Notes for a Monument to Claes Oldenburg," *Art News* (New York), October 1969, pp. 52–56.

108 ——. "The Object in Art," *Art and Artists* (London), May 1966, pp. 18–21.

109 Flynn, Betty. "You Can Take an Object and Change It from Small to Big to Colossal," *Panorama* (magazine of *Chicago Daily News*), July 22, 1967, pp. 2–3.
Accompanied by artist's description of *Giant Windshield Wiper* (see bibl. 61).

110 F[rança], J.-A. "Expositions à Paris: Claes Oldenburg," *Aujourd'hui* (Paris), January 1965, p. 86.
Review of one-man show at Ileana Sonnabend (see bibl. 228).

111 Fried, Michael. "New York Letter," *Art International* (Zurich), October 25, 1962, pp. 74, 76.
Review of one-man show at Green Gallery, September–October 1962.

112 G., D. "Oldenburg, the 'Soft-Touch' Artist," *Aspen Times* (Aspen, Colorado), August 10, 1967, p. 9 C.
Includes excerpts from interview with artist.

113 Gassiot-Talabot, Gerald. "Lettre de Paris," *Art International* (Zurich), December 1964, pp. 55–56.
Review of one-man show at Ileana Sonnabend (see bibl. 228).

114 Genauer, Emily. "The Large Oldenburgs and Small Van Goghs," *New York Herald-Tribune*, April 12, 1964, p. 39.
Review of one-man show at Janis Gallery (see bibl. 220).

115 Glauber, Robert. "Oldenburg and Wiley: Artistic Involvement in the Crisis of Our Time," *Skyline* (Chicago), May 21, 1969.
On one-man show at Feigen Gallery (see bibl. 285).

116 Glueck, Grace. "New York Gallery Notes," *Art in America* (New York), May–June 1967, pp. 115–116.
Review of one-man show at Janis Gallery (see bibl. 256).

117 ——. "Soft Sculpture or Hard—They're Oldenburgers," *New York Times Magazine*, September 21, 1969, pp. 28–29, 100, 102, 104–105, 107–109, 114–115 and cover.
Includes statements by the artist.

118 Goodman, Percival. "Proposed Colossal Monument for Park Avenue, Good Humor," *Progressive Architecture* (New York), June 1966, p. 228.

119 Graham, Dan. "Models and Monuments," *Arts Magazine* (New York), March 1967, pp. 32–35.

120 ——. "Oldenburg's Monuments," *Artforum* (New York), January 1968, pp. 30–37 and cover.

121 Granath, Ollie. "How I Learned To Love the Tube: Reflections Surrounding a Stockholm Visitor," *Konstrevy* (Stockholm), Vol. 42, nos. 5–6 (November–December) 1966, pp. 221–224.
In Swedish; English summary in supplement.

122 Gruen, John. "Things That Go Limp," *New York Magazine*, September 1, 1969, p. 57.

123 Hale, Barrie. "One Artist's Response to Toronto," *Telegram* (Toronto), January 17, 1967, p. 40.

124 Halstead, Whitney. "Chicago," *Artforum* (New York), September 1969, pp. 67–68.
Review of one-man show at Feigen Gallery (see bibl. 285).

125 Hansen, Al. "New Trends in Art," *Prattler* (New York), May 4, 1962, p. 4.
Review of Ray Gun Theater.

126 "A Happening," *Scene* (New York), August 1962, pp. 13–14.
Review of *Nekropolis*.

127 "Les Idées de Claes Oldenburg," *Aujourd'hui* (Paris), January 1967, pp. 132–134.
Picture story apropos of one-man show at Ileana Sonnabend (see bibl. 228).

128 Johnson, Ellen H. "Is Beauty Dead?," *Allen Memorial Art Museum Bulletin* (Oberlin, Ohio), Winter 1963, pp. 56–65.
On exhibition "Three Young Americans" at Oberlin (see bibl. 209).

129 ——. "The Living Object," *Art International* (Zurich), January 25, 1963, pp. 42–45.

130 J[ill] J[ohnston]. "Art without Walls: Claes Oldenburg," *Art News* (New York), April 1961, pp. 36, 57.
Review of *Ironworks/Fotodeath*.

131 ——. "Claes Oldenburg," *Art News* (New York), May 1962, p. 55.
On Ray Gun Theater.

132 ——. "Exhibitions for 1961–62: Claes Oldenburg," *Art News* (New York), January 1962, pp. 47, 60.
Review of The Store.

133 ——. "Reviews and Previews: Claes Oldenburg," *Art News* (New York), November 1962, p. 13.
Review of one-man show at Green Gallery.

134 ——. "Reviews and Previews: Claes Oldenburg," *Art News* (New York), May 1964, p. 12.
Review of one-man show at Janis Gallery (see bibl. 220).

135 Johnston, Jill. "Off Off-Broadway; 'Happenings' at Ray Gun Mfg. Co.," *Village Voice* (New York), April 26, 1962, p. 10.

136 J[udd], D[onald]. "Exhibition at the Janis Gallery," *Arts Magazine* (New York), September 1964, p. 63.
Review of one-man show at Janis Gallery (see bibl. 220).

137 Judd, Donald. "Specific Objects," *Arts Yearbook 8: Contemporary Sculpture* (New York: The Art Digest, © 1965), pp. 74–78.

138 Kelly, E.T. "Neo-Dada: A Critique of Pop Art," *Art Journal* (New York), Spring 1964, pp. 197–199.

139 Kostelanetz, Richard. [Review of *Store Days* (bibl. 23)]. *Kenyon Review* (Gambier, Ohio), Vol. 30, No. 3, 1968, pp. 413–418.

140 Kozloff, Max. "Art," *Nation* (New York), July 3, 1967, pp. 27–29.
Includes review of *Store Days* (bibl. 23). Reprinted in bibl. 220 as "Happenings. The Theater of Mixed Means."

141 ——. "New Works by Oldenburg," *Nation* (New York), April 27, 1964, pp. 445–446.
Review of one-man show at Janis Gallery (see bibl. 220).

142 "Il Lavoro di Oldenburg nel suo grande studio a New York," *Domus* (Milan), May 1966, pp. 54–56.
Picture story with photographs by Ugo Mulas.

143 Levin, Meyer and Eli Levin. "Painter Gives Intimacy to Art," syndicated review appearing in *Long Island Sunday Press, Philadelphia Inquirer*, etc., November 15, 1959.
Review of "Oldenburg–Dine" at Judson Gallery, November–December 1959.

144 Linde, Ulf. "Claes Oldenburg at the Moderna Museet: Two Contrasting Viewpoints," *Studio International* (London), December 1966, pp. 326–328.
Translation of essay in catalogue of one-man show, Moderna Museet (bibl. 246). Followed by essay by Oyvind Fahlström (bibl. 106).

145 Lippard, Lucy. "Homage to the Square," *Art in America* (New York), July 1967, p. 50.
Statement by artist on "Proposed Monument for Intersection of Broadway and Canal Street."

146 "The Master of the Soft Touch," *Life* (New York), November 21, 1969, pp. 58–64 D.
Includes statements by the artist.

147 McDonagh, Don. "Oldenburg," *Financial Times* (London), November 13, 1969.

148 Mekas, Jonas. "Movie Journal," *Village Voice* (New York), February 3, 1966, p. 21.
On *Hanging a Picture* and other John Jones films (bibl. 50–52); includes statements by the artist.

149 Mellow, James R. "New York," *Art International* (Zurich), Summer 1967, p. 49.
Review of one-man show at Janis Gallery (see bibl. 256).

150 Melville, Robert. "Common Objects," *New Statesman* (London), November 25, 1966, p. 804.
Review of one-man show at Robert Fraser Gallery (see bibl. 251).

151 ———. "Exhibit at the Robert Fraser Gallery," *Architectural Review* (London), February 1967, pp. 141–142.

152 "New Talent USA," *Art in America* (New York), 1962, No. 1, pp. 32–33. Includes brief comment by artist.

153 Nichols, Robert. "Entertainment: Ironworks Fotodeath," *Village Voice* (New York), March 2, 1961.

154 Nordland, Gerald. "Marcel Duchamp and Common Object Art," *Art International* (Zurich), February 1964, pp. 30–32.
Review of one-man show at Dwan Gallery, Los Angeles, October 1963.

155 Novick, Elizabeth. "Happenings in New York," *Studio International* (London), September 1966, pp. 154–159.
Review of First New York Theater Rally, including *Washes*.

156 Oeri, Georgine. "The Object of Art," *Quadrum* (Brussels), 1964, No. 16, pp. 4–26.
Includes review of *Bedroom Ensemble*, pp. 4–6.

157 Overy, Paul. "Sticklike and Drooping," *Listener* (London), December 22, 1966.
Review of one-man show at Robert Fraser Gallery (see bibl. 251).

158 Picard, Lil. "Voyeurama: Soft Imitations of Hard Objects," *East Village Other* (New York), April 1–15, 1966, p. 11.
Review of one-man show at Janis Gallery (see bibl. 242).

159 Preston, Stuart. "Current and Forthcoming Exhibitions: New York," *Burlington Magazine* (London), November 1962, p. 508.
Review of one-man show at Green Gallery, September–October 1962.

160 Price, Jonathan. "CO: or I Spent Four Very Long Years at Yale—I Can't Remember Anything About Them," *Yale Alumni Magazine* (New Haven), December 1968, pp. 26–31.
Includes quotations from the artist.

161 Ragon, Michel. "Oldenburg, ou art alimentaire," *Arts* (Paris), October 28, 1964.
Review of one-man show at Ileana Sonnabend (see bibl. 228).

162 Reichardt, Jasia. "Bridges and Oldenburg," *Studio International* (London), January 1967, pp. 2–3.

163 ———. "Gigantic Oldenburgs," *Architectural Design* (London), November 1966, p. 534.
Review of one-man shows at Moderna Museet, Stockholm, and Robert Fraser Gallery (see bibl. 246 and 251).

164 Restany, Pierre. "Claes Oldenburg 1965 e i disegni di 'Monumenti Giganti' per New York," *Domus* (Milan), December 1965, pp. 50–53.

165 ———. "Une personnalité charnière de l'art américain: Claes Oldenburg, premières œuvres," *Metro 9* (Milan), March–April 1965, pp. 20–26.

166 ———. "Le Raz de marée réaliste aux USA," *Domus* (Milan), February 1963, pp. 33–35.

167 ———. "Une Tentative américaine de synthèse de l'information artistique: Les Happenings," *Domus* (Milan), August 1963, pp. 35–42.

168 Richard, Paul. "The Man Who Wants To Make Real Monuments," *Washington Post-Times-Herald*, October 12, 1969.

169 Rigg, Margaret. "The Art of Protest," *Civil Liberties* (New York), February 1969, pp. 16–20.
On "Richard F. Daley" exhibition (see bibl. 282). Includes letter from the artist.

170 Robertson, Bryan. "Very Lovely Home," *Spectator* (London), December 2, 1966.
Review of one-man show at Robert Fraser Gallery (see bibl. 251).

171 Rose, Barbara. "Claes Oldenburg's Soft Machines," *Artforum* (New York), Summer 1967, pp. 30–35.

172 ———. "New York Letter," *Art International* (Zurich), April 1964, p. 53.
Review of "Four Environments" at Janis Gallery, January 1964.

173 ———. "New York Letter," *Art International* (Zurich), Summer 1964, p. 80.
Review of one-man show at Janis Gallery (see bibl. 220).

174 ———. "Oldenburg Joins the Revolution," *New York Magazine,* June 2, 1969, pp. 54–57.
On Lipstick Monument at Yale University.

175 ———. "The Origin, Life and Times of Ray Gun," *Artforum* (New York), November 1969, pp. 50–57.

176 ———. "The Politics of Art, Part II," *Artforum* (New York), January 1969, pp. 44–49.

177 Rosenberg, Harold. "From Pollock to Pop: 20 Years of Painting and Sculpture," *Holiday* (New York), March 1966, pp. 96–104, 136–140.

178 ———. "Marilyn Mondrian," *New Yorker,* November 8, 1969, pp. 167–170, 173–176.
Includes review of one-man show at Museum of Modern Art (see bibl. 289).

179 H[arris], R[osenstein]. "Exhibit at Janis Gallery," *Art News* (New York), Summer 1967, p. 64.
Review of one-man show at Janis Gallery (see bibl. 256).

180 Rosenstein, Harris. "Climbing Mt. Oldenburg," *Art News* (New York), February 1966, pp. 22–25, 56–59.
Includes excerpts paraphrased from a 1964 interview.

181 Rudikoff, Sonya. "New Realists in New York," *Art International* (Zurich), January 25, 1963, pp. 39–41.
Review of "New Realists" show at Janis Gallery (see bibl. 207).

182 Russell, John. "London," *Art News* (New York), February 1967, p. 58.
Review of one-man show at Robert Fraser Gallery (see bibl. 251).

183 Russell, Paul. "Dine/Oldenburg/Segal: Painting, Sculpture," *Arts Canada* (Ottawa), February 1967, Supplement p. 3.
Review of exhibition at Art Gallery of Ontario (see bibl. 254).

184 S[andler], I[rving] H[ershel]. "Reuben Gallery," *Art News* (New York), Summer 1960, p. 16.
Review of The Street.

185 Sandler, Irving Hershel. "New York Letter," *Quadrum* (Brussels), 1963, No. 14, pp. 115–124.
Includes review of "New Realists" exhibition at Janis Gallery (see bibl. 207).

186 ———. "Ash Can Revisited, A New York Letter," *Art International* (Zurich), October 1960, pp. 28–30.
Review of "New Forms–New Media" at Jackson Gallery (see bibl. 204).

187 Schlanger, J. "Oldenburg: Extension of Drawing, Sculpture, Time and Life at Janis Gallery," *Craft Horizons* (New York), June 1966, pp. 88–90.

188 Schulze, Franz. "Sculptor Claes Oldenburg: A Wry View of the 'Locked Mind of Chicago' and its Ruthless, Dominating Edifices," *Panorama* (magazine of *Chicago Daily News*), May 17, 1969, pp. 4–5.
On one-man show at Feigen Gallery (see bibl. 285).

189 Smith, Brydon. "Claes Oldenburg," *Gallery Notes,* Albright-Knox Gallery (Buffalo), Autumn 1966, pp. 20–21.

190 "Soft in the Head," *Progressive Architecture* (New York), July 1966, p. 178.
On one-man show at Janis Gallery (see bibl. 242).

191 Solomon, Alan R. "The New American Art," *Art International* (Zurich), March 20, 1964, pp. 50–55.
Translation of essay in exhibition catalogue, "Amerikansk popkonst" (bibl. 218).

192 Sottsass, Ettore, Jr. "Soft Typewriter 1963," *Domus* (Milan), July 1964, p. 48.

193 Sylvester, David. "The Soft Machines of Claes Oldenburg," *Vogue* (New York), February 1, 1968, pp. 166, 209, 211–212.

Accompanied by "Sculpture by Claes Oldenburg: Photographed by Lord Snowdon," pp. 168–169.

194 T[illim], S[idney]. "In the Galleries: Claes Oldenburg," *Arts Magazine* (New York), June 1960.
Review of The Street at Reuben Gallery.

195 Tillim, Sidney. "Month in Review: New York Exhibitions," *Arts Magazine* (New York), February 1962, pp. 34–37.
Review of The Store.

196 ———. "Month in Review: New York Exhibitions," *Arts Magazine* (New York), November 1962, pp. 36–39.
Includes review of one-man show at Green Gallery, September–October 1962.

197 Trini, Tommaso. "Un Diario segreto di quadri celebri: La Collezione Panza di Biumo," *Domus* (Milan), January 1968, p. 51.

198 ———. [Review of *Store Days* (bibl. 23)], *Domus* (Milan), August 1967, p. 45.

199 Tuten, Frederic. [Review of *Store Days* (bibl. 23)], *Arts Magazine* (New York), September–October 1967, p. 63.

200 "The Venerability of Pop," *Time* (New York), October 10, 1969, pp. 68–69 and illus.

201 V[entura], A[nita]. "In the Galleries: Claes Oldenburg, James Dine," *Arts Magazine* (New York), December 1959, p. 59.
Review of Oldenburg–Dine show at Judson Gallery.

202 Willard, Charlotte. "In the Art Galleries: Metamorphosis," *New York Post,* May 6, 1967, p. 48.
Review of one-man show at Janis Gallery (see bibl. 256).

203 Yates, Peter. "Non-Art," *Arts and Architecture* (Los Angeles), July 1967, pp. 30–32.
Review of *Store Days* (bibl. 23).

Exhibition Catalogues

(arranged chronologically)

204 New York. Martha Jackson Gallery. "New Forms – New Media I." June 6–24, 1960. 1 work.
Foreword by Martha Jackson. Texts by Lawrence Alloway and Allan Kaprow. Cover by Oldenburg.

205 New York. Martha Jackson Gallery. "Environments, Situations, Spaces." May 25–June 23, 1961.
Statement by the artist (see bibl. 4).

206 Dallas. Dallas Museum for Contemporary Arts. "1961." April 3–May 13, 1962.
Foreword by D[ouglas] M[acAgy].

207 New York. Sidney Janis Gallery. "New Realists." November 1–December 1, 1962. 3 works.
Foreword by Sidney Janis. Text by John Ashbery and Pierre Restany.

208 Los Angeles. Dwan Gallery. "My Country 'Tis of Thee." November 18–December 15, 1962. 1 work.
Introduction by Gerald Nordland.

209 Oberlin, Ohio. Allen Memorial Art Museum, Oberlin College. "Three Young Americans." January 8–29, 1963. 11 works.
Catalogue published in *Allen Memorial Art Museum Bulletin,* Winter 1963 issue, with cover by Oldenburg. See also bibl. 128.

210 Chicago. Art Institute of Chicago. "66th Annual American Exhibition: Directions in Contemporary Painting and Sculpture." January 11–February 10, 1963. 3 works.

211 New York. Thibaut Gallery. "According to the Letter." January 15–February 9, 1963. 1 work.
Flyer; text by Nicolas Calas.

212 Washington. Washington Gallery of Modern Art. "The Popular Image." April 18–June 2, 1963. 2 works.
Foreword by Alice M. Denney. Text by Alan R. Solomon (reprinted in *Art International,* September 1963, pp. 37–41, as "The New Art").

213 Kansas City. Nelson Gallery–Atkins Museum. "Popular Art: Artistic Projections of Common American Symbols." April 28–May 26, 1963. 12 works.
Text by Ralph T. Coe.

214 New York. Museum of Modern Art. "Americans 1963." May 22–August 18, 1963. 11 works.
Edited by Dorothy C. Miller. Statement by the artist from bibl. 4.

215 Oakland, California. Oakland Art Museum. "Pop Art USA." September 7–29, 1963. 1 work.
Text by John Coplans.

216 London. Institute of Contemporary Arts. "The Popular Image." October 24–November 23, 1963.
Organized in collaboration with Galerie Ileana Sonnabend, Paris. Text by Alan Solomon.

217 Buffalo. Albright-Knox Art Gallery. "Mixed Media and Pop Art." November 19–December 15, 1963. 1 work.
Foreword by Gordon M. Smith.

218 Stockholm. Moderna Museet. "Amerikansk pop-konst." February 29–April 12, 1964. 40 works.
Foreword by K. G. Hultén. Introduction by Alan R. Solomon. Text by Billy Klüver, Nils-Hugo Geber, and others. Exhibition subsequently shown at Louisiana Museum, Humlebaek (Copenhagen) and Stedelijk Museum, Amsterdam (see bibl. 224).

219 Middletown, Connecticut. Davison Art Center, Wesleyan University. "The New Art." March 1–22, 1964. 1 work.
Foreword by Lawrence Alloway.

220 New York. Sidney Janis Gallery. "Recent Work by Claes Oldenburg." April 7–May 2, 1964.

221 London. Tate Gallery. "Painting and Sculpture of a Decade, 1954–64." April 22–June 28, 1964. Sponsored by the Calouste Gulbenkian Foundation.

222 Waltham, Massachusetts. Rose Art Museum, Brandeis University. "Boston Collects Modern Art." May 24–June 14, 1964. 1 work.
Introduction by Sam Hunter.

223 Venice. U.S. Representation, XXXII International Biennial Exhibition of Art. "Four Germinal Painters—Four Younger Artists." June 20–October 15, 1964.
Text by Alan R. Solomon. Biog., bibl.

224 Amsterdam. Stedelijk Museum. "American Pop Art." June 22–July 26, 1964. 25 works.
Introduction by Alan R. Solomon, adapted from bibl. 218.

225 The Hague. Gemeente Museum. "Nieuwe Realisten." June 24–August 30, 1964.
Exhibition later shown in variant form at Vienna, Museum des 20. Jahrhunderts (bibl. 227), Berlin, Akademie der Kunst (bibl. 231), and Brussels, Palais des Beaux-Arts (bibl. 234).

226 New York. Solomon R. Guggenheim Museum. "American Drawings." September–October 1964. 3 works.
Introduction by Lawrence Alloway.

227 Vienna. Museum des 20. Jahrhunderts "Pop etc." September 19–October 31, 1964. 2 works.
Preface by W. H. Texts by Werner Hofmann, Otto A. Graf, and others (see bibl. 225, 231, and 234).

228 Paris. Galerie Ileana Sonnabend. "Claes Oldenburg." October–November 1964.
Text by Otto Hahn.

229 Pittsburgh. Carnegie Institute Museum of Art. "1964 Pittsburgh International Exhibition of Contemporary Painting and Sculpture." October 30, 1964–January 10, 1965. 1 work.

230 New York. Sidney Janis Gallery. "3 Generations." November 24–December 26, 1964. 1 work.

231 Berlin. Akademie der Kunst. "Neue Realisten und Pop Art." November 1964–January 1965. 2 works.
Introduction by Werner Hofmann (see bibl. 225, 227, and 234).

232 New York. Whitney Museum of American Art. "1964 Annual Exhibition of Contemporary American Sculpture." December 9, 1964–January 31, 1965. 1 work.

233 New York. Solomon R. Guggenheim Museum. "Eleven from the Reuben Gallery." January 1965.
Introduction by Lawrence Alloway.

234 Brussels. Palais des Beaux-Arts. "Pop Art – Nouveau Réalisme – Etc." February 5–March 1, 1965. 6 works.
Text by Jean Dypréau and Pierre Restany. Variant form of exhibition first shown at The Hague (see bibl. 225, 227, and 231).

235 Worcester, Massachusetts. Worcester Art Museum. "The New American Realism." February 18–April 4, 1965.
Preface by Daniel Catton Rich. Introduction by Martin Carey.

236 New York. Whitney Museum of American Art. "A Decade of American Drawing, 1955–65." April 28–June 6, 1965. 1 work.
Foreword by Donald M. Blinken.

237 Zurich. City-Galerie. "Pop Art?" June 15–July 10, 1965. 2 works.
Introduction by Otto Hahn. Biog., bibl.

238 Paris. Musée Rodin. "Etats-Unis – Sculpture du XXᵉ siècle." June 22–October 16, 1965. 2 works.
Organized by The Museum of Modern Art, New York. Subsequently shown at Berlin, Hochschule für Bildende Künste. November 20, 1965–January 6, 1966, and Baden-Baden, Staatliche Kunsthalle, March–April 1966.

239 New York. Bianchini Gallery. "Master Drawings – Pissarro to Lichtenstein." January 15–February 5, 1966. 1 work.
Preface by William Albers Leonard. Exhibition shown at Contemporary Arts Center, Cincinnati, February 7–26.

240 Philadelphia. Institute of Contemporary Art, University of Pennsylvania. "The *Other* Tradition." January 7–March 7, 1966.
Text by Gene R. Swenson.

241 Providence. Museum of Art, Rhode Island School of Design. "Recent Still Life." February 23–April 4, 1966. 3 works.
Text by Daniel Robbins. Biog.

242 New York. Sidney Janis Gallery. "New Work by Claes Oldenburg." March 9–April 2, 1966.
Includes excerpts "from studio notes by C.O."

243 Boston. Institute of Contemporary Art. "Multiplicity." April 16–May 27, 1966. 1 work.

244 Waltham, Massachusetts. Rose Art Museum, Brandeis University. "Selections from the Permanent Collection." May 15–September 3, 1966. 1 work.
Foreword by William C. Seitz.

245 New York. Museum of Modern Art. "The Object Transformed." June 28–August 21, 1966. 1 work.
Introduction by Mildred Constantine and Arthur Drexler.

246 Stockholm. Moderna Museet. "Claes Oldenburg: Skulpturer och teckningar, 1963–67." September 17–October 30, 1966.
Texts by Oyvind Fahlström and Ulf Linde (see bibl. 106 and 144). Statements by the artist. Biog., bibl.

247 Ridgefield, Connecticut. Larry Aldrich Museum. "Selections from the John G. Powers Collection." September 25–December 11, 1966. 1 work.
Introduction by Larry Aldrich. Text by John G. Powers.

248 New York. Whitney Museum of American Art. "The Art of the U.S.: 1670–1966." September 28–November 27, 1966. 1 work.
Text by Lloyd Goodrich.

249 New York. American Federation of Arts. "Art in Process: The Visual Development of a Collage." September 1966. 1 work.
Traveling exhibition (shown at Finch College Art Museum, New York, March 1967).

250 Minneapolis. Walker Art Center. "Eight Sculptors: The Ambiguous Image." October 22–December 4, 1966.
Introduction by Martin Friedman. Text on Oldenburg by Jan van der Marck. Biog., bibl.

251 London. Robert Fraser Gallery. "Claes Oldenburg." November 22–December 31, 1966.
Text by Gene Baro.

212

252 New York. Whitney Museum of American Art. "1966 Annual Exhibition of Contemporary Sculpture and Prints." December 16, 1966–February 5, 1967. 1 work.

253 Washington. Washington Gallery of Modern Art. "Permanent Collection." 1967. 1 work.
Introduction by Gerald Nordland.

254 Toronto. Art Gallery of Ontario. "Dine, Oldenburg, Segal." January 14–February 12, 1967. 23 works.
Preface by Brydon Smith. Text on Oldenburg by Ellen H. Johnson. Exhibition subsequently shown at Albright-Knox Art Gallery, Buffalo, February 24–March 26.

255 Ithaca, New York. Ithaca College Art Museum. "Selected New York City Artists, 1967." April 4–May 26, 1967. 5 works.
Introduction by Harris Rosenstein.

256 New York. Sidney Janis Gallery. "New Work by Claes Oldenburg." April 26–May 27, 1967.
See also bibl. 24.

257 Los Angeles. Los Angeles County Art Museum. "American Sculpture of the Sixties." April 28–June 25, 1967. 10 works.
Texts by Lawrence Alloway, Wayne V. Andersen, Dore Ashton, John Coplans, Clement Greenberg, Max Kozloff, Lucy R. Lippard, James Monte, Barbara Rose, and Irving Sandler. Biog., bibl. Exhibition subsequently shown at Philadelphia Museum of Art.

258 Houston. University of St. Thomas Art Department. "Mixed Masters." May 19–September 24, 1967. 2 works.
Introduction by Kurt von Meier.

259 Venice. Centro Internazionale delle Arti e del Costume, Palazzo Grassi. "Campo Vitale." July 27–October 8, 1967.
Text by Paolo Marinotti.

260 Cologne. Verein progressiver deutscher Kunsthändler. "Kunst Markt '67." September 13–October 8, 1967. 3 works.

261 São Paulo. Museu de Arte Moderna. "São Paulo IX: Environment U.S.A. 1957–67." September 22, 1967–January 8, 1968. 1 work.
Catalogue published by National Collection of Fine Arts, Smithsonian Institution. Text by William Seitz and Lloyd Goodrich. Statement by artist (see bibl. 27). Biog., bibl. Exhibition later shown at Brandeis University, Waltham, Massachusetts, February 19–March 23, 1968.

262 Boston. 180 Beacon Street. "The 180 Beacon Street Collection of Contemporary Art" [The Max and Jeanne Wasserman Collection]. October 1967.
Introduction by Sam Hunter.

263 New York. Administration of Recreation and Cultural Affairs. "Sculpture in Environment," Cultural Showcase Festival. October 1–31, 1967. 1 work.
Text by Irving Sandler.

264 St. Louis. City Art Museum. "7 for 67: Works by Contemporary American Sculptors." October 1–November 12, 1967. 19 works.
Introduction by Charles E. Buckley. Catalogue by Emily S. Rauh.

265 Rochester, Michigan. University Art Gallery, Oakland University. "Personal Preference: The Collection of Mr. and Mrs. S. Brooks Barron." October 3–November 12, 1967. 1 work.
Introduction by Henry Geldzahler.

266 New York. Solomon R. Guggenheim Museum. "Guggenheim International Exhibition 1967: Sculpture from 20 Nations." October 20, 1967–February 4, 1968. 1 work.
Introduction by Edward F. Fry.

267 Pittsburgh. Carnegie Institute Museum of Art. "1967 Pittsburgh International Exhibition of Contemporary Painting and Sculpture." October 27, 1967–January 7, 1968. 1 work.

268 Eindhoven. Stedelijk van Abbemuseum. "Kompas 3: Painting after 1945 in New York." November 9–December 17, 1967. 3 works.
Preface by Jean Leering and Paul Wember. Text (in English and Dutch) by J. Leering. Exhibition subsequently shown at Frankfurt, Frankfurter Kunstverein, December 30, 1967–February 11, 1968.

269 Champaign, Illinois. Krannert Art Museum, University of Illinois at Champaign. "Claes Oldenburg, Drawings, Projects for Monuments." December 1–31, 1967.
Text by J. U. D. Rank. Exhibition originally shown at Museum of Contemporary Art, Chicago, October 24–November 26, 1967.

270 New York. Sidney Janis Gallery. "Homage to Marilyn Monroe." December 6–30, 1967. 3 works.

271 Philadelphia. Moore College of Art. "American Drawings, 1968." January 13–February 16, 1968. 1 work.
Introduction by Harold Jacobs.

272 New York. Museum of Modern Art. "The Sidney and Harriet Janis Collection." January 17–March 4, 1968. 2 works.
Text by Alfred H. Barr, Jr. Exhibition subsequently circulated through United States and Europe.

273 Irvine, California. Art Gallery, University of California at Irvine. "20th Century Works on Paper." January 30–February 25, 1968. 1 work.
Foreword by James Monte.

274 New York. Museum of Modern Art. "Dada, Surrealism, and Their Heritage." March 27–June 9, 1968. 3 works.
Text by William S. Rubin.
Exhibition subsequently shown at Los Angeles County Museum of Art and Art Institute of Chicago.

275 Eindhoven. Stedelijk van Abbemuseum. "Three Blind Mice: de Collecties: Visser, Peeters, Becht." April 6–May 19, 1968. 10 works.
Introduction by J. Leering and J. v. d. Walle. Text by W. A. L. Beeren, Dr. Hubert Peeters, Pierre Restany.

276 London. Nash House Gallery. "The Obsessive Image, 1960–68." April 10–May 29, 1968. 1 work.
Organized by the Institute of Contemporary Arts.
Foreword by Roland Penrose, Robert Melville. Text by Mario Amaya.

277 Cologne. Wallraf-Richartz Museum. "Sammlung Hahn Zeitgenössische Kunst." May 3–July 7, 1968. 2 works.
Introduction by Paul Wember. Biog.

278 Munich. Neue Pinakothek. Haus der Kunst. "Sammlung 1968 Karl Ströher." June 14–August 9, 1968. 22 works.
Organized by Galerie-Verein, Munich.

279 Kassel. Internationale Ausstellung. "Documenta 4." June 27–October 6, 1968. 4 works.
Text by Arnold Bode, Max Imdahl, J. Leering, Jürgen Harten, and Janni Müller-Hauch. Biog.

280 New York. Museum of Modern Art. "The Machine as Seen at the End of the Mechanical Age." November 25, 1968–February 9, 1969. 3 works.
Text by K. G. Pontus Hultén. Subsequently shown at Rice University, Houston, and San Francisco Museum of Art.

281 New York. Whitney Museum of American Art. "1968 Annual Exhibition of Sculpture." December 17, 1968–February 9, 1969. 1 work.

282 Cincinnati. Contemporary Arts Center. "Richard J. Daley." December 19, 1968–January 4, 1969. 4 works.
Introduction by J.S.M. Exhibition previously shown at Richard Feigen Gallery, Chicago, October 1968.

283 Vancouver, B.C. Vancouver Art Gallery. "New York 13." January 21–February 16, 1969. 2 works.
Introduction by Doris Shadbolt. Catalogue edited by Lucy Lippard, with excerpts from artists' statements. Exhibition later shown at Norman MacKenzie Art Gallery, Regina, and Musée d'Art Contemporain, Montreal.

284 Cologne. Wallraf-Richartz Museum. "Kunst der Sechziger Jahre — Sammlung Ludwig." February 28, 1969—. 4 works.
Text (in German and English) by Gert von der Osten, Peter Ludwig, and Evelyn Weiss. Inaugural exhibition of works on permanent loan.

285 Chicago. Richard Feigen Gallery. "Claes Oldenburg—Constructions, Models, and Drawings." April 30–May 31, 1969.
Catalogue by Claes Oldenburg, including comments "rewritten from notes kept in Chicago during my visits there since October 1967."

286 New York. Sidney Janis Gallery. "7 Artists." May 1–31, 1969. 11 works.

287 New York. Jewish Museum. "Superlimited: Books, Boxes, and Things." April 16–June 29, 1969. 5 works.
Introduction by Susan Tumarkin Goodman.

288 London. Hayward Gallery. "Pop Art." July 9–September 3, 1969. 9 works.
Organized by the Arts Council of Great Britain. Introduction by John Russell and Suzi Gablik (see also bibl. 89).

289 New York. Museum of Modern Art. "Claes Oldenburg." September 25–November 23, 1969.
Checklist. Introduction by Alicia Legg. Variant form circulated to Amsterdam, Düsseldorf, and London.

290 New York. Metropolitan Museum of Art. "New York Painting and Sculpture: 1940–1970." October 18, 1969–February 1, 1970. 5 works.
Introduction by Henry Geldzahler.

Index

Page numbers in italics signify illustrations.
Notes are indexed by page number, followed by "n."
and number of the note.

220